LAOCOON'S BODY AND THE AESTHETICS OF PAIN

LAOCOON'S BODY AND THE AESTHETICS OF PAIN

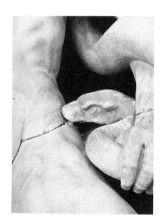

Winckelmann

Lessing

Herder

Moritz

Goethe

Simon Richter

Wayne State University Press

Detroit

KRITIK
German Literary Theory and Cultural Studies

Liliane Weissberg, *Editor*

BOOKS IN THIS SERIES

Walter Benjamin:
An Intellectual Biography
by Bernd Witte, trans. by
James Rolleston, 1991

The Violent Eye:
Ernst Jünger's Visions and
Revisions on the
European Right
by Marcus Paul Bullock, 1991

Fatherland: Novalis, Freud,
and the Discipline
of Romance
by Kenneth S. Calhoon, 1992

Metaphors of Knowledge:
Language and Thought in
Mauthner's Critique
by Elizabeth Bredeck, 1992

Laocoon's Body and the
Aesthetics of Pain:
Winckelmann, Lessing,
Herder, Moritz, Goethe
by Simon Richter, 1992

Copyright © 1992 by Wayne State University Press,
Detroit, Michigan 48202. All rights are reserved.
No part of this book may be reproduced without formal permission.
Manufactured in the United States of America.

97 96 95 94 93 92 6 5 4 3 2 1

Library of Congress Cataloging-in-Publication Data
Richter, Simon.
Laocoon's body and the aesthetics of pain : Winckelmann,
Lessing, Herder, Moritz, Goethe / Simon Richter.
p. cm. — (Kritik)
Includes bibliographical references and index.
ISBN 0-8143-2404-5 (alk. paper)
1. Athenodorus. Laocoön group. 2. Aesthetic, German—18th
century. 3. Aesthetics, German—19th century. I. Title. II. Series.
N64.R53 1992
700′.1—dc20 92-13152

Designer: Mary Krzewinski
Cover and Frontispiece art: Laocoon (with outthrust arm).
Reproduced with permission of the Vatican Museum, Rome.

CONTENTS

ILLUSTRATIONS

ACKNOWLEDGMENTS

This study was first written as a doctoral dissertation towards the completion of my degree in German at the Johns Hopkins University in 1990. Throughout its writing, I was guided and encouraged by Liliane Weissberg, whose scholarship, tolerance and good judgment continue to be a model for me. Michael Fried inspired me in his seminars and with his helpful commentary. I also profited generally from the opportunity of participating in the lively academic exchange fostered at Johns Hopkins. I would specifically like to thank Rainer Nägele, Werner Hamacher, Lieselotte Kurth, and Rüdiger Campe.

The graduate years are frequently not easy and I would like to acknowledge those whose friendship sustained me throughout this period: Reiner Ansen, Grady Harris, Fred Kapner, Mark van der Laan, Milan Rupic, Phoebe Sengers, Allen Weirick, Margaret van der Weit, and Rose van der Weit.

The generosity of my parents allowed me to visit Rome and see the Laocoon in March of 1988. I would like to express my gratitude to them, as well as to my brother and sister, for their continued love and support.

Finally, I would like to thank the editors and anonymous readers of Wayne State University Press for their insightful remarks and suggestions. It has been a pleasure to rethink and, in some cases, rework the manuscript in response to their intelligent comments. The responsibility for the book and all changes is of course my own.

INTRODUCTION

The once celebrated statue of Laocoon, the representation of a body in pain,[1] stands as it has for four centuries in the open Belvedere Courtyard of the Vatican Museum. A group of German tourists is among the first of the morning's visitors. There is no need to inform them, as their guide does, that they are standing in front of one of the most famous classical works of art—to them the Laocoon is a familiar cultural icon. The statue, the guide continues, exemplifies "edle Einfalt und stille Grösse" (noble simplicity and quiet grandeur), quoting the terms coined by Winckelmann that subsequently became the slogan of German classicism and classical aesthetics. The guide also urges them to trace the various movements of the figures, frozen in stone, back to their source in the snake-inflicted wound. This, he assures them, was the great insight of their nationally revered poet, Johann Wolfgang von Goethe.

Such scenes of packaged tourism, repeated numerous times daily, are generally not very edifying. Despite its banality, however, the present scene possesses several intriguing aspects. For one thing, there is the striking sense of a cultural continuity stretching from eighteenth-century Germany to the present. Even though housed abroad, the Laocoon statue is virtually a German cultural possession, as broadly meaningful to Germans today as it was two hundred years ago, and as it is to no other nation. The German tourists who consulted their Volkmann in the eighteenth-century learned much the same as their twentieth-century counterparts did from the tour guide.

The aura that surrounds the Laocoon depends on the beholder's remaining unaware of the jarring incongruity between the actual statue and the extravagant aesthetic and moral claims that attach to it. The eighteenth-century aesthetic and art-historical discourses must still have the beholder firmly in their grasp in order for her or him to be properly "blind" to the difference. Only in the twentieth-century and largely among

non-Germans has it become possible to note the wild discrepancy between Winckelmann's programmatic terms and what one British scholar called "this complicated, intricate, naturalistic piece of work, which is so painfully realistic at close quarters; and which, seen from a distance in its niche in the Vatican, resembles a decorative, graceful, fragile arabesque, of which every part is in motion."[2]

This description comes from E. M. Butler's polemical mid-century study of German classicism. Her insistence on the difference between the statue and the Winckelmannian terms to describe it is even rhetorically expressed in the asyndetic chain of anti-classical adjectives. Even so, her argument also succumbs to the power of the same eighteenth-century discourse she seeks to oppose. She has, perhaps unwittingly, paraphrased none other than Goethe, and from the very same essay to which the German tour guide referred.

This brings us to another intriguing aspect. The discursive continuity depends not only on overlooking the incongruity between the statue and the discourse that surrounds it, but also on a reluctance or an inability to notice that the discussions of the Laocoon by the major eighteenth-century luminaries do not fluidly dissolve into a single uniform discourse. By referring to Winckelmann and Goethe, the tour guide sets the stage for the potential awareness of a contradiction between their respective understandings of the Laocoon. Winckelmann, after all, places beauty, and a specialized classical beauty, at the center of his description and his aesthetics. Goethe, on the other hand, identifies the snake bite, the instant of intense bodily pain, as the statue's central point. In other words, a fundamental dichotomy seems to lie at the heart of both the statue and the discourse that concerns it—the dichotomy between pain and beauty.

There is no question that the Laocoon statue represents a body in pain. Nor is there any reason for us to decide if the Laocoon is a beautiful work of art. The single important fact is that eighteenth-century Germans since Winckelmann *theorized* the statue as beautiful and, in the course of their thinking, were obliged to deal with the question of pain in one way or another, even if by some strategy of avoidance.

The tendency among scholars in this century, however, to smile knowingly at the gaping discrepancy between statue and theory, while understandable, has had the unfortunate effect of dissociating pain and beauty before any question can be raised as to their relation. Once again, E. M. Butler can serve as an example:

> Nothing accounts so satisfactorily for Winckelmann's extraordinary blindness as the natural explanation that, dazzled by the flash of a great

revelation, he saw the distinctive qualities of Greek art as he looked at this supposedly genuine specimen. He was in fact in a trance; and like many another clairvoyant, he was uttering truths which did not apply to the object before him, but were associated with it in his mind.[3]

By Butler's account the Laocoon is merely the accidental object of Winckelmann's visionary aesthetics. It could as easily have been the Belvedere Apollo, the Antinous, or any other classical statue. But Winckelmann's descriptions of these other statues never attained the theoretical significance of the Laocoon, nor were they in any way as productive of discourse.

The argument of the present study is that there is nothing accidental about Winckelmann's choosing or being compelled to choose the Laocoon to bear the burden of his and subsequent aesthetic theorizing. On the contrary, I argue that the relation of pain and beauty is in every instance crucial to the various versions of classical aesthetics that were developed in the last half of the eighteenth century, whether we are speaking of Winckelmann and Goethe, or Lessing, Herder, and Moritz. To state my thesis as frankly and provocatively as possible: I argue that the classical aesthetics of beauty is at the same time, and even more, an aesthetics of pain. The serene surface of ideal beauty, as well as the equally serene surface of its discourse, simultaneously conceals *and is dependent on* some form of the dynamics of the infliction of bodily pain. Aesthetic discourse should no longer be artificially separated from the many other discourses that between them constitute a historically specific understanding of the human body.

In the chapters that follow, a series of close readings of individual texts by Winckelmann, Lessing, Herder, Moritz, and Goethe will show that each of these versions of classical aesthetic discourse is intersected by one of a variety of counter-classical discourses from "outside," discourses which more openly involve the body and entail violence (most are of a physiological or medical nature). The result of this rather unconventional contextualization will be an eccentric reading which, as it were, encircles the aesthetic discourse in order finally to attack it at its center, the point of pain. Each reading, in other words, is a double of the Laocoon statue itself.

Only the first chapter, "Laocoon's Two Bodies," is more conventional in its approach. Given the largely fragmented discussion of the Laocoon (in art history, aesthetics, archaeology, classics, literary studies, etc.) it seemed appropriate to attempt a more comprehensive account of the statue and the interpretive debates it has engendered. This approach also has the virtue of providing the reader with the necessary contextual and intertextual information needed for the close readings that follow.

1

Laocoon's Two Bodies

The entire complex debate that took place for centuries under the name of Laocoon, and even continues today, might never have occurred had it not been for a curious fold of history that brought Laocoon's two bodies, the ideal and the real, into jarring and unexpected contact. Before the sixteenth century, no one had seen the Laocoon since antiquity, but all were assured that it was an ideal work of art, calling on the authority of Pliny, who had said in his *Natural History*: "[The Laocoon] is a work to be preferred to all that the arts of painting and sculpture have produced. Out of one block of stone, the consummate artists, Hagesandros, Polydoros, and Athenodoros of Rhodes made, after careful planning, Laocoon, his sons, and the snakes marvelously entwined about them."[1] Pliny's high praise for the lost statue entitled all to conceive of the Laocoon, a work whose material body they had never seen, as the unapproachable and ideal model for imitation and aspiration.[2]

But then the unforeseen occurred. History reached back and uncovered the Laocoon. On January 14, 1506, a vintner by the name of Felix de Fredis discovered the statue at a place just outside Rome. Judging from where it was found, it had evidently graced the subterranean baths of the Roman emporer Titus (79–81 A.D.), who is mentioned by Pliny, and been walled in by an anonymous Roman in the fifth century A.D.,[3] presumably in the hope of protecting the statue from the Vandals, who were descending on Rome.[4] Once it had been found, Pope Julius II soon heard of it and sent

the architect Giuliano di Sangallo to investigate. Michelangelo chanced to be his house guest, and so it was that these two were among the first to see the Laocoon. A letter written by Sangallo's son recalls the event and claims that Sangallo immediately recognized the statue as the Laocoon described by Pliny.

The ideal was now real. The idea of Laocoon now had a material body. All the artistic and aesthetic desires, the directing principles and imperatives of art that had found an easy referent in the invisible Laocoon, were now confronted by its real presence. The next four hundred years would see artistic practice and aesthetic theory strain within the uneasy contradiction between an aesthetic ideal—the imaginary Laocoon as a repository of artistic values and aspirations—and a corporeal real—the material statue in all its determinacy. For centuries after its discovery, it was impossible to see the Laocoon in a manner unprejudiced by Pliny's remarks. Only in the twentieth century has it become possible to stand in puzzlement before the statue, astonished by the lack of fit between this "baroque" work and the superlative ideals it is claimed to embody (fig. 1).[5]

We can further underscore the tenuousness, even the sheer fatuousness of the debates that proceeded under Laocoon's name and within the contradiction, no matter how productive or necessary they were, by pointing to the most recent scholarship on the statue. It seems, as Bernard Andreae argues in *Laokoon und die Gründung Roms*, that Pliny's statement about the Laocoon was misinterpreted. Andreae maintains that while Pliny's term *statuaria ars* in the Italian of Michelangelo's time was synonomous with *scultura*, in Latin and above all in Pliny:

> it exclusively has the sense of a bronze and may not be interchanged with *sculptura*. The concept occurs no less than ten times in Pliny and always means bronze If one reads Pliny's statement with this knowledge, then it means: "The Laocoon (made of one stone) is, as a work of art, to be preferred to all others in painting and in bronze." Thus Pliny does not make an aesthetic judgment, according to which the Laocoon is the greatest work of all time, rather he repeats a general judgment of the taste of his time, namely that the Laocoon group in marble pleased him more than a painting of the subject, as one might be familiar with it from Pompeii, or than a bronze Laocoon, as the presumable original was.[6]

If Andreae is correct, then this elaborate fold of history is held together, ironically, by a single misunderstood word. Had the Renaissance read that word differently, such extravagant claims might never have attached to the Laocoon. The history of aesthetics would have a very different appearance.

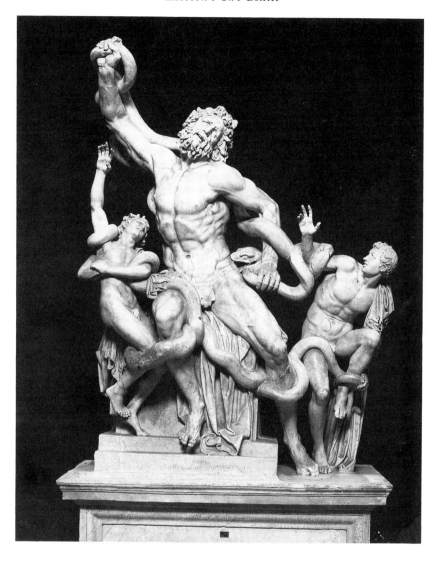

FIG. 1. LAOCOON (WITH OUTTHRUST ARM). REPRODUCED WITH PERMISSION OF
THE VATICAN MUSEUM, ROME.

On the other hand, this factual tension between the real and ideal bodies
of Laocoon underscores the tenuousness of eighteenth-century aesthetic
discourse in its attempts to mediate between real and ideal. This can best be
illustrated by undertaking a survey of the history of Laocoon's two bodies.

1

Two months after the discovery of the statue, Julius II had it transported to the Belvedere Courtyard of the Vatican and installed in a niche between the Belvedere Apollo and a Venus. The Laocoon was an immediate sensation and stimulated numerous and diverse responses. Sadoleto described the statue in a celebrated Latin poem.[7] Michelangelo was impressed by the powerful, vital, anatomically precise representation of the bodies in the statue group.[8] One could say that Michelangelo modeled his later work after the material body of the Laocoon, its imposing muscularity, and thus earned censure and begrudging praise from the later eighteenth-century theorists more oriented toward the ideal body. Nor was Michelangelo the only one to appreciate the Laocoon in terms of the starkness of the representation of the body. William S. Heckscher calls the Laocoon "Antiquity's great contribution to the problem of muscles and sinews" and speculates on a connection between the discovery of the statue and the fact that: "within twelve months, Benivieni's book on pathological anatomy, the first of its kind, had appeared in print. The synchronicity offers a powerful testimonial to the intensified interest of the Renaissance in the problems of human anatomy."[9] The deep connection extended to the point that anatomy books were illustrated with cadavers in classical poses.[10]

The German Renaissance was diverted by Martin Luther and the concerns of the Reformation. A thoroughgoing rediscovery of Greece and the Laocoon on the order of the Italian Renaissance had to wait for Johannes Joachim Winckelmann, the father of German Classicism, who described the statue anew in his *Gedancken über die Nachahmung der griechischen Werke in der Mahlerey und Bildhauerkunst* (1755). While the anatomical interest of the Italian Renaissance does not entirely recede, it is now accompanied by a more philosophical and idealizing articulation. Winckelmann chose the Laocoon to illustrate his concept of "edle Einfalt, stille Grösse," four terms that had been circulating in eighteenth-century European discussions of art, but which were first brought together by Winckelmann to designate what he considered the chief characteristic of the great works of classical Greece.[11] He measured the art and culture of his own day against the high standard of antiquity as embodied in the Laocoon and found, of course, that they failed miserably. From this judgment came the Winckelmannian imperative: "Der einzige Weg für uns, gross, ja, wenn es möglich ist, unnachahmlich zu werden, ist die Nachahmung der Alten" (The only way for us to become great or, if this be possible, inimitable, is to imitate the ancients).[12]

Winckelmann's critique of contemporary culture, his extravagant praise of antiquity, and his stress on imitation place him in the tradition known as the *querelle des anciens et des modernes*.[13] At the same time, however, he embraced the newer ideas of Dubos and Montesquieu according to which the culture of a people is largely influenced by geography and climate. This view includes the possibility of a theory of cultural plurality as well as a theory of history. In other words, Winckelmann's thought is marked by two contradictory positions: understanding the ancients as normative for all time, and understanding them as historically determined.[14]

While Winckelmann still holds up the Laocoon as a model for imitation (however troubled that possibility might be), the discourse around the statue has nonetheless taken a decidedly theoretical turn. This is confirmed by Gotthold Ephraim Lessing, who takes up the debate with his long essay entitled *Laokoon: Oder über die Grenzen der Mahlerey und Poesie* (1766), and complicates the theoretical discourse by placing it in yet another tradition, that one known as *ut pictura poesis*, the discussion of the similarities and differences of pictorial and linguistic systems of representation.[15] The Laocoon story, after all, was familiar from its most authoritative setting in Vergil's *Aeneid* (19 B.C.):

> Laocoon, by lot named priest of Neptune,
> was sacrificing then a giant bull
> upon the customary altars, when
> two snakes with endless coils, from Tenedos
> strike out across the tranquil deep (I shudder
> to tell what happened), resting on the waters,
> advancing shoreward side by side; their breasts
> erect among the waves, their blood-red crests
> are higher than the breakers. And behind,
> the rest of them skims on along the sea;
> their mighty backs are curved in folds. The foaming
> salt surge is roaring. Now they reach the fields.
> Their eyes are drenched with blood and fire—they burn.
> They lick their hissing jaws with quivering tongues.
> We scatter at the sight. Our blood is gone.
> They strike a straight line toward Laocoon.
> At first each snake entwines the tiny bodies
> of his two sons in an embrace, then feasts
> its fangs on their defenseless limbs. The pair
> next seize upon Laocoon himself,
> who nears to help his sons, carrying weapons.
> They wind around his waist and twice around
> his throat. They throttle him with scaly backs;

their heads and steep necks tower over him.
He struggles with his hands to rip their knots,
his headbands soaked in filth and in dark venom,
while he lifts high his hideous cries to heaven,
just like the bellows of a wounded bull
when it has fled the altar, shaking off
an unsure ax. But now the snakes escape:
twin dragons, gliding to the citadel
of cruel Pallas, her high shrines. They hide
beneath the goddess' feet, beneath her shield.[16]

A debate raged in the eighteenth century as to whether to accord the priority, both historical and artistic, to the statue or to Vergil's account. Already Winckelmann had mentioned Vergil, though disparagingly, in his description of the Laocoon: "Er erhebet kein schreckliches Geschrei, wie Vergil von seinem Laokoon singet" (He emits no terrible screams such as Vergil's Laocoon).[17] Winckelmann dated the statue to the time of Alexander the Great (fourth century B.C.). Being modern relative to Homer and the ancient Greeks, Vergil had no conception of the nature of Laocoon's "grosse und gesetzte Seele" (great and stalwart soul). No classical hero would cry out in the way described by Vergil.

Lessing agrees that Laocoon, as represented in the statue, does not cry out. But he disputes Winckelmann's reason. The Laocoon of the statue endures pain silently, says Lessing, not because he is a great-souled classical hero, but because he is visible as statue and not an actor in a poem. That heroes in poems are free to cry out like Vergil's Laocoon is amply proved by Lessing's reading of Sophocles' *Philoktetes*, a play slightly older than Winckelmann's dating of the Laocoon. Statues and paintings obey different aesthetic laws than poems. Lessing's *Laokoon* attempts to delineate those laws. As for who was first, Lessing decides for Vergil and dates the Laocoon to the reign of Emperor Titus some sixty years after Vergil's death. Interestingly, the most recent theory about the statue argues that Titus actually commissioned the work, and thus basically agrees with Lessing's dating.[18] While other current theories reach back as far as the early second century B.C., all are agreed that Winckelmann's estimate was far too early.

Johann Gottfried Herder took up some of the issues surrounding the Laocoon in the first of his *Kritische Wälder* (1769). Having noticed among his contemporaries an inclination to condescendingly attack Winckelmann under the authority of Lessing, Herder sought to correct the balance by reinscribing Lessing's formal insights into history. In the process, however, he problematizes the positions of both. With regard to Lessing he

shows that the formal characteristics which Lessing attributed to poetry belong more properly to music and that poetry is governed by yet others connected with "Kraft" or power. As for Winckelmann, it is in criticizing Lessing's reading of Sophocles' *Philoktetes* that Herder develops the notion of cultural plurality for the most part latent in Winckelmann and plainly at odds with the normative role which the Greeks do play in Winckelmann's thought. Herder's reflections in the first *Kritisches Wäldchen*, despite their importance in other respects, have little direct influence on the discussion of the Laocoon group. This is assured by the fact that the statue itself is scarcely discussed in his essay, having been almost entirely supplanted by Sophocles' *Philoktetes*. The sculpture as sculpture will take its place in a later writing, the *Plastik* (1770/78). What connects these and other intermediate writings is Herder's desire to ground all human activity in the body.

If Winckelmann and Lessing rather decisively set the German debate about the Laocoon in terms of both the *querelle des anciens et des modernes* and *ut pictura poesis*, the next two generations of Germans inserted still other contemporary concerns. In this way the Laocoon became entwined in issues that scholarship has come to recognize as constitutive for understanding the last half of the eighteenth century. These include the discussion about idealizing and realistic modes of representation; about the beautiful and the sublime; the autonomy of the work of art; and the opposition between symbol and allegory.

Christian Gottlieb Heyne, a professor of classical philology at the University of Göttingen, wrote a sober essay about the Laocoon included in his *Sammlung antiquarischer Aufsätze* (1779). Winckelmann's description of the statue, he says, is not intended to give "einen deutlichen Begriff und Vorstellung von der Gruppe" (a distinct concept and representation of the group).[19] He compares those who read Winckelmann without knowing the statue to Don Quixote, "[der sich] in eine Entzückung und Begeisterung hineinarbeitet, wozu nichts weiter fehlt, als nur—ein wirklicher, oder doch ein bestimmter Gegenstand" (who works himself into a rapture and an enthusiasm which is lacking nothing, except perhaps—a real, or at least a definite object).[20] Heyne discerns three "Bestimmungen [des Ausdrucks]:" pain, a father's anxiety, and muscular resistance. "Schmerz ist das Hauptgefühl" (Pain is the chief feeling).[21] Heyne is committed to a model of scholarly philological understanding that is at odds not only with Winckelmann's enthusiasm, but also, as we shall see, with Lessing's manipulation of classical texts.

Wilhelm Heinse treats the Laocoon provocatively in his *Ardinghello und die glückseligen Inseln* (1787). He is certainly the first to ignore Vergil

and prefer one of the alternate myths for an explanation of Laocoon's punishment. He cites Servius, who says: "es sei deswegen geschehen, *weil er seine Frau aus Unenthaltsamkeit im Tempel des Apollo beschlafen habe*" (It happened because he was so unrestrained as to sleep with his wife in the temple of Apollo).[22] The sculpture displays a sensuous man, "der wenig an- der Gesetz als seinen Vorteil und sein Vergnügen geachtet . . . hat," whose punishment consists in extreme bodily pain: "Sein ganzer Körper zittert und bebt und brennt schwellend unter dem folternden tötenden Gifte, das wie ein Quell sich verbreitet" (who observed few other laws apart from his own advantage and pleasure, whose punishment consists in extreme bodily pain: his whole body trembles and quakes and burns as it swells under the torturous deadly poison, that spreads like a spring).[23] Heinse's understanding of the Laocoon, though on the surface entirely out of step with all the other commentators, fits well with a conviction that underlies the entire novel, namely that erotic pleasure and aesthetic appreciation share a common sensuous basis. We will find this basic belief, if not stated, certainly enacted in different ways in the five thinkers under considera- tion. In any event, by embedding the statue in a story of unrestrained sexual pleasure that is then punished by the infliction of pain on the body, Heinse, more than any, openly focuses attention on the body of the sculpture.

Friedrich Schiller adduces Laocoon in the context of the sublime and the pathetic, texts that belong to his preoccupation since 1791 with Kantian ideas. "Die Gruppe des Laokoon und seiner Kinder ist ohngefähr ein Mass für das, was die bildende Kunst der Alten im Pathetischen zu leisten vermochte" (The group of Laocoon and his children is approx- imately a measure for what the visual arts of the ancients were able to achieve in the pathetic).[24] It is (ethically) sublime insofar as every part of Laocoon's body that is in some way subject to his will strives mightily against extreme pain. Such a reading of Laocoon's body as the battlefield where the forces of pain and the soul wage war against each other is indebted to Winckelmann's original reading of the statue. Schiller basically updates this one aspect of Winckelmann in terms of the newly developing concept of the sublime.

Aloys Ludwig Hirt, an art historian who became acquainted with Goethe in Rome in 1786, sets his discussion of the Laocoon in a debate between "Charakteristik" (an incipient realism) and the ideal. Laocoon was to his mind the epitome of realistic precision, though his appreciation differed from that of the Italian Renaissance by its pathological focus. His description of the Laocoon, published in Schiller's journal *Die Horen* (1797), illustrates this graphically:

Alles in der ganzen Figur verkündet einen Moment der Darstellung,
aber nicht einen gemilderten, nicht ein Seufzer, nicht ein Schreien,
nicht einen hilfflehenden Blick zu den Göttern—sondern das höchste
und letzte Anstrengen sich convulsivisch windender Kräfte, ein schon
betäubtes Gehirn, einen Mund, den der erstikende Schmerz umziehet
und bleichet—ein athemloses Bäumen der Brust, und Einzwängen des
Unterleibes—das Erstiken und der Tod folgt plötzlich.[25]

Everything in the entire figure announces a single moment of repre-
sentation, but not a moderated moment, not a sigh, not a screaming,
not a pleading glance to the gods—rather the highest and last effort
of convulsively winding powers, an already deadened brain, a mouth
which is covered and paled by the choking pain—a breathless heaving
of the chest, and constriction of the abdomen—asphyxiation and death
follow suddenly.

The Laocoon seen in this way is exemplary of what Hirt calls *Characteris-
tik*:

Die Erreichung des Eigenthümlichen in allen Theilen zum Ganzen
ist der Endzweck der Kunst, das Wesen des Schönen, der Prüfstein
von der Fähigkeit des Künstlers, und die Quelle des Wohlgefallens für
jeden, der das Kunstwerk ansieht und betrachtet.[26]

The attainment of the characteristic in all the parts to the whole is the
final aim of art, the essence of beauty, the proofstone of the ability of
the artist, and the source of pleasure for everyone who regards and
observes the artwork.

The notion of *Characteristik* would become better known as a term of
opposition to classical beauty in Friedrich Schlegel's early essay *Über das
Studium der griechischen Poesie*.

Johann Wolfgang von Goethe found Hirt's description of the statue
ludicrous and responded with "Über Laokoon" (1798), the first essay
of the first volume of his and Heinrich Meyer's short-lived journal, *Die
Propyläen*, and again, this time frankly ridiculing Hirt, in "Der Sammler
und die Seinigen" which appeared in a later volume of the same journal.[27]
Goethe's "Über Laokoon" establishes the aesthetic autonomy of the art
work, effectively cutting it off from its mythological context, if not from
reference altogether. He, as it were, "diagnoses" the body of Laocoon
with medical precision, but then sees the pain that Hirt spelled out to the
extreme contained by an aesthetic effect of "Milderung" or "Bändigung"

(moderation or constraint). The curious thing is that it is not the great-souled hero who contains the pain as Winckelmann's reading would have it, but the aesthetic performance of the snakes, the very animals that brought on the pain in the first place. Autonomous and self-contained in this way, the Laocoon begins to "mean" something very different than it did before. This explains the consternation in Hirt's response to Goethe:

> lasst uns . . . eine Bändigung des Affectes, eine Bemeisterung, ein Mod-eriren des Ausdrukes annehmen —Jedem äussern Ausdruk corre-spondirt ein Affect in der Seele: wenn aber der Künstler den äussern nicht markirt, wie kann man den innern errathen?[28]

> Let us assume a constraining of affects, a mastering, a moderating of expression —To every exterior expression corresponds an affect in the soul: if the artist does not mark the exterior, how can one guess the interior?

Hirt's question is right on target. The Laocoon has become and is, as our reading of Goethe's essay as well as the writings of the others will show, an allegory of itself, its history and the issues that surround it.

One last thinker from this period must be mentioned, Karl Philipp Moritz, for it is from him that we learn most about what is at work in Goethe. Moritz says very little explicitly about the Laocoon, only a single though crucial paragraph in his *Reisen eines Deutschen in Italien* (1792). (Like Hirt, Moritz first met Goethe in Rome.) Perhaps this is because, in a surprisingly violent attack on Winckelmann's description of the Belvedere Apollo, Moritz called the possibility of *ekphrasis* or the describing of an art work in words at all into question. His essay is called "Die Signatur des Schönen: In wie fern Kunstwerke beschrieben werden können" (1788). In this essay, one finds one of the earliest distinct theories of the autonomy of the art work as well as a nascent theory of symbol. As we shall see, these theories depend on images and figures of violent pain, as though Laocoon's pain, which Moritz had largely refused to describe, found its place in his theory of beauty.

Other philosophers in the nineteenth-century would write about the Laocoon—Hegel, August Wilhelm Schlegel, Schopenhauer, Friedrich Theodor Vischer—but it is clear that by then the statue had lost its central place in aesthetic discourse. As we have seen, the aesthetic discourse of the eighteenth century was greatly weighted toward the ideal body of the Laocoon, the idea of its representation, the Laocoon of Goethe, Winckelmann, and Lessing. Some of the writers we surveyed actually saw the statue

in the Vatican, under various conditions. Others saw only plaster casts or engravings. All saw the Laocoon as idea.

But the statue has another body, its material body, its chiseled marble actuality. This, to refer to the chapter's epigraph from Hellmut Sichtermann, is the Laocoon of Gisela Richter, Seymour Howard, and Filippo Magi, to name a few. The story of this singular material body is quite remarkable in its own right, and worth the telling, especially insofar as it spells out the diverse material conditions of the interpretations of the statue's ideal body and thus problematizes them. The eighteenth century may have seen classical unity in the Laocoon; the statue's real history is a story of fragmentation and indeterminacy. It is difficult to know what the real Laocoon is or looks like, or whether it might not be better to speak of multiple Laocoons.

We have already mentioned how the Laocoon came to be discovered in the subterranean baths of Titus and how Pope Julius II soon had it moved to the Belvedere Courtyard. While the statue was unusually well preserved considering the circumstances, it was missing the right arm of both the father and the younger son. In any event, Francis I, king of France, saw and admired the Laocoon on a visit to the Vatican and made it clear that the statue would be much appreciated as a gift. The pope, naturally, was reluctant to part with it and commissioned Baccio Bandinelli to make a bronze copy. This he did, and, for the sake of completeness, designed a right arm, for both father and son, first in wax, and then in bronze. Bandinelli, as Walther Amelung says, "ist der Erfinder des gerade ausgestreckten Arms" (Bandinelli is the inventor of the outthrust arm).[29] In the meantime, the political scene had changed, Francis no longer wielded the same power, and the pope was able to retain both the original and the copy.

Pope Clement VII came to power in 1523 and enjoyed spending his mornings in the Belvedere Courtyard among the statues. He turned to Michelangelo with the desire to see all the statues in a complete state. The artist recommended a former comrade, Giovanni Montorsoli, who then fashioned Laocoon's right arm of clay, and that of the son, essentially along the lines of Bandinelli's model. It was this Laocoon with the radically outthrust arm that was seen either in the original or plaster casts by all the Germans of the eighteenth century. Michelangelo himself also laid his hand to the task, leaving an unfinished model in clay that more resembles the arm as we know it today.[30]

By 1565, under the reign of Pius IV, the niches of the courtyard containing the Laocoon, the Apollo, and others "were enclosed in wooden boxes as a form of protection against ignorant and vandalous visitors," thus

restricting admission.[31] The statues remained in these boxes for more than two hundred years, until 1770 when Clement XIV founded his Vatican museum. When we consider that Winckelmann died in 1768, it becomes clear that he never saw the statues he so admired in anything but dismal light or by the illumination of a flickering torch. Goethe, on the other hand, saw the statue in 1786 when it was once more lit by the sun. Nonetheless, in his "Über Laokoon" Goethe recommends seeing the statue at night by torchlight in order to win an impression of its concentrated transitoriness.

By the time Goethe published his essay on the Laocoon, it was no longer in Rome. Napoleon had launched an unprecedented conquest of classical and European art, coupling his demands for surrender everywhere with a detailed list of artworks to be forfeited by the besieged or defeated city. Major works of Raphael and other Renaissance painters, in addition to the most significant classical statues including the Laocoon, were crated up and transported to Paris where triumphal entries were staged. It is in this connection that Goethe writes: "Möge dieses [the Laocoon] bald wieder so aufgestellt sein, dass jeder Liebhaber sich daran freuen und darüber nach seiner Art reden könne!" (It is to be hoped that the sculpture will soon again be exhibited in such a way that everyone can enjoy it and express his own views about it).[32] This brief stay in Paris (until 1815) was to be the only interruption of the statue's long Roman tenure. The statue was returned to Rome after Napoleon's defeat and exile.

The nineteenth-century attempted an approach to the material body of the Laocoon through careful philological research, the kind already exemplified in Christian Gottlieb Heyne. Scholars combed the Greek and Latin corpus for any mention of the Laocoon. It was noted that Homer, the principal classical authority, does not mention the death of Laocoon. Nonetheless, three traditions with different outcomes for the three victims emerged. The oldest account of the Laocoon myth was to be found in Arctinus of Miletus, whom Albin Lesky dates to the late seventh century B.C., one of the so-called cyclical poets who recounted the adventures of the Greek heroes after the fall of Troy.[33] While Arctinus's writing is lost, its contents are known from a later grammarian called Proclus, who wrote: "Inmitten dieser Ereignisse [the festive entry of the Trojan horse] erscheinen zwei Drachen und töten den Laokoon und den einen seiner Söhne" (In the midst of these events, two dragons appear and kill Laocoon and one of his sons).[34] Two other later writers, Euphorion (second century B.C.) and Servius (cited by Heinse) have a similar outcome and supply an explanation: Laocoon, a priest of Apollo and not Neptune as Vergil would have it, violated the temple by sleeping with his wife Antiope in front of the image of Apollo. The snakes were sent to punish Laocoon and the

fruit of that union. The other son escaped, and the whole story in this form became understood as an allegory of the fall of Troy and the escape of Aeneas.[35]

The second tradition reaches back to the tragedy of Sophocles called the *Laocoon*, preserved only in fragments, and in the *Fabulae* of Hyginus. In Sophocles, according to the scholia, the snakes actually had names, Porkes and Chariboia. They attacked the two sons, and Laocoon was left alive to bemoan his fate. Summarizing Hyginus, Carl Robert writes: "Apollo had forbidden Laocoon to marry . . .; because he disobeyed, Apollo seeks his punishment for the transgression in the fruit of the marriage, and that is why according to this version both sons, not one, as in Arktinos, must die; but also, at least as far as the god is concerned, only the sons."[36]

The third tradition is the one we are most familiar with and dates to Vergil's *Aeneid*. As Robert says: "Vergil kept the catastrophe, the depiction of which must have been especially appealing to the peculiarly Vergilian talent, but he abandoned its motivation as it had been produced by the Greek lyric and tragic poets, and replaced it with another, freely invented."[37] Vergil makes of Laocoon a priest of Neptune, removes the scene from Apollo's temple to the beach, explains Laocoon's guilt with reference to his impiously hurling a spear at the Trojan horse, and is the first to have all three, Laocoon and the two sons, die. Robert concludes his argument by saying: "Consideration of the development undergone by the Laocoon saga in poetry has thus shown us that the old judgment made by Lessing in the *Laokoon* still stands today: 'Vergil is the first and only one to have both father and children killed by the snakes.' I need not state what consequence that has for the Vatican group."[38]

Robert assumes that it is clear from the sculpture that all three victims die and that this vindicates Lessing and his contention that the statue was made in the time of Titus, after Vergil. Heinrich Brunn, however, calls on Goethe, who suggested in his "Über Laokoon" that the eldest son was not yet so entwined as to preclude hope of his escape. Brunn thus sees in the Laocoon an actualization of the Arctinus version.

> The younger son is unified with him on the altar, and indeed is so firmly tied to his side that it is only for that reason that he does not fall to the ground. The bodies of both, however, stand as though under the impression of a uniformly effective power, which is artistically expressed in the fact that when seen from the front the bodies appear to be in a parallel situation: they share the same fate. The older son stands beside the altar; he nowhere touches his father, he stands independently, relying on his own strength

[25]

In the conception and depiction of these circumstances lies the especial merit of Goethe.[39]

A more recent theory corroborates Brunn (and Goethe) from a formal perspective without directly naming either. Peter Heinrich von Blankenhagen argues that: "The right side of the group, i.e., the older son of Laocoon, has the effect of an addition."[40] He goes on to argue that the Vatican statue is neither copy nor original, but both. He posits an original group of two, Laocoon and the younger son, copied and with the original addition of the third son. Thus, according to Blankenhagen, the statue as we have it is both earlier and later than the Vergilian account.

While the nineteenth-century disputed the Laocoon in terms of sources, in the hope of fixing a date, the early twentieth-century was stunned by a discovery that fundamentally altered the appearance of the statue. In 1905, Ludwig Pollak, a German art dealer and archaeologist, was rummaging through marble statue fragments in a shop in Rome when he suddenly saw something that could only be Laocoon's missing arm. The arm had been found, according to the artisan in the shop, in the Via Labicana at the foot of the Oppius hill. It was not an out-thrust arm, but bent at the elbow, the hand reaching back to the head. When Pollak, however, computed the relative proportions, he found that the dimensions of the arm were ten percent shorter than those of the statue. He concluded that the arm belonged to a lost copy of the Laocoon. Still, his evidence was compelling enough to force scholars to acknowledge that Montorsoli's out-thrust arm gave a distinctly wrong impression of the original Laocoon. While in Dresden a full-sized plaster cast with the new arm was made, no one ventured to touch the Vatican statue.[41]

In the 1950s, however, Ernesto Vergara Caffarelli noticed that despite different coloring (because of rust and other conditions), the statue and the newly found arm were made of the same material. Furthermore, a recalculation of the dimensions showed that the arm was, in fact, the right size for the Laocoon. Pollak had miscalculated by ten percent because a portion of the original shoulder had been removed, probably by Michelangelo, in order to accommodate his, not Montorsoli's arm, even though the latter was attached. A comparison with the Bandinelli copy in bronze showed the shoulder as it had been before Michelangelo's tampering. In 1957, then, Filippo Magi, vice-director of the Vatican Museums, once more closed off the niche in the Belvedere Courtyard with a wooden barrier and set about dismantling the Laocoon statue. Contrary to Pliny and to eighteenth-century opinion, the statue proved to be made up of seven or eight distinct pieces that are attached by iron and bronze pegs. Several

things were adjusted (e.g., the position of the older son was changed by a few degrees) but the most striking, of course, when the statue was opened to public view in 1960, was the right arm. In this itself, the Laocoon as we know it is profoundly different from that of Goethe and Winckelmann (fig. 2).

How strange, therefore, that when the effort is made by art historians of this century to express the difference between the two versions of the statue, the language used to describe the "new" Laocoon is straight from Winckelmann's and Goethe's description of the "old." Sichtermann, for example, writes:

> Der Unterschied zur alten Ergänzung springt sofort in die Augen: die Unruhe, ja Gewaltsamkeit, die der weit ausgestreckte Arm des Vaters gegenständlich und ästhetisch in die Gruppe gebracht hatte, ist einer *Ruhe* gewichen, die den übrigen Teilen entspricht und in Form und Gehalt dem Werke die *Geschlossenheit* wiedergibt, die es als echt antik erweisen.[42] (My emphasis)

> The difference to the old addition strikes one immediately: the disquiet, yes, the violence, which the outthrust arm of the father brought into the group objectively and aesthetically, has given way to a tranquillity which corresponds to the other parts, and in form and content has restored to the work its enclosedness, which prove its authentic antiquity.

One is forced to conclude that the eighteenth-century descriptions of Goethe and Winckelmann did not fit the statue they were describing, or that they overlooked (or failed to read) the out-thrust arm. They described the idea of a Laocoon that corresponds now to the reconstructed statue. (Conversely, one might wonder to what extent the reconstruction depends on the idea of the Laocoon.) The use of their language in Sichtermann's description signals a desired continuity between their vision, their ideal Laocoon, and the present reality. But it is precisely such continuity, such harmony, that the reading to be pursued in the following chapters wants to avoid, even disrupt at all costs.

The object of this survey of the history of Laocoon's two bodies, the ideal body of aesthetic discourse and the real body of art history, was to show that the Laocoon consists in a remarkable and fascinating complex of random, fortuitous, and variously motivated circumstances of a historical, political, artistic, or philosophical nature. The material basis of this complex includes three distinct literary sources, dating estimates that

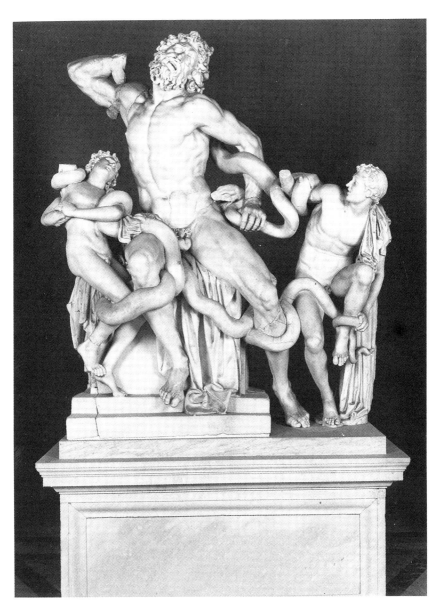

FIG. 2. LAOCOON (WITH ORIGINAL ARM). REPRODUCED WITH PERMISSION OF THE
VATICAN MUSEUM, ROME.

span five centuries, and a statue that has had two very different contours, not to mention minor changes and additions.

2

Today, the Laocoon still stands in the Belvedere Courtyard. Statues have been moved from niche to niche, or removed altogether, reflecting fluctuating taste. The Laocoon, the Antinous, the Venus, and the Belvedere Apollo belong to a core group of statues that has remained constant. Friedrich von Ramdohr in his book *Über Mahlerei und Bildhauerkunst in Rom für Liebhaber des Schönen in der Kunst* (1787) describes the courtyard as it was at the time when Goethe, Moritz, and Herder were there, and as it still seems today. In addition to the sculptures, Ramdohr notices a fountain: "In der Mitte dieses Hofes steht ein grosses Wasserbehältniss von Porphyr, in dessen Mitte eine Fontaine springt. Ein Porticus mit Arcaden geht rund umher." (In the middle of this courtyard stands a great water container made of porphyry, in the middle of which a fountain springs. A portico with arcades surrounds it . . .).[43] The immense porphyry fountain, originally found in Nero's *domus aurea*, is no longer in the middle of the courtyard; it was removed to the Sala Rotunda in 1792 where it now stands dry.[44] The sound of water, however, is still to be heard. Amelung noticed it at the turn of the century: "In the middle of the courtyard a spring arises whose water emerges from the mouth of an antique spring."[45] The sound of gurgling, splashing water has been there since antiquity. Though Ramdohr is struck by the magnificent porphyry fountain, he is most sensitive to the atmosphere created by the sound of the water splashing in the resonant acoustic space of the courtyard, and its power to enhance the viewer's experience:

> Man sieht neben sich die Formen der höchsten idealischen Schönheit, und über sich den Himmel. Die Einbildungskraft steigt auf der bequemsten Leiter bald von den Umstehenden zu den obern Regionen hinauf, bald von diesen zu ihren wahrscheinlichen Bewohnern herab; und das einförmige Getöne des stets steigenden, stets herabfallenden Wassers der Fontaine unterhält die Seele in der feierlichen Stimmung, die dem Genuss des Schönen so zuträglich ist.[46]

> One sees beside oneself the forms of the highest ideal beauty, and over one's head the heavens. The imagination ascends on the easiest ladder from the surrounding gods to the upper regions and then back down to their probable inhabitants; and the monotone sound of the constantly ascending, constantly descending water of the fountain sustains the

soul in the solemn mood that is so conducive to the enjoyment of the beautiful.

Ramdohr reads the acoustic and visual space of the open courtyard as essentially vertical. The monotonous though engaging sound of the water sustains the viewer's soul in an appropriately solemn spirit. While I do not agree with this interpretation of the space and the effect of water, Ramdohr must be credited with formulating a rudimentary "geography" of aesthetic experience. The Laocoon has always been close to water. In Vergil's account the sacrifice takes place on the beach. The statue was hidden for centuries in the baths of Titus, then displayed only meters away from the Belvedere fountain. Even in its most famous description it maintains a proximity to water, as Winckelmann resorts, as always, to an image of water:

> So wie die Tiefe des Meers allezeit ruhig bleibt, die Oberfläche mag noch so wüten, ebenso zeiget der Ausdruck in den Figuren der Griechen bei allen Leidenschaften eine grosse und gesetzte Seele.
> Diese Seele schildert sich in dem Gesichte des Laokoons, und nicht in dem Gesichte allein, bei dem heftigsten Leiden.[47]

> Just as the depths of the sea always remain calm however much the surface may rage, so does the expression of the figures of the Greeks reveal a great and composed soul even in the midst of passion.
> Such a soul is reflected in the face of Laocoon—and not in the face alone—despite his violent suffering.

The arrangement of the Belvedere Courtyard lays out the relation of water to sculpture. The obvious question, then, is what is the significance of water.

Ramdohr's word *eintönig* points in the right direction. Water, in the last half of the eighteenth century, represents beauty seen under a particular and highly important aesthetic aspect. Winckelmann names that aspect in the theoretical section on beauty in the *Geschichte der Kunst des Alterthums* (1764):

> Aus der Einheit folgt eine andere Eigenschaft der hohen Schönheit, die Unbezeichnung derselben Nach diesem Begriff soll die Schönheit sein wie das vollkommenste Wasser aus dem Schosse der Quelle geschöpft, welches, je weniger Geschmack es hat, desto gesunder geachtet wird, weil es von allen fremden Teilen geläutert ist.[48]

> From the principle of unity proceeds another characteristic of high beauty, the undesignation of the same According to this concept,

beauty should be like the most perfect water drawn from the lap of
the source, which, the less taste it has, the healthier it is considered to
be, since it is purified of all foreign parts.

We will treat the paradoxical concept of *Unbezeichnung* at length in the
chapter on Winckelmann. Important for now is to realize that the water in
the center of the courtyard is pure beauty, the source and origin (*Quelle*)
and even mother (*Schoss*)[49] of the sculptures that surround it. The fountain
is an omphalos.

If the fountain represents pure beauty, then the Laocoon, as our
survey of the German theoretical discussion showed, represents beauty in
relation to pain, however that relation may be understood. Pain reveals. The
snake's bite causes not only the muscles of Laocoon's body to be exposed,
but even more (and none of the eighteenth-century writers noticed this)
displays Laocoon's bones. Pain calls forth the baroque *memento mori* that
beauty hides. In the *Geschichte der Kunst des Alterthums*, Winckelmann
describes the relation between beauty and pain ("Leidenschaft") as follows:
"Die reine Schönheit allein [kann] nicht der einzige Vorwurf unserer Betra-
chtung seyn, sondern wir müssen dieselbe auch in den Stand der Handlung
und der Leidenschaft setzen" (Pure beauty alone cannot be the sole object
of our attention, rather we must also place beauty in the condition of
action and passion).[50] Pure beauty (as water drawn from the spring) is
placed in a situation of pain (the statue). Heyne uses the same language
to describe a possible reverse process, extracting the Laocoon from pain:
"Man setze, soll Ritter Mengs gesagt haben, den Kopf des Laokoon in eine
ruhige Fassung, so weicht er dem Apollo in Belvedere wenig an Schönheit"
(Ritter Mengs is supposed to have said: "Place the head of Laocoon in a
calm state and he will not lag behind the Belvedere Apollo in beauty").[51]
Pain and beauty, the statue and the fountain, appear to be the fundamental
antinomy underlying the layout of the courtyard as well as any discussion
of the Laocoon.

The chapters that follow will amply investigate the antinomy of pain
and beauty. At this point it is useful to recall the various debates summa-
rized in the survey of the discourses around the Laocoon. Each of these
debates can be likewise understood in terms of an antinomy. Thus there is
the antinomy between the ideal and the real, the beautiful and the sublime,
symbol and allegory. These antinomies, in turn, can be understood to stand
in a relation of homology to the fundamental antinomy obtaining between
beauty and pain. Other antinomies, perhaps not called by name, but instru-
mental nonetheless, might also be adduced; for example, between indeter-
minacy and determinacy, mother and father, woman and man. Problems

and paradoxes arise when we attempt to integrate the two basic antinomies that broadly structured the discussion of the Laocoon, namely, the *ut pictura poesis* and the *querelle des anciens et des modernes*. According to the logic of Lessing's argument, the visible work of art, observing the strict rule of beauty, must cling as closely as possible to the fountain, while the poem or text, free to represent in writing situations of pain, sojourns among the statues made visible by pain. But the distinguishing characteristic of beauty is its *Unbezeichnung*, its invisibility, just as the chief property of pain is its power to make visible. We are left with the paradox of invisible pictures and visible texts. The antinomies of the *querelle* encounter a similar inversion. Beauty as normative for imitation is invisible. The statue as beauty given to pain becomes a historically determined text for reading.

What we are seeing are the symptoms of a fundamental inversion, a decentering of beauty within the discourse of eighteenth-century aesthetics. I am not suggesting that the various antinomies and debates are not pertinent, nor that they were not instrumental in organizing and structuring the writings of the thinkers we have referred to. I am suggesting, however, that the oppositions are not as stable as one might think. We see this most drastically at the level of the most fundamental antinomy, the one between pain and beauty. For, if it seems in the aesthetic discourse that beauty was its center, its source and origin, and pain an important but marginal, even external determinant in the production of classical art, we are beginning to sense, if not see, that in the eighteenth century pain is the origin of beauty. Pain decenters beauty.

In the eighteenth century, aesthetic discourse is not the only place where pain begins to take a central role. In 1753, two years before Winckelmann's *Gedancken* was published, the great German physiologist Albrecht von Haller published two lectures entitled *De partibus corporis humani sensilibus et irritabilibus*. A German translation appeared in 1756 called *Von den empfindlichen und reizbaren Teilen des menschlichen Körpers*. These lectures summarize the results of hundreds of experiments carried out on live animals to determine how all the different body parts react to pain. Haller's achievement has been described as accomplishing for physiology what Copernicus, Newton, and Huygens accomplished for their fields.[52] Medical discourse relied on the application of pain in order to bring the body into view. The modern physiology inaugurated by Haller is based on the simple structure of pain.[53]

There are compelling reasons for considering a connection between the medical and aesthetic discourses of the eighteenth century. First, there is the fact that all of the five thinkers under consideration studied medicine in some fashion: either enrolling as medical students (Herder, Lessing) or

attending medical seminars and anatomies (Winckelmann, Goethe, Moritz). Second, the writers themselves occasionally acknowledge the relation between the two discourses. This is most evident, as we shall see, in Herder, who attempts to insert Haller's medical discourse into aesthetics, but also in Winckelmann and Goethe. And third, it should not be overlooked or discounted that one of the German words for the aesthetic term grace is *Reiz*, the very word that Haller used to designate the painful stimulus that makes the body visible.

Indeed, the medical discourse of the eighteenth century has the very same focus as the aesthetic discourse of the same time. Both are treating the human body, and both—medicine in Haller's clinic, aesthetics in connection with the Laocoon—are doing so through the instrumentality of pain. But, whereas medical discourse openly avows its recourse to pain—in the first sentences of his lecture, Haller admits: "Ich habe in der Tat hierbei mir selbst verhasste Grausamkeiten ausgeübet" (I have indeed had to carry out hateful cruelties)[54]—the aesthetic discourse instanced in the five thinkers of our study generally seeks to avoid a direct confrontation with the problem of the representation of pain, and instead attempts to trope pain through one strategy or another. This circumstance alone guides our reading.

In each of the following chapters—on Winckelmann, Lessing, Herder, Moritz, and Goethe—we will probe for the place of pain. The pressure of this reading will have the tendency of turning the various versions of classical aesthetics based on the Laocoon into their opposites, more or less on the model of the inversion of pain and beauty. We find pain not at the periphery of classical aesthetic discourse, but at its center.

An initial reading of eighteenth-century aesthetic texts that treat the Laocoon and related issues may give the impression of a uniform discourse. So many of the idealizing concepts that Winckelmann set into play to recur so monotonously and inevitably that we may be reminded of the sound of falling water in the Belvedere Courtyard. The reading that I propose to carry out, however, will have the result that the apparently tranquil classical discourse is broken down into a diversity of discursive settings, including, of course, the clinic and anatomy theater of medical discourse. Once beauty is decentered, the Laocoon is no longer found only in the aesthetic setting of the Vatican. It is encountered in a multiplicity of unexpected places, though all of them are incontrovertibly places of the body.

Perhaps the best image for representing the shape of the following interpretations is the Laocoon itself. The prominent aesthetic discourse stands in classical tranquillity like the figure of Laocoon. When our reading finds the place of pain, there is a shocking contact between an intrusive heterogenous discourse and the discourse of aesthetics. No matter how diverse

the figures and tropes, the images and counter-images that we encounter may be, the pain of the snake bite will be a constant. At the conclusion of this study, we should have a sense of mulitiple images, Laocoon's Others, superimposed on the picture of the statue, and connected at the point of pain.

Certainly one of these counter-images is that of the satyr Marsyas, whose statue stands in the Uffizi in Florence, a copy of the same in the Capitoline Museum in Rome.[55] While the eighteenth century enthusiastically discussed the Laocoon and statues of Niobe and her daughters, it generally avoided the Marsyas, even though these three groups are the primary instances of antique representations of pathetic subjects. This was certainly in part because the Marsyas did not conform to the classical ideal. It is not, in the eighteenth century sense, a beautiful or noble statue. But perhaps there are deeper reasons for its exclusion. They can be found in the story itself. We conclude this chapter with that story.

Marsyas was a satyr famed for his ability to play the flute. Apollo, who was also reknowned for his musical talents, challenged Marsyas to a contest to be decided by the muses. The winner, it was agreed, could decide on an appropriate punishment to be inflicted on the loser. The two of them played, Marsyas on the flute, Apollo on the lyre, and both played beautifully. Unable to defeat Marsyas musically, Apollo resorted to cunning. He challenged Marsyas to play, first, with his instrument upside down, and, second, while singing at the same time. Naturally, Marsyas failed to do either, given the technical restrictions of flute playing, while Apollo could easily do both. Apollo was declared the winner and chose as an apt if excessively cruel and violent punishment for his opponent that Marsyas be skinned alive. The antique statue of Marsyas shows him tied by his hands overhead to a tree presumably waiting for the torture to begin. It is easy to see that this statue violated the rules of eighteenth-century classicism. The raised and bound arms distort the body, making it practically a torso, and conveying the idea of a cramped and restricted captivity. The satyr himself, more a wild than a beautiful creature by nature, is even less beautiful under these circumstances.[56]

The conventional interpretation of the Marsyas story fixes on a strange abhorrence of flute music that is attributed to the Greeks and particulary the Athenians.[57] Flute playing, according to this theory, unduly distorts the face. It is undignified and uncivilized in contrast to playing the lyre, for instance. A basic nature/culture opposition is assumed; Plato would prohibit flute playing in his ideal city. Alcibiades, as Plutarch reports, refused to learn the flute. Such an opposition at this level should prove troublesome to any theory of the Greeks as "naive"—(I am thinking of

Schiller's *Über naive und sentimentalische Dichtung*)—but that is not our concern here.

What is of particular interest to us in connection with the problematic of pain and beauty is the punishment that Apollo exacts, and, even more, the fact that it is Apollo who exacts it. For we cannot think of Apollo, especially not in this story that concerns the beauty of appearance, without regarding him as an exemplar of classical beauty. An engraving by a sixteenth-century German or Swiss artist confirms this (fig. 3). It depicts in the center a young Apollo unmistakeably modeled after the Belvedere Apollo. Indeed, we should let Winckelmann describe him with the words that he used for the Belvedere Apollo, for they are applicable to both:

> Über die Menschheit erhaben ist sein Gewächs, und sein Stand zeuget von der ihn erfüllenden Grösse. Ein ewiger Frühling, wie in dem glücklichen Elysien, bekleidet die reizende Männlichkeit vollkommener Jahre mit gefälliger Jugend und spielet mit sanften Zärtlichkeiten auf dem stolzen Gebäude seiner Glieder. . . .
>
> Er hat den Python, wider welchen er zuerst seinen Bogen gebraucht, verfolget, und sein mächtiger Schritt hat ihn erreichet und erleget. Von der Höhe seiner Genugsamkeit geht sein erhabener Blick, wie ins Unendliche, weit über seinen Sieg hinaus: Verachtung sitzt auf seinen Lippen, und der Unmuth, welchen er in sich zieht, bläht sich in den Nüstern seiner Nase, und tritt bis in die stolze Stirn hinauf. Aber der Friede, welcher in einer seligen Stille auf derselben schwebet, bleibt ungestört, und sein Auge ist voll Süssigkeit, wie unter den Musen, die ihn zu umarmen suchen.[58]

> Sublime beyond humankind is his body, and his stance testifies to the grandeur that fills him. An eternal spring, as in the blessed Elysian fields, clothes the charming manliness of mature years with pleasing youthfulness and plays with gentle caresses on the proud build of his limbs. . . .
>
> He has followed the python, against which he first used his bow, and his mighty stride has reached and defeated it. From the height of his self-sufficiency, his sublime gaze goes beyond his victory, as into infinity: scorn rests on his lips, and the displeasure which he draws into himself dilates the nostrils of his nose, and rises as far as the proud forehead. But the peacefulness, which hovers in a blessed stillness on the same, remains undisturbed, and his eye is full of sweetness, as if among the muses, who attempt to embrace him.

Where Winckelmann talks about the python, we need only substitute Marsyas; where he mentions Apollo's bow, we see in the engraving the

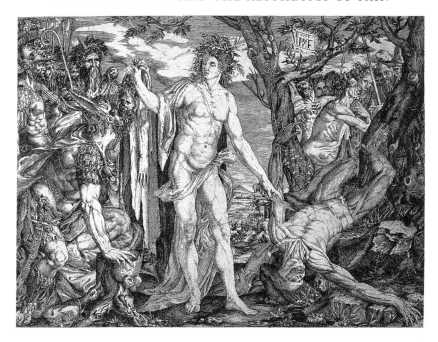

FIG. 3. *APOLLO AND MARSYAS*, M. F. (POSSIBLY AFTER MELCHIOR MEIER), 16TH
CENTURY. REPRODUCED WITH PERMISSION OF THE PHILADELPHIA MUSEUM
OF ART, SMITH KLINE BECKMAN CORPORATION.

knife in Apollo's hand and the flayed skin of Marsyas in the other. If
Apollo preserves his classical tranquillity despite the contempt that flares
his nostrils, he is the only one, for all others cringe at the hideousness of
his action. Marsyas, still tied to the tree, lies stripped of his skin, in full
anatomical display, almost as though we were in beauty's laboratory. The
artist seems to have striven to reproduce Ovid's own vivid detail:

> "Why do you strip myself from me?" he cried.
> "O I give in, I lose, forgive me now,
> No hollow shin-bone's worth this punishment."
> And as he cried the skin cracked from his body
> In one wound, blood streaming over muscles,
> Veins stripped naked, pulse beating; entrails could be
> Counted as they moved; even the heart shone red
> Within his breast.[59]

[36]

Why did the eighteenth century largely avoid the image of Marsyas? Very likely because this image so graphically represented the aspect of classicism that it denied. In the place of the snake bite, we find the knife wound inflicted by Apollo, the god of beauty. How else can we read this picture as well as the texts of German classicism without thinking that both are characterized by a troubled and conflicted relation to the body? The story of Marsyas is the untold story of Laocoon as it is to be found in the writings of Winckelmann, Lessing, Herder, Moritz, and Goethe. This study is the telling of that story.[60]

2

Winckelmann: Laocoon and the Eunuch

Winckelmann certainly had it coming to him.

Paul de Man,
"Aesthetic Formalization:
Kleist's *Über das Marionetten-theater*"

By 1760, five years after his arrival in Rome and four years before the publication of *Die Geschichte der Kunst des Alterthums*, Winckelmann had seen an enormous amount of antique art. While he was certainly not disappointed by classical sculpture, the relatively fewer examples of painting, even the new finds at Herculaneum, did not seem to meet the standard of their descriptions in Pliny and Philostratus, nor to compare well with the quality of the statues.

It is therefore not surprising that Winckelmann can barely contain his excitement when he is fortunate enough to be privy to a clandestine showing of an antique fresco illegally removed from an unknown place and smuggled into Rome. He confides this event in a letter to his Danish friend Hans Wiedewelt, a sculptor with whom he had lived and traveled in Rome and Italy in 1757 and 1758:

> Mein Freund! ich will Ihnen eine Nachricht mittheilen, die weder * * *, noch sonst jemand, ausser vier Personen wissen. Es ist ausser Rom ein Gemählde gefunden worden, (ich weiss aber noch nicht eigentlich, an welchem Orte,) welches das schönste Gemählde ist, was jemals aus dem Alterthume das Licht zu unseren Zeiten erblicket hat. Es stellet in Lebensgrösse den Jupiter vor, der den Ganymedes küsset, mit einem Ausdruck und einer Ausführung, die sich in keinem andern Werke findet. Es ist al fresco: denn wenn es atempera wäre, wie die mehrsten zu Portici sind, wäre nichts mehr davon zu sehen. Weil

es eine Entdeckung ist, die in geheim gemachet worden, so hat man das Gemählde nicht mit der Mauer abgesäget, sondern eine Person, die völlig unwissend in dergleichen gewesen, hat es Stückweise mit der Uebertünchung, oder dem Kalk von der Mauer abgerissen, und mit nassen Sägespänen in einem Kasten geleget und nach Rom gebracht. Hier sind die Stücken ganz heimlich von jemand, der es nicht verstanden, zusammen gesetzet, und müssen nunmehro von neuem abgebrochen werden.[1]

My friend! I want to tell you some news known by neither * * * nor anyone else except for four people. A painting was discovered outside of Rome (I actually do not yet know where), that is the most beautiful painting of antiquity ever to have seen the light of day in our time. It represents Jupiter in life-size, who kisses Ganymede, with an expression and an execution, that cannot be found in any other work. It is *al fresco*: for if it had been *atempera*, as most of the paintings in Portici are, there would be nothing left to see. Because it is a discovery that was made secretly, the painting was not removed with the wall, rather a person, who was entirely unknowledgeable in these things, tore it from the wall in pieces with the covering layer, or the lime, and laid it in a chest with wet wood shavings and brought it to Rome. Here the pieces were very secretively put together by someone who did not know how and must therefore be broken off again.

Not only was Winckelmann so privileged as to see "das schönste Gemählde" of antiquity, the artwork that would match the Laocoon, even as it loosely duplicated some of the circumstances that attended the discovery of the statue, the painting itself represented a most rare visual motif of the Ganymede story, Jupiter actually kissing the beautiful boy.[2] Perhaps no other motif would have appealed so strongly to Winckelmann's interest and desire (fig. 4).

Six days later Winckelmann reported the same news to his friend and sometime patron, the Baron von Stosch, a person to whom he is accustomed to confiding also personal and amorous matters. His description of the painting is duly marked by this difference:

Es ist ausser Rom, ich weiss nicht an welchem Orte, das allerschönste alte Gemählde entdecket, welches noch bis itzo an das Tages Licht erschienen ist, und übertrifft alles was zu Portici ist. Es ist Jupiter welcher den Ganymedes küsset in Lebensgrösse, ja der Bardasse ist in der Grösse eines schönen wohl-gebildeten jungen Menschen von Achtzehn Jahren. Der Kopf desselben ist schön über allen Begriff.[3]

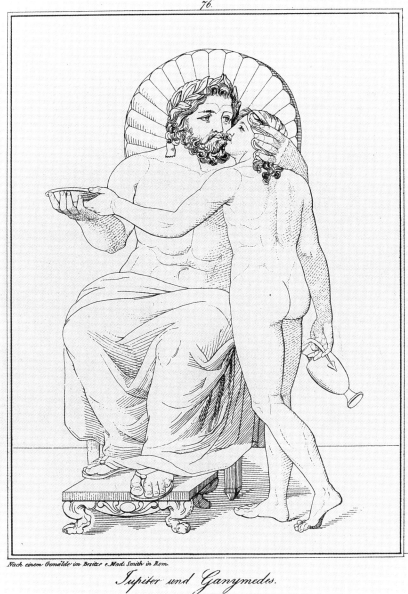

76.

Nach einem Gemälde im Besitze e.Mad. Smith in Rom.

Jupiter und Ganymedes.

FIG. 4. *JUPITER AND GANYMEDE*, ATTRIBUTED TO ANTON RAPHAEL MENGS. RE-
PRODUCED BY COURTESY OF THE UNIVERSITY RESEARCH LIBRARY OF THE
UNIVERSITY OF CALIFORNIA AT LOS ANGELES.

> Outside of Rome, I do not know where, the most beautiful old paint-
> ing was discovered that up until now has ever seen the light of day,
> and which surpasses everything in Portici. It is a Jupiter who kisses
> Ganymede in life-size, yes the *bardasse* is the size of a beautiful well-
> formed young man of eighteen years. His head is beautiful beyond
> all concept.

This letter sets the tone for all subsequent treatments of the fresco both
in private correspondence and eventually in the *Geschichte der Kunst*. Cer-
tainly no one expected Winckelmann to refrain from giving the painting
its proper place of honor, even though he seems to have waited until the
owner's unexpected death. The Ganymede motif, by its nature a place
where scholarship and homoerotic desire can meet, allows the blending in
Winckelmann of the language of connoisseurship and art history with the
discourse of eighteenth-century Italian homoeroticism, the heterogenous
discourse of the present chapter. The Italian word *bardasse*, masquerading
against its background of German language, gives it away. In the eigh-
teenth century it meant "Lustknabe" or "Schandbube," in other words,
a catamite. The very word indicates a gender ambiguity. Etymologically
derived from the Persian word *bardag'* meaning female slave, it is in
the Italian a masculine word with a feminine ending. The use of the
word *bardasse* to designate Ganymede slices through Winckelmann's art
historical discourse in such a manner as to connect it with the homoerotic
underground of his time.

When Winckelmann's *Geschichte der Kunst* finally appeared, there
was a description of the Ganymede painting in the section entitled "Von
der Malerey der alten Griechen." Although he does not call Ganymede a
bardasse, his erotic interest is evident:

> Nachdem man in langer Zeit keine alte völlig erhaltene Gemälde in und
> um Rom entdecket hatte, und wenig Hoffnung darzu übrig schien,
> kam im September des 1760. Jahres ein Gemälde zum Vorschein,
> desgleichen niemals gesehen worden, und welches die Herculanischen
> Gemälde, die damals bekannt waren, so gar verdunkelt. Es ist ein
> sitzender Jupiter, mit Lorbeer gekrönet, . . . im Begriffe, den Gany-
> medes zu küssen, welcher ihm mit der rechten Hand eine Schale, mit
> erhobener Arbeit gezieret, vorhält, und in der linken ein Gefäss, woraus
> er den Göttern Ambrosia reichte. Das Gemälde ist acht Palme hoch,
> und sechs breit, und beyde Figuren sind in Lebensgrösse, Ganymedes
> in der Grösse eines sechzehenjährigen Alters. Dieser ist ganz nackend,
> und Jupiter bis auf den Unterleib, welcher mit einem weissen Gewande
> bedecket ist; die hält derselbe auf einem Fussschemmel. Der Liebling

des Jupiters ist ohne Zweifel eine der allerschönsten Figuren, die aus dem Alterthume übrig sind, und mit dem Gesichte desselben ist nichts zu vergleichen: es blühet so viel Wollust auf demselben, dass dessen ganzes Leben nichts, als ein Kuss, zu seyn scheinet.[4]

After a long period when no completely preserved antique painting had been discovered in and around Rome, and there seemed to be little hope left, a painting emerged in September of 1760, the likes of which have never been seen, and which causes the well known paintings of Herculaneum to pale in comparison. It is a seated Jupiter, crowned with laurel, . . . on the point of kissing Ganymede, who presents him a bowl with the right hand, decorated in relief, and with the left a vessel from which he poured nectar for the gods. The painting is eight palms high and six wide, and both figures are life-size, Ganymede the size of a sixteen-year-old. The latter is completely naked, and Jupiter is naked but for his lower body which is covered with a white robe. The beloved of Jupiter is undoubtedly one of the most beautiful figures that remain from antiquity, and there is nothing to compare with his face: so much sensuality blossoms there that his whole life appears to be nothing but a kiss.

The scandal of the Ganymede fresco, of course, is that it is a forgery. Winckelmann was duped either by his friend Anton Raphael Mengs, who, on his deathbed, is said to have "confessed to having forged the *Jupiter and Ganymede*, urgently requesting that his 'cheat upon antiquity' be made public,"[5] or, as has been more recently argued, by Giovanni Casanova, brother of the great adventurer, who definitely did execute at least two other forgeries with the express purpose of humiliating Winckelmann.[6] Winckelmann never acknowledged that the Ganymede was fake, though he was publicly outraged by Casanova's prank and sought to have all mention of the forgeries that had fooled him expunged from a second edition of his *Geschichte der Kunst*. Even though it was clear that Casanova and Mengs were involved in the secretive circumstances surrounding the Ganymede fresco, Winckelmann was reluctant to give up the claim to the painting's authenticity. Obviously a lot was at stake.

The *Ganymede* concentrates a great many of the pertinent issues of Winckelmann's aesthetics. This is not surprising, since whoever executed the forgery was an excellent reader of Winckelmann, both his character and his work—so good, in fact, as to have produced the perfect embodiment of his aesthetics.[7] Among the issues raised are, first, the question of the authenticity of Winckelmann's conception of antiquity. If he was so easily fooled by this painting, is not his entire vision of antiquity seriously

Winckelmann: Laocoon and the Eunuch

compromised? It is almost as though the Ganymede were the most accurate representation of Winckelmann's counterfeit antiquity.

The second issue concerns the relation between aesthetics and homo-erotic desire. Recent gay scholarship seems to have agreed to call Winckelmann a homosexual, even though the designation is admittedly anachronistic.[8] We will see that a decidedly homoerotic discourse penetrates and configures Winckelmann's classical aesthetic discourse all the way to its center.

A third issue involves the complex relations between the biographical, the historical, and the theoretical. There is no intention here of explaining Winckelmann's aesthetics by referring to biographical or historical circum-stances. The Ganymede fresco stands at a point where the biographical, the historical, and the theoretical meet. The arrangements that enabled Winckelmann to see the fresco formally duplicate those of a clandestine homosexual assignation; the word *bardasse* betrays him. Indeed, Winck-elmann seems to delight in the precise historical occasion, so much so that he carefully documents the details even in the published *Geschichte*. Choosing not only to include but actually to celebrate the Ganymede in his magnum opus, Winckelmann takes a considerable risk: he allows a highly personal, secretive homoerotic discourse to intersect with the highly public and theoretical discourse of aesthetics and art history. He does this, I believe, because the theory—and it is a highly idiosyncratic theory, as we shall see—requires these and many other biographical and historical details in order to be articulated. The discourse from outside, that is, the historical and the biographical, is theory's body.

The one issue that seems to be missing from his account of the *Ganymede*, however, is pain. This is only an appearance. It will take a discussion of the Laocoon in the *Gedancken über die Nachahmung*, and the eunuch in the *Geschichte der Kunst*, before we will be able to return to the *Ganymede* and realize that it too is one of Laocoon's Others.

1

Winckelmann's *Gedancken über die Nachahmung der Griechischen Wercke in der Mahlerey und Bildhauer-Kunst* was published in 1755, just months before he left Dresden for Rome. It is in this text, praised by Herder as Winckelmann's best—"so wie gewissermassen immer das Erste Werk eines Menschen sein bestes seyn wird" (just as in a certain sense a person's first work will always be their best)[9]—while Goethe was inclined to call it "barock und wunderlich,"[10] that Winckelmann first described the Laocoon, which he had seen as a plaster cast, claiming it as the best exemplar of "eine

[43]

edle Einfalt, und eine stille Grösse." This famous phrase is familiar to the point of meaninglessness, and therefore it will repay us to consider it again in the context of its original setting. When we reread the passage in the *Gedancken*, we find it concerns the apparently irreconcilable demands of aesthetic and semiotic systems of representation.

> Das allgemeine vorzügliche Kennzeichen der griechischen Meisterstücke ist endlich eine edle Einfalt, und eine stille Grösse, sowohl in der Stellung als im Ausdrucke. So wie die Tiefe des Meers allezeit ruhig bleibt, die Oberfläche mag noch so wüten, ebenso zeiget der Ausdruck in den Figuren der Griechen bei allen Leidenschaften eine grosse und gesetzte Seele.
>
> Diese Seele schildert sich in dem Gesichte des Laokoons, und nicht in dem Gesichte allein, bei dem heftigsten Leiden. Der Schmerz, welcher sich in allen Muskeln und Sehnen des Körpers entdecket, und den man ganz allein, ohne das Gesicht und andere Teile zu betrachten, an dem schmerzlich eingezogenen Unterleibe beinahe selbst zu empfinden glaubet; dieser Schmerz, sage ich, äussert sich dennoch mit keiner Wut in dem Gesichte und in der ganzen Stellung. Er erhebet kein schreckliches Geschrei, wie Vergil von seinem Laokoon singet: Die Öffnung des Mundes gestattet es nicht; es ist vielmehr ein ängstliches und beklemmtes Seufzen, wie es Sadoleto beschreibet. Der Schmerz des Körpers und die Grösse der Seele sind durch den ganzen Bau der Figur mit gleicher Stärke ausgeteilet, und gleichsam abgewogen. Laokoon leidet, aber er leidet wie des Sophokles Philoktet: sein Elend gehet uns bis an die Seele; aber wir wünschten, wie dieser grosse Mann, das Elend ertragen zu können.[11]

> The general and most distinctive characteristics of the Greek masterpieces are, finally, a noble simplicity and quiet grandeur, both in posture and expression. Just as the depths of the sea always remain calm however much the surface may rage, so does the expression of the figures of the Greeks reveal a great and composed soul even in the midst of passion.
>
> Such a soul is reflected in the face of Laocoon—and not in the face alone—despite his violent suffering. The pain is revealed in all the muscles and sinews of his body, and we ourselves can almost feel it as we observe the painful contraction of the abdomen alone without regarding the face and other parts of the body. This pain, however, expresses itself with no sign of rage in his face or in his entire bearing. He emits no terrible screams such as Vergil's Laocoon, for the opening of his mouth does not permit it; it is rather an anxious and troubled sighing as described by Sadoleto. The physical pain and the nobility of soul are distributed with equal strength over the entire body and are,

as it were, held in balance with one another. Laocoon suffers, but he suffers like Sophocles' Philoctetes; his pain touches our very souls, but we wish that we could bear misery like this great man.

The statue is described as a struggle for expression (*Ausdruck*) between two forces, pain and the great and resolute soul. We might have expected Winckelmann to describe the struggle between Laocoon and the snakes, but his attention is entirely concentrated on Laocoon's body, almost as if the struggle between man and animal had been transferred there. Both forces are conceived of as self-representing: the soul depicts itself (*schildert sich*), the pain discovers itself (*entdecket sich*), and expresses itself (*äussert sich*). The body is where this struggle for self-representation takes place.

Pain struggles for full unrestrained expression, *parenthyrsis*, as Winckelmann calls it. *Parenthyrsis*, a term from rhetoric, means exaggerated, unseemly pathos. Winckelmann habitually accuses Bernini of this excess. The presence of the word *thyrsis*, the sacred staff of Bacchus, reveals its Dionysian background. The soul, on the other hand, struggles to stifle and conceal the pain, "um den Schmerz in sich zu fassen und zu verschliessen" (in order to grasp and lock up the pain),[12] as Winckelmann says in another place. The soul thus expresses itself through its effort to suppress or conceal any opposing expression. These two forces, pain and the soul, are held in a permanent synchronic tension. Indeed, this tension produces the single expressive contour that figures Laocoon's body, so that as long as the tension is maintained it becomes difficult to distinguish the pain from the "grosse und gesetzte Seele." This is expressed grammatically by the pronoun *er* which can stand for *der Schmerz* or *der Laokoon*.

Should the tension relax, however, the two forces would lapse into a kind of death. This can be graphically illustrated if we pursue Winckelmann's allusion to Sophocles—"Er [Laocoon] leidet wie des Sophokles Philoktet" (he suffers like Sophocles' Philoctetes)—for we find in Sophocles' play a scene that sets the opposing self-representing forces in motion. Philoctetes, of course, was a Greek hero who suffered from a chronic foot wound sustained from a snake bite. According to legend, not only did the wound emit a disgusting stench, but the pain was so severe that he cried out constantly. For these reasons, Odysseus had long ago abandoned Philoctetes on a deserted island. The gods, however, required that Philoctetes and his bow be involved in the Greek triumph over Troy. That is why Odysseus and Neoptolemos have come to the island to trick Philoctetes into joining them.

The scene that Winckelmann has in mind when he alludes to Sophocles begins when Philoctetes is suddenly and unexpectedly struck by violent

pain. "Why have you nothing to say? Why do you stand, in silence trans-fixed?"[13] asks Neoptolemos. *Siopas kapoplektos*—the Greek has the adjective "apoplectic," disabled by a blow, or literally: struck off, struck, as it were, from the course of one's action or narrative and petrified. The term is equally applicable to the sudden snakebite that configures the Laocoon and so fascinated Goethe as we shall see in a later chapter. At any rate, the sudden pain renders Philoctetes a silent statue. Neoptolemos is puzzled by what he sees and asks repeatedly, "What is it?" (733, 734, 740, 751). "Tell me; do not keep silence." That concealment is at stake becomes clear lines later when Philoctetes says:

> I am lost, boy.
> I will not be able to hide [*krupsai*] it from you longer.
> Oh! Oh!
> It goes right through me, right through me!
> Miserable, miserable!
> I am lost, boy. I am being eaten up. Oh!
> By God, if you have a sword ready to hand, use it!
> Strike the end of my foot. Strike it off, I tell you, now.
> Do not spare my life. Quick, boy, quick. (742–50)

The drama is precisely that of the Laocoon: the powerful struggle between violent pain and the soul's effort to contain it. Finally Philoctetes succumbs and Neoptolemos describes what he sees:

> In a little while, I think,
> sleep will come on this man. His head is nodding.
> The sweat is soaking his body all over,
> and a black flux of blood and matter has broken
> out of his foot. (821–25)

Pain passes from his body visibly in the form of the flux. Doing so, it leaves him asleep, just as he had longed for death. Sleep, as the chorus sings, "knows not pain nor suffering" (827). When the two interlocked oppositional forces are separated they fall apart into the expelled pain on the one hand and sleep or death on the other. Herder, in his notes to the section of the *Gedancken* that we are considering, wrote that: "Ruhe allein ist Trägheit, und eine Art [von Nichts] Tod: übertriebene Leidenschaft und Handlung Krankheit und also eine Art Tod ebenfalls" (Repose by itself is lethargy, and a sort of [nothing] death: exaggerated passion and action is disease and thus also a sort of death).[14] Herder has put his finger on the problem. If the self-representing forces of the soul and pain are left to

represent themselves without resistance, the result is nothing (*Nichts*), a sort of death. Death means the failure of representation, either the invisible soul entirely at rest within what amounts to a corpse or the unchecked agonized scream that defies representation. Representation depends on resistance. Though pain and the soul's effort to conceal pain are violently opposed, it is only in their mutual tension that representation takes place.

To my knowledge this is the first time that such an "agonistic" theory of representation has been formulated. Theories of beauty abounded, but a theory of classical beauty that relies on pain as a self-representing force is something altogether new, so new, in fact, that Winckelmann himself was uncomfortable with it. He was uncertain whether he had solved a problem or uncovered a dilemma.

Pain is where the difficulty lies. It is an ambivalent force. Any representation of human nature, whether in a play, a poem or a painting, requires action, expression, passion—Aristotle calls it plot. For Winckelmann, subscribing to a fundamental Epicurean dichotomy, pain and the absence of pain, these are all types of pain. As such they satisfy the semiotic demands of representation, for they tell a story, they signify. Beauty, however, which is what the aesthetic demands of representation require, is compromised by pain, by the semiotic demands. Winckelmann makes this clear in his theoretical reflections on the description of the Laocoon:

> Je ruhiger der Stand des Körpers ist, desto geschickter ist er, den wahren Charakter der Seele zu schildern: in allen Stellungen, die von dem Stande der Ruhe zu sehr abweichen, befindet sich die Seele nicht in dem Zustande, der ihr der eigentlichste ist, sondern in einem gewaltsamen und erzwungenen Zustande. Kenntlicher und bezeichnender wird die Seele in heftigen Leidenschaften; gross aber und edel ist sie in dem Stande der Einheit, in dem Stande der Ruhe. Im Laokoon würde der Schmerz, allein gebildet, Parenthyrsis gewesen sein; der Künstler gab ihm daher, um das Bezeichnende und das Edle der Seele in eins zu vereinigen, eine Aktion, die dem Stande der Ruhe in solchem Schmerze der nächste war. Aber in dieser Ruhe muss die Seele durch Züge, die ihr und keiner andern Seele eigen sind, bezeichnet werden, um sie ruhig, aber zugleich wirksam, stille, aber nicht gleichgültig oder schläfrig zu bilden.

> The more tranquil the state of the body the more capable it is of portraying the true character of the soul. In all positions too removed from this tranquillity, the soul is not in its most essential condition, but in one that is agitated and forced. A soul is more apparent and distinctive when seen in violent passion, but it is great and noble when

seen in a state of unity and calm. The portrayal of suffering alone in Laocoon would have been *parenthyrsos*; therefore the artist, in order to unite the distinctive and the noble qualities of the soul, showed him in an action that was closest to a state of tranquillity for one in such pain. But in this tranquillity the soul must be distinguished by traits that are uniquely its own and give it a form that is calm and active at the same time, quiet but not indifferent or sluggish.

Although the conflict of pain and the soul, expression and beauty—the semiotic and aesthetic demands of representation—is the condition for representation to take place at all, the consequences for a classical aesthetics of beauty when pain is admitted this close to the origin of representation are troubling, to say the least. Pain causes the soul to be "kenntlicher und bezeichnender"—it satisfies the semiotic demands (indicated in *bezeichnend*) of representation. But pain causes the soul to be signified in a condition that is other than its own—it falsifies the soul and violates the aesthetic demands. How can a representation be beautiful if pain is essential, but at the same time necessarily disfigures beauty and makes it different from itself? Remove pain, and beauty becomes invisible or dead, "gleichgültig oder schläfrig." Winckelmann tries to insist that the "action" of the Laocoon, the violent attack and constriction of the snakes, is one that unifies "das Bezeichnende und das Edle der Seele," but his remarks are wistful and unconvincing. Goethe, as we shall see, will be the first to harness the attack of the snakes for the production of beauty. Winckelmann, whether he admits it or not, has effectively proven the inadequacy of the Laocoon to embody the qualities of "noble simplicity" and "quiet grandeur." He will describe the Laocoon one more time in the first year after his arrival in Rome (1755) and incorporate that description whole cloth in his *Geschichte* nine years later. The statue, however, no longer holds a central place in his aesthetic thinking. It has been supplanted, however discreetly, by the figure of the eunuch.

2

Winckelmann's *Geschichte der Kunst des Alterthums* underwent many transformations in the course of its writing. Initially conceived of as a description of the statues in the Belvedere Courtyard, for a time Winckelmann and Mengs planned a joint venture of ekphrasis and theory. Eventually Mengs published his own treatise *Gedanken über die Schönheit und über den Geschmack in der Malerey* (1762), a work which he dedicated to Winckelmann. When the *Geschichte* appeared in 1764, the foreword concluded

with the following: "Diese Geschichte der Kunst weihe ich der Kunst, und der Zeit, und besonders meinem Freunde, Herrn Anton Raphael Mengs" (I dedicate this History of Art to Art, to the time in which we live, and especially to my friend, Mr. Anton Raphael Mengs).[15] As late as September, 1767 Winckelmann mentions in a letter that he is hard at work on a second edition of the *Geschichte*, partially to erase all mention of Casanova's forgeries, but more importantly because he has continued to advance in his knowledge of antiquity and the theory of beauty. Writing to his friend Baron von Stosch, he says: "Um gegen einen Freund zu reden, schmeichele ich mir, es werde endlich etwas vollkommenes zum Vorschein kommen, und ich bin so verliebt in diese Arbeit, dass ich dieselbe niemahls aus der Hand lege" (To speak to a friend, I flatter myself that finally something perfect will emerge, and I am so in love with this work, that I never put it out of my hand).[16] Winckelmann never really completed the second edition, though it appeared, such as it was, a compendium of notes roughly twice the size of the first edition, in Vienna in 1776, eight years after his death.[17]

It is interesting that Winckelmann tells Stosch, "Ich bin so verliebt in diese Arbeit," for certainly one way to indicate the difference between the *Gedancken* and the *Geschichte* is to point to the role that the erotic comes to play in the latter. Already in the first edition, Winckelmann was aware that he was breaking new ground in the theory of beauty, though he did not directly state its connection with the erotic. Indeed, one gets the feeling that he regarded the central theoretical portions, the compositional counterpart to the coining of "edle Einfalt, stille Grösse" on the description of the Laocoon, as his greatest pride. In a boastful letter to his friend Hieronymus Dietrich Berendis he flaunts both his social freedom and his breakthrough in aesthetics:

> Heute speiset ein wunderschöner junger Castrate bey mir, welcher mit mir Deine Gesundheit trinken soll. Meine Anmerkungen über die alte Baukunst werden itzo in Leipzig ans Licht getreten seyn und mein hiesiges Werk zu Florenz und hier gedruckt überbringet Bianconi nach München von da es der Herr Graf erhalten wird. Diesen Winter wird man meine Geschichte der Kunst zu drucken anfangen: es ist in derselben eine Abhandlung über die Schönheit von 6 oder 8 Bogen, welche einiges Aufsehen, hoffe ich machen soll.[18]

> Today a fabulously beautiful young castrato will eat with me, who shall together with me drink to your health. My *Remarks Concerning Antique Architecture* should have appeared now in Leipzig and my present work that has come out in Florence and here Bianconi will

bring to Munich where Herr Graf will receive it. This winter my History of Art will begin to be printed; it contains a treatise on beauty of 6 or 8 sheafs which, I hope, will provoke some sensation.

What is of interest here is the jarring proximity of Winckelmann's dalliance with a young castrato and the theoretical portion of the *Geschichte der Kunst*. I hope to show that these two very different discourses are connected in the *Geschichte* at the deepest level, a thesis, it goes without saying, "welche einiges Aufsehen, hoffe ich machen soll" (which, I hope, will provoke some sensation).

Winckelmann's remarks on castrati are not confined to his private correspondence. The urgency for pursuing this line of inquiry comes in part from the sheer numerical frequency of reference in the *Geschichte* to what he calls "der Verschnittene." One stumbles across the word so often that it cannot be dismissed as an accident or insignificant quirk. Indeed, the word crops up in the most important places. The remarkable thing about Winckelmann's *Geschichte der Kunst* is that every time he looks for the visual instance that best embodies the classical ideal, his eye strays past the Laocoon and the Apollo Belvedere, and fixes on the eighteenth-century Italian castrato.

The castrati, of course, had their heyday in the eighteenth century. The opera of every royal court across Europe was populated with castrati who took not only the women's parts, but also those of Orestes, Achilles, Ajax, and even Hercules. While Winckelmann still resided in Dresden, there were three castrati attached to the royal court. There is no doubt that Winckelmann attended the opera regularly. In a letter to August Hermann Francke from 1758 he writes: "Des Abends gehe ich in die Opera.... Mich deucht, ich bin in Dresden: denn die Pilaja singet, und Lenzi und seine Frau tanzen. Der schöne, ja der schönste Belli singet zu Lucca" (Evenings I go to the opera.... I think that I am in Dresden: for the Pilaja sings, and Lenzi and his wife dance. The beautiful, nay the most beautiful Belli sings in Lucca).[19] Giovanni Belli was a famous soprano castrato who sang in the opera in Dresden from 1750 to 1756 and then returned to Italy. In another letter, written the year the *Geschichte* was published, Winckelmann writes: "Morgen werde ich *alla Valle* gehen, um den schönen Venanzio, *chi fa la parte di donna*, zu sehen und zu hören" (Tomorrow I will go *alla Valle* in order to see and hear the beautiful Venanzio, *chi fa la parte di donna*). Just as with *bardasse*, Winckelmann reverts to Italian in order to express the cultural and sexual ambiguity involved in this situation. Venanzio will play the part of the woman because he too is a castrato.

Most opera enthusiasts praised castrati for the quality of their voices. "With the Italians one could almost speak of a thoroughgoing disinclination toward the bass whom they held to be appropriate only for wrath and comedy. For them the concept of the hero was connected with that of eternal divine youth, and youth required a high-pitched voice, the sound of the unbroken voice of a boy—the castrato's voice!"[20] While Winckelmann would no doubt agree with this reasoning, he nonetheless gives the priority to seeing: the castrato's physical beauty affords visual pleasure. This was evident in his letter about Venanzio: "den schönen Venanzio . . . zu sehen und zu hören." It also explains his association with castrati in situations totally divorced from the opera, such as his intimate dinners with the young castrato mentioned above. In another letter about the same castrato we read: "Ich lasse mir itzo das Portrait eines schönen Castraten von 14 Jahren bey mir im Zimmer machen; ich wünsche, dass es gerathen mag" (I am now having the portrait of a beautiful castrato of 14 years of age painted in my room; I hope that it will succeed).[21] It is when the castrato becomes an object of aesthetic seeing that we are justified in calling him a eunuch as well. His ambiguous gender is then disengaged from its relatively stable social position in the eighteenth century, and he becomes available for other uses.

What intrigued Winckelmann about Belli, Venanzio, and other castrati was the eunuch's body and its peculiar physical beauty. Already as a student of medicine (1751), he had copiously excerpted passages from Buffon's *Histoire naturelle* pertaining to "the problems of sexual differentiation, [and] the sexual hybrid forms."[22] In the *Geschichte der Kunst* he speculates that the Greek artists had a similar interest:

> Diese Aufmerksamkeit griechischer Künstler auf die Wahl der schönsten Theile unzählbar schöner Menschen, blieb nicht auf die männliche und weibliche Jugend allein eingeschränket, sondern ihre Betrachtung war auch gerichtet auf das Gewächs der Verschnittenen, zu welchen man wohlgebildete Knaben wählete. Diese zweydeutigen Schönheiten, in welchen die Männlichkeit, durch Benehmung der Samengefässe sich der Weichlichkeit des weiblichen Geschlechts, in zärtlichen Gliedern, und in einem fleischigern und rundlichern Gewächse näherte, wurden zuerst unter den asiatischen Völkern hervorgebracht, um dadurch den schnellen Lauf der flüchtigen Jugend, wie Petronius saget, einzuhalten; ja unter den Griechen in Klein-Asien wurden dergleichen Knaben und Jünglinge dem Dienste der Cybele und der Diana zu Ephesus gewidmet.[23]

The attention which the Greek artists paid to the selection of the most beautiful parts from innumerable beautiful persons did not remain

limited to male and female youths alone, but their observation was directed also to the conformation of eunuchs, for whom boys of handsome shape were chosen. Those equivocal beauties effected by the removal of the seminal vessels—in which the masculine characteristics approximated, in the superior delicacy of the limbs, and in greater plumpness and roundness generally, to the softness of the female sex—were first produced among the Asiatics, for the purpose, as Petronius says, of retarding the rapid career of fleeting youth. Among the Greeks in Asia Minor, boys and youths of this kind were consecrated to the service of Cybele, and the Diana of Ephesus.

Two things distinguish the beauty of the eunuch's body: its artificially prolonged youthfulness and the physiological effects of the castration, "[die] Benehmung der Samengefässe."

The value Winckelmann placed in the extended youthfulness of the eunuch involves the problematic of temporality. That beauty is fleeting is a familiar topos. The application of the knife in the surgical procedure of castration in order to prolong the youthful beauty of the boy sets the eunuch in analogy to the statue, beauty immortalized with the chisel.

As for the physiological effects, which we now know are caused by the interference with the hormonal processes, these are enumerated in any number of passages of the *Geschichte* and can be summarized as follows. The eunuch is an ambiguous hybrid growth, a crossing of the male and female form. The hard determinate contours of the masculine body are softened and filled. What is masculine in the boy is erased by the feminine without his becoming a woman, i.e., without his being endowed with her genitals or breasts.[24] Thus the eunuch is marked by a double loss and as such is the opposite of the hermaphrodite or androgyne, who is doubly endowed.[25] The erasure of the masculine, says Winckelmann, is evident in the hands, and especially in the hips and back. "[D]ie Hüften sind völliger," he writes in the *Geschichte*,

> und haben eine stärkere Ausschweifung als in männlichen Körpern, und der Rückgrat lieget nicht so tief als bey uns, so dass sich weniger Muskeln zeigen, wodurch der Rücken mehr Einheit im Gewächse, wie bey Weibern, zeiget; sie haben auch ebenfalls wie diese über dem heiligen Beine das, was wir den Spiegel nennen, gross breit und flach.[26]

> [T]he hips are fuller and have a greater radius than in male bodies, and the spine does not lie as deep as it does with us, so that fewer muscles show, thus the back shows more unity in its form, as with women.

They also have, as do women, above the sacrum, that which we call the *Spiegel* [mirror], large broad and flat.

The whole description of the eunuch's body at this point in the *Geschichte* should be understood as the pendant to the description of the Laocoon. I call particular attention to the last sentence, for it covers the eunuch's wound. We will return to it at the end of this section.

Winckelmann refers to this ideal eunuch at crucial points in the *Geschichte der Kunst*, especially in those sections where he attempts to define beauty and to show its causes in Greek sculpture. In book 5, chapter 1, where he describes all the types of ideal male Greek statuary, from the gods down to the heroes, it is always with reference to two different hybrid forms of the eunuch. The first, he says, is "ein Ideal, theils von männlichen schönen Körpern, theils von der Natur schöner Verschnittenen genommen, und durch ein über die Menschheit erhabenen Gewächs erhöhet" (an ideal, partly taken from beautiful male bodies, partly from the nature of beautiful eunuchs, and then elevated through an organic form which is sublime beyond the human).[27] Many statues of Apollo conform to this type. Even the young Hercules, says Winckelmann, "findet sich ebenfalls in der schönsten Jugend vorgestellet, mit Zügen, welche den Unterschied des Geschlechts fast zweydeutig lassen" (Hercules can be found represented in the most beautiful youth, with contours that leave the difference between the genders almost ambiguous).[28] "Die zwote Art idealischer Jugend von verschnittenen Naturen genommen, ist mit der männlichen Jugend vermischt im Bacchus gebildet" (The second type of ideal beauty taken from castrated natures, is represented as mixed with male youth in Bacchus).[29] Bacchus is more frankly effeminate than the first type, but, as Winckelmann goes on to point out, "[i]n einigen Statuen des Apollo ist die Bildung desselben einem Bacchus sehr ähnlich" (in some statues of Apollo the shape is very similar to a Bacchus). [30]

Winckelmann justifies his obsessive resort to the eunuch by referring to Greek mythology and the poets.[31] He is able, by virtue of his prodigious classical erudition, to recall the slightest story and turn it to his support. Hercules and Achilles, he remembers, were disguised as women in order to escape detection, as was Hercules' son Telephos. Insofar as the disguise was successful, the youths must have been strikingly effeminate in appearance. Bacchus, he says, was frankly reared as a girl. There is the story of Attis, Cybele's beloved, who castrated himself and died under a tree. Winckelmann mentions Cybele's eunuch priesthood, and also the circumstance that statues of Apollo and Bacchus are sometimes found where the absence of testicles is not to be attributed to chance or to "freventliche

Verstümmelung" (blasphemous mutilation), but has a secret meaning. Bacchus "[wurde] von einigen mit dem Attis verwechselt, und [war] wie dieser des Gemächts beraubet. Da nun wieder auf der anderen Seite, im Bacchus auch Apollo verehret wurde, hatte in diesem die Verstümmelung besagten Theils eben dieselbe Bedeutung" (Bacchus was confused by some with Attis, and, like him, deprived of his privy parts. And since, on the other hand, Apollo was also honored in Bacchus, the mutilation of his privy parts has here the same meaning). It is striking to what extent the gods are interchangeable, a condition that appears to belong to the nature of the eunuch, the erasure of difference and individuation.

Although Winckelmann's evidence from Greek mythology and the poets is certainly interesting, he is a long way from persuading us that the Athenian agora was populated with beautiful eunuchs. If in the *Gedancken* Winckelmann posited the image of Greek youths wrestling naked in the sand, artists and others looking on, an image that is certainly credible on the basis of a reading of Plato, it is clear that for the *Geschichte* he wants a like situation but involving eunuchs. Just as there is no classical statue known as the eunuch—though Winckelmann tried to reidentify a number of statues as such[32]—there was never any classical situation to compare to Winckelmann's own time. The eunuchs in the *Geschichte*, the counterparts of the Greek youths in the *Gedancken*, can only be eighteenth-century castrati. This is confirmed when Winckelmann adduces the hands of Greek statues as evidence that ancient artists used eunuchs as their models, for we know on the strength of another of Winckelmann's observations that this cannot be. The hands of ancient statues, as he points out in the preface to his *Geschichte der Kunst*, if they have hands at all, are almost exclusively modern additions.[33] Winckelmann must be referring to the hands of living castrati.

At this point we are certain of two things. First, on the biographical level, it is clear that Winckelmann had an abundant and idiosyncratic interest in castrati and that his circumstances in Rome afforded him numerous occasions for experience with them. Second, on the philological level, it is obvious that the *Geschichte* relies on the figure of the eunuch as exemplary for classical beauty. What we do not yet know, and what is most important to establish, is *why* the eunuch figures so prominently, why the eunuch embodies beauty better than the Laocoon or the Apollo? What is the deep connection between Winckelmann's personal homoerotic interest in castrati and the aesthetic discourse around the eunuch? The answer concerns origins.

Italian audiences were not naive about castrati. It is reported that occasionally in the frenzy of their applause for a particularly well sung

aria by a famous castrato such as Farinelli or Caffarelli, audiences would call out: "Evviva il coltello!" (Long live the little knife!).[34] Insofar as Winckelmann's aesthetics must account for the origin of beauty so well embodied in castrati, and since castration is the necessary condition for this beauty, it is possible that an analogue to castration will be found at the center of Winckelmann's aesthetics. We are looking for the little knife.

As we have seen, what is distinctive about the eunuch as the epitome of youth and beauty is his physical indeterminacy, the crossing of genders in the blurring of the hard masculine contours. Take any line of his body and you will find, says Winckelmann,

> dass, da die Umrisse der jugendlichen Gestalten unmerklich einer in den anderen fliessen, es sehr schwer ist, die eigentlichen Punkte der Höhe und die Linie, welche dieselbe umschreibt, so wie die Stellen aufzufassen, wo die eine Linie sich mit der andern verbindet.

> [S]ince the lines of the youthful figures flow unnoticeably into each other, it is very difficult to lay your hands on the actual highest points and the line which describes them, as are those places where one line is connected to another.[35]

The line of the eunuch's body, in other words, defies representation, whether on paper or in the mind. It exists once and cannot be duplicated. But what Winckelmann is saying about this line is exactly what he says about beauty.

Book 4, chapter 2, of the *History* is entitled "Von dem Wesentlichen der Kunst." Winckelmann admits that it is extremely difficult to give a general account of beauty, since, as he says, "Die Schönheit ist eins von den grossen Geheimnissen der Natur, deren Wirkung wir sehen, und alle empfinden, von deren Wesen aber ein allgemeiner deutlicher Begriff unter die unerfundenen Wahrheiten gehöret" (Beauty is one of the greatest secrets of nature; we see its effects, and all people sense them, but a universal clear concept of its essence belongs to the undiscovered truths).[36] The great difficulty with beauty is that its cause can only be found in itself. Beauty is like the line of the eunuch's body: it is impossible to give it a mathematical determination or to reproduce it in or as something other than itself. Thus beauty cannot even consist in *Vollkommenheit* (perfection) as some have said. By *Vollkommenheit* Winckelmann means the teleological fitness that obtains between a thing and its purpose. Beauty consists in beauty. Appropriate principles then are such that do not disturb this tautology—simplicity and unity, for example. From the principle of unity Winckelmann

derives a new principle that seems to capture in a paradox precisely what he understands by classical beauty.

The new principle is called the *Unbezeichnung* of beauty, and is defined, in somewhat tortured syntax, as follows:

> Aus der Einheit folgt eine andere Eigenschaft der hohen Schönheit, die Unbezeichnung derselben, das ist, deren Formen weder durch Punkte, noch durch Linien beschrieben werden, als die allein die Schönheit bilden; folglich eine Gestalt, die weder dieser oder jener bestimmten Person eigen sei, noch irgendeinen Zustand des Gemüts oder eine Empfindung der Leidenschaft ausdrücke, als welche fremde Züge in die Schönheit mischen, und die Einheit unterbrechen. Nach diesem Begriff [der Unbezeichnung] soll die Schönheit sein wie das vollkommenste Wasser aus dem Schosse der Quelle geschöpft, welches, je weniger Geschmack es hat, desto gesunder geachtet wird, weil es von allen fremden Teilen geläutert ist.[37]

> [Its] forms are described by neither points nor lines, as such alone form beauty; consequently, a figure that belongs to neither this nor that particular person, nor expresses any condition of the spirit nor a sensation of passion, as such mix foreign aspects into beauty and disturb the unity. According to this concept [of *Unbezeichnung*] beauty should be like the most perfect water drawn from the lap of the spring, which, the less taste it has, the healthier it is considered to be, because it is purified of all foreign parts.

Unbezeichnung undoes *Bezeichnung*. On the strength both of the etymology and the definition, we can say that *Unbezeichnung* undoes both visual and linguistic reference, including narrative or contextual reference. It undoes both the *Zeichnung* and the *Zeichen*, the drawing and the sign, in *Bezeichnung*. We find an analogue in English: the word "designation," the English equivalent of *Bezeichnung*, contains both the words "design" and "sign." With regard to the visual, Winckelmann is talking about the indescribable line, the eunuch's contour, in other words. As for the linguistic sign, as his definition makes clear, he means the undoing of narrative context or expression: "noch irgendeinen Zustand des Gemüts oder eine Empfindung der Leidenschaft ausdrücke, als welche fremde Züge in die Schönheit mischen, und die Einheit unterbrechen." The undoing of narrative is no less than the denial of time.[38]

Winckelmann finds an image for *Unbezeichnung* in "das vollkommenste Wasser aus dem Schosse der Quelle geschöpft." We are reminded of the ancient fountain in the Belvedere courtyard that was mentioned in

the first chapter. In addition to meaning spring, the word *Quelle* also means source; taken together with *Schoss* it is evident that we have found the only place where the mother intrudes into Winckelmann's aesthetic system.[39] But is it correct to speak about intrusion when we are so obviously at the system's center? Is it not more an inevitable result of Winckelmann's marginalization of women, that the mother now appears at the center, and that the drama of his male gaze as it constitutes the beautiful statue involves the spectacle of a violently imposed return of another to the mother? *Unbezeichnung*, like castration, negates the determinate masculine line and removes its object from the order of time. *Unbezeichnung*, like castration, restores its object to the mother, to the pre-oedipal region of sexual non-difference. It would be fair, I think, to call *Unbezeichnung* a euphemism for castration in the realm of aesthetics.

Whenever there is castration, there is, of course, the implication of violence. When the beautiful Belli or Venanzia sings it is almost entirely forgotten that their parents brought them as boys to Naples to undergo the operation. In the same way, the violence that produced the eunuch, as it plays the role of the Greek statue, is concealed in its indeterminate beauty, its *Unbezeichnung*. Let us return now to Winckelmann's description of the eunuch to see if any sign of castration's violence remains.

We left him admiring his eunuch, describing its body in a passage that concluded: "Sie haben auch ebenfalls wie diese über dem heiligen Beine das, was wir den Spiegel nennen, gross breit und flach" (They also have, as do women, above the sacrum, that which we call the *Spiegel* [mirror], large broad and flat). At first sight, it is difficult to say what Winckelmann is looking at. This is because the two terms, *heiliges Bein* and *Spiegel*, may be unfamiliar in this context. The first is a literal translation of the Latin *os sacrum* (sacred bone) which is more commonly rendered in German with the words *Kreuz* (cross) or *Kreuzbein*. Any anatomy book will show that the sacrum does indeed bear the shape of a cross. Winckelmann's choice of the word *heiliges Bein* conceals the cross in a manner similar to the way *Unbezeichnung* stands in for castration. At the same time, Winckelmann's neologism for rendering the Latin into German is an inverse variant of employing Italian for homoerotic designations, as was the case with *bardasse*. As for *Spiegel*, Adelung, an eighteenth-century lexicographer, says it can designate any flat surface, and Grimm's lexicon calls attention to uses of *Spiegel* that are "scherzhaft verwandt als Bezeichnung von culus, anus, podex" (jokingly applied to designate culus, anus, podex).[40]

We now know what Winckelmann is looking at—his gaze is fixed on the area just above the eunuch's buttocks. He sees a *Spiegel*, a smooth, sensuous surface of flesh. One cannot help but think back to Winckelmann's

use of water imagery: the tranquil *Wasserspiegel* of this passage would contrast with the raging surface in the simile connected with the Laocoon. The unbroken line of the eunuch's contour is mirrored in Winckelmann's language: contrary to his custom, he does not insert commas between the adjectives, "gross breit und flach." The mirror points to the narcissistic dimension of classical aesthetics at the same time that it conceals beneath it, in invisible depths, the place where genders crossed and where, even if it sounds farfetched, the youth was crucified in their crossing.[41] To speak plainly, I am arguing that the buttocks, shaped as they are by castration, and the obvious erotic focus of the gaze, metonymically stand for *and* conceal the scar where the testicles were once injured, the site of this strange crucifixion.

It must seem very strange to find the crucifixion at this place in the foundational text of classical aesthetics. Nor, if we may anticipate the chapters still to come, is this the only text in which the cross will be encountered. The crucified Christ is, with Marsyas, Laocoon's unspoken Other. Most eighteenth-century theorists of classical beauty contrasted their Greek ideal with the medieval or baroque image of a gruesomely tormented or dead Christ. In painting or sculpture, the crucifixion and the pieta insist in their representation on the ponderous presence of the body. In death, the muscles lose their tautness, Christ's chest hollows, his belly sags. No wonder that Winckelmann, in one of his very infrequent references to paintings of Christ, writes:

> In den mehrsten Bildern aber, um von Michael Angelo anzufangen, scheinet man die Idee von den barbarischen Arbeiten der mittleren Zeit genommen zu haben, und man kann nichts Unedleres von Gesichtsbildung als solche Köpfe des Christus sehen.[42]

> But the idea of most figures of him [Jesus], beginning with Michael Angelo, appears to be borrowed from the barbarous works of the Middle Ages, and there can be nothing more ignoble than the face in such heads of Christ.

Winckelmann would prefer to see a beardless Christ, preferably modeled on none other than the eunuch.

It is clear now why the eunuch better embodies classical beauty than the Laocoon. The latter, we recall, consisted in the synchronic tension of two self-representing forces, pain and the soul. The aesthetic demands of representation were in conflict with the semiotic demands. With the figure of the eunuch this problem is resolved. The two forces that configured

the Laocoon are temporally separated, the pain of castration displaced to a distant past. All that remains is the absence, the empty cross, and the physiological effects that emanated from that point to mold the eunuch's body into its ambiguous and fascinating form. It is this sensuous potency that enlivens the eunuch's otherwise sleepy body and captivates the beholder's attention (or desire). Indeed, the immortalized beauty of the eunuch is a type of living death. The eunuch gives the lie to the doctrine of "schöner Schein" (beautiful appearance) thirty years before it is even formulated.

Kant and Schiller would, in the next decades, formulate notions of aesthetic autonomy, just as Goethe, Moritz, and others would elaborate theories of the symbol. They would speak of the autonomous art work, provocatively calling it useless, non-referential, and unproductive. They would see the beautiful as a symbol of morality, the beautiful art work as a symbol of freedom. In all cases, whether directly or not, they are referring to the Greek statue in its self-contained, self-sufficient perfection, the statue, in other words, as it had been understood by Winckelmann. But, as we have seen, that self-containment and self-sufficiency are bought at a price, namely *Unbezeichnung* or castration, and produce a very unusual if not totally compromised form of aesthetic perfection. Is the artwork useless? non-referential? unproductive? All of these qualities are simply the effects of castration. The eighteenth-century castrato, the type for Winckelmann's conception of the classical Greek statue, is, finally, the unlikely and impossible referent of all subsequent theories of classical beauty, aesthetic autonomy, and the symbol—in other words, aesthetic theory's cruelty to the body.

3

Now we are in a better position to interpret the Ganymede forgery, which Winckelmann called "das allerschönste alte Gemählde" (the most beautiful ancient painting). Perhaps the first thing to strike our attention is Ganymede's pose. It perfectly displays the posterior view that Winckelmann elaborated in his description of the eunuch. The beholder is treated to the sight of the *Spiegel*: "gross breit und flach." Winckelmann's use of the Italian word *bardasse* acquires more resonance. It involves the ambiguity of gender, the notion of a male/female slave, and Persian origins—what else is the *bardasse* if not the eunuch to whom Winckelmann, as we saw, also ascribes a Persian origin?

Various attempts have been made to identify the sources for the fresco and particularly the figure of Ganymede. One writer has gone so far as to

state that Ganymede is in fact a portrait of one of Winckelmann's beloved and cites the incident of Winckelmann's commissioning a painting of the fourteen-year-old castrato.[43] This seems speculative in the extreme, and not very useful. More interesting is the suggestion of Thomas Pelzel that a "possible source [for Ganymede] may have been Winckelmann's familiar and beloved *Apollo Belvedere.*"

> From the unaccustomed dorsal view of the statue we may note several basic points of similarity to the figure of Ganymede: the flowing, "Achillean" locks of hair, held at the brow by an encircling band; the relaxed extension of the left arm, with the right dropping quietly to the side; the placement of the elegantly trailing left leg in contrast to the straightened right leg.[44]

I believe Pelzel is right about the visual quotation of the Belvedere Apollo, a suggestion that is doubly attractive insofar as we have already seen the same Apollo visually quoted in the Marsyas engraving.

One other source might be considered, based on an argument that proceeds from the interpretation of Winckelmann's aesthetics that has been presented here. Perhaps the Ganymede fresco is based on the Laocoon group, altered according to the same logic that forced Laocoon to be supplanted by the eunuch. Admittedly a good many things must be transformed, but nonetheless I think the two images allow a meaningful superimposition. We must exclude the young son and turn the older around to face his father. The painful struggle with the snakes is relaxed, just as the move from the Laocoon to the eunuch expelled the pain. Jupiter, the lover, is seated like Laocoon. His mouth is open, not in a scream or sigh, but in anticipation of the kiss. His arm encircles Ganymede as the snakes surrounded their victims. Indeed, the play of arms produces a circle of grace not unlike what Goethe will propose in his reading of the Laocoon. Ganymede's buttocks, presented to the beholder's view, cover the place of the snake's bite, as they cover, if we are right, the place of his castration and pain.

The statues that are the pillars of Winckelmann's aesthetics—the Laocoon, the Apollo, as well as the Antinous and the Belvedere Torso—are no longer as highly esteemed as they were at the time of his death. Nonetheless, their place in aesthetic and art historical discourse is secure. The Ganymede, however, this painting that Winckelmann himself continued to uphold as authentic despite the evidence, and that became the centerpiece of his aesthetics, occupies a marginal position in every respect. It straddles the boundary between original and forgery, ancient and modern, man and

woman, theoretical and historical. The aesthetics of classicism would seek to represent itself as an authentic discourse, as decidely antique as opposed to modern, as manly in contrast to a diseased and effeminate modernity, as a timeless norm and not a historical contingency. The picture of Ganymede destabilizes classicism's self-representation totally. As we have discovered in connection with the eunuch, in classical aesthetics pain is beauty's story.

3

Lessing:
Euphemism and the Grave

At first sight, the image does not resemble a
cadaver, but it could be that the strangeness of
a cadaver is also the strangeness of the image.

Maurice Blanchot

Farewell, I must not look upon the dead. My
eye must not be polluted by the last gaspings
for breath.

Euripides

Strange to say, but Lessing's *Laokoon oder über die Grenzen der Malerei und Poesie* (1766) is hardly about the Laocoon at all. Instead, it is about the denial of the statue, the denial of corporeality and death. Contemporary beholders of the Laocoon may be struck by many things, but certainly they will notice that just above the visual center of the statue, where the snake bites, Laocoon's ribs protrude mightily. The mortality of Laocoon's body is on display; it is the baroque within the classical, the *memento mori* in the beautiful.

We can underscore and elaborate this aspect of the statue by placing it in the proximity of images that eighteenth-century German classicism desperately sought to exclude. A dramatic variation of the Man of Sorrows motif from Christian iconography, the Lamentation or Grave-Deposition, could be seen as an obvious if infrequently noted counterpart to the Laocoon. Seated on the edge of the grave, flanked by Mary and John, Jesus is represented as profoundly present in his heavy lifeless corporeality. Both the Laocoon and the Lamentation share the context of pain, and it is pain that makes mortality visually evident.

Another and far less obviously related image is the anatomy. Many have argued for the significant relation of the dead Christ and the anatomy lesson, most frequently in connection with Rembrandt's *Anatomy Lesson*

of Dr. Tulp.[1] But none have seen that it is in the anatomy motif that the Laocoon and the Man of Sorrows are, as it were, superimposed. One example will suffice to illustrate this.[2] Consider the woodcut by Baldung Grien produced for Walter Hermann Ryff's *Anatomi* (1541) (fig. 5).[3] It is striking to what an extent the image duplicates first of all the Man of Sorrows motif: similarly seated, the one arm and hand lifelessly outstretched. Even more striking, however, are the visual echoes of the likewise seated Laocoon: the corpse's feet are exactly posed like those of Laocoon, the legs vary only slightly; the coil of the large intestine reproduces the interplay of snake and the arm of the younger son; the hair and beard of both are the same; and the tilted head, the furrowed brow, upturned eyes, and open mouth of the corpse are clearly visual quotations of the Laocoon.

In the anatomy, Christ's wounded side and Laocoon's snakebite have been opened up into a total wound. The point of pain is display, a word derived from the Latin *displicare*, to spread out, the same root for the English word "splay." Laocoon and the Man of Sorrows, as their exaggerated pendant confirms, are splayed bodies, bodies on display as bodies in all their material and mortal presence. What inflicts the pain is another question—in Winckelmann, as we saw, it was the beholder's desire for beauty. In Lessing, as we shall see, pain, desire, and beauty operate differently. But what is interesting and essential in Lessing is his reaction to the body displayed in the statue or crucifixion. He responds to the body, the dead or dying body, with fascination and abhorrence. It therefore should not surprise us that Lessing's aesthetics, as we shall see, is based on a denial of death. Appropriately, its primary trope is euphemism.

Euphemism is derived from the Greek word *euphemos*, an auspicious utterance or religious silence. Euphemism is the rhetorical maneuver of substituting a pleasant, harmless, or beautiful word for the terrible reality signified by another. Death was likely the first circumstance to provoke a euphemizing response. Sexuality, disease, and excrement also required cautious semantic treatment.[4] Clearly, all four of these are involved with the corporeality of the body.

Euphemism does not appear in all books of rhetoric, but it certainly appears in a number. Gustav Gerber, whose nineteenth- century rhetoric *Die Sprache als Kunst* influenced Nietzsche, mentions the rhetorics of Demetrius and Tryphon as including euphemism in their catalog of tropes.[5] Euphemism is understood as a type of antiphrasis. As such, it is classified together with irony, which operates in a technically similar manner but to an opposite end. The classical example of euphemism is from the last play of Aeschylus's *Oresteia, The Eumenides.* With this name meaning the "solemn ones" or the "kindly ones," the Greeks sought to soften the horrifying

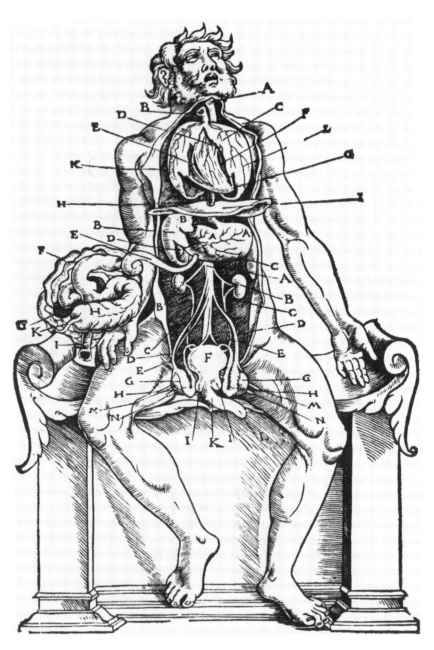

FIG. 5. *INTESTINAL TRACT OF A SEATED MAN*, HANS BALDUNG GRIEN. ILLUS-
TRATION FOR WALTER HERMANN RYFF'S *ANATOMI*, 1541. COURTESY OF THE
NATIONAL LIBRARY OF MEDICINE.

Erinyes or Furies, beings closely associated with the terror of death and the primeval mother. It goes without saying that a gesture analogous to euphemism could also be practiced in the visual arts, although, as we shall see, it will be attended by additional problems. In any event, Lessing felt confident enough to say: "Ich darf behaupten, dass sie [the Greeks] nie eine Furie gebildet haben" (I may declare that the Greeks never depicted a fury).[6]

That euphemism is understood as a type of antiphrasis is not without strategic importance to us. Euphemism denies the death of the body; it thus withdraws its object from the temporal order; it consists in being other than itself. In fact, what euphemism denies is precisely what rhetoric calls allegory, the trope which insists on the mortality of the body, and which inserts its object in the temporal order.[7] This being the case, a reading in terms of allegory is exactly what is needed to counteract Lessing's euphemism. We shall see that allegory decomposes euphemism in a way that imitates the chemistry of death.

A preliminary example of euphemism in Lessing's *Laokoon* is given with the story of a painting by Timanthes. We quote this in its entirety.

> Sein [Timanthes'] Gemälde von der Opferung der Iphigenia, in welchem er allen Umstehenden den ihnen eigentümlich zukommenden Grad der Traurigkeit erteilte, das Gesicht des Vaters aber, welches den allerhöchsten hätte zeigen sollen, verhüllte, ist bekannt, und es sind viel artige Dinge darüber gesagt worden. Er hatte sich, sagt dieser [Plinius], in den traurigen Physiognomien so erschöpft, dass er dem Vater eine noch traurigere geben zu können verzweifelte. Er bekannte dadurch, sagt jener [Valerius Maximus], dass der Schmerz eines Vaters bei dergleichen Vorfällen über allen Ausdruck sei. Ich für mein Teil sehe hier weder die Unvermögenheit des Künstlers, noch die Unvermögenheit der Kunst. Mit dem Grade des Affekts verstärken sich auch die ihm entsprechenden Züge des Gesichts; der höchste Grad hat die allerentschiedensten Züge, und nichts ist der Kunst leichter, als diese auszudrücken. Aber Timanthes kannte die Grenzen, welche die Grazien seiner Kunst setzen. Er wusste, dass sich der Jammer, welcher dem Agamemnon als Vater zukam, durch Verzerrungen äussert, die allezeit hässlich sind. So weit sich Schönheit und Würde mit dem Ausdrucke verbinden liess, so weit trieb er ihn. Das Hässliche wäre er gern übergangen, hätte er gern gelindert; aber da ihm seine Komposition beides nicht erlaubte, was blieb ihm anders übrig, als es zu verhüllen?— Was er nicht malen durfte, liess er erraten. Kurz, diese Verhüllung ist ein Opfer, das der Künstler der Schönheit brachte. Sie ist ein Beispiel, nicht wie man den Ausdruck über die Schranken der Kunst treiben, sondern wie man ihn dem ersten Gesetze der Kunst, dem Gesetze der Schönheit, unterwerfen soll. (16–17)

What did Timanthes do? We know the answer from his painting of the sacrifice of Iphigenia: he imparted to each bystander the particular degree of sadness appropriate to him but concealed the face of the father, which should have shown the most intense suffering. Many clever things have been said about this. One critic, for instance, says that he had so exhausted himself in depicting the sorrowful faces of the bystanders that he despaired of his ability to give a still more sorrowful one to the father. Another says that by so doing he admitted that the anguish of a father in such circumstances is beyond expressing. For my part, I see no incapacity on the part of either the artist or his art. The intensity of the emotions intensifies the corresponding expression in the features of the face; the highest degree will cause the most extreme expression, and nothing is easier in art than to express this. But Timanthes knew the limits which the Graces had set for his art. He knew that the anguish appropriate to Agamemnon as the father would have to be expressed through distortions, which are always ugly. He went as far as he could in combining beauty and dignity with the expression of anguish. He would have preferred to pass over the ugly or to soften it, but since his composition did not permit him to do either, there was nothing left him but to veil it. What he might not paint he left to conjecture. In short, this concealment is a sacrifice that the artist has made to beauty; it is an example, not of how one pushes expression beyond the limits of art, but how one should subject it to the first law of art, the law of beauty.[8]

Lessing knows that the legendary explanations for the veiling of Agamemnon's face—that the artist or his medium were technically inadequate—are mistaken. Winckelmann had already argued that facial expressiveness makes the artist's task easier, not more difficult. The cloth covering Agamemnon's face is a kind of *Unbezeichnung*,[9] a euphemism, a visual silence, the refusal to represent. Lessing, using legal and political metaphors, explains Timanthes' rationale as the resolution of a conflict between semiotic and aesthetic systems of representation. In the semiotic system of representation (*Ausdruck*), painting is in principle able to represent all things that are visible. The aesthetic system (*Schönheit*), however, draws a strict border (*Grenze*) and imposes a rule of law (*Gesetz der Schönheit*) that severely limits the objects of representation. "Diese Verhüllung," says Lessing, "ist ein Opfer, das der Künstler der Schönheit brachte" (This concealment is a sacrifice that the artist has made to beauty). Law requires a victim.

It is striking that the word *Opfer* suddenly occurs here, for isn't Timanthes' painting about the "Opferung der Iphigenia?" Just as Agamemnon was prepared to sacrifice his daughter, so the artist sacrifices . . . what? In the final analysis, it is both the representation of the body and painting

itself that he sacrifices—there is no other way to read the concealment, the effacing of Agamemnon's face. He tropes the body through a visible euphemism and so doing denies the body and compromises painting. Why do the eyes travel like snakes to the image if not to see it opened to display? The veil is an affront to vision. It is a shroud over the body, the death of the body, the denial of the body. At the same time, and this gives a first indication of how our reading of Lessing will proceed, the euphemizing veil can be read as the canvas of the painting: by hiding materiality euphemism only displays it all the more.

Notice too that euphemism is accompanied by a deflection from and a disappropriation of the woman in favor of the man. The pain of Iphigenia, the pain of painting, is not only left in pious silence, it is actually claimed for the men in each instance. "Der Schmerz des Vaters" describes Agamemnon's condition, totally ignoring his assent to her sacrifice. Similarly, "[D]er Künstler [bringt] ein Opfer"—it would be the artist's (or the beholder's) pain (or pleasure), not the painting's.

The thematics of sacrifice almost force a consideration of Lessing's *Emilia Galotti* (1772). At the play's conclusion, as is well known, Emilia's father kills his daughter at her request lest she be violated by the prince who desires her. Emilia, too, is an *Opfer*, but a willing one. From the beginning of the drama, Emilia is associated with painting and the visible. She is first seen not in person, but as a painted portrait that kindles the prince's desire. What ensues is an elaborate struggle for the possession of her body fought out between a tyrannical and a bourgeois order. The father wants to extract her from the prince and remove her from public view entirely by installing her in a convent. The prince, on the other hand, desires nothing so much as her sexual violation.

At the point where the struggle reaches its greatest intensity, where father and prince desperately vie for Emilia's body, two remarkable and outrageous deflections occur. First, the father's murderous wrath is deflected from the prince onto Emilia's body, and, second, the responsibility for her murder is deflected from the father to herself in so far as she seduces him to kill her. She accomplishes this by an allusion to the story of Virginia, whose father would rather kill her than know her virtue violated. As Neil Flax has argued, Lessing causes not only this story to be reenacted, but also, and even more, a popular eighteenth-century engraving of the same tableau.[10] Emilia seduces her father to the violent and erotic re-production of a history painting, a Laocoon-like moment, that is at the same time the dramatic negation of the body. Thus the sacrificed Iphigenia and the veiled painting come together in the action of Emilia's death. If Emilia's status in the play is that of the aesthetic object, then Lessing has succeeded in

representing the myth of the victim that welcomes and encourages her own victimage, who assumes the responsibility for her violation on her assailant's behalf. If Emilia represents painting, the visual arts, then, according to Lessing, she, in so far as she desires moral propriety, willingly submits to the restrictive rule of beauty, sacrificing herself, fearing her own flagrancy just as Emilia is represented as doubting her ability to withstand the powers of eros. Painting is a willing victim.

The reader will have noticed that I am using a number of terms as homologies: death, body, corporeality, materiality, painting, woman. These terms and their opposites (life, mind, spirituality, ideality, poetry, man) are deeply inscribed not only in Lessing's work but in the thought of the eighteenth century generally.[11] Our initial discussion of Lessing has turned up two tropes: the euphemizing veil or shroud and the willing victim. The former is a response to death, the latter to woman and sexuality. I do not wish to separate these artificially; however, insofar as Lessing's semiotic aesthetics is primarily a denial of materiality empowered by a fascinated abhorrence of death (the sexuality is located in the fascination), in this chapter we will concentrate on euphemism. The myth of the willing victim will be treated at length in the chapter on Karl Philipp Moritz.

Our reading of Lessing will show that euphemism is not at all as simple as a cloth draped over a dead body. Lessing's euphemism, beneath its veil, is a form of violence directed toward the body, a kind of grave desecration. What is finally most surprising is that euphemism's original and founding violence occurs not on the side of painting, where one would expect it, but on the side of language and poetry, thus calling into question the crucial distinction on which Lessing's *Laokoon* is based. Euphemism not only covers the body of language, but in so doing violently assaults it.

1

Unlike the texts we are considering in other chapters of this study, Lessing's *Laokoon* has been and continues to be the subject of lively debate and interpretation. While the relevant Winckelmann and Goethe texts are available in some form of English translation, however inadequate and outdated,[12] the essays of Herder and Moritz have never been translated. Lessing's *Laokoon*, by contrast, is readily available and widely read. An even more curious phenomenon is the power of Lessing's text to engender types of itself from time to time. In 1910, Irving Babbit published *The New Laokoon: An Essay on the Confusion of the Arts* in which he strove as "a humble imitator of Lessing" to clarify the genre disputes of his time. In 1940, Clement Greenberg's influential "Towards a Newer Laocoon"

appeared. And these are only two of many.[13] The most recent incarnation is perhaps the collection of essays edited by Gunther Gebauer entitled *Das Laokoon Projekt* (1984). In the introduction Gebauer programmatically states: "Like no other work of aesthetics, the *Laocoon* opens a new path which we can only now pursue with the present advance of semiotics, the theory of the interpretive sciences and formal language theory, and at the end of which is a theory that one could call 'semiotic.'"[14]

With the word "semiotic" Gebauer has named the feature that most distinguishes Lessing's text from the others we are considering and explains the peculiar "timeless" relevance it seems to enjoy. This is not to say that Winckelmann and other thinkers of the eighteenth century were not sensitive to the difference and tension between aesthetics and semiotics. Our reading of Winckelmann showed the aesthetic and semiotic demands to be in conflict. Winckelmann's terms, *Schönheit* and *Ausdruck*, are precisely the ones Lessing used in discussing Timanthes' decision for the veil: "[Die Verhüllung] ist ein Beispiel, nicht wie man den Ausdruck über die Schranken der Kunst treiben, sondern wie man ihn dem ersten Gesetze der Kunst, dem Gesetze der Schönheit, unterwerfen soll" ([The veil] is an example, not of how one pushes expression beyond the limits of art, but how one should subject it to the first law of art, the law of beauty). Where Lessing apparently differs is in grounding his aesthetics in what can only be called a semiotic consideration of the media of signification. While *Ausdruck*, or signification as such, is restricted by the rule of *Schönheit*, or considerations of an aesthetic nature, the rule of beauty itself is determined by the nature of the visual sign.

David Wellbery's *Lessing's Laocoon: Semiotics and Aesthetics in the Age of Reason* (1984) is a model of systematic representation, analysis, and reflection. Already his title reveals that he too is aware of the dual stakes, aesthetics and semiotics, in Lessing's work. In his introduction he states: "Lessing's distinctions between poetry and painting (actually the plastic arts in general) constitute a global model of aesthetic signification, a remarkably penetrating and articulate development of the aesthetic semiotics which Baumgarten first imagined and which Meier and Mendelssohn began to work out."[15] Dwelling with great sensitivity on the media semiotics of the *Laokoon*, Wellbery rearticulates insights that plainly belong to Lessing, but in such a way that they strike one with new force. Two such insights deserve our particular attention: his analysis of the nature of beauty in relation to painting, and, as he says in the introduction, "Lessing's attempt to evaluate the arts in terms of the degree of imaginative freedom they afford both artist and audience."[16] If the Laocoon statue could serve as a figure for Wellbery's analysis, then clearly it is the imagination that is entangled

by the material signs of painting as well as painting's contamination of poetry. The imagination is constricted in the snakes' grasp and in dire need of liberation.[17]

In Winckelmann, as we saw, beauty or the beholder's desire for beauty was a potent and tyrannical force requiring the infliction of pain. In Lessing, by contrast, beauty's role is seriously restricted. It is true that Lessing states that "Der Ausdruck körperlicher Schönheit ist die Bestimmung der Mahlerey," "The expression of beauty is the task of painting," but this should not mislead us into thinking that Lessing shares Winckelmann's enthusiasm for beauty. Wellbery perceptively states that "Lessing's insistence on the supremacy of beauty in the plastic arts must be interpreted not as enthusiasm for the beautiful but as a complaint that physical beauty is all that the arts can achieve."[18] Beauty is a restrictive rule that is applied to the visual image to control its "flagrancy."[19] In the semiotic system, the possibilities of pictorial representation are enormous. It is only when the aesthetic system is imposed on the semiotic, when the rule of beauty is applied, that the possibilities are drastically curtailed. "Beauty," as Wellbery says, "is the supreme value in the plastic arts not because it is intrinsically of great worth, but because it is the only form of the sensuously present that does not overwhelm us on the existential level of sensation."[20]

These considerations lead Lessing to the concept of the "fruchtbarer Moment" (the pregnant or fecund moment) and a consideration of freedom:

> Kann der Künstler von der immer veränderlichen Natur nie mehr als einen einzigen Augenblick, und der Maler insbesondere diesen einzigen Augenblick auch nur aus einem einzigen Gesichtspunkte, brauchen; sind aber ihre Werke gemacht, nicht bloss erblickt, sondern auch betrachtet zu werden, lange und wiederholtermassen betrachtet zu werden: so ist es gewiss, dass jener einzige Augenblick und einzige Gesichtspunkt dieses einzigen Augenblickes, nicht fruchtbar genug gewählet werden kann. Dasjenige aber nur allein ist fruchtbar, was der Einbildungskraft freies Spiel lässt. (19)

> If the artist can never make use of more than a single moment in ever-changing nature, and if the painter in particular can use this moment only with reference to a single vantage point, while the works of both painter and sculptor are created not merely to be given a glance but to be contemplated—contemplated repeatedly and at length—then it is evident that this single moment and the point from which it is viewed cannot be chosen with too great a regard for its effect. But only that which gives free rein to the imagination is effective. The more we see,

the more we must be able to imagine. And the more we add in our imaginations, the more we must think we see. In the full course of an emotion, no point is less suitable for this than its climax. There is nothing beyond this, and to present the utmost to the eye is to bind the wings of fancy and compel it, since it cannot soar above the impression made on the senses, to concern itself with weaker images, shunning the visible fullness already represented as a limit beyond which it cannot go. (19–20)

Two orders of temporality are introduced. The pregnant moment consists in their discreet and tasteful collaboration. In the first order, a single moment from a succession of moments constituting an action is selected for visual representation. That represented moment then enters a second order where, unchanging itself, it undergoes prolonged and repeated observation. The selected moment is "fruchtbar" only if it leaves the imagination "freies Spiel." Wellbery explains this freedom as follows:" [A]s a result of the suggestiveness of the representation, the viewer's imagination acquires a freedom of production that exceeds the perimeters of the painted content. The viewer himself engenders the images of the prior and subsequent phases of the action without relying on or being limited by the determinate material representation provided by the painting or sculpture."[21] Once again the visual image is called upon to deny itself. Its existence in the second order of prolonged beholding is guaranteed only if it is self-effacing, if it stimulates further representations that are actualized only in the beholder's imagination. This does not mean that the represented moment must be transitory in its nature, but that the image as image must be transitory and quick to recede. The modest visual image is thus relegated to an invisibility that is usually ascribed to the artificial signifiers of language, the word that disappears without remainder in the conveyance of meaning.

Should the visual image not represent a "fruchtbaren Moment" it becomes of necessity a *furchtbarer* (an awful or terrifying)*Moment*. Laocoon screaming at the height of his pain would be an insufferable image: "dem Auge das Äusserste zeigen, heisst der Phantasie die Flügel binden." Transitory moments do not assure transitory images:

[A]lle solche [transitorische] Erscheinungen, sie mögen angenehm oder schrecklich sein, erhalten durch die Verlängerung der Kunst ein so widernatürliches Ansehen, dass mit jeder wiederholten Erblickung der Eindruck schwächer wird, und uns endlich vor dem ganzen Gegenstande ekelt oder grauet. (20)

> However, the prolongation of such phenomena in art, whether agree-
> able or otherwise, gives them such an unnatural appearance that they
> make a weaker impression the more often we look at them, until they
> finally fill us with disgust or horror. (20)

The impression of transitoriness weakens and gives way to a sensation of
disgust and horror. The terrifying or awful moment refuses to deny itself;
it holds the viewer's imagination and virtually decomposes before them,
forcing them to confront its materiality. That such a confrontation awakens
Ekel or *Grauen* confirms that for Lessing, to face corporeality is to face
death. The rule of beauty entailing the choice of the pregnant moment is
clearly involved in the troping process that we have called euphemism.

The affective responses of *Ekel* and *Grauen* are enormously important
in Lessing's *Laokoon*. They guide Lessing in the construction of his aesthetic
system at every step of the way. For this reason alone, it is of no little
significance that the first of the two stages that form the abrupt conclusion
of the *Laokoon* involves a meditation three chapters long on the ugly (*das
Hässliche*) and the disgusting (*das Ekelhafte*) in painting and poetry.[22] The
disgusting itself, Lessing says, is not suitable for imitation. But it may be
used for the production of mixed effects like the comic. Though the ugly is
a visual phenomenon, painting should refrain from representing it. Poetry,
on the other hand, can more freely make use of the ugly and disgusting
for the reason that the artificial signs of language by their nature are poor
signifiers of the visual and necessarily moderate the powerful effects of the
ugly and disgusting.

Lessing's argument about the disgusting is accompanied and over-
whelmed by an endless series of examples. If readers of Lessing have
understandably avoided these chapters as though the *Laokoon* ended at
chapter 22, Carol Jacobs brings them to our attention in such a way
that her questions must be addressed: "At each turn, with each example,
Lessing reminds us that the disgusting is in its proper place. But is it? Is the
disgusting—here is the real question—is the disgusting in its proper place
in Lessing's text? Why does he insist on piling up example after example?
Why does he gorge himself on the disgusting? Why does he delight in
serving up these morsels, or rather ramming them down our throats?"[23]
Her own answer belongs to the program of her reading and will not help
us in pursuing ours. What is important for us to notice is, first, the giddy
fascination with the lugubrious details of truly disgusting scenes.[24] Second
is the fact that it becomes apparent that the final referent of all disgusting
details is the decaying body. Lessing comments on an assertion of Christian
Adolf Klotz (who will figure in the last section of this chapter) that restricts

the perception of the disgusting to the sense of touch, taste and smell. Klotz mentions "übermässige Süssigkeit" (extreme sweetness) and "eine allzugrosse Weichheit der Körper" (an excessive softness of bodies) as sensations that prompt disgust (147). Would not all such sensations, no matter what the context, refer finally to the decomposing corpse? For Lessing, of course, the disgusting can also be visually perceived. That is why, third, according to Lessing, no matter how much the disgusting might exert a fascinating force, i.e., be involved in the production of a mixed effect, in painting it should be avoided at all costs. Thus in a painting of Christ in the grave or Lazarus's emergence from the tomb all signs of the disgusting, such as bystanders who plug their noses, should be avoided even though expressly authorized by scripture. "[S]obald die Überraschung vorbei, sobald der erste gierige Blick gesättiget, trennet es [the disgusting] sich wiederum gänzlich, und liegt in seiner eigenen cruden Gestalt da" (156; [F]or as soon as our surprise is over and our first eager look satisfied, the disgusting becomes a separate thing again and appears before us in its own crude form; 137).

The corpse always remains; but we are not necessarily speaking about a represented corpse, but about the materiality of the semiotic medium. Any violation of the aesthetic rules grounded in the nature of the sign causes the corpse to appear and provokes *Ekel* and *Grauen*. The same can be said from the opposite perspective: through the aesthetic rules, the process of euphemism assures that the dead body does not come to appearance. We have already seen that failure to select the *fruchtbarer Moment* for a painting results in the representation of the *furchtbarer Moment*. All such appearances, as Lessing says, cause *Ekel* and *Grauen*. What happens when a trangression occurs in poetry?

Allegorical attributes such as the scales of justice, the lightning bolts of Zeus, etc., are the instruments of painting. They serve the painter (and not very well) as the common identifying name of the represented object. The attributes could, of course, be poetically motivated, as they are in a passage by Horace. But, says Lessing, "auch als solche sind sie zu sehr gehäuft, und die Stelle ist eine von den *frostigsten* des Horaz" (84, my emphasis; also as such they pile up and the passage is one of the *coldest* in Horace). Likewise, any attempt to describe somebody or something through the enumeration of descriptive details is a violation of the aesthetic rules of poetry.

Ausser diesem Gebrauche sind die ausführlichen Gemälde körperlicher Gegenstände, ohne den oben erwähnten Homerischen Kunstgriff, das Coexistirende derselben in ein wirkliches Successives zu verwandeln, jederzeit von den feinsten Richtern für ein *frostiges* Spielwerk erkannt

worden, zu welchem wenig oder gar keine Genie gehöret. (105, my emphasis)

With the exception of this use, the detailed depictions of physical objects (without the above-mentioned Homeric device for transforming what is coexistent in them into what is really consecutive) have always been recognized by the best critics as being an *icy-cold* mechanism, to which little or no genius can be attributed. (89)[25]

Every time again, the poetic imitation of painting, the transgression of the code appropriate to its medium, is said to result in something *frostig*,[26] something cold and lifeless. Just as in painting, these violations make the materiality of poetry's medium evident. Lessing's experience of language's materiality is, through the recurrent use of *frostig*, affectively likened to the coldness of the corpse. Language, too, has a body.

We have reached a very significant point, for this acknowledgment of the corporeality of language necessitates a revision of Lessing's theory of *ut pictura poesis*. Everyone agrees that Lessing attempts to draw a border between painting and poetry. Those who stress Lessing's sensitivity to semiotic concerns add a second intersecting border to the first, namely that between signifier and signified. The following diagram illustrates the situation.

The materiality of painting, that is, painting at the level of the signifier, has a tendency to contaminate painting's signified—this is what Lessing means by the restriction of the imagination's freedom. The signs of poetry, on the other hand, are peculiar in that they are practically unaffected by language's materiality, or, to put it another way, language as material has already attained a high degree of immateriality compared to the signs of painting (or so Lessing and Wellbery believe). In both cases, in painting and poetry, Lessing has established euphemizing rules that guarantee what

Wellbery calls "the attempt to elide the materiality of the art work."[27] It is necessary to be very severe with painting because of its "flagrancy." Poetry, by contrast, is awarded every freedom and privilege, just as long as it continues to deny its materiality.[28]

Our reading, however, has come to the conclusion that language has a body, which, when it becomes evident, is regarded by Lessing as the cold body of death. This significantly alters the traditional sense of *ut pictura poesis* insofar as the orderly set of basic oppositions is disrupted:

painting : poetry :: body : mind

If we look at the diagram again, we see that the shaded area, representing what is homologous to the body, has infected the territory of poetry and mind.

It would, however, be mistaken to think that Lessing is prepared to sacrifice his system of euphemism without a struggle. In fact, what we have discussed so far is merely the preliminary to the real battle which takes place not in Lessing's *Laokoon* (it is announced there in a footnote), but in its sequel, *Wie die Alten den Tod gebildet*. At issue apparently is the representation of death. It is also and more fundamentally a dispute over language's body. We will find in this essay the original violence against language's body that constitutes Lessing's euphemism.

2

If we compare the entries for the Greek word *diastrepho* in the standard German- and English-Greek language lexica, Passow's *Handwörterbuch der Griechischen Sprache* (1841) and Liddell/Scott's *A Greek-English Lexicon* (1843), we find them so remarkably similar that the suspicion may arise that the later English edition was influenced by the German. *Diastrepho*:

"verdrehen, verrenken . . . oft im Pass. verdreht, schief werden . . . , beson-
ders aber von den Gliedern des Körpers . . . : sich verrenken . . . verrenkte
Glieder." Likewise in English: "turn different ways, twist about, to distort:
—mostly passive, to be distorted or twisted, of the eyes, limbs, etc." Both
the German and English editions include the metaphorical application: "in
Unordnung, Verwirrung bringen . . . die Wahrheit verdrehen, entstellen."
The only real difference between the two lengthy entries is their respective
treatment of the phrase from Pausanias: *diestrammenous tous podas*, Paus. 5,
18, 1. Liddell/Scott simply translates the passage in such a way that is con-
sistent with all other occurrences of the word: "with the feet twisted." In
Passow, on the other hand, we read: "aber *diestrammenous tous podas*, mit
verschlungenen, über einander geschlagenen Füssen, . . . vgl. Lessing Schr.
3 p. 94 fg" (however *diestrammenous tous podas*, with crossed feet, slung
over each other, . . . cf. Lessing Schr. 3 p. 94 fg). Lessing left his mark.

The discussion about *diestrammenous* to which the dictionary refers is
embedded in a much larger discussion about how the ancients represented
death. Lessing, in a long footnote to the *Laokoon*, had argued against the
implication of Count Caylus's *Tableaux tirés de l'Illiade* (1757) that the
ancients represented death as a skeleton. Lessing offered as an alternative
that death was considered as the twin brother of sleep, both of them
sons of the night. The classical sources for his suggestion were Homer
(*Iliad* 16:681–82) and that passage of Pausanias to which both dictionary
entries refer. Referring to a putatively ancient coin on which a skeleton
is represented, Lessing first called into question its antiquity and then
added: "Den Tod überhaupt kann es wenigstens nicht vorstellen sollen,
weil ihn die Alten anders vorstellten" (77; It certainly cannot be meant to
represent death since the ancients represented him differently). Christian
Adolf Klotz came to the defense of Caylus in his introduction to an edition
of the latter's writings, specifically criticizing the argument in the *Laokoon*
footnote. Johann Gottfried Herder also contributed to the discussion in
his first *Kritisches Wäldchen* (1769), basically agreeing with Lessing but
taking exception to his analysis of *diestrammenous.*

Klotz's remarks, as Lessing says in his preface, proved to be the
"verächtliche Veranlassung" (3; miserable occasion) for the writing of *Wie
die Alten den Tod gebildet* (1769), essentially a greatly elaborated ver-
sion of that first footnote. While Lessing treats Klotz condescendingly, he
mentions Herder's objection respectfully but still rejects it. Nor does the
discussion, either of death or the word, end with Lessing's essay. Christian
Gottlob Heyne dealt at considerable length with the Pausanias passage
in a published lecture, *Über den Kasten des Cypselus, ein altes Kunstwerk
zu Olympia mit erhobnen Figuren* (1770). Herder responded to Lessing's

essay in 1774 and again in 1786 with writings bearing exactly the same title as Lessing's *Wie die Alten den Tod gebildet*, though with a question mark attached. Beyond Herder there is still Novalis, who, in the "Hymnen an die Nacht," takes up the "classical" figure of death as established by Lessing and boldly identifies it with Christ triumphant over death. Novalis is followed in this by Joseph von Eichendorff in *Das Marmorbild*.[29] What the romantics make of the figure of death, however, is not our concern.

Obviously there is a lot at stake for Lessing and his contemporaries in determining how the ancients represented death. The skeleton is understood as a benighted medieval Christian remnant that persists in disfiguring the eighteenth century. No natural religion would have arrived at such a concept of death. If the ancients are to serve as an ideal and corrective to the stubborn irrationality of Lessing's time, then it is crucial that their attitude to death be an enlightened one. The last line of Lessing's essay divulges this programmatic aspect: "Nur die missverstandene Religion kann uns von dem Schönen entfernen: und es ist ein Beweis für die wahre, für die richtig verstandene wahre Religion, wenn sie uns überall auf das Schöne zurückbringt" (55; Only misunderstood religion can distance us from the beautiful: and it is a proof for the true, for the properly understood religion, if it everywhere returns us to the beautiful).

Mention of "das Schöne," however, necessarily brings us back to Lessing's aesthetics and the trope of euphemism. The alternatives, apparently, for the ancient representation of death are a skeleton or a beautiful winged young man. It is likely that what Lessing really does is to trope the former with the latter. If the skeleton is death in all its insistent corporeality, then the winged figure is clearly its denial. Because, as our reading of *Wie die Alten den Tod gebildet* will show, the place where this euphemizing denial occurs is in language, what is finally at issue here is the question of language's body.

Lessing's essay is divided into two parts. In the first part he proposes his candidate for the antique representation of death. In the second, having denied that skeletons in classical art ever represent death, he argues that they represent *larvae*, the wandering souls of the evil dead. His candidate for death is a beautiful winged figure, virtually indistinguishable from any representations of Cupid, with legs crossed, bearing an inverted torch, and appearing frequently with his identical twin brother, sleep (fig. 6). The stated conditions for the success of his argument are 1) the authority of Homer and the brief Sarpedon passage;[30] 2) the Pausanias description and particularly his, i.e., Lessing's, interpretation of *diestrammenous*; and 3) a principle of figural non-contradiction. By the latter is meant his statement early in the essay that once the ancients had decided on a figure for an

allegorical representation they unswervingly clung to it (8). A corollary of this principle is that the attributes and actions of the allegorical figure may not be in contradiction with each other or with the essential nature of the figure.

These three conditions are joined by two unstated conditions: 1) the use of unforgivably bad engravings of the Roman grave monuments he refers to, and 2) the denial of the enormous gulf that separates ancient Greek literary sources from Roman funeral statuary. With regard to the first Ludwig Uhlig says: "Lessing's engravings are not only artistically very unsatisfactory, they also reproduce their objects very unfaithfully and must already in their time have appeared as fully antiquated."[31] The primary difficulty is that the *Todesgenius* "is almost throughout represented in a misleading way, as a youth instead of a putto."[32] As for the second condition, the gulf separating the two components of his argument, ancient literary and later Roman visual sources, is not only historical, as Uhlig argues,[33] but also involves the fundamental problem of the transition from word to picture, a problem to which Lessing should have been sensitive. In other words, we are dealing with yet another instance of *ut pictura poesis*.

One of the problems in writing about Lessing's *Wie die Alten den Tod gebildet* is determining how to approach it. From an art historical or a conventional philological point of view it is long out of date. In the late nineteenth century a rash of German classical philologists debated the issue of the ancient representation of Thanatos, the Greek word and name for death. Albin Lesky, who stands at the discussion's terminus with his article on Thanatos in *Pauly-Wissowa* (1934), summarized the chief concern: "The basic problem is the question whether Thanatos is a figure of folk-belief or the purely literary personification of an abstract concept."[34] As for Lessing's candidate for the representation of Thanatos, Lesky generously states: "The countless Eros-like figures with the upside-down torch, however, have almost nothing in common with the Thanatos of the saga and folk representations."[35] Lessing's argument identifying skeletons with *larvae* never found any currency.

A more common approach is that of cultural and intellectual history. A good example is Walter Rehm's *Der Todesgedanke in der deutschen Dichtung vom Mittelalter bis zur Romantik*.[36] Lessing's essay holds a significant place in Rehm's long chapter on the Enlightenment conception of death since it expresses, as Rehm maintains, "the deepest conviction about death, not only of Lessing, but of his time."[37] Rehm concludes his chapter with a quotation from Lessing's essay as though it most clearly showed the Enlightenment's victory over death, "diese sieghafte Überzeugung Lessings: 'Totsein hat nichts Schreckliches, und insofern Sterben nichts

Wie die Alten

den Tod gebildet:

. Nullique ea tristis imago!
STATIUS.

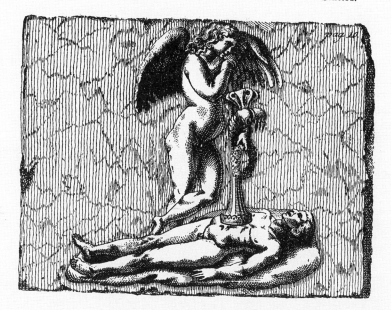

eine Unterſuchung

von

Gotthold Ephraim Leſſing.

Berlin, 1769.

Bey Chriſtian Friedrich Voß.

FIG. 6. TITLE PAGE OF LESSING'S *WIE DIE ALTEN DEN TOD GEBILDET*, 1769.
COURTESY OF THE NATIONAL LIBRARY OF MEDICINE, PRIVATE COLLECTION.

als der Schritt zum Totsein ist kann auch das Sterben nichts Schreckliches haben'" (this victorious conviction of Lessing: "Being dead is nothing to be afraid of, and insofar as dying is nothing but the step to being dead, dying also is nothing to be afraid of").[38] Thus, even though by philological standards the essay is no longer relevant, it remains an important historical document testifying to a new enlightened concept of death. As Uhlig says: "The essay introduces something entirely new, which probably also explains the fame which the work already attained among Lessing's contemporaries: the beautiful image expesses a new conception of death."[39]

The classicism of Rehm and other German philologists and historians could be corrected by a consideration of the essay in line with the convictions of Philippe Ariès. Indeed, I regard it as an omission on his part that he fails to take any note of Lessing in his history of death, *L'Homme devant la mort* (1977). It is clear, however, that *Wie die Alten den Tod gebildet* would be seen as yet another symptom and version of the modern horror and fear of death. The confusion in Lessing and Herder over Cupid and Thanatos would complement at a sublimated level Ariès's insights into the eighteenth century's eroticization of death.

The difficulty with these and other conventional approaches is that they fail to get at the distinctly idiosyncratic nature of Lessing's text. Lessing himself makes a distinction between two sorts of archaeologist, a distinction that is also applicable here.

> Ein anderes ist der Altertumskrämer, ein anderes der Altertumskundige. Jener hat die Scherben, dieser den Geist des Altertums geerbet. Jener denkt nur kaum mit seinen Augen, dieser sieht auch mit seinen Gedanken. Ehe jener noch sagt: "So war das!" weiss dieser schon, ob es so sein können. (37)

> It's one thing to be a petty "grocer" of antiquity, another to be a true scholar. The former has inherited the shards of antiquity, the latter its spirit. The former barely thinks with his eyes, the latter sees also with his thoughts. Before the former can say: "Thus it was!" the latter already knows whether it could have been.

Walter Rehm has too much inherited the spirit of German Classicism. His entire reading is programmed by the idea of the development of German literature toward its peak in Goethe's classicism. His is the profound arrogance of knowing "ob es so sein können."

What we have actually inherited, however, are fragments, not only the fragments of Greek art and poetry, but the writings, the words and letters, say of Lessing, understood as fragment. What is given to us with the text

of *Wie die Alten den Tod gebildet* is not the spirit or meaning of the work. We inherit its shards and pieces. According to a related and appropriate metaphor, we could say that we inherit its bones, its desiccated skeleton. Lessing's criticism of Klotz may be more suitably applied to us (since it is questionable whether Klotz really deserved it). "Mit den Augen denken" (Thinking with the eyes)—that is precisely the kind of reading we will try to practice here. Such a reading entails scrupulous attention to the words of the text, the skeleton of Lessing's discourse. It means beginning to *see* the body of language, allowing the words and images to assume contours and to be configured with each other, not at the level of meaning, first of all, but at the level of the text. It means, among other things, *seeing diestrammenous* instead of *overlooking* it.

It must be said to Uhlig's credit that he noticed the prominence of *diestrammenous* in Lessing's argument. It is, however, a bone that he rejects. "The same footnote, quite coincidentally, with the interpretation of a passage from Pausanias provided the occasion for another purely philolgical antiquarian debate between Lessing and Herder, which, beginning in the first *Kritisches Wäldchen*, accompanies the discussion of the *Todesgenius* in stubborn detail, although it contributes little to the topic."[40] Is it merely coincidence that links the discussion of the representation of death with the debate about *diestrammenous*? Or does the "hartnäckige Ausführlichkeit," the insistent presence of the word, particularly in Lessing's essay, indicate a more necessary connection between death and *diestrammenous*? The only way to find out is to begin looking through the bones.

The *diestrammenous* comes into play as soon as Lessing formally opens his argument.

> Die alten Artisten stellten den Tod nicht als ein Skelett vor; denn sie stellten ihn nach der Homerischen Idee als den Zwillingsbruder des Schlafes vor und stellten beide, den Tod und den Schlaf, mit der Ähnlichkeit unter sich vor, die wir an Zwillingen so natürlich erwarten. Auf einer Kiste von Zedernholz in dem Tempel der Juno zu Elis ruhten die beiden als Knaben in den Armen der Nacht. Nur war der eine weiss, der andere schwarz; jener schlief, dieser schien zu schlafen; *beide mit übereinander geschlagenen Füssen*. (7–8; my emphasis)

> The old artists did not conceive of death as a skeleton; for they represented him according to the Homeric idea as the twin brother of sleep, with that resemblance between them, that we so naturally expect among twins. On a cedar chest in the temple of Juno in Elis, both of them rested as boys in the arms of night. Only the one was white,

the other black; the former slept, the latter seemed to sleep: *both with crossed feet.*

Homer provides the idea of sleep and death as brothers, though there is no real description of either, leaving the passage open to such interpretations as that of Caylus that upset Lessing in the first place. Pausanias, another literary source, seems to provide Lessing with still more. He confirms the fraternal relationship of death and sleep, and, more importantly, adds several visual attributes: one brother is white, the other black; one sleeps, the other only seems to be sleeping; both have crossed feet. Though the first attribute, color, would seem most telling, Lessing can go nowhere with it. Not only did this attribute find no currency in later representations of death, it is unclear from the Pausanias passage who is black and who is white, as Lessing himself admits. Sleeping and seeming to sleep also hold little promise as attributes. Thus Lessing fixes on the *diestrammenous,* a word which, even if it were certain what it meant, would still seem to be of an accidental rather than a significant nature.

Another attribute of Lessing's candidate for death is the inverted torch. In the best cases, the genius is actually extinguishing the torch on the corpse of the deceased. Lessing uses this fact to argue against Klotz and Bellori that the figure represents not Cupid but Thanatos: "Was kann das Ende des Lebens deutlicher bezeichnen, als eine verloschene, umgestürzte Fackel?" (12; What can more clearly signify the end of life than an extinguished, upside-down torch?). While a certain logic attends his argument, the limitation of the attribute of the inverted torch is that it is mentioned in no ancient literary source. The gulf between Homer and a Roman grave monument, between word and picture remains, unless Lessing can make *diestrammenous* bridge that gulf.

Pausanias's discussion of the Chest of Cypselus occurs in his *Description of Greece,* written between 150 and 170 A.D. The chest he describes was at that time to be found in the temple of Juno in Olympia. It was made of cedar, with gold and ivory inlay. On all sides, emblems and numerous events from the sagas were depicted in relief, among them the representation of night with her sons, sleep and death. According to the legend connected to the chest, faithfully reported by Pausanias, Cypselus, a later tyrant of Corinth, was hidden in the chest as an infant and thus spared from death. If one believes this story, then the chest must have been made sometime in the eighth century B.C. since Cypselus became tyrant midway through the seventh. In James G. Frazer's considered opinion, "the chest was probably made by a Corinthian artist who lived in the early part of the sixth century B.C."[41] In any case, the chest was very old

and clearly predated the beautiful art of Periclean Athens and Alexandrian Greece. Christian Gottlob Heyne reminds us that Pausanias "[h]ier von einem der ältesten Kunstwerke [redet]," (speaks here of one of the oldest art works), suggesting that the carvings would have been in an awkward, archaic style.[42] The problem with the chest is that it no longer exists. We have only Pausanias's description.

The following is a reasonably literal translation of the relevant passage:

> A woman is represented bearing a sleeping white boy on her right arm, a black boy on her left, who resembles a sleeping one, both with twisted feet (*amphoterous diestrammenous tous podas*). (My translation)

These words are the bones from which one must, like a palaeontologist, reconstruct the ancient appearance of death. Before turning to Lessing's reconstruction, let us consider what a formidable "Altertumskrämer," Christian Gottlob Heyne, thinking with his eyes, said about the Pausanias passage.

Everyone is agreed that the *diestrammenous* presents a problem. Heyne calls it "ein etwas dunkles Wort" (a somewhat obscure word).[43] It is a barrier that impedes the passage of his interpretation, "dass ich nicht über sie [die verrenkten Füsse] hinweg schreiten konnte" (so that I was unable to stride over them).[44] The difficulty is that when one reconstructs the appearance of death on the basis of normal word usage, death and sleep both wind up with deformed feet of some kind. Heyne is sympathetic to Lessing's "bequemere Erklärung" (more comfortable explanation),[45] but finds absolutely no support for it. Indeed, Heyne is able, on the strength of his philological investigation, to ascertain in what way the feet were deformed. Finding passages in Pollux, Lucian, and others where *diastrophos* is used expressly for deformed feet or legs, and seeing in *sunestrammenon*, turned inwards, a logical and stable opposite, Heyne states that "freylich müssen eigentlich auswärts gebogene Füsse verstanden werden" (feet bent to the outside must indeed actually be understood).[46] Having arrived at this conclusion, he must answer the question, what "diese verbogenen Füsse"[47] mean? He offers three tentative explanations. First, he reminds us of how old the chest is and consequently how primitive still the art of the time. The deformed feet could thus be a result of technical inexpertise. Second, being archaic, the art of the time used "eine rohe Bildersprache" (a coarse picture language). Perhaps "das Schwache und Kraftlose" of the deformed feet expressed "den Zustand der Entkräftung . . . in welchen uns beyde [sleep and death] schon bey ihrer Annäherung setzen" (Perhaps the weakness and powerlessness of the deformed feet expressed the condition

of weakening . . . into which both [sleep and death] put us already by their approach).[48] Third, we know from Homer that all the figures of the underworld are decidedly weak. Heyne recalls Agamemnon's inability to summon enough strength to embrace Odysseus during the latter's *nekyia*. Heyne is not really satisfied with any of these explanations, but stands by his philological judgment: "Nach dem Worte also, das Pausanias braucht, zu urtheilen, ist es auf unserm Kasten des Cypselus immer noch misslich, an den beyden Knaben andere als auswärts gebogene Füsse zu verstehen" (Thus, judging according to the word that Pausanias uses, it is misguided to understand the two boys on our Cypselus chest to have anything other than feet bent outwards).[49]

Diestrammenous lies there like crooked bones in a grave. Let us examine the word more closely. It is, as we noted in the beginning, a passive participial form derived from the verb *diastrepho*. *Diastrepho*, in turn, is a compound word made up of *strepho* plus the prefix *dia*. *Strepho* is one of two etymologically unrelated words for 'to turn.' The other is *trepo*. From the former we get strophe, from the latter trope. In German the word *Wende* can serve for both. Add *dia* to either and immediately the notion of distortion or perversion is introduced.

Both strophe and trope, of course, hold places in the vocabulary of poetics. While in the case of trope a departure from the "natural" or "proper" meaning of a word is indicated, strophe originally designated the group of verses sung by the chorus in Greek tragedy as it turned from one side of the stage to the other. Now it generally means stanza, implying still a turn or move from the previous group of verses. Related to strophe is catastrophe, a word not only meaning a tragic event of huge proportions, but also belonging to the poetics of plot. It designates a reversal or *peripeteia*. It remains for us to coin the new word *diastrophe* to designate the kind of figurative philology that Lessing practices in "Wie die Alten den Tod gebildet." *Diastrophe* would be a specific type of euphemism. It forcibly turns a word in such a way as to beautify its meaning, which is the same thing as denying its "natural" or "proper" meaning. Just as euphemism's original situation involves putting a beautiful face on the horror of death, so we find in Lessing's tampering with the bones of death an original instance of *diastrophe*. The reading that reverses *diastrophe*, that undoes the turn, we will call allegorical.

Lessing suspects that the whole debate about the crooked legs may be a "Grille" (hoax). "Sie [die Altertumskrämer] begründen sich auf eine einzige Stelle des Pausanias, auf ein einziges Wort in dieser Stelle [he fails to note that he does this even more]: und dieses Wort ist noch dazu eines ganz andern Sinnes fähig!" (16; They base themselves on a single passage

from Pausanias, on a single word in this passage: and, moreover, this word
is capable of an entirely different sense). What Lessing means is that the
word will be able to withstand the pressure he will apply in an effort
to straighten the word out. A straightened word, a straightened leg, a
straightened problem—he will unbend the *diestrammenous* by applying
what we have called *diastrophe*, in other words, he will turn distortion
on itself.

> Denn *diastrammenous* von *diastrephein*, heisst nicht sowohl *krumm*,
> *verbogen* als nur überhaupt *verwandt*, *aus seiner Richtung gebracht*,
> nicht sowohl *tortuosus*, *distortus*, als *obliquus*, *transversus*, und *podes
> diestrammenoi* sind also nicht nur ebensowohl durch *quer*, *überzwerch
> liegende* Füsse als durch *krumme* Füsse zu übersetzen, sondern durch
> jenes sogar noch besser und eigentlicher zu übersetzen als durch
> dieses. (16)

> For *diestrammenous* from *diastrephein* does not mean only *crooked*,
> *bent out of shape* but *turned*, *brought out of its direction*, not only *tor-
> tuosus*, *distortus* but also *obliquus*, *transversus*, and *podes diestrammenoi*
> can not only be equally well translated by *crossed feet* as by *crooked* feet,
> but is better and more actually translated by the former than the latter.

It is a subtle point. Legs may in their nature be crooked— *tortuosus*,
distortus—or they may be straight but then crooked with regard to each
other—*obliquus*, *transversus*. Underlying the rhetorical posing of Lessing's
argument seems to be the conviction that language observes a natural
logic. Lessing wants *diestrammenous* to stand for the set of things that are
crooked which would include the subset of things that are deformed, as well
as the subset of those that are not deformed but merely and temporarily
crooked in some other way. Thus he says that the legs have been brought
out of their natural direction, *aus ihrer Richtung gebracht*. The same is
true of the word *diestrammenous*. Its "natural direction," its *Richtung*, is
crooked in the sense of malformed, as Heyne adequately showed. Lessing
has brought it out of its "natural" direction; it is now in oblique relation
to its "proper" meaning. This is also evident insofar as he has introduced
podes diestrammenoi, the nominative plural, rendering the word somewhat
independent of its place in Pausanias's text. *Podes diestrammenoi*, standing
in oblique relation to the usual meaning of *diestrammenous tous podas*,
can now be better and more actually (*eigentlicher*) translated by "quer,
überzwerch liegende Füsse" (diagonally crossed feet) than by "krumme
Füsse" (crooked feet).

[85]

Having produced a "better, more actual" meaning for the word, Lessing also wants make a truth claim for his definition—"Der eigentliche Sinn ist nicht immer der wahre" (16; The actual meaning is not always the true one). He acknowledges an aesthetic motive in seeking an alternative definition—"die schönste angemessenste Bedeutung" (16; the most beautiful most appropriate meaning)—but claims that the truth of his proposal is guaranteed by antique monuments (read: Roman funeral statuary). The key to the true meaning of *diestrammenous*, then, is to be found not in other literary passages (those that Heyne collected), but in figural representations. Here is the point where Lessing leaps from the *diestrammenous* of Pausanias's description to the grave monuments of Roman time, from 600 B.C. to the first centuries A.D., from word to picture.

The final step away from nature (death, materiality, literal meaning) is to find nature itself prepared to testify to the justice of his definition. "Übereinandergeschlagene Füsse sind die natürliche Lage, die der Mensch in einem ruhigen gesunden Schlafe nimmt" (16; Crossed feet are the natural position that a person assumes in a peaceful sleep). The ancient artists, faithful imitators of nature, are witnesses to this: "Diese Lage haben die alten Künstler auch einstimmig jeder Person gegeben, die sie in einem solchen Schlafe zeigen wollen" (16; The ancient artists unanimously gave this position to every person whom they wanted to show in such a sleep). Lessing supplies numerous examples: the so-called Cleopatra, a nymph, a hermaphrodite. Even animals—two lions in the Berlin antique collection—sleep with crossed feet. He finds only one counter-example, a drunken faun, but it is precisely that faun's inebriation that prevents a peaceful sleep. Crossed feet are also a sign of *Ruhe* in figures that are awake—leaning, seated, or standing. Lessing thinks of representations of rivergods, and of Mercury and fauns, especially when the latter two play flute. He has now arrived at the point where he wants to be, for the figures of death in the grave monuments, cupids with inverted torches, are largely standing with crossed legs. He need only reject Herder's criticism (which he does in a few words) and he is free to describe with unassailable authority how the ancients represented death, relying now entirely on untrustworthy pictures of Roman grave monuments.

Does *diestrammenous* really span the gulf between Pausanias's description of the chest to the cupid-like figures that adorn the grave monuments, even if their legs are crossed? Of course not. A Greek statue of a woman sleeping may show crossed legs—that does not make her legs *diestrammenous*. A faun playing the flute may have crossed legs, but they do not signify sleep, much less are they *diestrammenous*. Indeed, I can think of only one visual motif that might have assisted Lessing in the move from

word to image: the medieval and Renaissance motif of the Madonna and sleeping child. Here, finally, we have a picture of a child in its mother's lap. And frequently the baby is shown asleep with crossed legs. Even if Lessing had been familiar with this motif, he would have rejected it. The crossed legs along with the slack and hanging arms of the sleeping Jesus anticipate the *diestrammenous* of the corpse's limbs when it will once again be held by the mother in the pietà. But these crossed legs illustrate the original and proper meaning of *diestrammenous*. It is an allegorical reading that restores death to its rightful form.

Our reading of *Wie die Alten den Tod gebildet* under the rubric of euphemism was anticipated and even prompted by the almost contemporary reception by Herder. We already mentioned that Herder wrote two versions of an essay, giving both the same name that Lessing had given his. This in itself indicates a certain continuity. Thus, while Herder seems to reverse some of the claims made by Lessing (blurring the distinction between Cupid and Thanatos; still rejecting Lessing's proposal for *diestrammenous*; clarifying the difference between a mythological and an allegorical figure), he does all this within the thrust of a greater continuity with what he perceives to be the basic intent of Lessing's essay. In a word, Herder describes and gives a name to what he thought Lessing had uncovered. As far as we are concerned, Herder describes and gives a name to what Lessing had done:

> Der Tod war ihnen [the Greeks] ein so fürchterliches, gehasstes Wesen, dass sie seinen Namen nicht gern nannten, ja dass ihnen sogar der erste Buchstab desselben, als ein unglückliches Zeichen verhasst war und sie statt *thanatos* lieber *phthonos* (Neid) sprachen. War dies, wie konnten sie Päane singen oder sein gegenwärtiges Bild lieben? Aus Sprache und Kunst ward er verbannet, und in der letzten ein Genius an die Stelle gesetzt, der—nicht den Tod vorstellen sondern—ihn nicht vorstellen, vielmehr verhüten sollte, dass man nicht [*sic*] an ihn dächte.
>
> Hiemit bekommt die ganze Vorstellung eine andere Wendung [the turn or *diastrophe* we have been talking about!]. An die Gottheit des Todes sollte bei dem Genius nicht gedacht werden; dieser Erinnerung wollte man vermittelst seiner eben entweichen. Beide Jünglinge waren nichts als ein Euphemismus der Kunst, den man über den Tod auch in der Sprache liebte: denn was sagen sie anders als was so viele Grabschriften sagen: *somno perpetuali, aeternali, quieti aeternae*, dem ewigen Schlaf oder wie die Griechen auch sagten: dem langen heiligen Schlummer. Lassen Sie uns diesen Gesichtspunkt festhalten und wir werden nicht nur diese beiden Genien im rechten Licht sehen, sondern auch eine Reihe andrer schöner Vorstellungsarten bemerken, womit

Griechen und Römer sich das Andenken des bittern Todes versüssten
oder verscheuchten.[50]

To the Greeks, death was such a frightening, hated being, that they did
not like to say its name, yes, even the first letter of its name was hated
and they preferred to say *phthonos* (envy) instead of *thanatos*. If this
was so, how could they have sung paeans or loved his contemporary
image? He was banned from language and art, and, in the latter, a
genius was put in the place, not in order to represent death, but *not*
to represent him, much more to prevent that one thought of him.

 With this the entire conception receives a different turn. The genius
should not cause one to think of the god of death; one wanted to
escape this memory through his agency. Both youths were nothing
more than a euphemism of art, a euphemism for death that was loved
in language as well: for what else do they say but what so many grave
inscriptions say: *somno perpetuali, aeternali, quieti aeternae*, dedicated
to eternal sleep or, as the Greeks also said: to the long holy slumber.
Let us hold onto this point of view and we shall not only see these
two genies in the right light, but we will also notice a series of other
beautiful kinds of representation with which the Greeks and Romans
sweetened or scared off the thought of bitter death.

Herder's promise of the interpretive sweep of euphemism once identified
is made good when he turns to the story of Cupid and Psyche. Appalled by
the vulgar materiality of the story's setting in *The Golden Ass of Apuleius*,
Herder interprets the story in such a way that Cupid is indistinguishable
from the *Todesgenius*: love becomes the euphemism for death.[51] Far from
breaking with Lessing and his euphemism, Herder embellishes and ex-
tends it.

 By contrast to Herder, our reading has sought to reverse Lessing's
essay, to break the continuity, to undo the turn. We have opposed eu-
phemism and diastrophe with allegory. According to this understanding of
allegory, reading operates in analogy to the chemistry of death. If Lessing,
his contemporaries (e.g., Herder) and his interpreters (e.g., Walter Rehm)
have given us a beautiful picture, the spirit of "Antiquity" and Classicism,
then our reading mortifies it, decomposes the picture, and rejects the spirit
in favor of the letter.

 "Aus Sprache und Kunst ward er [der Tod] verbannet, und in der
letzten ein Genius an die Stelle gesetzt, der—nicht den Tod vorstellen
sondern—ihn nicht vorstellen, vielmehr verhüten sollte, dass man nicht an
ihn dächte" (He was banned from language and art, and, in the latter, a
genius was put in the place, not in order to represent death, but *not* to

represent him, much more to prevent that one thought of him). Banned entirely from representation, whether by word or image, replaced by a *Genius* that precisely does *not* represent death, euphemized out of the picture, death is nonetheless always there in the materiality of representation. Lessing's entire energy, as we saw, was concentrated on the single Greek word *diestrammenous*, and for good reason. Could he successfully, if violently, bend this word, desecrate this grave where death lies, then the body of language would have been elided; instead of the stubbornly present corpse of language, a beautiful winged figure flies into spirit's oblivion— "dass man nicht an ihn dächte." The classical aesthetics of beauty conceived from Lessing's original trope is this euphemizing response to death. Our reading has shown that the veil of euphemism cloaks not only the body of representation —word and image—but classicism's violence to the body even more.

4

Herder:
Laocoon in Pain

A touch is worth a thousand pictures.

fter Winckelmann and Lessing, Johann Gottfried Herder is the third
to take up the issues arising in the discussion about the Laocoon.
His position as third is not without significance. Winckelmann
established for Germany the authoritative version of the opposition of an-
cients and moderns, an opposition that simultaneously entails the difference
between south (Greece, Italy) and north (Germany, England).[1] Lessing,
working within the fundamental Winckelmannian oppositions, seemed to
insist on a strict differentiation between the two terms of the *ut pictura
poesis*, the visual arts and poetry. Where, in the midst of all these binary
oppositions, between these two giants, is there a place for a third? Where
is there a place for Herder?

Herder makes his first inroad with the first of his three *Kritische
Wälder; oder Betrachtungen, die Wissenschaft und Kunst des Schönen betr-
effend, nach Maasgabe neuerer Schriften*, published anonymously in 1769,
and dedicated to "Herrn Lessings Laokoon." A letter that he sends Less-
ing in January of the same year expresses the trepidation he feels at his
incursion: "Entschuldigen Sie, hochgeschätzter Herr, die gegenwärtige
Zuschrift eines Unbekannten, der auch gerne unerkannt bleiben will"
(Dear Sir, please forgive the present letter from an unknown, who also
wishes to remain unknown).[2] He warns Lessing about the imminent

publication of a work in which he has taken the liberty: "einige Stücke in Ihrem Laokoon zu beleuchten, und ihn insonderheit von der Seite der alten griechischen Zeugnisse, und der derauf gebauten Philosophie durchzugehen" (of illuminating some parts of your Laokoon, and to go through it particularly from the perspective of old Greek documents and the philosophy which is based on them).[3] This characterization does indeed accord with the beginning of his essay. Finding that many are criticizing Winckelmann on the basis of Lessing's remarks in the *Laokoon*, Herder wants to defend both against the many detractors of either. Consistent with Lessing's fundamental principle, Herder deftly associates Winckelmann with the visual arts, Lessing with poetry. About Lessing he says: "Wo Lessing in seinem Laokoon am vortrefflichsten schreibt, spricht— der Criticus: der Kunstrichter des Poetischen Geschmacks: der Dichter" (Where Lessing in his Laokoon is writing at his best, there speaks—the critic: the arbiter of poetic taste: the poet).[4] Winckelmann's style, on the other hand, "ist wie ein Kunstwerk der Alten. Gebildet in allen Theilen, tritt jeder Gedanke hervor, und stehet da, edel, einfältig, erhaben, vollendet: er ist" (is like an ancient art work. Formed in all its parts, each thought strides forth, and stands there, noble, simple, sublime, complete: it is).[5] Summing up, he writes: "Winckelmann der Künstler, der gebildet hat, Lessing der schaffende Poet" (Winckelmann the artist, who has sculpted, Lessing the creating poet).[6] The individual writings of these two men can peacefully coexist in the same way that the Laocoon statue and Homer's *Iliad* together attest to the greatness of the Greeks.

Herder's beginning, however, does not really open up a place for himself. It is not until he ventures to explode the very principle and opposition he adopted from Lessing that he is able to introduce a third. He does this in the sixteenth chapter of the first *Kritisches Wäldchen*. Lessing had argued that painting is a spatial art using colors and figures to represent bodies through natural signs. Poetry, on the other hand, is a temporal art using articulated sounds in succession to represent actions through arbitrary signs. Critical for Lessing's argument is that there be a necessary relation between signifier and signified; i.e., because painting is a spatial art it must represent bodies in space; because poetry is a temporal art it must have a temporal signified, namely, actions. Herder, however, notices a flaw or rather an unjustified leap in Lessing's reasoning:

Hr. L. [macht] einen Sprung, den ich ihm nicht nachthue. "Die Poesie schildert durch successive Töne; folglich schildert sie auch Successionen, folglich hat sie auch Successionen, und eigentlich nichts als Successionen zum Gegenstande. Successionen sind Handlungen:

folglich"—und folglich hat Hr. L. was er will; aber woher kann ers haben?[7]

> Mr. L. makes a leap that I refuse to imitate. "Poetry depicts through successive tones; therefore it also depicts succession, therefore poetry has succession, and actually nothing but succession as its object. Successions are actions: therefore"—and therefore Mr. L. has what he wants; but whence does he have it?

The relation between the successive tones of language and the successive events of an action is arbitrary: "die artikulirten Töne haben mit der Sache nichts gemein, die sie ausdrücken sollen; sondern sind nur durch eine allgemeine Convention für Zeichen *angenommen*. Ihre Natur ist also sich völlig ungleich, und das *Tertium comparationis* schwindet" (The articulated tones have nothing in common with that which they should express; rather they are taken as signs only because of a general convention. Their nature is thus entirely unlike to that which they express, and the *tertium comparationis* disappears).[8] In other words, Herder has pried open the fundamental binary opposition from Lessing's aesthetics by prying open the relation between signifier and signified.

If Lessing's principle is to be consistently applied, says Herder, then music and not poetry would be the art by nature appropriate to successively articulated tones: "Hier kann ich sagen: Malerei wirkt ganz durch den Raum, so wie Musik durch die Zeitfolge. Was bei jener das Nebeneinanderseyn der Farben und Figuren ist, der Grund der Schönheit, das ist bei dieser das Aufeinanderfolgen der Töne, der Grund des Wohlklanges" (Here I can say: Painting is effective in space, just as music is in time. What in the former the contiguity of colors and figures is, the ground of beauty, that is with the latter the successivity of tones, the ground of good sound).[9] Music depends on the materiality of its signs in a fashion analogous to painting and distinctly different from poetry. In poetry, as Herder says: "ist das Natürliche in den Zeichen, z. E. Buchstaben, Klang, Tonfolge, zur Wirkung der Poesie wenig oder nichts: der Sinn, der durch eine willkürliche Uebereinstimmung in den Worten liegt, die Seele, die den artikulirten Tönen einwohnet, ist alles" (what is natural in the signs, e.g., the letters, the sound, the sound sequence, contributes little or nothing to the effect of poetry: the meaning, which through an arbitrary agreement lies in the words, the soul, which inhabits the articulated sounds, is everything).[10] This being the case, Herder asks if there is not a fundamental concept with which poetry should be associated in the same way that painting is with space, music with time.

Wir wollen das Mittel dieser Wirkung *Kraft* nennen: und so, wie in der Metaphysik *Raum, Zeit* und *Kraft* drei Grundbegriffe sind, . . . so wollen wir auch in der Theorie der schönen Wissenschaften und Künste sagen: die Künste, die Werke liefern, wirken im Raume; die Künste, die durch Energie wirken, in der Zeitfolge; die schönen Wissenschaften, oder vielmehr die einzige schöne Wissenschaft, die Poesie, wirkt durch *Kraft*. —Durch *Kraft*, die einmal den Worten beiwohnt, durch Kraft, die zwar durch das Ohr geht, aber unmittelbar auf die Seele wirket. Diese *Kraft* ist das Wesen der Poesie, nicht aber das Coexistente, oder die Succession.[11]

We shall call the means of this effect *force*: and so, just as in metaphysics *space, time,* and *force* are three basic concepts, . . . so we also in the theory of the beautiful sciences and arts want to say that: the arts that produce works function in space; the arts that operate through energy function in successivity; the beautiful sciences, or much more the single beautiful science, poetry, functions through *force*. —Through *force*, which at one time accompanies the words, through force, which indeed goes through the ear, but has a direct effect on the soul. This *force* is the essence of poetry, not coexistence or successivity.

Kraft or force is thus the third that splits open the opposition of poetry and painting, that makes a place for Herder between Winckelmann and Lessing. But what is *Kraft*? If we confine our attention to this passage, it is clear that Herder means the power of poetry to stimulate sense images in the imagination. In other words, he is giving a more appropriate name to the same phenomenon that Lessing analyzed in Homer under the concept of successivity. But *Kraft* means much more than that to Herder. Patrick Gardiner points out that: "all Herder's writings on psychological subjects [and this would include Herder's aesthetics] were ultimately based upon an explicitly metaphysical conception, the notion of *Kraft*."[12] We thus find *Kraft* not only playing a significant role in the first *Kritisches Wäldchen*, but also in *Vom Erkennen und Empfinden* and in *Plastik*, essays written in the 1770s and finally revised and published together in 1778. The difference between the earlier and later versions of both, as Robert T. Clark has argued, is Herder's reading of Albrecht von Haller's *Elementa physiologiae corporis humani* (1759–66).[13]

Vom Erkennnen und Empfinden was first written in response to a prize question formulated by J. G. Sulzer on behalf of the Berlin Academy of Sciences: essays were solicited that would examine "[die] beiden Grundkräfte der Seele, des Erkennens und des Empfindens" (the two basic powers of the soul, cognition and feeling).[14] The question itself designates two faculties of the human being as "Kräfte." Herder was fundamentally opposed to

the artificial hypostatization of "powers of the soul," the so-called faculty psychology. He dissolved all "powers" into one "force," one *Kraft*. Already in the first versions he is concerned to begin at the simplest and deepest level of preconscious sensation. After reading Albrecht von Haller, the great eighteenth-century physiologist, he can do so with authority and thus entitle his first section "Vom Reiz." *Reiz*, originally the German equivalent of grace or *Anmut*, an aesthetic term, came also to be used in eighteenth-century medical discourse for any unpleasant stimulus to the body, which is only another way of saying pain. Obviously, whether the Laocoon is named or not, the statue is a crucial referent of this discussion.

Plastik, on the other hand, is interested in working out an aesthetics of sculpture based on the sense of touch. Picking up a distinction he had already laid down in the fourth *Kritisches Wäldchen*, Herder insists on an essential difference between sculpture and painting, the former oriented to touch, the latter to sight. As Herder points out, all thinkers, including Lessing, failed to account for the different media of these two art forms and simply disregarded the three-dimensionality and tactility of sculpture, treating sculpture as a type of painting and relegating it to sight. Once again, Herder sets up a tripartite structure, but with a critical difference. He now distinguishes between painting, music, and sculpture, associating the first with sight, the second with hearing, and the third with feeling. Painting consists of coexistent parts on a surface; music, of tones in succession. Sculpture consists of parts "auf einmal in-neben- beieinander, Körper oder Formen" (simultaneously in, next to, and with each other, bodies or forms).[15] "Und alle Drei verhalten sich zu einander, als Fläche, Ton, Körper, oder wie Raum, Zeit und Kraft, die drei grössten Medien der allweiten Schöpfung, mit denen sie alles fasset, alles umschränket" (And all three are related to each other as surface, sound, body, or as space, time, and force, the three greatest media of the entire creation, with which creation comprehends everything, delimits everything).[16]

Once again there is *Kraft*, this time not in connection with poetry but with the sense of touch. Language and *Kraft*, psychology and *Kraft*, sculpture and *Kraft*: in all of these moments there is a significant gesture. It is a gesture toward the human body, a gesture implied already in the etymology of *Kraft*. As Adelung says:

> Da alle abstracte Bedeutungen in allen Sprachen Figuren sinnlicher Bedeutungen sind: so ist es sehr wahrscheinlich, dass dieses Wort von greifen, mit den Händen fassen abstammet, so wie das Niederdeutsche Kracht zunächst von kriegen, in eben dieser Bedeutung, herkommt.[17]

> Since all abstract meanings in all languages are figures of sensory
> meanings: thus it is very likely that this word is derived from grasp, to
> grasp something with the hands, just as the lower German *Kracht* first
> of all comes from *kriegen* in precisely this meaning.

The hand that touches, that feels and gives pain, is already involved in
the word. Herder's systematic reference to *Kraft* is a way of approaching
the body. Winckelmann, too, approached the body, but only in order to
disfigure it in *Unbezeichnung*. Lessing, on the other hand, was repulsed by
the body and driven to violence by his abhorrence. In Herder, by contrast,
we find an incipient materialism, not untouched by Winckelmann's sensu-
ousness nor Lessing's repulsion, as we shall see, but basically nonviolent, a
respectful and determined, if finally faltering, approach to the human body.

1

Herder's *Vom Erkennen und Empfinden* begins with the problem of the
abyss separating human consciousness from "todte Natur" (dead nature).
"Wir sprechen täglich das Wort *Schwere, Stoss, Fall, Bewegung, Ruhe, Kraft*,
sogar *Kraft* der *Trägheit* aus, und wer weiss, was es, inwendig der Sache
selbst, bedeute?" (Daily we utter the words *heaviness, push, fall, movement,
calm, force*, even *force* of *inertia*, and who knows what they mean in the
things themselves?)[18] The signifiers we use for various manifestations of
Kraft remain on this side of the abyss, unassured of their material signifieds.
If we made no effort to cross this gap, our psychology would resemble a
chess game played on the "Leibnizschen Schachbrett mit einigen tauben
Wörtern und Klassifikationen von dunkeln und klaren, deutlichen und
verworrenen Ideen, vom Erkennen in und ausser sich, mit sich und ohne
sich selbst u. dgl." (179–80; Leibnizian chessboard with several deaf words
and classifications of dark and clear, distinct and confused ideas, about
cognition in and outside itself, with itself and without itself and the like).
Not philosophical discourse, but the praxis of physiological investigation
provides the possibility of making the transition from living consciousness
to dead materiality. Thus, Herder invites us to approach the dissection
table, to observe the body, both living and dead. The body itself is the
abyss: "Vor solchem Abgrunde dunkler Empfindungen, Kräfte und Reize
graut nun unsrer hellen und klaren Philosophie am meisten: sie segnet sich
davor, als vor der Hölle unterster Seelenkräfte" (179; Faced with such an
abyss of dark sensations, powers and *Reize*, our bright and clear philosophy

shudders the most: it crosses itself as if facing a hell of the darkest forces of the soul). Herder, however, makes the bold programmatic statement that:

> keine Psychologie, die nicht in jedem Schritte bestimmte Physiologie sei, möglich [ist]. Hallers physiologisches Werk zur Psychologie erhoben und wie Pygmalions Statue mit Geist belebt—alsdenn können wir etwas übers Denken und Empfinden sagen. (180)[19]

> In my humble opinion, no psychology is possible that is not distinctly physiology in every step. Haller's physiological work raised to psychology and brought to life with spirit like Pygmalion's statue—only then can we say something about thinking and feeling.

We had occasion to mention Haller's "physiologisches Werk" in the introductory chapter. It will be remembered that Haller's chief means for empirically conceiving the body was the application of pain. In Herder's programmatic statement, it is clear that he desires to write a psychology that is continuous with Haller's physiology, i.e., grounded in the human body. But interestingly and, above all, tellingly, Herder sets his "physio-psychology" in analogy to the bringing to life of Pygmalion's statue. This analogy prefigures the two conflicting tendencies or logics of Herder's *Vom Erkennen und Empfinden*. The one is a medical logic of stimulus and response. The other is an aesthetic logic of analogy in the service of beauty. Our primary question in reading *Vom Erkennen und Empfinden* is: which logic prevails? If the medical, then the body is affirmed; if the aesthetic, then the body, especially as it is represented in medical discourse, is denied.

There is a compelling historical and philological reason for the perhaps surprising proximity of these two heterogeneous discourses, the discourses of medicine and art. There is a single term that they have in common, the word *Reiz*. *Reiz* is the noun form of the verb *reizen*, to cause someone or something to experience a sensation, whether painful or pleasant. The tradition of rhetoric and aesthetics had isolated the pleasant side of *Reiz*, making it largely synonomous with *Anmut* and *Grazie*, terms that designate grace, a species or form of beauty. Lessing, and Schiller after him, called *Reiz* "Schönheit in Bewegung" (beauty in motion). Increasingly during the course of the century, however, medical discourse also appropriated *Reiz* and restored to it the meaning of causing painful sensations. Thus while Adelung's lexicon of 1774 still registers only the aesthetic definition, Campe in 1808, in a sort of delay, includes both. As *Grimms Wörterbuch* notes: "Reiz befestigt sich während des 18. Jahrhunderts in mannigfaltigem Gebrauche, besonders in der wissenschaftlichen Sprache"

(*Reiz* establishes itself during the course of the eighteenth century in a variety of usages, especially in the language of science).

The laboratory of *Reiz* was Haller's clinic in Göttingen. Most Germanists remember Haller as a descriptive poet and straw man for Lessing's argument in *Laokoon, oder über die Grenzen der Mahlerey und Poesie*. Haller, however, was much more accomplished as a professor of medicine and physiology; together with La Mettrie, author of *L'Homme Machine*, he was one of the most famous students of Boerhaave, the great Dutch physiologist of Leiden. A good part of his reputation rested on the results of experiments that he and his students performed in Göttingen, subjecting all the known body parts of hundreds of living animals of all kinds to a variety of painful stimuli or *Reize* in order to determine whether the part in question was irritable (*reizbar*) or sensible (*empfindlich*). If the former, then the part would contract or shrink but fail to register pain in the brain of the animal; if the latter, then the part would show no contraction, but the nerves would convey a representation of pain to the brain and the animal would scream or show other signs of pain. We will let Haller describe his procedure:

> Ich habe bei lebendigen Tieren von mancherlei Gattung und von verschiedenem Alter, denjenigen Teil entblösset, von welchem die Frage war; ich habe gewartet, bis das Tier ruhig gewesen ist, und zu schreien aufgehört hat, und wenn es still und ruhig war, so habe ich den entblössten Teil durch Blasen, Wärme, Weingeist, mit dem Messer, mit dem Ätzsteine, (Lapis infernalis) mit Vitriolöle, mit der Spiessglasbutter, gereizet. Ich habe alsdann Acht gehabt, ob das Tier durch berühren, spalten, zerschneiden, brennen oder zerreissen, aus seiner Ruhe und seinem Stillschweigen gebracht würde; ob es sich hin- und herwürfe, oder das Glied an sich zöge, und mit der Wunde zückte, ob sich ein krampfhaftes Zücken in diesem Gliede zeigte, oder ob nichts von dem allen geschähe. Ich habe die wiederholten Erfolge dazu aufgezeichnet, wie sie ausgefallen sind.[20]

> I exposed that part in living animals of several species and various ages that was in question; I waited until the animal was calm and had stopped screaming, and when it was quiet and peaceful, I stimulated the exposed part by blowing, by heat, alcohol, with the knife, with corrosive stone (Lapis infernalis), with oil of vitriol, with antimonium chloride. I then observed whether the animal were brought out of its calm and its silence by touching, splitting, cutting, burning, or ripping; whether it threw itself back and forth, or drew the limb into itself, and twitched with the wound, whether a cramped twitching showed in this limb, or whether nothing of all this occurred. I recorded the repeated results as they happened.

What are these gruesome scenes with cats, frogs, horses, and dogs, if not hundreds of miniature replicas of the Laocoon? Haller himself admits: "Ich habe in der Tat hierbei mir selbst verhasste Grausamkeiten ausgeübet" (I have indeed had to carry out cruelties hateful to myself).[21] The results he speaks of were summarized in two lectures delivered on April 22 and May 6, 1752, in Göttingen and published as *De partibus corporis humani sensilibus et irritabilibus* in 1753. An English translation appeared in 1755 as *A Dissertation on the Sensible and Irritable Parts of Animals*, and, in 1756, a German translation from the Danish anticipated Haller's own in 1772, published as *Von den empfindlichen und reizbaren Teilen des menschlichen Körpers*. The reader of Haller, in whatever language, was equipped with a detailed picture of how pain is represented in the body, which is to say, every reader of Haller had the knowledge needed to diagnose the Laocoon.

Herder was fascinated by the phenomenon of *Reizbarkeit* and made it the center and origin of his physio-psychological model of human being. "Tiefer können wir wohl die Empfindung in ihrem Werden nicht hinabbegleiten, als zu dem sonderbaren Phänomenon, das Haller 'Reiz' genannt hat" (171; We cannot accompany sensation any deeper into its becoming than to the extraordinary phenomenon that Haller called *Reiz*). (*Reiz* will be Herder's designation for Haller's concept of *Reizbarkeit*.) It is not surprising that Herder found *Reiz* so compelling. Haller had stressed its autonomy and that the "Reizbarkeit nicht, wie man insgemein glaubet, von den Nerven entspringe, sondern aus dem Bau des reizbaren Teils selber folge" (Irritability does not, as is commonly believed, originate in the nerves, rather it follows from the structure of the irritable part itself).[22] Haller had discovered that even in limbs and organs that had been severed from the body, as long as they remained supple, the property of *Reizbarkeit* remained as well. It is dead matter, but when it is prodded, cut, or burned it shrinks back. Haller says as much: "Die Reizbarkeit hängt also weder von dem Willen, noch von der Seele ab" (Irritability thus depends on neither the will nor the soul).[23] For Herder, this is an origin, an *Ursprung*. He calls out: "Reiz, Leben" (174) almost mimicking in language the prodding of the flesh (*Reiz*), and its response (*Leben*). This is the place where body and soul are knotted together, where embodied consciousness has its origin:

> Das gereizte Fäserchen zieht sich zusammen und breitet sich wieder aus; vielleicht ein Stamen, das erste glimmende Fünklein zur Empfind-
> ung, zu dem sich die todte Materie durch viele Gänge und Stufen
> des Mechanismus und der Organisation hinaufgeläutert.—So klein und

dunkel dieser Anfang des edlen Vermögens, das wir Empfinden nennen, scheine; so wichtig muss er seyn, so viel wird durch ihn ausgerichtet. (171)

The stimulated little fiber contracts and expands again; perhaps a stamen, the first shining little spark towards sensation, to which dead material purified itself through many passages and levels of mechanism and organization.— As small and dark as this beginning of the noble capability that we call sensation may appear; so important must it be, so much is carried out by it.

Notice how the terms and notions of Winckelmann's Greek ideal and his description of the Laocoon have been clustered round this scene: Haller waits until the animal is calm (*Stille*, *Ruhe*) before applying pain for what can only be called sublime effects (*Grösse*); Herder states that the *Reiz* phenomenon may be small and dark (*Einfalt*) but it is continuous with a noble capability (*edel*). "Edle Einfalt, stille Grösse." Indeed, insofar as the snake's bite is the center and origin of the Laocoon, as Goethe will argue in *Über Laokoon*, it seems that Herder's human being is constructed as much on the model of the Laocoon as it is on Haller's physiology. One could say that Herder is practicing an aesthetic physiology.

Haller, however, had something far different in mind when he discussed *Reizbarkeit*. For centuries, phenomena like the headless chicken running around the barnyard and the spasms of a severed limb had confused people in their speculations about the seat of the human soul and the nature of life. Haller used the designation *reizbar* to protect the sense of life that he associated with sensation and the soul. For Haller, *Reizbarkeit* is a power of dead matter: "[D]iese Kraft [der Reizbarkeit] hat nichts mit dem Leben gemein" (This power of irritability has nothing in common with life). Herder has plainly misread Haller on this point.[24]

Herder makes yet another shift. For Haller, *Reizbarkeit* is "die contractile Kraft."[25] The phenomenon consists in a single movement, the tissue's contraction, followed by an eventual relaxing to its original state. For Herder, on the other hand, *Reiz* involves two possible motions: either "Ausbreiten" (expansion) or "Zusammenziehen" (contraction) (174). With their "A" and "Z" they are like the alpha and omega of his physiopsychology; important to note is that according to Haller, of course, "Ausbreiten" would only be possible after "Zusammenziehen" and only back to an original relaxed condition. Herder has once again exploded two into three (as he did with Lessing's oppositions), placing "Ausbreiten" and "Zusammenziehen" at opposite ends of an intermediate state. Whereas

Haller's is a physiology founded on pain, Herder's is a physio-psychology of pleasure and pain, *Reiz* and *Reiz*.

There are reasons for Herder's misreading of Haller, and we are certainly entitled to speak of misreading—according to Haller's terms, the only acceptable refutation of his claims would be original and repeated experiments, an unlikely undertaking for Herder. Herder feels that he has found an *Ursprung*, a power within dead materiality that is its own, even if reactive, and that is in itself already life-like, even living. That power of *Reizbarkeit*, subdivided into expansion and contraction, becomes then the primary cause, not to say figure, of all powers and motions: plant, animal, and human. Having isolated and modified *Reiz* as a basic form of *Kraft*, Herder can construct his model of human being. But first he must decide whether this model will be based on the medical logic of stimulus and response or on the aesthetic logic of analogy. He begins with the latter.

Herder had introduced and argued for the necessity of analogy at the outset of *Vom Erkennen und Empfinden*: "Was wir wissen, wissen wir nur aus Analogie, von der Kreatur zu uns und von uns zum Schöpfer" (170; What we know, we know from analogy alone, from the creature to us and from us to the creator). The constraints of human perception and consciousness force us to have recourse to analogy as the only possibility for knowledge of things and their powers that are external to us. We project our self-knowledge by analogy into the play of things that we perceive around us. Analogy, it seems, enables the crossing of the gap between dead materiality and human consciousness, too, even if in an entirely different manner from that of *Reiz*. The question, then, is whether or not the physiology of *Reiz* and the principle of analogy can work in tandem to show that all human powers are merely variations and modifications of the basic power of *Reiz* and hence deeply anchored in the body, no matter how spiritual or abstract they may seem.

Initially Herder produces human analogies to *Reiz* with considerable ease. A first series turns more on words than the phenomenon. Touching on hunger and thirst—"welche mächtige Stacheln und Triebe!" (what powerful spurs and drives!)—Herder finishes with love—"der tiefste Reiz, so wie der mächtigste Hunger und Durst, die Liebe!" (175–76; the deepest *Reiz*, as well as the most powerful hunger and thirst, love!). A second series finds physio-psychological analogies to the phenomena of contraction and expansion: "Der Muth des Löwen, wie die Furchtsamkeit des Hasen, liegt in seinem beseelten innern Baue" (179; The courage of the lion, like the cowardice of the hare, lies in its ensouled interior makeup). Courageous an-imals and men have expansive hearts and chests, cowardly ones contractive.

Das Herz Achills wurde in seinen Netzen vom schwarzen Zorn ge-
rüttelt, es gehörte die Reizbarkeit dazu, ein Achilles zu werden. . . .
Die Tapfersten waren meistens die fröhlichsten Menschen, Männer
von offener, weiter Brust: oft Helden in der Liebe, wie im Leben.
Ein Verschnittener ist wie an Stimme so an Handlung ein stehen
gebliebener Jüngling ohne Kraft und tiefen Ausdruck. (179)

The heart of Achilles was shaken in its network by black wrath; *Reizbar-
keit* was needed to become an Achilles. . . . The bravest were usually
the most cheerful people, men of open, wide breast: often heroes in
love, as in life. A castrato is as in voice so in action an eternal youth
without power and deep expression.

But these analogies are too facile and unsystematic. Beginning with
Reiz, Herder wants to construct a model of the human being where each
level is analogous to the original (*Reiz*) and where each level is the stimulus
(*Reiz*) for the succeeding one. In other words, each analogy to *Reiz* is
produced by a *Reiz*. The levels of Herder's model are: *Reiz, Sinn, Ein-
bildungskraft, Erkennen*, and *Wollen*. Though it was customary according
to faculty psychology to identify these (and others) as independent powers
(*Kräfte*), Herder wants to show that it is a single continuous *Kraft* that is
variously modulated from the origin of *Reiz*.

The first level beyond *Reiz* is that of the senses. The senses rely on
the nerves and thus correspond to Haller's category of *Empfindlichkeit*,
which was entirely dependent on the nerves. Herder's commitment to
the principle of analogy, however, causes him to diverge completely from
Haller. From the outset of his discussion concerning *Reizbarkeit*, Haller
insists that the nerve is *not* subject to contraction: "Erstlich, so ist der
Nerv, von welchem alle Empfindung zur Seele gebracht wird, selbst von
aller Reizbarkeit entblösset. Dieses scheinet zwar wunderlich, indessen aber
ist es so gewiss als wunderbar" (First of all, the nerve, by which all sensation
is brought to the soul, is void of all *Reizbarkeit*. This indeed appears
astonishing, at the same time it is as certain as it is amazing).[26] To achieve
absolute certainty on this point Haller undertook a very precise experiment:

Ich habe bei einem lebendigen Hunde einen langen Nerven über ein
subtil eingeteiltes mathematisches Instrument gelegt, so dass der Nerv
bei der geringsten Bewegung notwendig von einem Grade des Instru-
ments zum anderen fortrücken musste: alsdann habe ich ihn gereizt:
allein er ist unbeweglich geblieben, und nicht um den geringsten mess-
baren Raum von dem Striche abgewichen, auf welchen er lag. Dieses

sind nun neue Beweise, welche zeigen, dass den Nervenfäserchen wider
alle Erfahrung eine schwingende Kraft zugeschrieben wird.[27]

I laid a long stretch of nerve from a living dog over a subtly calibrated
mathematical instrument so that the nerve at the slightest movement
would necessarily have to move from one gradation of the instrument
to another: then I stimulated it: only it remained immobile, and did
not deviate in the slightest from the line on which it lay. These now
are new proofs which show that a vibrating power is falsely attributed
to the nerve fibers.

The importance of this experiment should not be underestimated. For
centuries and still in the eighteenth century, the nerves were thought of
in analogy to the tautly strung strings of a musical instrument. Haller lays
this notion to rest.

Herder, by contrast, even as he appeals to Haller, posits a continu-
ity between *Reizbarkeit* and *Empfindlichkeit*: "Der Nerv beweiset feiner,
was dort von den Fibern des Reizes allgemein gesagt wurde, er ziehet
sich zusammen oder tritt hervor nach Art des Gegenstandes, der zu ihm
gelanget" (185; The nerve shows more finely what was said already about
the fibers of *Reiz* in general, it contracts or expands according to the sort
of object that comes to it). What he means is that the sense-nerves re-
spond to pleasant and painful stimuli in different ways. "Grausen, Schauer,
Erbrechen, bei dem Geruche das Niesen, sind lauter solche Phänomene
des Zurücktritts, des Widerstandes, der Stemmung, als ein sanftes Hin-
wallen und Zerschmelzen bei angenehmen Gegenständen Uebergang und
Uebergabe zeiget" (185–86; Terror, shuddering, vomitting; in the case of
smell, sneezing; these are nothing but such phenomena of retracting, of
resistance, of bracing, as a soft surge forward and melting in the case
of pleasant objects shows transition and surrender).

The senses are gathered up on the next level, that of *Einbildungskraft*.

Hier indess fahren wir fort, dass, so verschieden dieser Beitrag ver-
schiedener Sinne zum Denken und Empfinden seyn möge, in unserm
innern Menschen Alles zusammenfliesse und Eins werde. Wir nennen
die Tiefe dieses Zusammenflusses meistens Einbildung: sie besteht aber
nicht blos aus Bildern, sondern auch aus Tönen, Worten, Zeichen und
Gefühlen, für die oft die Sprache keinen Namen hätte. (189)

Here, meanwhile, we proceed to the effect that, as various as this con-
tribution of the various senses to thinking and feeling may be, in our
inner person, everything flows together and becomes one. We usually

call the depth of this confluence imagination: it consists however not merely of images, but also sounds, words, signs, and feelings, for which language often has no name.

The various sense impressions are conveyed by the nerves to the *Einbildungskraft* where they are unified. What occupies the *Einbildungskraft*, in turn, is the object of *Erkennen*, the penultimate level: "Wir empfinden nur, was unsre Nerven uns geben; darnach und daraus können wir auch nur denken" (190; We sense only what our nerves give us; only according to and from that are we able to think).

The analogy to *Reiz* on the level of *Erkennen* now involves consciousness. Consciousness is an interplay of *Zurückziehung* and *Ausbreitung*. The soul knows:

> dass sie nur das erkenne, was dieser Platz [in der Welt] ihr zeige Sie ist in einer Schule der Gottheit, die sie sich nicht selbst gegeben: sie muss die Reize, die Sinne, die Kräfte und Gelegenheiten brauchen, die ihr durch eine glückliche, unverdiente Erbschaft zu Theil wurden, oder sie zieht sich in eine Wüste zurück, wo ihre göttliche Kraft lähmet und erblindet. (194)

> The soul knows that it only recognizes what this place [in the world] shows it It is in a school of the Godhead, which it did not give to itself: it must use the stimuli, the senses, the powers and occasions which became its part through a happy, unearned inheritance, or it withdraws into a desert, where its divine power becomes lame and blind.

Complete withdrawal from all sense impressions cripples *Erkennen*.[28] At the same time, however, a non-instrumental *Ausbreitung* would also not be appropriate: "[S]ie muss die Reize, die Sinne, die Kräfte und Gelegenheiten brauchen" (It must use the *Reize*, the forces and opportunities). For *Erkennen* to be able to use the sense impressions it needs a medium:

> Wie aber? hat diese innere Elasticität [des Erkennens] keinen Helfer, keinen Stab, an dem sie sich stütze und halte? kein Medium, wenn ich so sagen darf, das sie wecke und ihre Würkung leite, wie wirs bei jedem Reiz, bei jedem Sinne fanden? Ich glaube, ja! und dies Medium unsres Selbstgefühls und geistigen Bewusstseyns ist—Sprache. (196–97)

> But how? has this inner elasticity [of cognition] no helper, no staff on which it can lean and hold itself? no medium, if I may say so, that wakens it and guides its effectiveness, as we found this to be the case

with every *Reiz*, every sense? I believe, yes! and this medium of our self-feeling and spiritual consciousness is—language.

The *Stab* or staff of *Erkennen* is the *Buchstab* of language.

The final level of Herder's psychology is *Wollen*, for: "Auch Erkennen ohne Wollen ist nichts, ein falsches, unvollständiges Erkennen" (198; Also cognition without the will is nothing, a false, incomplete cognition). Counter to his teacher Kant, Herder makes *Erkennen* and *Wollen* inseparable: "Ist jedes gründliche Erkenntniss nicht ohne Wollen, so kann auch kein Wollen ohn' Erkennen seyn: sie sind nur Eine Energie der Seele" (199; If every thorough knowledge is not without will, then there can also not be any will without cognition: they are but one energy of the soul). With *Wollen* Herder is most insistent about the analogy to and the continuity with *Reiz*: "Reiz ist die Triebfeder unsres Daseyns, und sie muss es auch bei dem edelsten Erkennen [i.e., *Wollen*] bleiben" (199; *Reiz* is the motor of our existence, and it must remain this even in the case of the most noble cognition [i.e., willing]). *Wollen* is also structured according to *Ausbreitung* and *Zurückziehen*.

> Menschheit ist das edle Maas, nach dem wir erkennen und handeln: Selbst- und Mitgefühl also, (abermals Ausbreitung und Zurückziehung) sind die beiden Aeusserungen der Elasticität unsres Willens; Liebe ist das edelste Erkennen, wie die edelste Empfindung. Den grossen Urheber in sich, sich in andre hinein zu lieben und denn diesem sichern Zuge zu folgen: das ist moralisches Gefühl, da ist Gewissen. Nur der leeren Spekulation, nicht aber dem Erkennen stehets entgegen, denn das wahre Erkennen ist lieben, ist menschlich fühlen. (199–200)

> Humanity is the noble measure according to which we know and act: self-feeling and sympathy therefore (once again expansion and contraction) are the two expressions of the elasticity of our will; love is the most noble cognition, as it is the most noble feeling. To love the great creator in oneself, to love oneself into others and then to follow this certain move: that is moral feeling, that is conscience. It only stands opposed to empty speculation, but not to cognition, for the true cognition is love, is human feeling.

A balanced orientation to the self (*Zurückziehung*) and to others and other things (*Ausbreitung* based on analogy) amounts to love at the level of *Wollen*, just as love is "das edelste Erkennen, wie die edelste Empfindung"; nor should we forget Herder's earlier statement that love is "der tiefste Reiz." (176)

Thus Herder's model seems to round out to a perfect system of analogy and causality based on the doubleness of *Reiz*. There is, of course, as we have seen, one crucial flaw in the system, namely the misinterpretation of Haller's concept of *Reizbarkeit*. Early in his *Von den empfindlichen und reizbaren Teilen des menschlichen Körpers* Haller almost seems to anticipate Herder's strategy with a criticism: "Ich bin gewiss, die grösste Ursache der Irrtümer sei gewesen, dass sich die Ärzte weniger, oder auch wohl gar keiner Erfahrungen bedienet, sondern anstatt derselben die Analogie zur Hilfe genommen haben" (I am certain that the greatest cause of errors has been that doctors have made less or even no use of experiences, but instead of them have sought assistance in analogy).[29] Herder looked to *Reiz* to span the gap or account for the transition from death to life, from materiality to consciousness. In actuality, the gap was only displaced. The phenomenon of *Reizbarkeit*, the severed limb or dead and extracted heart that moves spastically when touched, belongs profoundly to the uncanny otherness of the body. I do not dispute the sincerity of Herder's attempt to approach the body. However, the initial misinterpretation of Haller caused Herder's argument to forfeit its connection to the body in the clinic. By converting *Reiz* into a figure, by resorting to the logic of analogy, Herder certainly succeeds in spanning the gap between matter and spirit, signifier and signified, and in producing a model of human embodiment. That model, however, is more like Pygmalion's statue than Haller's physiology. Indeed, the best one can say is that Herder has produced an aesthetic physiology, materially based on Haller and the language of medical discourse, but formally approximating the Laocoon statue. For all his desire to ground his thinking in the body, Herder turned away from the material body at the decisive moment.

Before turning to the *Ursprung* treatise and the *Plastik*, we might offer an anecdote from Herder's life, an analogy, really, to our reading of *Vom Erkennen und Empfinden*, and, as analogy, just as compromised as Herder's model of human being. In 1762, the young Herder was placed under the guardianship of a medical doctor and taken to Königsberg, where he was to study medicine. His wife, Karoline, related the experience of Herder's first day of medical instruction:

Mit raschem Schritt sollte es nun an die Erlernung der Chirurgie gehen. Der russische Feldchirurg, sein Erretter, nahm ihn bald nach ihrer Ankunft in Königsberg zu einer Sektion mit—hier sank der junge Herder vor Grausen in Ohnmacht. Dieser Zufall entschied seine Lebensbahn für immer. Es war keine Verstellung: denn auch später

konnte er dergleichen nicht aushalten, und schon das blosse Sprechen-
hören von chirurgischen Operationen erschütterte seine zarten
Nerven.[30]

In quick tempo, the time to begin learning surgery had come. The
Russian field doctor, his savior, took him soon after their arrival in
Königsberg to a dissection—here the young Herder passed out in
horror. This chance occurrence decided the course of his life forever.
It was no deception: for also later he could not endure anything
like it, and even the mere hearsay of a surgical operation shook his
delicate nerves.

The sight of the dissected body was a painful *Reiz* for Herder; spontaneous
contraction (*Zurückziehung*) occurred in the form of passing out. He
became all body as his consciousness fled. Returning to consciousness,
his repulsion for the body decided him once and for all for the study of
theology and philosophy. Days later he began attending the lectures and
seminars of Immanuel Kant.

If the initial position of Herder's discourse is philosophy and theology
(the Leibnizian chessgame), then the approach is clearly to the body as it
is laid out in Haller's lab or the anatomy theater. The discourse, however,
"passes out," it reels back in horror from the reality of the body, especially
as it is manifest in *Reiz*. Avoiding *Reiz* in its painful uncanny association
with the body, Herder resorts to analogy in order to construct an aesthetic
physio-psychology, an idealized statue of the human being, a Laocoon in
the clinic.

Interpretation is threatened by a similar predicament. A gulf separates
Herder's writings from his life and his body. An analogy between text
and biographical anecdote, such as the one above, is easily made, even
charming (*reizvoll*), and perhaps useful for representation. The anecdote,
lifted from the subject's life, has the status of a rhetorical figure vis-à-vis
the interpreted text. An effort to connect the text and the biographical
anecdote according to a medical logic, however, can only be as banal as
Karoline Herder's statement: "Dieser Zufall entschied seine Lebensbahn
für immer" (This chance occurrence decided the course of his life forever).
We cannot make our way to Herder's life or Herder's body. What we can
do is to read Herder, and not only Herder, with an eye to the body, both
as it is represented *in* language and *as* language. This, after all, is how we
read the eunuch's body in the chapter on Winckelmann, and the body of
death in the chapter on Lessing. We will proceed similarly with Herder,
Moritz, and Goethe, too.

2

In June 1771, three years before the writing of *Vom Erkennen und Emp-finden*, Herder's *Abhandlung über den Ursprung der Sprache* was awarded the prize by the Berlin Academy. The continuity between these two essays, however, proves that the preoccupations of *Vom Erkennen und Empfin-den*—the singleness of *Kraft* despite its various manifestations and the search for the original point where materiality and consciousness are one—have their place in the late sixties and early seventies, when Herder was writing both the *Abhandlung* and the *Plastik*. Indeed, a single statement in the *Abhandlung* expresses the main thesis of *Vom Erkennen und Empfinden*. Speaking of the human being exercising reason, Herder says:

> Es ist die *ganze Einrichtung aller menschlichen Kräfte; die ganze Haus-haltung seiner sinnlichen und erkennenden, seiner erkennenden und wollenden Natur*; oder vielmehr—es ist *die einzige positive Kraft des Denkens*, die, mit einer gewissen *Organisation des Körpers* verbunden, bei den Menschen *Vernunft* heisst.[31]

> It is the entire arrangement of all human powers, the entire economy of his sensory and cognitive and willing nature; or, much more—it is the single positive power of thinking, which, connected with a certain organisation of the body, is called reason among humans.

Despite the reverse chronology, the reading of *Über den Ursprung der Sprache* that we will now pursue proceeds from the later essay as from a ground. The reason for that is the fundamental primacy of *Reiz*.

The *Abhandlung* begins with pain: "*Schon als Tier hat der Mensch Sprache*. Alle heftigen und die heftigsten unter den heftigen, die schmerz-haften Empfindungen seines Körpers, alle starke Leidenschaften seiner Seele, äussern sich unmittelbar in Geschrei, in wilde, unartikulierte Töne" (5; Already as an animal the human being has language. All powerful, and the most powerful among the powerful, the painful sensations of his body, all strong passions of his soul, express themselves immediately in screaming, in wild, unarticulated sounds). Liliane Weissberg has shown that, contrary to Condillac and Rousseau, Herder's predecessors in this question of the origin of language, and whose speculative scenarios in-volved children and primitives on islands or in jungles, Herder proposes Philoctetes, the cultured Greek hero of Sophocles' tragedy, who was aban-doned on an island for almost ten years or the duration of the Trojan War.[32] Philoctetes suffered from a persistent foot wound acquired from a snake bite. A sudden attack of pain could reduce him to heart rending cries

represented in the famous Sophoclean onomatopoeia: *papai, apappapai, papappapappapappapai*. Pain breaks down cultured language and returns the human to language's origin. "Ein leidendes Tier sowohl als der Held Philoktet, wenn es der Schmerz anfället, wird wimmern, wird ächzen, und wäre es gleich verlassen, auf einer wüsten Insel, ohne Anblick, Spur und Hoffnung eines hülfreichen Nebengeschöpfes" (5; A suffering animal as well as the hero Philoctetes, when pain attacks, will whimper, will groan, and even if it were abandoned, on a deserted island, without sight, trace, or hope of a helpful companion creature).

It is significant that Philoctetes or any animal in pain would continue to utter sounds regardless of their isolation. Thus Herder does not require a sociological explanation of the origin of language; instead, he seeks a physiological one. Though he has not yet read Haller, and is even doubtful about the possiblity of Haller's accomplishment, a passage in the *Abhandlung* clearly points out the direction he will take in *Vom Erkennen und Empfinden*: "Sollte die Physiologie je so weit kommen, dass sie die Seelenlehre demonstrierte, woran ich aber sehr zweifle, so würde sie dieser Erscheinung manchen Lichtstrahl aus der Zergliederung des Nervenbaues zuführen" (6; Should physiology ever advance so far as to demonstrate psychology, something I am very doubtful about, it would be able to cast some light on this appearance from the analysis of the nervous system). Philoctetes feels pain; with his scream, he almost feels some relief: "Es ist, als obs [das Tier] freier atmete" (5; It is as if the animal breathed more freely). Herder has in fact anticipated the *Zusammenziehung* and *Ausbreitung* of his understanding of *Reizbarkeit*. Here, in the question of the origin of language, we are at the primary level of *Reiz*. We are also back in Haller's clinic, subjecting the animal to pain, and observing the primitive signs of language that come in response.

Philoctetes is more like us than he is like Rousseau's prelingusitic primitive. And when we hear him cry out in pain and see the contortions of his body, we respond physically, imitating involuntarily the sound and shape of his expression of pain. Thus language is not autistically grounded in the body of each individual, rather it is a common language felt, imitated, and understood by all members of a species. This is very significant, for it establishes the possibility of a universal continuity between us cultured Europeans and the most primitive humans who necessarily already spoke the language of pain. "Überall sind die Europäer, trotz ihrer Bildung und Missbildung, von den rohen Klagetönen der Wilden heftig gerührt worden" (15; Europeans everywhere, in spite of their culture and non-culture, have been powerfully moved by the coarse plaintive sounds of the savages). There are remnants of this original language in our artificial language use:

"*Dass der Mensch sie [die Sprache] ursprünglich mit den Tieren gemein habe*, bezeugen jetzt freilich mehr gewisse Reste als volle Ausbrüche; allein auch diese Reste sind unwidersprechlich" (6; That humankind originally had language in common with the animals is admittedly proved now more by certain remnants rather than full outbursts; but even these remnants are undeniable). The sounds of the original language are not "die Hauptfäden der menschlichen Sprache. Sie sind nicht die eigentlichen Wurzeln, aber die Säfte, die die Wurzeln der Sprache beleben" (9; the main threads of human language. They are not the actual roots, but the sap, which enlivens the roots of language). Like a tree, our language would be dead but for the sap that enlivens it. But is that not precisely what Herder was looking for in the power of *Reizbarkeit*? Pain and the responding cry, "Reiz, Leben"— language is born in pain, an involuntary reflex of the body.

The language of birth is strongly in evidence in the *Abhandlung*. Numerous times Herder refers us back to our childhood. He speaks about the "ursprünglich[e] wild[e] Mutter des menschlichen Geschlechts" (The original savage mother of the human race). The primitive sounds of original language have nothing to do with "*menschlich[e]* Bildung der Sprache" (the human shape of language); they must rather be considered as "rohe Materialien" (9; raw materials). It is important to hear the Latin *mater* in this word used in such proximity to *Mutter*. Language, says Herder, the closer it is to its origin, the less articulated ("desto unartikulierter") it is (13). Herder is repeating the movement for language that Winckelmann called *Unbezeichnung*, the return to the mother, to *mara*, to *mater*. This origin is cloaked in darkness; *dunkel* is used repeatedly and valorized positively in contrast to *hell* (bright) which is associated with vision, "der kälteste Sinn" (56; the coldest sense). The place of the origin of language is dark and warm. Our mimetic or sympathetic response to a cry of pain or powerful use of language thus finds its explanation:

> Diese Worte, dieser Ton, die Wendung dieser grausenden Romanze usw. drangen in unserer Kindheit, da wir sie das erstemal hörten, ich weiss nicht, mit welchem Heere von Nebenbegriffen des Schauders, der Feier, des Schreckens, der Furcht, der Freude in unsre Seele. Das Wort tönet, und wie eine Schar von Geistern stehen sie alle mit einmal in ihrer dunkeln Majestät aus dem Grabe der Seele auf: sie verdunkeln den reinen, hellen Begriff des Worts, der nur ohne sie gefasst werden konnte. Das Wort ist weg, und der Ton der Empfindung tönet. Dunkles Gefühl übermannet uns: der Leichtsinnige grauset und zittert— nicht über Gedanken, sondern über Silben, über Töne der Kindheit, und es war Zauberkraft des Redners, des Dichters, uns wieder zum Kinde zu machen. (15–16)

These words, this sound, the turn of this horrifying romance, etc., penetrated our soul in our childhood, when we heard them the first time, I know not with what hordes of associated concepts of shuddering, solemnity, terror, fear, and joy. The word sounds, and like a throng of ghosts they all stand up simultaneously from the grave of the soul in their dark majesty; they darken the pure, bright concept of the word, which can only be comprehended without them. The word is gone, and the sound of the sensation resounds. Dark feeling overwhelms us: the feeble-minded is horrified and trembles—not at the thought, but at the syllables, the sounds of childhood, and it was the magic of the orator, the poet, to make us into a child again.

We are involuntarily reminded of the pain of our birth. The word that accomplishes this sudden retrograde movement is our first word, our pain, in all its vitality. Not the signified (*der Gedanke*) but the word in its full materiality (*die Silben, die Töne der Kindheit*) affects us. Just as the gap between dead matter and human consciousness was proved illusory in the power of *Reizbarkeit* (or so Herder thought), here there is no gap between signifier and signified in the original language of pain.

In *Vom Erkennen und Empfinden*, Herder sought to establish a continuous line of *Kraft* from *Reiz* all the way through *Sinn, Einbildungskraft, Erkennen*, and *Wollen*. In like manner, he must pursue the line from the original cry of pain to the abstract and grammatically complex languages of civilized man. Just as the gap that seemed to be closed in the phenomenon of *Reiz* was in fact displaced and finessed by misreading, so Herder finds a gap yawning between the language we have in common with animals and distinctly human language. Animals have a certain completeness about them; there is a perfect fit between their needs, their instincts, and their powers.

Bei dem Menschen ist alles in dem grössten Misverhältnis—Sinne und Bedürfnisse, Kräfte und Kreis der Würksamkeit, der auf ihn wartet, seine Organe und seine Sprache. —Es muss uns also ein gewisses Mittelglied fehlen, die so abstehenden Glieder der Verhältnis zu berechnen. (25)

With humans there is a great disparity between everything—senses and needs, powers and the field of effectiveness that awaits them, their organs and their language. —We must be lacking a certain middle term to mediate such disparate terms of the proportion.

Once again Herder introduces a third; this time it is the power of reasoning or, as he prefers to call it, *Besinnung*.

It is not difficult to conjecture why Herder chooses the word *Besinnung* over *Verstand* or *Vernunft*. The *Sinn* in *Besinnung* is itself an argument for the continuity between this human power and the senses. *Besinnung*, in other words, corresponds to *Erkennen*, and involves a consciousness about what one perceives. It has the power to isolate perceptions and to connect two things in a third, a word. Herder uses the example of a sheep:

> Sobald er [der Mensch] in die Bedürfnis kommt, das Schaf kennenzulernen, so störet ihn kein Sinn auf dasselbe zu nahe hin oder davon ab: es steht da, ganz wie es sich seinen Sinnen äussert. Weiss, sanft, wollicht—seine besonnen sich übende Seele sucht ein Merkmal—das Schaf *blöket*! sie hat Merkmal gefunden. Der innere Sinn würket. Dies Blöken, das ihr am stärksten Eindruck macht, das sich von allen andern Eigenschaften des Beschauens und Betastens losriss, hervorsprang, am tiefsten eindrang, bleibt ihr. Das Schaf kommt wieder. Weiss, sanft, wollicht—sie sieht, tastet, besinnet sich, sucht Merkmal—es blökt, und nun erkennet sies wieder! "Ha! du bist das Blökende!" fühlt sie innerlich, sie hat es menschlich erkannt, da sies deutlich, das ist mit einem Merkmal, erkennet und nennet. . . . So kann kein sinnliches Geschöpf ausser sich empfinden, da es immer andre Gefühle unterdrücken, gleichsam vernichten und immer den Unterschied von zween durch ein drittes erkennen muss. (33)

As soon as man feels the need to become acquainted with sheep, no sense prevents him from going too close or too far: the sheep stands there, precisely as it is expressed to his senses. White, soft, woolly—his reasonably operating soul searches for a characteristic—the sheep bleats! the soul has found a mark. The interior sense functions. This bleating, that makes the strongest impression on the soul, that cuts itself off from all the other characteristics of looking and touching, and sprang forward, penetrated most deeply, this remains. The sheep comes again. White, soft, woolly—the soul sees, touches, considers, searches for a characteristic—it bleats, and now the soul recognizes it! "Aha! you are the bleater!" the soul feels inside, it has recognized the sheep humanly, in that it recognizes and names it distinctly, that is, with a mark. . . . No other sensory being can feel outside of itself like that, since it is always oppressed by other feelings, destroyed as it were, and always needs to recognize the difference between two by reference to a third.

"Das Schaf *blöket*!" The sheep provides the name whereby the human comes to know it and name it. "Weiss, sanft, wollicht": the sheep is too

uncertain in these characteristics for vision and touch to mark it; it is nebulous like a cloud. The sound, however, *das Blöken*, gives the name at the same time that it is the name.

Or does it? If we examine the name, the gap springs wide open again. Considerable confusion attends the word *blöken*. First of all, it is confused with another word, *blecken*. As Grimm says: "*Blecken* . . . schreiben einige für *blöken*, andere *blöken* für *blecken*" (Some write *blecken* for *blöken*, others *blöken* for *blecken*).[33] But *Blecken*'s primary meaning is associated with seeing: "blicken, erscheinen, sehen lassen," particularly "hervorragen," but especially of a body part that is very close to sound, namely, a dog's bared teeth. So while the *Blöken* of the sheep "sprang hervor," as Herder says, it did so entirely as sound, not as sight. But there are more difficulties. Adelung says about *Blöken* that it imitates "das natürliche Geschrey des Rindviehes und der Schafe" (the natural cry of cattle and sheep).[34] "Von den Schafen," however—and Adelung was compiling his lexicon at the same time as Herder was writing—"ist dieses Word im gemeinen Leben wenig mehr üblich; es scheinet auch ihrer natürlichen Stimme wenig angemessen zu seyn, man müsste es denn in diesem Falle *bläken* schreiben und sprechen" (With regard to sheep this word is in common parlance not much used any longer; it also seems rather unfitting for the sheep's natural voice, unless one were to write or say *bläken* in this case). He then goes on to derive *blöken* from *be* and *leuen*, the word for the "growling" not only of *cows* but also *lions*. He finishes by noting that *bläken*, the word that would properly capture the sound of sheep, "kommt in Niedersachsen auch von dem Bellen der Hunde vor" (in Lower Saxony it is also used for the barking of dogs).

The problem is obvious: what animal speaks when there is *Blöken*? a sheep? a dog? a cow? a lion? Perhaps Herder did not really mean *blöken*, but meant the actual sound that a sheep produces. But he does say: "Du bist das Blökende" and seems to share Adelung's commitment to onomatopoeic origins for words. And even if he did mean the real *Schall* of the sheep, the gap then appears between that *Schall* and the word *blöken* that Herder uses. The distinct sound of the sheep cannot be entirely reached by human language, and, as the confusion around *blöken* shows, the sound is abused and distorted by human language. Similarly, the privileging of hearing is called into question insofar as *blöken* and *blecken* seem interchangeable, "als wenn das Schreien und Brüllen eins wäre mit dem Weisen der Zähne" (as if the crying and screaming were one with the white of the teeth).[35]

The confusion of the senses points to the second difficulty in the movement from animal language to human. Even if we were to grant Herder that the first words of distinctly human language were the names

that animals gave with their natural sounds, where did the words come from for things that appeal to senses other than sound? In other words: "Wie hat der Mensch . . . eine Sprache, wo ihm kein Ton vortönte, erfinden können? Wie hängt Gesicht und Gehör, Farbe und Wort, Duft und Ton Zusammen?" (54; How was man able to invent a language where no sound sounded? How do sight and hearing, color and word, odor and sound hang together?). Herder's answer comes from the *Plastik*, which he laid aside in order to write the *Abhandlung*. The answer is *Gefühl*: "Allen Sinnen liegt Gefühl zum Grund, und dies gibt den verschiedenartigsten Sensationen schon ein so inniges, starkes, unaussprechliches Band" (54; Feeling [in the sense of touch] is the basis for all the senses, and this itself already gives the most diverse sensations a strong, inner, ineffable bond). *Gefühl*, not hearing, is the privileged sense.

Herder's theory of the interrelation of the senses will be examined in more detail when we treat the *Plastik*; what Herder says in the *Abhandlung* is enough for now. Herder constantly calls *Gefühl* "dunkel." *Gefühl* is the first sense of the child, close to birth, and the level at which most of our significant and structuring contacts with objects in the world are made. Basically, Herder is arguing that the sensations of our other senses—vision, hearing, smell—have been prestructured by the dark sense of touch. All find their common ground in touch, that is to say, in the body.

The problem now is to close the gap between an object seen and a word that names that object. "Das Sehen," as Herder says, "ist der kälteste Sinn, und wäre er immer so kalt, so entfernt, so deutlich gewesen, als er uns durch eine Mühe und Übung vieler Jahre geworden ist, so sehe ich freilich nicht, wie man, was man sieht, hörbar machen könne?" (56; Sight is the coldest sense, and had this sense been ever so cold, so distant, so distinct as it has become for us through much effort and practice in the course of many years, I still do not see how one could make what one sees audible). But what if *Gefühl* underwrites both seeing and hearing, even if at a level we are usually not conscious of? Then this gap would prove illusory as well.

> denn selbst dies Gesicht war, wie Kinder und Blindgewesene zeugen, anfangs nur *Gefühl*. Die meisten sichtbaren Dinge bewegen sich; viele tönen in der Bewegung, wo nicht, so liegen sie dem Auge in seinem ersten Zustande gleichsam näher, unmittelbar auf ihm und lassen sich also fühlen. Das Gefühl liegt dem Gehör so nahe, seine Bezeichnungen, z.E. hart, rauh, weich, wolligt, sammet, haarigt, starr, glatt, schlicht, borstig usw. die doch alle nur Oberflächen betreffen und nicht einmal tief einwürken, *tönen alle, als ob mans fühlte.* Die

Seele, die im Gedränge solcher zusammenströmenden Empfindungen und in der Bedürfnis war, ein Wort zu schaffen, griff und bekam vielleicht das Wort eines nachbarlichen Sinnes, dessen Gefühl mit diesem zusammenfloss—so wurden für alle und selbst für den kältesten Sinn Worte. (56)

for even this sense of sight was, as children and those once blind testify, merely feeling in the beginning. Most visible things move; many make a sound in moving, if not, then they lie closer to the eye as it were in their first condition, impress themselves immediately on the eye and allow for touching. Feeling is so close to hearing, its designations, e.g., hard, coarse, soft, woolly, velvet, hairy, stiff, smooth, bristly, etc., all of which merely have to do with surfaces and do not penetrate deeply—*they all sound, as though one felt them*. The soul, which in the pressure of such confluent sensations and in need of producing a word, grabbed and perhaps got the word of a neighboring sense whose feeling flowed together with this one—thus words arose for all and even for the coldest sense.

Herder adds the senses of taste and smell: "Da Wort: Duft, Ton, süss, bitter, sauer usw. tönen alle, als ob man fühlte; denn was sind ursprünglich alle Sinne anders als Gefühl" (Since word: scent, sound, sweet, bitter, sour, etc., all sound, as though one felt them; for what were all senses originally if not feeling)—and makes a final move to clinch the continuity between human language and the animal cry of pain: "Wie aber das Gefühl sich in Laut äussern könne, das haben wir schon im ersten Abschnitte als ein unmittelbares Naturgesetz der empfindenden Maschine angenommen, das wir weiter nicht erklären mögen!" (57; How the feeling is able to express itself in sound, that we already assumed in the first paragraph as an immediate law of nature of the sensitive machine, which we need not explain any further!).

Herder's repeated thesis—"[sie] tönen alle, als ob mans fühlte" (they all sound, as if one felt it)—does not have the force of argument that he wants it to have. If we concede that words like "hart" or "weich" have a sound quality that awakens a corresponding association in our minds (perhaps even established in our preconscious childhood, as Herder would argue), we still have not produced the words "hart" or "weich" in the first place. All we could possibly have are the sounds of objects that we chose as their *Merkmale*. The error that Herder describes, namely, the soul's grasping for a word and happening on one from a neighboring sense—this error could only have resulted in all the various sense impressions bearing the names of sounds produced by animals and other objects. Herder's

argument, in other words, is torn apart by competing claims for superiority between hearing and feeling or touch. Once again the move from the body to human language fails. Analogy, of course, would make the leap possible, but Herder does not resort to it here, as though he knew that he would have been unsatisfied with any explanation that analogy might provide.

Liliane Weissberg's article "Language's Wound: Herder, Philoctetes, and the Origin of Speech" approaches the same problem but from a somewhat different perspective. She focuses on the question of Philoctetes' cry from the beginning, tracing Philoctetes back to Homer and Sophocles and then forward again to Winckelmann, Lessing, and the Herder of the first *Kritisches Wäldchen*. Philoctetes' cry was as much disputed as Laocoon's scream. While Lessing claimed that Sophocles' Philoctetes filled his island and the stage with unrestrained expressions of pain, Herder's impression was of a hero

> der mitten im Schmerz seinen Schmerz bekämpft, ihn mit holem Seufzen zurückhält, so lange als er kann, und endlich, da ihn das Ach! das entsetzliche Weh! übermannet, noch immer nur einzelne, nur verstolne Töne des Jammers ausstösst, und das übrige in seine grosse Seele verbirgt.[36]

> who in the grasp of pain fights his pain, restrains it with hollow sighs, as long as he can, and finally, since the *Ach!* the terrible *Weh!* overwhelm him, still only emits single, stolen sounds of suffering, and hides the rest in his great soul.

According to Weissberg's reading, there are two possible responses to pain—the animal cry and silent restraint. "In drawing the parallels between animal and man, and in pointing at the difference of their expression, Philoctetes' restraint assumes a place later occupied in the *Abhandlung* by articulated speech."[37] Human language as well as other distinctly human arts (like sculpture), are, paradoxically, types of restrained silence. This is stated provocatively somewhat later in her essay: "The cry, as a cry of nature, has to be silenced into the articulated speech of art."[38] Thus in Weissberg's reading, the gulf that separates the body from human language is understood as a conversion into registers of culture.

Our reading of the *Abhandlung* determined that Herder wanted to trace a continuous line from the cry of pain to articulated language, and attempted to do so by grounding all language in the body, a strategy that is consonant with what he does in *Vom Erkennen und Empfinden*. Weissberg's moment of restrained silence as the dominant type of all human language and standing in some relation of opposition to the cry of pain, however,

distinctly complicates the picture. It is not that there is a rupture between the two, the cry and silence; it is more that the cry is absorbed by silence and acquires its character as heroically restrained silence only because of the interior presence of pain. In fact, Herder, as Weissberg argues, has reformulated the basic notion of Winckelmannian classicism as it applies to language, that is to say, at the deepest level.

Weissberg's reading involves an anecdote from Herder's life, as did our discussion of *Vom Erkennen und Empfinden*. She relates the story of a prolonged and painful tearduct surgery that Herder underwent in Strasbourg. Herder's letters to his future wife Karoline Flachsland and to his friend Johann Friedrich Merck show that he understood himself in analogy to Philoctetes. Strasbourg is for him a deserted island; he lives there in a cave like an "Einsiedler" (hermit).[39] Nor is he free from pain. He elects to undergo surgery to correct a condition that has plagued him since childhood, hoping to recover in a week to ten days. In fact, the procedure needs to be repeated several times, and is not only unsuccessful, but leaves him disfigured.

It is in the midst of this period of physical torment, as Weissberg points out, in December 1770, that Herder writes the *Abhandlung* in just a matter of weeks. The *Abhandlung*, if one pursues the analogy that Herder's self-description suggests, is grounded in the pain of his own body, like Philoctetes' struggle with the cry of pain. "While Herder attempts to write *about* the cry, its representation—an inadequate, but the only possible one—strives to overcome the written letter, and tries to document the performance of the eruption and silencing of sounds. The text tries to stage, enact, the question of origin within its articulation."[40] Thus the *Abhandlung* could be understood as language's restrained cry, in analogy to Herder's struggle to suppress his own pain.

In reading Herder's correspondence, Weissberg has focused on those letters that are written in a "heroic" mode. Other letters show that Herder finds a variety of ways to represent his pain, varying from the jocular to the hopeless, sometimes even assuming poetic form.[41] In his last letter to Karoline from Strasbourg, dated March 28, 1771, he looks back on his correspondence of the last months:

> Meine Briefe sind oft kalt gewesen, und zuletzt Monathe durch fast nichts als kalt, u. was am ärgsten ist, selbst die Wärme in ihnen, einge- heitzte, erzwungne Gartenhauswärme und nicht Frühling der Natur gewesen: das ist wahr, u. wer hat es mehr gefühlt, als ich? Wer hats aber auch mehr gesagt, als ich? Und wenn ichs nicht sagte, nicht sagen wollte, muste da nicht die ganze Situation vor mich sprechen? Was ist der Vogel der Luft, aus den freien Gegenden des Himmels, wo die

Wolken ziehen, herabgeworfen, in eine dumpfige Höle eingekerkert voll Schmerzen u. voll Todesgefühl, ohne Luft, Aussicht u. süssen Traum der Hoffnung? u. wer kann ihn denn schelten, wenn er da traurig sitzet, kaum mehr den Flügel regt
 nur seinen sträubgen Nacken beugt
 und sich die Brust zerspaltet![42]

My letters have often been cold, and finally for months at a time almost nothing but cold, and, what is worst, even the warmth in them, was artificial forced greenhouse warmth and not the spring of nature: this is true, and who has felt it more than I? Who said so more often than I? And if I said nothing, did not want to say anything, shouldn't the entire situation have spoken for me? What is the bird of the air, thrown down out of the free regions of the heavens, where the clouds move, locked up in a musty hole full of pain and feeling of death, without air, view, and sweet dreams of hope? and who can scold him if he sits there sadly, barely moves his wings any longer
 only bends his ruffled neck
 and pierces his own breast!

Herder sounds a note in this letter that seems to have been missing from the *Abhandlung*. While the *Abhandlung* has been about the origin of language, its birth in pain, Herder himself has been writing from a kind of death. Notice the coldness that he mentions repeatedly, and the admission of an artificial warmth. The "dumpfige Höle," which does indeed recall Philoctetes, but also Christ's grave, is full of "Todesgefühl." Most striking, however, is the image of the bird which climaxes in two verses of poetry. At the moment that the caged bird bends its head and punctures its breast it becomes a perverse and idle type of the pelican, the traditional image for the crucifixion. Only whereas the pelican opens its breast in order to feed its children with its blood, Herder's pain seems in vain. He is left in the absolute isolation and abandonment of the crucifixion—at this level the analogy is to Jesus, and not Philoctetes.

He then continues:

—bin ich denn so unglücklich, dass niemand, keine freundschaftliche Seele, meinen Zustand auch nur so fern fühlt, um, ohne dass ich schreie u. wimmere, es glauben zu können, einem solchen Menschen muss es da sehr weh thun?— —Doch es sei!

—am I then so unfortunate that no one, no friendly soul, feels my condition enough in order to believe, without my screaming and moaning, that such a person must be hurting very much?— —So be it!

The language of civilized restraint fails to represent the pain of the human body to another human body. Heroic silence and the gulf between language and the body are one and the same. To communicate his pain, to awaken a sympathetic response in the body of his listener or reader, Herder must revert to crying and whimpering—and he does. He acknowledges this with the lines that follow his "Doch es sei": "Ich schreibe diesen Brief zu nichts anders als den Ton aus meiner Seele zu bannen, den er erregt hat, u. ihn gleichsam eher zu verreden" (I write this letter for no other reason than to ban the sound from out of my soul, which it caused, and as it were to get rid of it by speaking). So saying, he repeats the beginning of the *Ursprung*, where he writes about the animal or hero who gives vent to pain: "es ist, als obs einen Teil seines Schmerzes verseufzte und aus dem leeren Luftraum wenigstens neue Kräfte zum Verschmerzen in sich zöge, imdem es die tauben Winde mit Ächzen füllet" (5; It is as if it sighed away a part of its pain and drew in from the empty air at least some new powers for fighting the pain, in that it filled the deaf winds with moans). In neither case, then, in the *Abhandlung* nor in his own experience, does he succeed in bridging the gap between the body and language.

<div align="center">

3

</div>

Herder subtitled the final 1778 version of his *Plastik: Einige Wahrnehmungen über Form und Gestalt aus Pygmalions bildendem Traume*. With the name Pygmalion, the sculptor from Ovid's story who fell in love with the statue of a woman he had made, and whose secret wish that she be brought to life was granted by Venus,[43] Herder alerts us that his essay is not only about sculpture, but about love and desire. Indeed, Herder stages an erotic encounter with the body; he re-enacts the Pygmalion story. The status of this encounter, however, is called into question in the very same subtitle. These are observations "aus Pygmalions bildendem Traume" (from Pygmalion's sculpting dream). As we shall see, Herder goes to enormous lengths, continuing what he began in the fourth *Kritisches Wäldchen* and in *Vom Erkennen und Empfinden*, to separate and differentiate painting and sculpture. As he says in the *Plastik*:

> die Bildnerei ist Wahrheit, die Mahlerei Traum: jene ganz Darstellung, diese erzählender Zauber, welch ein Unterschied! und wie wenig stehen sie auf Einem Grunde! Eine Bildsäule kann mich umfassen, dass ich vor ihr knie, ihr Freund und Gespiele werde, sie ist gegenwärtig, sie ist da. Die schönste Mahlerei ist Roman, Traum eines Traums.[44]

<div align="center">

[118]

</div>

sculpture is truth, painting dream: the former representation entire, the latter narrative magic, what a difference! and how little do they stand on a common ground! A statue can embrace me, so that I kneel before her, become her friend and playmate, she is present, she is there. The most beautiful painting is a novel, dream of a dream.

If sculpture is truth, and painting is dream, what is the status of the statue's embrace within a sculpting dream? Herder at no point directly explains his subtitle; our reading of the *Plastik* will have to supply its commentary.

In the interpretation of the texts by Herder so far, it has become clear that he is concerned every time to identify a fundamental power within matter itself that is modulated into the various more advanced and complex powers that make up animal and human experience. In *Vom Erkennen und Empfinden* it was the power of *Reizbarkeit*. In the *Abhandlung* it was the response to pain, basically the same phenomenon as that treated in *Vom Erkennen und Empfinden* but treated toward a different end. The *Abhandlung* also argued for the primacy of *Gefühl* as the sense that underlies all the other senses. The connection between *Gefühl* and *Reiz* is, of course, not at all difficult to see. The *Plastik* continues in this line and gives the most radical formulation to the argument about the primacy of *Gefühl*, understood now, in the first place, as the sense of touch, *Tastsinn*.[45]

Like Diderot in *Lettre sur les aveugles*, Herder begins the *Plastik* with accounts of blind men and men whose vision has been restored. The blind, as he says, rely heavily on the sense of touch to accomplish what others seem to do with their eyes. But the experiences of a blind person who can suddenly see put the relations between the senses in a different perspective. Here is Herder's account:

Nun ward ihm sein Auge geöfnet, und sein Gesicht erkannte nichts, was er voraus durchs Gefühl gekannt hatte. Er sah keinen Raum, unterschied auch die verschiedensten Gegenstände nicht von einander; vor ihm stand, oder vielmehr auf ihm lag eine grosse Bildertafel. Man lehrte ihn unterscheiden, sein Gefühl sichtlich erkennen, Figuren in Körper, Körper in Figuren verwandeln; er lernte und vergass. "Das ist Katze! das ist Hund! sprach er, wohl, nun kenne ich euch, und ihr sollt mir nicht mehr entwischen!"—sie entwischten ihm noch oft, bis sein Auge Fertigkeit erhielt, Figuren des Raums als Buchstaben voriger Körpergefühle anzusehen, sie mit diesen schnell zusammenzuhalten, und die Gegenstände um sich zu lesen. (4)

Now his eye was opened, and his face recognized nothing of that which he had formally known through feeling. He saw no space, nor

differentiated the most diverse objects; before him stood, or much more lay, a large canvas. He was taught to differentiate, to recognize his feeling visually, to transform figures into bodies, bodies into figures; he learned and forgot. "That is a cat! that is a dog!" he said, "well, now I know you and you won't escape me any more!"—they escaped him often still until his eye attained the skill of taking figures of space for the alphabet of former body feelings, to hold the two together quickly and to read the objects around him.

The objects of sight make up the letters and words that are associated by knack (7; *Fertigkeit*) or habit (*Gewohnheit*) with former corporal contact with objects, especially, as we shall see, with the hands. The objects that surround the blind man with restored vision must be read. Herder is essentially arguing, or preparing to argue, that the objects of vision are artificial signs, like words, that refer by convention to the perceptions of touch, the only really natural signs. In other words, Herder has launched an anomalous assault on a favorite doctrine of the eighteenth century, one that we encountered already in Lessing, when he stated that painting uses natural signs (icons), while poetry uses artificial signs (language).

A blind man who can suddenly see may be a special case, not entirely relevant for those who could see from their birth. With a gesture familiar from the *Abhandlung*, Herder invites us back to our childhood:

> Kommt in die Spielkammer des Kindes, und sehet, wie der kleine Erfahrungsmensch fasset, greift, nimmt, wägt, tastet, misst mit Händen und Füssen, um sich überall die schweren, ersten und nothwendigen Begriffe von Körpern, Gestalten, Grösse, Raum, Entfernung u. dgl. treu und sicher zu verschaffen. Worte und Lehren können sie ihm nicht geben; aber Erfahrung, Versuch, Proben. In wenigen Augenblicken lernt er da mehr und alles lebendiger, wahrer, stärker, als ihm in zehntausend Jahren alles Angaffen und Worterklären beibringen würde. (7–8)

> Come into the play room of the child and see how the little experience-person touches, grasps, takes, weighs, feels, measures with hands and feet, in order to acquire truly and certainly the important, first, and necessary concepts of bodies, shapes, size, space, distance, and the like. Words and theories cannot give them to him; but experience, experiment, practice. In a few moments he learns more there and everything more vitally, truer, stronger than all looking and verbal explanation would teach him in a thousand years.

[120]

Through all manners of touching, the child acquires the basic concepts of sense experience. Repeated touchings are coordinated and eventually associated with sight.

> Die schweren Begriffe, die wir uns langsam und mit Mühe ertappen, werden von Ideen des Gesichts begleitet: dies klärt uns auf, was wir dort nur dunkel fassten, und so wird uns endlich geläufig, das mit einem Blick wegzuhaben, was wir uns Anfangs langsam ertasten musten. Als der Körper unsrer Hand vorkam, ward zugleich das Bild desselben in unser Auge geworfen: die Seele verband beide, und die Idee des schnellen Sehens läuft nachher dem Begrif des langsamen Tastens vor. Wir glauben zu sehen, wo wir nur fühlen und fühlen sollten; wir sehen endlich so viel und so schnell, dass wir nichts mehr fühlen, und fühlen können, da doch dieser Sinn unaufhörlich die Grundveste und der Gewährsmann des vorigen sein muss. In allen diesen Fällen ist das *Gesicht* nur *eine verkürzte Formel des Gefühls.* (8–9)

> The important concepts that we acquire slowly and with effort are accompanied with ideas from sight: this illuminates what we only darkly touched, and we finally grow accustomed to take up in a glance what in the beginning we slowly had to touch. When the body was felt in our hand, the image of same was simultaneously thrown into our eye: the soul connected the two, and the idea of speedy vision later runs ahead of the concept of slow touching. We mean to see, where we only feel and should feel; we eventually see so much and so fast, that we no longer feel anything, nor can feel anything, even while this sense does not cease to be the foundation and the guarantor of the former.

Several notions familiar to us from the other Herder texts occur in this passage. The sense of touch is "dunkel." The structures it establishes in early childhood lie deep and virtually below consciousness. Touch or *Gefühl* is the foundation and guarantor of vision, which stands in a linguistic relation to touch, a kind of shorthand of touch.

After the blind man and the child, useful for establishing the primacy of touch, Herder turns to the lover and artist, Pygmalion, whether he names him or not, for this is, after all, a treatise about sculpture. Imagine a beautiful statue executed with Hogarth's line of beauty (12; "die schöne Linie") (male or female is not clear, though presumably it is Pygmalion's woman statue) and a man beholding it. If he should stand in one place and look at it with only his eye, converting it into two-dimensional space, he would destroy it: "Das Gesicht zerstört die schöne Bildsäule, statt dass es sie schaffe: es verwandelt sie in Ecken und Flächen" (12; Sight destroys the beautiful statue instead of creating it: it transforms it into angles and

planes). The continuous serpentine line which properly moves through three dimensions, breaks down and becomes angular in two, not unlike a letter from the alphabet.

The real lover, however, regards the statue much differently:

> Seht jenen Liebhaber, der tiefgesenkt um die Bildsäule wanket. Was thut er nicht, um sein Gesicht zum Gefühl zu machen, zu schauen als ob er im Dunkeln taste? Er gleitet umher, sucht Ruhe und findet keine, hat keinen Gesichtspunkt, wie beim Gemählde, weil tausende ihm nicht genug sind, weil, so bald es eingewurzelter Gesichtspunkt ist, das Lebendige Tafel wird, und die schöne runde Gestalt sich in ein erbärmliches Vieleck zerstückt. Darum gleitet er: sein Auge ward Hand, der Lichtstral Finger, oder vielmehr seine Seele hat einen noch viel feinern Finger als Hand und Lichtstral ist, das Bild aus des Urhebers Arm und Seele in sich zu fassen. Sie hats! die Täuschung ist geschehen: es lebt, und sie fühlt, dass es lebe; und nun spricht sie, nicht als ob sie sehe, sondern taste, fühle. (12–13)

> See that lover, who deeply involved wavers around the statue. What will he not do in order to convert his vision into feeling, to see as if he were touching in darkness? He glides around, searches for restfulness and finds none, has no fixed point of perspective, as with a painting, because a thousand are not enough for him, because, as soon as it is a rooted perspective, the vital becomes a tableau, and the beautiful round shape fragments itself into a pitiful angular thing. That is why he glides: his eye becomes hand, the beam of light vision, or rather his soul has even finer fingers than the hand or light in order to grasp the image from the creator's arm and soul into himself. The soul has it! the deception has occurred: it lives and the soul feels that it lives; and now it speaks, not as if it sees, but touches, feels.

The observer's restlessness as he circles the statue, as his eye refuses or is unable to remain fixed on one point of view, is equated with the emotional restlessness of the lover. He wants to convert sight to touch, to extinguish the light and be in darkness. His eye becomes hand, no, his soul becomes a much more sensitive finger—at this point Herder has made a move that must be understood in connection with his passing out at the anatomy, but which, in the idiom of the *Plastik*, we cannot yet discuss. For the moment, we must remain with touch and the body. In any event, Pygmalion's wish is granted, and the statue comes to life through this tactile beholding—*Reiz* in action. Not only what he sees, but what he says is shot through with tactility.

The difference between the coldness of two-dimensional seeing and the warm passion of the lover's gaze is the desire and necessity to close the distance between subject and object.

> Ueberhaupt, je näher wir einem Gegenstande kommen desto lebendiger wird unsre Sprache, und je lebendiger wir ihn von fern her fühlen, desto beschwerlicher wirds uns der trennende Raum, desto mehr wallen wir zu ihm. Wehe dem Liebhaber, der in behaglicher Ruhe seine Geliebte von fern als ein flaches Bild ansieht und genug hat! (13)

> The closer we get to an object the livelier our language becomes, and the livelier we feel it from afar the more upsetting becomes the separating space, the more we surge towards it. Woe to the lover who in cosy tranquillity regards his beloved from afar as a flat picture and has enough!

Herder's gaze is the farthest thing possible from disinterested. It seems almost a challenge to men and, by implication, a sort of boasting with regard to his own sexual adventurousness. It will have been such passages that prompted Goethe to cast Herder as an unabashedly lecherous satyr in his *Satyros oder der vergötterte Waldteufel* (1773).[46]

This small scenario we have discussed is merely a prototype of a much bigger enactment of the Pygmalion story where we will not be observing the observer, but rather join Herder in the role of reverent lover before an ideal statue. This extraordinary scene of some fifteen pages in length mixes a number of discourses, traditions, and types. First of all, it duplicates Winckelmann's grand inventory of the body in the *Geschichte der Kunst*, only from the perspective of touch as opposed to sight. We will encounter yet another duplication in the chapter on Moritz. Second, it mixes Greek and Hebrew traditions, citing not only items familiar from Greek mythology, but quoting extensively from the Old Testament, especially from the Song of Songs.[47] Indeed, the long section closes by stressing the sculptural aspect of the biblical creation myth. Herder quotes Genesis 2:7 from the Septuagint, the Greek version of the Old Testament, as though that itself authorized this wild syncretism. In many respects this long passage is like a sermon. Third, as if this were not enough, Herder also quotes Shakespeare, especially *Hamlet*. Though the Yorick speech is not referred to, we may think of it as being in the shadows. And, finally, throughout, of course, this is a version of Pygmalion's encounter with his statue, first recounted in the Latin poet Ovid.

Herder begins by inviting us into the dark. There is no mistaking the religious tone:

> Doch genug geredet. Wir treten an eine Bildsäule, wie in ein heiliges Dunkel, als ob wir jetzt erst den simpelsten Begrif und Bedeutung der Form und zwar der edelsten, schönsten, reichsten Form, eines Menschlichen Körpers, uns ertasten müssten. Je einfacher wir dabei zu Werk gehen, und wie dort Hamlet sagt, alle Alltags-Kopien und das Gemahl und Gekritzel von Buchstaben und Zügen aus unserm Gehirn wegwischen:[48] desto mehr wird das stumme Bild zu uns sprechen und die heilige Kraftvolle Form, die aus den Händen des grössten Bildners kam und von seinem Hauch durchwehet dastand, sich unter der Hand, unter dem Finger unsres innern Geistes beleben. Du Hauch dessen, der schuf, wehe mich an, dass ich bei seinem Werk bleibe, treu fühle und treu schreibe! (41)

> Enough said. We approach a statue, as in a holy darkness, as if we now for the first time had to acquire through touching the simplest concept and meaning of form and indeed of the most noble, the most beautiful and richest form, that of the human body. The more directly we go to work, and, as Hamlet says, erase all mundane copies and the painting and scribbling of letters and lines from our brain; the more the mute image will speak to us and the more will the holy powerful form, which came from the hands of the greatest sculptor and stood there breathing from his breath, be enlivened under the hand, under the finger of our inner spirit. You breath of him who created, blow on me that I may remain with my work, feel truly and write truly!

Herder begins with the head and its features, indeed, most of his description is preoccupied with the head. "Die Gottheit selbst," he says, "hat diese heilige Höhe, den Olympus oder Libanon unsres Gewächses . . . mit einem Haine bedeckt" (42; The Godhead itself covered this holy height, the Olympus or Lebanon of our frame, with a grove). The either-or of Olympus and Lebanon indicates his syncretism. The reference to the Lebanon is also the first to the Song of Songs. He quotes it outright when he comes to the neck: "[E]in elfenbeinerner Thurm, sagt das älteste und wahreste Lied der Liebe" (An ivory tower, says the oldest and truest song of love).[49] So doing, he has also named the erotic if religious situation of the songs.

Coming to the rest of the body, he claims he can be briefer, since the head is already an *Auszug* of the body (51). This is, of course, a surprising claim for someone who seemed to boast his sexual daring. As his description reaches the belly, Herder finds he must not only be brief, but discreet: "Wenn schon Winckelmann es beklagte, dass er nicht für

Griechen schreibe und also vieles müsse verschweigen: so habe ich diese Vorsichtigkeit leider! noch mehr nöthig, kann also auch nur mit wenigen Zügen enden" (53; If even Winckelmann complained that he was not writing for Greeks and therefore had to be silent about so many things, I am, sadly! in need of this carefulness even more, and can therefore also conclude with only a few strokes). While Winckelmann did not hesitate to name the genitals, Herder gets no further than the navel, and that in yet another quotation from the Song of Songs. "Wir machen uns Schürze von Feigenblättern, wie jene Ersten, und meistens auch aus derselben Ursach. Ich schweige also und spreche nur noch Ein Wort von Rücken, Hand und Fuss" (We make a skirt of fig leaves, like those firstlings, and usually for the same reason. I am silent therefore and say only one more word about the back, hand and foot). He actually reverses the order slightly and finishes first with the woman's hand and finally with the man's.

> Und wie die Schenkel verjüngte Marmorsäulen, so sind die Arme zarte Cylinder, um die die Liebe den ersten Brautkranz schlang und die daher noch immer das Armband lieben. Und wie die gute Mutter Natur den Ellbogen schonte und nun am Weibe die Hand hinabfliessen liess, bis sie in kleinern Cylindern endet. Und wie sie von innen sie bepolstert mit dem sanften Druck der Fühlbarkeit und Liebe und von aussen den Hügel der Hand mit Milch wusch zur ungetheilten und doch Gliedervollen Höhe. Und wie unaussprechliche Berührsamkeit und Fühlbarkeit sie in jedes sammetne Mäuschen der Hand und der Finger legte, die wie Blumenbüsche dastehen, den Duft der kommenden Gegenstände zu trinken. Und wie wächsern und beweglich und regsam jedes Glied, und der Finger ein tastender Sonnenstral ist, der sich innig um die schöne Form, fast bis auf die Farbe des Verlangens anschmiegt. (54)

> And as the thighs are youthful marble columns, so the arms are gentle cylinders, around which love threw the first bridal bouquet and which therefore still always love an armband. And how good mother nature spared the elbow and now let the hand flow down on the woman until it ends in smaller cylinders. And how she padded the hand from within with the gentle pressure of touch and love and from without washed the hill of the hand with milk to an undivided and yet memberful height. And how she laid unspeakable ability to move and touch into every velvety mouse of the hand and finger, which stand there like flower bushes, to drink the odor of coming objects. And how waxen and mobile and excitable every member, and how the finger is a touching ray of light, which closely nestles around the beautiful form, almost to the color of longing.

[125]

It does not require much imagination to realize that a good part of the earlier suppressed sensuousness has been concentrated in the description of the woman's hand to such an extent that it seems more the fanciful description of a woman's pudenda. As for the man's hand, Herder writes: "Und die Hand ein Gebilde voll feinen Gefühls und tausandförmiger Organischer Uebung" (55; And the hand a structure full of fine feeling and thousandfold organic practice).

So, despite Herder's boastfulness about laying out an aesthetics based on tactility and sexual encounter, what we have consistently met with is a kind of timidity. Promising the body, he veers elsewhere, or hurries, or abbreviates. In fact, a high-toned moral discourse is concurrently at work to check the erotic potential of the main discourse, while at the same time insisting on its basic innocence. The function of this discourse is at the last minute to divert attention from the material to the spiritual. This is what occurred when Herder described the lover/artist as he circled the beautiful statue: "[S]ein Auge ward Hand, der Lichtstral Finger, oder vielmehr seine Seele hat einen noch viel feinern Finger als Hand und Lichtstral ist" ([H]is eye becomes hand, the beam of light vision, or rather his soul has even finer fingers than the hand or light).

This second discourse is also in evidence in a discussion about the moral difference between sculpture and painting. Sculpture is innocent; painting, however, has distinctly pornographic possibilities.

> Eine Statue steht ganz da, unter freiem Himmel, gleichsam im Para-
> diese: Nachbild eines schönen Geschöpfs Gottes und um sie ist Un-
> schuld. Winkelmann sagt recht, dass der Spanier ein Vieh gewesen
> seyn muss, den die Statue jener Tugend zu Rom lüstete, die nun die
> Decke trägt; die reinen und schönen Formen dieser Kunst können wohl
> Freundschaft, Liebe, tägliche Sprache, nur beym Vieh aber Wohllust
> stiften. —Mit dem Zauber der Mahlerei ists anders. Da sie nicht körper-
> liche Darstellung, sondern nur Schilderung, Phantasie, Repräsentation
> ist, so öfnet sie auch der Phantasie ein weites Feld und lockt sie in ihre
> gefärbte, duftende Wollustgärten. Die kranken Schlemmer aller Zeiten
> füllten ihre Kabinette der Wohllust immer lieber mit unzüchtigen Ge-
> mählden als Bildsäulen: denn in diesen, selbst im schlummernden
> Hermaphroditen, ist eigentlich keine Unzucht. (24–25)

A statue stands there entire, under the open sky, in paradise, as it were: the after-image of a beautiful creature of God and around it is innocence. Winckelmann correctly says that that Spaniard must have been an animal who lusted after the statue of virtue in Rome, which now bears the ceiling; the pure and beautiful forms of this art can

certainly inspire friendship, love, daily conversation, but only with an animal would they awaken lust. —The magic of painting is another matter. Since it is not bodily representation [in the literal sense], but rather depiction, imagination, representation [in the metaphorical], painting opens a wide field for the imagination and entices it into its colorful, odorous pleasure gardens. The sick bon vivant of all time preferred to fill their pleasure cabinets with unchaste paintings rather than statues: for in the latter, even in sleeping hermaphrodites, there is actually no unchastity.

Isn't this a denial of the Pygmalion myth? The eroticism of sculpture and sensual touch is denied and transferred to painting and vision, the medium and sense that were originally supposed to be cold and uninterested in the body. Now the prurient, that is, erotic interest in the sexual body is located among men who have no access to the body (or perhaps who fear it), while those who profess not to be afraid of the body nor to come close enough to touch, deny eros. The denial, in any event, is not entirely effective. We note that the "gefärbte, duftende Wollustgärten" of painting could quite suitably refer to the amorously described hand of the woman.

Is Herder's aesthetics of touch really afraid of the body? And why? The answer to this question will show Herder finally not to be too distant from Lessing, even if they started out with very different intentions. What Herder is afraid of is the unavoidable presence of death in the material body. Once again confronted with the body, Herder passes out, and parts company altogether from the body, even as his own body slumps to the ground.[50]

Death first comes up in the *Plastik* when Herder answers the question: "Warum wird die Bildsäule durch Färbung nach der Natur und ähnliche Anwürfe nicht schön, sondern hässlich?" (Why does the statue not become beautiful, but rather ugly through the application of paint and other such things?) His answer comes from his touch-oriented aesthetics of sculpture. Feeling the statue with closed eyes, the fingers would encounter interference, the grit of paint, fur applied for hair, etc. Herder then goes on to identify other sources of interference, but these, surprisingly, are parts of the body:

> Viel feinere Sachen, als Tünche und Kuhhaut [he had been talking about Myron's cow] müssen von der Statue wegbleiben, weil sie dem Gefühl widerstehen, weil sie dem tastenden Sinne keine ununterbrochne schöne Form sind. Diese Adern an Händen, diese Knorpel an Fingern, diese Knöchel an Knien müssen so geschont und in die Fülle des Ganzen verkleidet werden; oder die Adern sind kriechende Würme,

die Knorpel aufliegende Gewächse dem stillen dunkeltastenden Gefühl. Nicht ganze Fülle eines Körpers mehr, sondern Abtrennungen, losgelöste Stücke des Körpers, die seine Zerstörung weissagen, und sich eben daher schon selbst entfernten. Dem Auge sind die blauen Adern unter der Haut nur sichtbar: sie duften Leben, da wallet Blut; als Knorpel und Knochen sind sie nur fühlbar und haben kein Blut und duften kein Leben mehr, in ihnen schleicht der lebendige Tod. (27–28)

Much finer things than paint and cow hide must be kept away from the statue because they are loathsome to feeling, because they are not an uninterrupted beautiful form for the touching sense. These arteries on a hand, these knuckles on fingers, this cartilage in the knees must be delicately spared and dressed up in the fullness of the whole; otherwise the arteries will be encountered by the quietly darkly touching feeling as crawling worms, the knuckles and cartilage as strange tumors. No longer the entire fullness of the body, rather fragments, separated pieces of body that prophesy the body's destruction, and for that reason already distance themselves. To the eye the blue arteries under the skin are merely visible: they exude life, blood pulses there; as cartilage and bones they can only be touched and have no blood and breath no life, living death creeps in them.

Not only do these parts of the body offer resistance to the feeling hand, interfering with the construction of the "whole," that is, idealized, body, they immediately refer to material death in its grotesque, baroque form. If the human statue is not idealized (*unbezeichnet*, as Winckelmann would say; or brought under the rule of beauty, according to Lessing), it turns into a worm-ridden mass of decaying matter.

This sudden intrusion of death in the *Plastik* came first and unexpectedly in the discussion of the appropriateness of applying paint to statue. When, a little later, Herder considers whether sculpture should represent "Hässlichkeiten" it is not surprising that death preoccupies him completely.

Jener Mahler, der einen verwesenden Leichnam so hinzauberte, dass, nicht wie in Poussins Gemählde, der Zuschauer auf der Tafel, sondern jeder leibhafte Zuschauer selbst, sich die Nase zuhalten musste; (wenn anders das Märchen wahr ist) war gewiss ein eckler Mahler. Der Bildner aber, der einen Leichnam, die abscheuliche Speise der Würmer, unserm Gefühl also grausend vorbildete, dass die in uns überginge, uns zerrisse und mit Eiter und Abscheu salbte—ich weiss für den Henker unsres Vergnügens keinen Namen. Dort kann ich mein Auge wegwenden und mich an andern Gegenständen erholen; hier soll ich mich blind und

langsam durchtasten, dass alle mein Fleisch und Gebein sich zernagt fühlet, und der Tod durch meine Nerven schauert! (30)

> That painter who so magically depicted a rotting corpse that, not as in Poussin's painting, where the viewer in the painting was forced to plug his nose, but every live viewer was compelled to; (if the story is true) he was certainly a disgusting painter. The sculptor, however, who so horrifyingly represented to our touch a corpse, the appalling feast of worms, so that it went over into us, ripped us open and salved us with pus and repulsion—for that hangman of our pleasure I know no name. With the former I can avert my eyes and recover on other objects; here I should blindly and slowly feel my way through, so that all my flesh and bones feel masticated and death shudders through my nerves!

From the *Abhandlung*, we recall the involuntary and immediate sympathy and understanding that the cry of pain stimulated in the hearer. In this scene, too, of moving the fingers over the representation of a rotting corpse, the mimetic power breaks down individual boundaries and allows the contagion to spread from the corpse to the beholder. No wonder that Herder fears such contact!

Herder's entire abhorrence culminates in the image of the half-flayed Bartholomew, the Christian type of Marsyas. A statue of Bartholomew comes to life just like Pygmalion's statue, and approaches Herder, who responds in horror:

> Wenn der heilige Bartholomäus da halbgeschunden, mit hangender Haut und zerfleischtem Körper vor mich tritt, und mir zurufft: *non me Praxiteles, sed Marcus finxit Agrati!* und ich soll seine schreckliche natürliche Unnatur durchtasten, durchfühlen; —grausamer Gegenstand, schweig' und weiche! Kein Praxiteles bildete dich, denn er würde dich nie haben bilden wollen. Dich, wie du bist, aus dem Steine hervorzufühlen, hervorzuschinden, welcher Grieche würde das vermocht haben? — (31)

> If the holy Bartholomew approached me half flayed with hanging skin and flayed body, and called to me: *non me Praxiteles, sed Marcus finxit Agrati!* and I should feel through his awful unnatural nature; —gruesome thing, be quiet and disappear! No Praxiteles made you, for he would never have wanted to. To model you, to flay you out of the stone, what Greek would have been capable of such a thing?

Bartholomew is the true Other of Pygmalion's statue, just like Marsyas is Laocoon's. In the introductory chapter, we argued that the primal scene

of classicism is Apollo's flaying of Marsyas. Herder struck out to establish an aesthetics of touch, to ground all human activities in the body, to approach the body at its most elemental and material in the phenomenon of *Reizbarkeit*. Here he is again at the anatomy table, confronted by the tortured body, the profound cry of pain, the living statue—and he passes out. He orders the body away, and asks, rhetorically, what Greek artist could have made such a statue. The answer, by no means rhetorical, is Apollo.

5

Moritz:
The Victim's Discourse

> ...tausenderlei romanhafte Ideen durchkreuzten sich in seinem Kopfe, worunter eine ihm besonders reizend schien, dass er in Weimar bei dem Verfasser von Werthers Leiden wollte Bedienter zu werden suchen, es sei unter welchen Bedingungen es wolle.
>
> ...thousands of romantic ideas crisscrossed in his head, one of which seemed especially charming to him, that he attempt to become a servant in Weimar to the writer of Werther's *Leiden*, under whatever conditions were necessary.
>
> Karl Philipp Moritz

In the chapters on Winckelmann, Lessing, and Herder, we have discerned a variety of responses to the human body, ranging from the sensuous to the timid and horrified. We have identified Laocoon's body as a concentration point for the various forms of violence that attend these responses. Interestingly, the eighteenth century was agreed that the Laocoon of the statue did not speak; at the most he emitted a barely audible sigh. The body is a silent victim.

But what if Laocoon could speak? What would Laocoon say about the desire that constitutes his body in its gaze? In "Die Signatur des Schönen: In wie fern Kunstwerke beschrieben werden können?", an essay by Karl Philipp Moritz, better known as the author of the autobiographical novel *Anton Reiser*, the unique possibility presents itself of deciphering the victim's discourse, and, in so doing, writing an accusation against the eighteenth-century classical aesthetics of beauty.

1

We begin with a story. It was autumn of 1786. Moritz had been in Rome for about three weeks when Goethe suddenly arrived and Moritz

finally had the opportunity to meet him. Indeed, shortly after their initial acquaintance, the two of them, joined by three German artists, Johann Heinrich Wilhelm Tischbein, Johann Georg Schütz, and Fritz Bury, made a day trip to the mouth of the Tiber. On the way back, as they were entering Rome, Moritz's horse was unable to keep its footing on the wet cobblestones. "Mein Pferd [glitschte] mit den Vorderfüssen, ich riss es zum zweiten und drittenmal wieder in die Höhe, endlich konnte es sich nicht länger halten, sondern glitschte mit allen vier Füssen aus, und schlug mit mir auf die linke Seite" (My horse slipped with its front feet, I jerked it up for the second and third time, finally it could no longer support itself, and slipped with all four feet, and fell with me to the left).[1] Moritz emerged from the accident with the upper part of his left arm broken, at that time a very serious injury.

The scene that followed made a big impression on Tischbein, Goethe's artist companion. A hurried sketch made shortly after the accident shows Moritz being treated by a doctor (fig. 7). We see Goethe on his knees in front of Moritz, holding the injured arm, gazing intently and posed more like a proposing lover. Moritz is seated, his eye askew, seeming to look away from Goethe and directly at the beholder. The doctor stands with his back to the scene, cutting a strip of bandage that dangles like a throttled snake.

Thirty years later Tischbein recalled the incident in a letter to Goethe. "Ich habe Sie in tausend Abwechselungen gesehen, aber immer mit dem Zepter, der dem Aufwogen Ruhe gebot: als Sie vor Moritz auf den Knien lagen ihn haltend und ich musste ziehen und Sie sein Höllisches Fluchen mit sanften Freundes Worten dämpften" (I have seen you in a thousand transformations, but always with the scepter that dictated peace to the turmoil: when you lay before Moritz on your knees, holding him, and I had to pull and you moderated his hellish cursing with the gentle words of a friend).[2] The scene has all the trappings of a modern day Laocoon or Philoctetes: Moritz as the unclassical and unrestrained locus of pain, Goethe imposing *Ruhe* with a gentle, classical sovereignty.

Moritz's broken arm forced him to remain in bed for forty days. During this time, he was tended to by none other than Goethe. Moritz describes Goethe's apparently selfless and uncharacteristic care in a letter to Johann Heinrich Campe, his publisher in Braunschweig:

> Was nun während den vierzig Tagen, die ich unter fast unaufhörlichen Schmerzen unbeweglich auf einem Fleck habe liegen müssen, der edle menschenfreundliche Goethe für mich gethan hat, kann ich ihm nie verdanken, wenigstens aber werde ich es nie vergessen; er ist mir in dieser fürchterlichen Lage, wo sich oft alles zusammenhäufte, um die

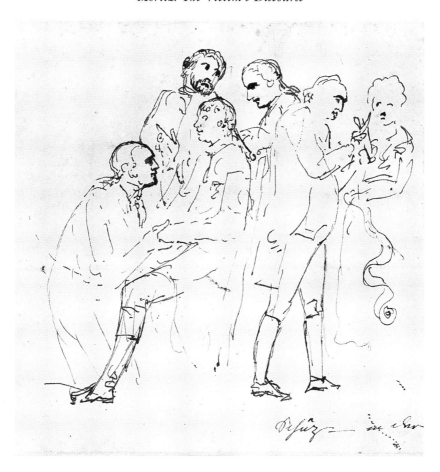

FIG. 7. *MORITZ, GOETHE, AND THE SURGEON,* JOHANN HEINRICH WILHELM
TISCHBEIN, 1786, SKETCH, WEIMAR. REPRODUCED WITH PERMISSION OF
STIFTUNG WEIMARER KLASSIK—GOETHE-NATIONALMUSEUM.

unsäglichen Schmerzen, die ich litt, noch zu vermehren, und mei[nen]
Zustand zugleich gefahrvoll und trostlos zu machen, alles gewesen,
was ein Mensch einem Menschen nur sein kann. Täglich hat er mich
mehr als einmal besucht, und mehrere Nächte bei mir gewacht; um alle
Kleinigkeiten die zu meiner Hülfe und Erleichterung dienen konnten
ist er unaufhörlich besorgt gewesen, und alles hervorgesucht, was nur
irgend dazu abzwecken konnte, mich bei guten Muthe zu erhalten.
Und wie oft, wenn ich unter meinem Schmerz erliegen und verzagen

[133]

wollte, habe ich in seiner Gegenwart wieder neuen Muth gefasst, weil ich gern standhaft vor ihm erscheinen wollte, bin ich oft dadurch wirklich standhaft geworden.[3]

For what the noble philanthropic Goethe did for me during the forty days that I lay confined and immobile under almost constant pain I will never be able to thank him, at least I will never forget it; in this terrible situation, where often everything conspired to increase the unspeakable pains which I suffered and to make my condition more dangerous and inconsolable, he was everything to me that a person can be to another. Daily he visited me more than once, and watched over me several nights; he was incessantly concerned to supply me with all the little things that could serve to help and ease me, and brought forth everything that could help in any way to keep my spirits up. And often, when I wanted to despair and to succumb to my pain, have I not in his presence taken new courage, because I badly wanted to appear strong before him, I thus often really became strong.

Many would like to celebrate this period as an instance of Goethe's caring humanism (there are too many examples of its opposite). In his book on the German "artist colony" in Rome, Friedrich Noack proposes that the house in the Via Babuino where Moritz lived "uns Deutschen eine geweihte Stätte sein soll" (should be a hallowed place for us Germans),[4] since it was there that Goethe displayed his humanity. I propose a frankly opposite reading of the same incident, however, according to which Moritz is Goethe's victim and as such gives voice to the mute victims of classical aesthetics— among them, Laocoon, Marsyas, and the eunuch. The record of his cry, however muted, is to be found in the second of two essays on aesthetics that he wrote during his time in Rome and after recovering from the broken arm. The first of these, and by far the better known, "Über die bildende Nachahmung des Schönen" (1788) will concern us only marginally. Our reading will focus on the essay called "Die Signatur des Schönen: In wie fern Kunstwerke beschrieben werden können?" (1788).

Any reading of Moritz's aesthetic and philosophical writings is fraught with difficulties. Various theories have been offered in explanation. Robert Minder reads Moritz's aesthetic writings as a sort of "aesthetic Guyonism," continuous, in other words, with his "quietist" upbringing.[5] Mark Boulby brings all manner of biographical factors to bear: constantly impoverished, paid by the page, Moritz never had the time to prepare any writing with care.[6] Raimund Bezold would deny Moritz's aesthetic thinking any coherent depth; instead Moritz's thought moves derivatively at the level of *Popularphilosophie*.[7]

Despite these difficulties, the greater part of contemporary Moritz scholarship has wanted to rehabilitate him from past neglect or disdain. This effort proceeds on two fronts. First, scholars have wanted to show that Moritz anticipates the later Kant. Focusing on the "Versuch einer Vereinigung aller schönen Künste und Wissenschaften unter dem Begriff des *in sich selbst vollendeten*" (1785) as well as "Über die bildende Nachahmung" they argue that Moritz's theory of "das in sich selbst vollendete" (the complete in itself) and the concepts of "innere Zweckmässigkeit" (inner purposiveness), "Unnützlichkeit" (uselessness), and "disinterestedness" it implies, predate and anticipate their systematic development in Kant's *Kritik der Urtheilskraft* (1790).[8] The second part of the effort to rehabilitate Moritz has involved extricating him from Goethe. Tzvetan Todorov is perhaps the most influential contemporary writer to have attempted this in his book *Théories du Symbole.* Todorov, however, by trying to assert Moritz's independence of Goethe and precisely in connection with the writing of "Über die bildende Nachahmung des Schönen," misses the point altogether. Moritz's writing in the two Italian essays does not proceed from a position of individual autonomy, rather it proceeds from a position of "aesthetic autonomy," that is, the compromised autonomy of the eunuch as we developed it in the chapter on Winckelmann. In other words, in treating Moritz's texts we are in fact reading the victim's discourse.

The victim's discourse presents unique difficulties to interpretation, since strictly speaking the point of victimization is to strip the victim of its voice and to deny its subjectivity through violence. Through the pain of torture, as Elaine Scarry has shown in *The Body in Pain*, the language of the victim is systematically destroyed.[9] Frequently the torture victim is forced to learn a new language, inscribed by the torturer on the victim's body, and which denies or makes a mockery of the victim's subjectivity. If the victim speaks, it is a discourse intimately bound up with both the pain of his or her body and the dominant discourse of the victimizing subject.[10] In other words, the victim's discourse is based on transgression: it is very difficult to know precisely who is speaking, where the language comes from, and how the language refers to and represents the victim's body and pain. In short, the victim's discourse cannot be read in isolation from the scene of victimization. In the case of Moritz that means that we cannot separate a reading of his text from a consideration of his relation to Goethe.

It may seem inappropriate and lurid in the extreme to compare the situation between Goethe and Moritz in Rome to that of the torturer and his victim. At the same time, however, the comparison forces and underscores the realization that this situation was of an unusual order. The

props of torture were there: pain; confinement to a small room; frequent, regular, and intensely intimate contact with a virtual stranger—even if the infliction of pain is dissociated from Goethe.

Indeed, the aspect of incongruous and brutal intimacy suggests yet another interpretive scenario for the encounter between Goethe and Moritz, one that will find its justification in the primary figure of Moritz's "Signatur des Schönen"—the scene of rape. The violence of rape also negates the subjectivity of the victim and denies her language (" 'no' means 'yes' ").[11] Admittedly, the effect of referring an incident from Moritz's life to scenes of rape and torture is to render that incident fictitious and imaginary. That does not make the incident less telling or significant. Indeed, the recasting of the banal into the sensational very much resembles a constitutive process in Moritz's autobiographical novel *Anton Reiser*.

Anton Reiser is a study of victimage and pain. Practically from birth, the protagonist suffers disease, rejection, ostracism, and hunger. Reiser strives to construct himself as a respected and resilient individuality, but more often events and persons, as well as his stronger self-destructive tendencies, seem to conspire to reduce him to an object of scorn and derision, both for others and himself. Periodically throughout the novel, Reiser is cut to the quick by utterly banal and meaningless social slights. These are deeply impressed on his memory and recited like a litany of humiliation each time he is newly slighted:

> —dies zuvorkommende "ich habe die Ehre mich Ihnen zu empfehlen" gesellte sich plötzlich in seiner Idee zu dem "dummer Knabe!" des Inspektors auf dem Seminarium, zu dem "ich meine Ihn ja nicht!" des Kaufmanns, zu dem "par nobile Fratrum" der Primaner und zu dem "das ist ja eine wahre Dummheit!" des Rektors.—Er fühlte sich auf einige Augenblicke wie vernichtet, alle seine Seelenkräfte waren gelähmt.[12]

> —this anticipatory "I have the honor of bidding you good day" suddenly joined in his mind the "stupid boy!" of the inspector at the seminary, the "I don't mean *you*!" of the shopkeeper, the "par nobile Fratrum" of the older classmate, and the "that is a real stupidity" of the rector.—For several moments he felt as though destroyed, all the powers of his soul were as crippled.

Moritz is sensitive to the violence involved even in mundane social exchanges. He realizes that it is often a question of power, a struggle with high stakes. This is evident in the analysis in *Reiser* of what it means to be a laughing stock:

Und so scheint nun einmal das Verhältnis der Geisteskräfte gegeneinander zu sein; wo eine Kraft keine entgegengesetzte Kraft vor sich findet, da reisst sie ein und zerstört wie der Fluss, wenn der Damm vor ihm weicht. Das stärkere Selbstgefühl verschlingt das schwächere unaufhaltsam in sich—durch den Spott, durch die Verachtung, durch die Brandmarkung des Gegenstandes zum Lächerlichen. —Das Lächerlichwerden ist eine Art von Vernichtung und das Lächerlichmachen eine Art von Mord des Selbstgefühls.[13]

And that is simply how the relationship between the forces of spirit is; where a power does not encounter a resistant power, it breaks in and destroys like a river when the dam gives way. The stronger individual devours the weaker irrevocably—by mockery, by disdain, by branding the object as laughable. —Becoming laughable is a sort of destruction and making someone laughable is a sort of murder of individuality.

Moritz himself is inclined to be lurid. The description of the collapsing dam, and the flooding of the weaker subject by the stronger corresponds precisely to the relation between Goethe and Moritz that we are trying to represent.

Another way in which Reiser seeks to shore up his individuality, to preserve his voice and protect himself from shame, is through the profound avoidance of plagiarism, lest he be accused of it. We see this at one point when he is commissioned to write an encomium for a local celebration of the king. The person whom he most fears plagiarizing and whom it seems to be impossible not to plagiarize is, of course, Goethe.

vor dem Plagiat hatte er die entsetzlichste Scheu—so dass er sich sogar des Ausdrucks am Schluss seiner Rede: "dass Wald und Gebürg' es widerhallen," schämte, weil einmal in Werthers Leiden der Ausdruck steht: "dass Wald und Gebürg' erklang"—ihm entschlüpften zwar oft Reminiszenzien, aber er schämte sich ihrer, sobald er sie bemerkte.[14]

He was most desperately afraid of plagiarism—so much so that he was ashamed of the expression at the conclusion of his encomium: "that forest and mount give echo" because somewhere in Werther's *Leiden* there is the expression: "that forest and mount' resound"—such reminiscences often slipped out, but he was always ashamed of them as soon as he noticed.

Goethe's language, especially in *Werther*, has so far penetrated Reiser's discourse that it slips from his pen or mouth in the form of a reminiscence.

The sense of encroachment is so extreme that even the most indistinctive formulations—"Wald und Gebürg' "—seem to have Goethe's signature.[15]

Reiser and *Werther* are one thing, actually meeting Goethe is another. If *Anton Reiser* gives the fictionalized account of a fragile, self-disdaining, and brutalized subject, the first prolonged and intense encounter with Goethe will involve a dynamics of a higher order. Goethe himself, years after Moritz's death, confirmed Moritz's worst fears with regard to plagiarism. In 1829, the third volume of Goethe's *Italienische Reise* finally appeared including a discussion of and extensive (seven-page) excerpt from Moritz's Italian essay "Über die bildende Nachahmung des Schönen." Goethe writes:

> [E]s [Moritz's text] war aus unsern Unterhaltungen hervorgegangen, welche Moritz nach seiner Art benutzt und ausgebildet. Wie es nun damit auch sei, so kann es geschichtlich einiges Interesse haben, um daraus zu ersehen, was für Gedanken sich in jener Zeit vor uns auftaten, welche, späterhin entwickelt, geprüft, angewendet und verbreitet, mit der denkweise des Jahrhunderts glücklich zusammentraffen.[16]

> It proceeded from our conversations, which Moritz used and developed according to his nature. However that may be, it is perhaps of some historical interest in order to see what sort of thoughts presented themselves in that time, thoughts which, being developed, tested, applied, and disseminated, later fortuitously coincided with the century's manner of thought.

Ever so casually, if effectively, Goethe compromises Moritz's authorship; the text proceeds from *their* conversations (among them, those when Moritz was laid up with his broken arm), and who would doubt the predominant role of Goethe's voice? That Goethe appropriates seven pages of text for his *Italienische Reise* would seem to be proof enough that he regards the discourse as his. The consequence, evident in literary history, is that Moritz is seen as a derivative thinker, merely Goethe's mouthpiece.

By understanding Moritz's text according to the model of the victim's discourse, however, a more subtle reading becomes possible. What has been called derivative is now understood as the result of the inscription of the victimizer's discourse onto that of the victim. But even as the victim's now mesmerized discourse proceeds, the violence of the inscription itself comes into view and thus it becomes possible to formulate an accusation through and against the victim's discourse.

We shall see that two moments predominate in Moritz's aesthetic thinking. The first is entirely utopian, a vision of autonomous self-sufficient

aesthetic subjects that never interfere with each other and refer to one another only indirectly by reflecting in their structure the completeness that characterizes each one. The second moment is one of mutilation and violation.[17] Though Moritz tries to understand these two moments as strict opposites or to absorb violence (*Zerstörung*) in beauty,[18] he is not successful. There is, as we have already seen in treating Winckelmann's aesthetics, a necessary and original link between pain and beauty. Moritz would like to understand his relation to Goethe according to the utopian moment. In fact, as our reading will show, it is the violent moment that constitutes their friendship.

But let us return to the story. The critical period in question is the forty days during which Moritz kept to his bed. Goethe, as was mentioned, attended Moritz daily. What was it about Moritz that awakened this response in Goethe? In a letter to Charlotte von Stein, the woman he had left behind in Weimar, Goethe writes: "Er ist wie ein jüngerer Bruder von mir, von derselben Art, nur da vom Schicksal verwahrlost und beschädigt, wo ich begünstigt und vorgezogen bin" (He is like a younger brother, of the same type as me, only neglected and damaged by fate, there, where I have been favored and preferred).[19] A few days after Moritz's bandages are removed, he writes to her again:

> Moritz wird mir wie ein Spiegel vorgehalten. Denke Dir meine Lage als er mitten unter Schmerzen erzählte und bekannte dass er eine Geliebte verlassen, ein nicht gemeines Verhältnis des Geistes, herzlichen Anteils pp zerrissen, ohne Abschied fortgegangen, sein bürgerlich Verhältnis aufgehoben. Er gab mir einen Brief von ihr, den ersten zu eröffnen, den er zu lesen sich in dem fieberhaften Zustande nicht getraute. Ich musste ihr schreiben, ihr die Nachricht seines Zufalls geben.[20]

> Moritz is held up to me like a mirror. Think how I felt when he confessed to me in the midst of his pains that he had left a beloved, had torn the bond of an exalted relationship of the spirit, etc., departed without saying good-bye, had thrown up his bourgeois circumstances. He gave me a letter from her, in order to open the first, which he did not trust himself to read in his feverish condition. I had to write her, to tell her the news of his accident.

Goethe was struck not only by the apparent duplication of his amorous circumstances by those of Moritz, but also saw himself strangely mirrored in Moritz, not as the fortunate and confident individual he was, but as victim. That he reads the letter of Moritz's beloved and writes her back already indicates a breaking down of subject boundaries.

Although Goethe may have understood his relationship to Moritz in this way, the Tischbein sketch, the logic of Goethe's letters, and Moritz's "Die Signatur des Schönen" itself tell a different story. In Goethe's letters the key word is *Schmerz*. On December 13, 1786 (during Moritz's convalescence), he writes Charlotte: "Dein Zettelchen hat mich geschmerzt aber am meisten dadrum dass ich dir Schmerzen verursacht habe" (Your note pained me, but mostly because I caused you such pains).[21] On December 23, Goethe responds to her first letter: "Dass du krank, durch meine Schuld krank warst, engt mir das Herz so zusammen dass ich dirs nicht ausdrucke" (That you were sick, and sick through my fault, constricts my heart so much that I cannot express it to you).[22] Then on January 6, 1787, the fortieth day of Moritz's convalescence, Goethe writes:

> Eben komme ich von Moritz dessen zerbrochener Arm heute aufge-
> bunden worden. Es geht und steht recht gut. Was ich diese 40 Tage bey
> diesem Leidenden, als Beichtvater und Vertrauter, als Finanzminister
> und geh. Sekratair pp gelernt, soll auch dir, hoff ich, in der Folge zu
> Gute kommen.
> Heute früh erhielt ich deinen bitter süssen Brief vom 18ten Dec. Un-
> sre Correspondenz geht gut und regelmässig, dass sie nun nicht wieder
> unterbrochen werde solang wir leben. Ich kann zu den Schmerzen die
> ich dir verursacht nichts sagen als: *vergib*![23]

> I have just come from Moritz, whose broken arm was unbound
> today. Everything goes well. What I have learned these 40 days with
> this sufferer as father confessor and confidante, as minister of finance
> and personal secretary etc. shall also accrue to your advantage I hope.
> Early this morning I received your bitter sweet letter of the 18th
> of Dec. Our correspondence goes well and regularly, that it not be
> broken again as long as we live. I can say nothing to the pains that I
> caused you except: *forgive*!

Goethe may have seen himself mirrored in Moritz, but the logic of the correspondence shows that Moritz substitutes for Charlotte, and precisely with respect to pain and victimage. In other words, Goethe responds to the bedridden Moritz as to a woman.[24] He perceives and tends to Charlotte's pain in Moritz. He sees the break in their relation represented in Moritz's broken arm. This explains his uncharacteristically solicitous behavior, his kneeling like a lover before the pain-crazed Moritz in Tischbein's sketch. On the day that Moritz's arm is unbandaged and declared healthy, Goethe likewise proclaims that the broken communication between him and Charlotte is restored. This is reflected even in the language of his

letter. Compare: "Eben komme ich von Moritz dessen zer*brochener* Arm *heute* aufgebunden worden. *Es geht und steht recht gut*" with: "*Heute* früh erhielt ich deinen . . . Brief. Unsre Correspondenz *geht gut und regelmässig*, dass sie nun nicht wieder unter*brochen* werde" (my emphasis). Despite what Goethe avers, he and Charlotte never do resume their friendship as before.

By any account, it was a very unusual situation. Bedridden, in extreme pain, occasionally feverish, Moritz was vulnerable in the highest degree. Nor should we forget that he and Goethe barely knew each other, before the latter lavished this incongruous attention on him. What did Goethe do to Moritz? Herder, writing to his wife from Rome some two years later at a time when Goethe is playing host to Moritz in Weimar, gives a preliminary answer which contradicts the appearance of the humane and caring Goethe: "Er [Goethe] ist nur in sich und für sich; andern schadet er eher, als dass er ihnen helfe" (He is only in himself and for himself; he rather harms others, than that he helps them.)[25] He goes on to write about Moritz's "Über die bildende Nachahmung," the essay which Moritz wrote in Rome, read aloud to Herder there, and which was now being enthusiastically received in Weimar. Herder writes:

> So ists auch mit Moritz' Philosophie und Abhandlung. Sie ist ganz Goethisch, aus seiner und in seiner Seele; er ist der Gott von allen Gedanken des guten Moritz mir ist diese ganze Philosophie zuwider; sie ist selbstisch, abgöttisch, untheilnehmend und für mein Herz desolierend.[26]

> Thus it is also with Moritz's philosophy and treatise. It is completely *Goethisch*, from and in his soul; he is the god of all the thoughts of the good Moritz this whole philosophy is disgusting to me; it is idolatrous [*abgöttisch*], unsympathetic, and desolating for my heart.

The "in sich und für sich" certainly refers to Goethe's autonomy, but not an "aesthetic" autonomy in the sense we have been developing; rather, if it is an aesthetic autonomy, it is at the same time a tyrannical one. Goethe has become Moritz's idol, his god, as Herder says—we can hear Goethe's name in Herder's word *abgöttisch*. It is even reported that Moritz was in the habit of calling Goethe God.[27] While some are inclined to offset Herder's remarks by calling them peevish or referring to his envious nature,[28] in the story we are unfolding they cannot be taken seriously enough.

The answer as to what Goethe did to Moritz is woven into the text of "Die Signatur des Schönen." Moritz cherishes Goethe's face there, especially the eye that watched him so long, remembering his face like the rape victim who cannot erase the image of her assailant. There is a letter that

Moritz wrote to Goethe from Rome when the latter had already returned to Weimar. Dated August 9, 1788, one-and-a-half years after the accident, it frankly establishes the connection between Goethe and the writing of "Die Signatur des Schönen," though, of course, in the peculiar mode of the victim's discourse. "Ich habe diese Tage über eine grosse Sehnsucht nach Ihnen gehabt," writes Moritz,

> die ich vorzüglich dann empfinde, wenn ich anfange mit mir selbst zufrieden und in einer harmonischen Gemütsstimmung zu sein; ich sehe dann die Welt gewissermassen in Ihrem Auge, und wünsche auch Ihr Auge zu sehen, welches alle die Schönheiten, die ich hier um mich her erblicke, so oft in sich gefasst, und in sich vereinigt hat.[29]

> I have had during these days an enormous longing for you which I most feel when I begin to be content with myself and in a harmonious frame of mind; I then see the world to some extent in your eye, and wish also to see your eye, which so often grasped in itself and united in itself all the beauties that I perceive around me here.

We notice first that Moritz's autonomy and happiness ("mit mir selbst zufrieden") have an aesthetic cast ("harmonisch") and that they are entirely dependent on and thus compromised by Goethe for whom he longs. He fixes on Goethe's eye which roved the beautiful Roman sights and brought them to aesthetic unity within its gaze. Longing for Goethe's eye, he longs also to be seen by Goethe.

> Doch kann mein Umgang mit Ihnen mir nun nicht mehr entrissen werden; auch von Ihnen selber nicht, wenn Sie es gleich wollten, weil ich immer mehr suche, in mein innerstes Wesen einzuweben, was ich sonst zu verlieren Gefahr laufen könnte; und weil nun einmal, mit Ihren Gedanken zusammengenommen, der Ton Ihrer Stimme und Ihr Bild mir vorschwebt.[30]

> My intercourse with you can no longer be torn away from me; also not by you yourself, even if you wanted to, because I always seek to weave into my innermost being what I would otherwise run the danger of losing; and because once and for all, taken together with your thought, the tone of your voice and your image hover before me.

No one can take away Moritz's intercourse with Goethe; he has "woven" it into his innermost being. Goethe's voice and image hover before him. Our reading of "Die Signatur" will show that Goethe's voice and eye have in fact carved Goethe's image into Moritz. Moritz's text is woven in such

a way as to both hide his wound and reveal the crime, regardless of his own awareness.

The letter continues with news about his stay in Rome, questions with regard to whether Herder, Goethe's "paraclete," is really coming, word that Maler Müller is impoverished. Then Moritz refers to the essay he has been writing.

> Mich hat die Abhandlung: in wie fern Kunstwerke beschrieben werden können? sehr weit geführt; weil sie zugleich die Bestimmung der Grenzen zwischen Bildung und Poesie mit in sich begreift.—Die Gedanken worauf mich dies geführt hat, und welche selbst eine Art von Poesie sind ergötzen mich ungemein, und machen mir oft sehr angenehme Stunden.—Denn was mir gegeneinanderstreitend und widersprechend schien, löst sich immer mehr in dem Einem [?] auf, das nicht durch Worte, sondern durch Bildung sich selbst bezeichnet.[31]

> The treatise: to what extent artworks can be described? has advanced me very far; because it at the same time comprehends the determination of the borders between formation [*Bildung*] and poetry.—The thoughts this has led me to, and which are themselves a sort of poetry, delight me uncommonly, and make the time pass very pleasantly.—For what appeared to me to be oppositional and contradictory, dissolves itself more and more into the one [?], which signifies itself not through words, but through formation [*Bildung*].

Moritz claims that his essay comprehends the question of "die Bestimmung der Grenzen zwischen Bildung und Poesie," his version of *ut pictura poesis*, in other words. Note that he writes *Bildung* and not *Bild*. The former absorbs the latter, though without reducing itself to picture. In any event, he concedes that his thoughts in this connection are themselves "eine Art von Poesie." Conflicting and contradictory things are resolved in the "One," which signifies itself not through words, but through "Bildung." It is too early to say what this means, but we must expect Moritz's essay to be difficult, dispersed, conflicting, and contradictory, *Poesie*, in other words, unless somehow within it *Bildung* also takes place.

> Möcht' ich doch itzt nur eine einzige Stunde mit Ihnen hierüber reden können! um mich auf die Weise mit dem Gegenstande selbst, worüber ich nachdenke, mündlich zu besprechen, und seine antwortende Stimme zu vernehmen.[32]

> If only I could talk with you about this now for a single hour! in order in this way to discuss orally with the object itself, about which I am thinking, and to hear his answering voice.

Here Moritz's longing is once again evident. But what a curious formulation, a thorough confusion of subjects and objects! I am referring to the phrase "um mich auf die Weise mit dem Gegenstande selbst, worüber ich nachdenke, mündlich zu besprechen." There are some four ways this phrase could be "rationally" reconstructed.

1. um mich mit Ihnen zu besprechen;
2. um den Gegenstand mit Ihnen zu besprechen;
3. um mit Ihnen zu sprechen; or possibly
4. um mit dem Gegenstande zu sprechen.

But Moritz writes none of those. Instead, it is clear that Goethe is the object (*der Gegenstand*) of Moritz's reflections in his essay, and that Moritz as subject (*ich*) is at the same time transformed by Goethe as subject into an object (*mich*). What has been rendered grammatically here is nothing less than the record of Goethe's crime against Moritz.

2

Moritz's essay was published twice in his lifetime under two different titles. It appeared first in a series of three installments under the title "In wie fern Kunstwerke beschrieben werden können?" in the *Monats-Schrift der Akademie der Künste und mechanischen Wissenschaften zu Berlin* in 1788–89. It was then printed a second time in Moritz's own *Die Grosse Loge, oder der Freimauerer mit Wage und Senkblei* (1793), a collection of short writings for the most part on masonic themes. The title was changed to "Die Signatur des Schönen." What was known as the "Beschluss" in its first printing, a critical attack on Winckelmann's description of the Belvedere Apollo, was omitted. These are by no means minor changes. While in its first form the concluding attack on Winckelmann refers back to the question programmatically posed in the title, the omission of the conclusion and the change in title in the second version have the effect of expanding the focus of the essay considerably. Furthermore, there is no occurrence of the word *Signatur* in the body of the essay, in either version. Since it is not at all certain what Moritz means by *Signatur*, we will begin by discussing its possible meaning.

The word *Signatur* is derived from the Latin *signo*, "to put a mark upon, to inscribe," and refers, of course, in the first place to the name that seals and authorizes a statement of one kind or another. Raimund Bezold, in his book *Popularphilosophie und Erfahrungsseelenkunde*, argues that the immediate context for understanding the *Signaturbegriff* as it occurs in

Moritz is Salomon Maimon's preoccupation with Giordano Bruno as evidenced in articles published in the *Magazin zur Erfahrungsseelenkunde*, edited by Moritz.[33] According to Maimon's interpretation of Bruno the *Signatur* is "eine zurückgelassene Spur," which "in eigentlicher Bedeutung . . . das zurückgelassene Merkmal von den Fussstapfen eines sich bewegenden lebendigen Wesens [ist], woran wir erkennen, dass es da war, und den von ihm genommenen Weg verfolgen können" (a trace left behind which in its actual meaning is the mark of the footsteps of a moving living being, by which we can recognize that it was there and can follow the path that it took).[34] For Bruno, these traces allow us to infer the existence of a creator. Despite Beizold's insistence that this metaphysical aspect is crucial for Moritz, I believe that only the formal structure of the trace is significant, and primarily within the severely restricted circumstances of the encounter with Goethe in Rome.

We must follow Moritz to the Greeks, and translate *Signatur* into its Greek form *hypographé*.[35] Consistent with Bruno, the word means trace. But how much more! A *hypographé* is the outline or contour of an image, but also the description as opposed to the definition of a thing. Thus both word and picture (of a sort) are included in *hypographé*. A *hypographeus* is a secretary (remember Goethe's writing Charlotte that he played secretary to the disabled Moritz) introducing the sense of dictation.[36] The secretary writes with a *hypographis*, a writing instrument, but also a surgical instrument, indeed a knife, reminding us of the context of Albrecht von Haller's experiments.[37] Thus the "secretary" inscribes his discourse onto the body and discourse of the patient. In our reading of Moritz's "Signatur," we will encounter knives at almost every turn.

Two other meanings should be considered. Paul de Man calls attention to one of them in his essay "Hypogram and Inscription." Speaking of Saussure's coining of the word "hypogram" in *Les mots sous les mots*, de Man notes that:

> Saussure seems to be disturbed by the meaning of *hypographein* as "signature," but he also mentions a "more special, though more widespread meaning as 'to underscore by makeup the features of a face.'" This usage is not incompatible with his own adoption of the term which, by analogy, "underscores a name, a word, by trying to repeat its syllables, and thus giving it another, artificial, mode of being added, so to speak, to the original mode of being of the word."[38]

De Man goes on to note that: "*Hypographein* is close in this meaning to *prosopon*, mask or face. Hypogram is close to prosopopeia, the trope

of apostrophe."[39] If Goethe inscribes his signature on Moritz's body and discourse, then our reading of Moritz elicits a picture of Goethe's face in the weave of his text. Our reading is a hypogram, an underscoring of words and syllables to produce a picture not unlike Tischbein's sketch and typologically similar to the Laocoon and the Marsyas engraving discussed in chapter 1. The hypogram is that subtle part of the victim's discourse that represents the crime against the victim. Thus it is appropriate that the final meaning of *hypographé* is a signed bill of indictment, a criminal accusation.

Moritz's essay begins with three stories of rape or attempted rape: the story of Philomela, of Lucretia the wife of Collatinus, and of Virginia. The first story, by far the most significant for Moritz's essay (the other two are more by way of corroborating examples), is from Ovid's *Metamorphoses*, book 6. Moritz fixes on a single aspect of the story, the efficacy of the woven cloth:

> Als Philomele ihrer Zunge beraubt war, webte sie die Geschichte ihrer Leiden in ein Gewand, und schickte es ihrer Schwester, welche es aus einander hüllend, mit furchtbarem Stillschweigen, die grässliche Erzählung las.
>
> Die stummen Charaktere sprachen lauter als Töne, die das Ohr erschüttern, weil schon ihr blosses *Daseyn* von dem schändlichen Frevel zeugte, der sie veranlasst hatte.
>
> Die Beschreibung war hier mit dem Beschriebenen eins geworden— die abgelöste Zunge sprach durch das redende Gewebe.[40]

> When Philomela was robbed of her tongue, she wove the story of her sufferings into a cloth and sent it to her sister, who, unwrapping it, read the gruesome story with horrifying silence.
>
> The mute characters spoke more loudly than sounds that shatter the ear because their mere existence testified to the scandalous misdeed which had been their occasion.
>
> The description here had become one with the described—the amputated tongue spoke through the speaking cloth.

It is important to be acquainted with the full story of Philomela. Philomela's sister Prochne was married to the tyrant Theseus. She longed to see her sister and finally persuaded Theseus to travel to her father's house to bring Philomela back with him. Once there, Theseus promptly fell in love with the beautiful Philomela and determined to have her. Instead of bringing her to his wife, he hid her in a cottage and raped her. She threatened to publish his crime, if not to people, then by calling out incessantly to the gods. At this Theseus's "anger rose in flames," as Ovid says,

No less his fear; quickened by both, he drew
Sword from its scabbard at his side, and seized
His mistress by her hair and pinned her arms
Behind her as he bound them. Philomela
Saw the sword flash before her eyes and gave
Her neck to meet the blow, to welcome death;
Instead he thrust sharp tongs between her teeth,
Her tongue still crying out her father's name.
Then as the forceps caught the tongue, his steel
Sliced through it, its root still beating while the rest
Turned, moaning on black earth; as the bruised tail
Of a dying serpent lashes, so her tongue
Crept, throbbed and whimpered at her feet.[41]

Philomela later wove her story[42] painstakingly into a cloth and had the cloth smuggled to her sister, who had meanwhile been told by Theseus that Philomela had died in an accident. Reading the real story, Prochne was filled with a desire for revenge. She managed to release Philomela without Theseus's knowledge and together the two sisters slaughtered Theseus's son. Cutting him into small pieces, Prochne prepared a meal for her husband and thus Theseus unwittingly consumed his own son. Prochne's revenge was complete.

On the basis of the original title, "In wie fern Kunstwerke beschrieben werden können?", we might have expected Moritz's first story to be in the service of a distinction between word and image. This is, however, not directly the case. Both Ovid and Moritz are very clear about the fact that Philomela's story was woven into the fabric not in the form of a picture, the likely substitute for the loss of language, but as letters (*notas*) and that Prochne reads (*legit*) the story. These woven words are charged with a potency that does not normally attend spoken or written discourse. The reason for this potency is given in the formulation: "Die Beschreibung war hier mit dem Beschriebenen eins geworden—die abgelöste Zunge sprach durch das redende Gewebe" (The description here had become one with the described—the amputated tongue spoke through the speaking cloth).

This formulation is part of a complex that expresses Moritz's theory of beauty and that is repeated throughout his writings.[43] Later in the essay he writes: "Denn darinn besteht ja eben das Wesen des Schönen, dass ein Theil immer durch den andern und das Ganze durch sich selber, redend und bedeutend wird—dass es sich selbst erklärt—sich durch sich selbst beschreibt—" (95; For therein consists the essence of beauty, that one part always speaks and becomes significant through the other and the whole through itself—that it interprets itself—describes itself through itself—).

This is a highly developed notion of aesthetic autonomy that was incipient in Winckelmann, a notion that is on the verge of being cast as the theory of the difference between symbol and allegory.[44] Written or spoken words that describe the crime perpetrated against Philomela would merely point to the crime and be essentially different from the fact of the story itself. But there, where the description and what it describes are somehow one and the same, the sign achieves a self-referring independence, an autonomy, what Todorov calls "intransitivity."[45]

The symbol-allegory debate has, of course, been discussed at great length and more recently been the subject of renewed critical attention as a consequence of Benjamin's revaluation of allegory. Our reading of Winckelmann has already made us suspicious of any claims about aesthetic autonomy. It is therefore only natural that we focus our attention now on the curious and alienating circumstance that Moritz's discussion of beauty—what will later be called symbol—is set in a story about a rape and an amputated tongue. In other words, the amputated tongue is the initial if not primary figure (or "symbol") of the symbol, at least for this text.

What produces aesthetic autonomy? What is it that makes the description identical with the described? If we look back at Moritz's version of Philomela's story, we see that it depends on a kind of proximity (*Nähe*). He writes: "Denn nichts lag ja dem Unglück der weinenden Unschuld *näher*, und war so innig damit verwandt, als eben diess mühsame Werk ihrer Hände, wodurch sie allein ihr Daseyn kund thun, und ihre Leiden offenbaren konnte" (93; Moritz's emphasis; For nothing was closer to the misfortune of crying innocence, and was so closely related, as precisely this laborious work of her hands, through which alone she could give note of her existence and publish her sufferings). The same seems to be true of the two supporting examples:

> So war dem unglücklichen Weibe des *Kollatinus* nichts *näher*, als ihr Gatte, und ihr Vater selbst, welche durch die blosse Erzählung ihres beweinenswerthen Schicksals, ein ganzes unterdrücktes Volk gegen die Macht der Tyranney empörten, und die erloschne Freiheitsliebe in aller Busen wieder weckten.
>
> Mit seiner eignen, unschuldigen Tochter Blut bespritzt, durfte *Virginius* nur den Mund eröfnen, um alles zur lebhaftesten Theilnehmung an siener Erzählung hinzureissen, und durch die einfachste Beschreibung der jammervollen Szene, konnte er dasselbe Volk noch einmal bewegen, das Joch der Knechtschaft von sich abzuschütteln.
>
> Eben das nahe Band, welches den überlebenden Gatten und Vater an jenes Schlachtopfer der willkürlichen Herrschaft knüpfte, machte,

dass die Erzählung, *zugleich mit der erzählten Sache*, auf die Gemüther wirkte, und bis ins Innerste erschütterte. (94; Moritz's emphasis throughout)

> Likewise nothing was *closer* to the unfortunate wife of *Collatinus* than her husband, and her father, who through the mere telling of her tearful fate, aroused an entire oppressed people against the power of tyranny and awoke once again the extinguished love of freedom in all breasts.
>
> Spattered with the blood of his own innocent daughter, *Virginius* only needed to open his mouth in order to wrench the liveliest attention to his narrative, and through the simplest description of the sad scene he was able to move the people one more time to shake off the yoke of servitude.
>
> Precisely that close bond which tied the surviving husband and father to that victim of arbitrary rule caused the story, *together with what the story told*, to affect the people and to touch them most deeply.

In every case it is *Nähe* that guarantees the potency of the expression, that makes signifier and signified coincide. In fact, what Moritz is doing is establishing a highly idiosyncratic version of a commonplace eighteenth-century opposition for distinguishing pictorial systems of representation from linguistic ones (as we saw in Lessing). What he means by *Nähe* is the family relation (wife, daughter, sister) or even closer (tongue to body). These are natural relations in the same way that it was argued that the visual image was a "natural" sign. The opposite of the "natural" sign is the "artificial" sign, typically the signs of language. While the system of natural signs is marked by an identity between signifier and signified (as, for example, in an iconic sign), artificial signs function on the basis of difference; their relation to the object they signify is arbitrary. That is why it is important to note the political context in the last two of Moritz's examples: Kollatinus' story "[empört] ein ganzes unterdrücktes Volk gegen die Macht der Tyranney" (horrified an entire oppressed people with regard to the power of tyranny); likewise Virginius "konnte . . . dasselbe Volk noch einmal bewegen, das Joch der Knechtschaft von sich abzuschütteln" (was able to move the people once more to shake off the yoke of slavery). In his summary of these examples he calls the victims "Schlachtopfer der *willkürlichen* Herrschaft" (my emphasis; victims of arbitrary rule). The relation of the three tyrants to their respective victims is arbitrary in the same way that language is to its referents.

W. J. T. Mitchell has shown that there are strong political undercurrents to Lessing's apparently formal analysis of the differences between

the arts.[46] But certainly Moritz's version of the same is even more highly politicized, if not entirely realized. Moritz posits two systems of representation, one natural and familial, the other arbitrary and tyrannical. While the models for each are the visual image and language respectively, a picture or a speech can be either natural or tyrannical with respect to its referent depending on whether its relation is natural or arbitrary. The only thing Moritz fails to mention is that for the identity of the *Beschreibung* with the *Beschriebenem* to occur some sort of violation is required. The familial relation is the utopian moment; the tyrannical relation, of course, the violent one. The autonomous, self-referring work of art is created only when the tyrannical moment interferes with the other.

The production of autonomous works of art on the basis of proximity is marked by an internal paradox. The proximity of family members (or body members) becomes apparent and efficacious when the tyrannical moment intrudes violently. At the same instant that the autonomous work is produced, proximity is necessarily denied, for if continued it would compromise the autonomy. The logic of this is reflected in the answer Moritz gives to his next question: how can anyone who does not stand in a familial relation to his[47] object represent it in such a way that it approximates the effect of Philomela's cloth or Virginius's speech?

Moritz's question is directed to any type of representation—whether by artist, actor, poet, or historian. In every case he phrases the question with the word *beschreiben* to suggest that the relation from the outset is external, based on the model of language. "Wer den Schmerz des *Virginius* würdig beschreiben wollte" (Whoever wanted to describe the pain of Virginius worthily) must contrive to make his representation autonomous, to cause signifier and signified to coincide. In this way, he would attain what proximity afforded naturally.

In any event, Moritz collapses the concept of proximity into the concept of formal completeness, the intransitive sign.

> Denn darinn besteht ja eben das Wesen des Schönen, dass ein Theil immer durch den andern und das Ganze durch sich selber, redend und bedeutend wird—dass es sich selbst erklärt—sich durch sich selbst beschreibt—und also ausser dem bloss andeutenden Fingerzeige auf den Inhalt, keiner weitern Erklärung und Beschreibung mehr bedarf. (95)

> For therein consists the essence of the beautiful, that one part speak and become significant through the other and the whole through itself— that it explain itself—describe itself through itself—and that it require

no further explanation and description apart from the mere pointing of a finger to its content.

If a work of art required more than this mere gesture toward its *Inhalt*, it would be incomplete: "denn das erste Erfordernis des Schönen ist ja eben seine *Klarheit*, wodurch es sich dem Auge entfaltet" (95; for the first requirement of the beautiful is precisely its clarity, whereby it unfolds itself to the eye). The concept of clarity is the occasion for an important distinction between nature and art. In nature the beautiful can be hidden, even under an ugly surface. Art, by contrast, necessarily seeks to disclose beauty on a beautiful surface, to make it appear in an instance of completeness. In nature one finds degrees of concealment and revelation.

Moritz organizes nature through oppositions.[48] In "Die Signatur" he sets up a "chain of being," beginning with inanimate nature, running through plant and animal, and seeming to culminate in humankind, especially in its ability to speak and write. He counts the links of this chain under three aspects as shown in the chart (table 1). In all cases the primary opposition is between *Zufall* and *Bestimmtheit*. As one moves upward, *Bestimmtheit* increases as *Zufall* decreases. In the first column, the relevant sub-opposition is between hiddenness and nakedness. Whereas the human body represents a maximum of determinacy, stripped of the accidental, showing only the necessary on its surface, the "surface" or skin of animals is not sufficient or not sufficiently determined to be able to do without a protective covering of scales, hair, or feathers (96). The plant (or tree) hides its delicate "Schatz von Vollkommenheit" with a hard covering that denies our eyes a glance (97).

In the second column, the opposition *Zufall/Bestimmtheit* is considered under the aspect of *Gestalt*. Moritz hears in both words, *Zufall* and *Bestimmtheit*, a literal meaning that is identical with its conceptual meaning. These are examples, in other words, of what Moritz means by the coincidence of signifier and signified. In the case of inanimate nature, he says, "der Tropfen *fällt* dem Tropfen, der Staub dem Staube, *zu*—" (97; his emphasis; the drop falls to the drop, dust particle to dust particle). Moritz's ear for language is able to distinguish the undifferentiated, unorganized, accidental nature of *Zufall* or *das Zufällige*.[49] Organic nature raises itself from the ground of the accidental first in the form of plants. They are still rooted in the earth. The embryo further differentiates itself through movement. The center of its being, its point of gravity is no longer in the earth, but in itself. Such determinacy culminates in the human form, especially in the human tongue:

	Hidden/Naked	Zufall/ Bestimmtheit (Gestalt)	Zufall/ Bestimmtheit (Sound)
Inanimate Nature		Dust, raindrop, snowflake, stone	
Plant	Tree trunk	Plant	Tree leaves moved by wind
Animal	Fur-covered animals	Embryo	Singing nightingale
Human	Naked body	Tongue	Shepherd: writing, singing

TABLE 1. *ZUFALL* AND *BESTIMMTHEIT* IN "DIE SIGNATUR DES SCHÖNEN."

[Dann] tritt endlich, in dem beweglichsten Theile des Organs, die *redende Stimme* selbst ein, welche als das Resultat der vollkommensten Bestimmtheit, nun auch alles übrige in der Natur *bestimmt*, und durch das Wort ihm seine Grenzen vorschreibt. (97)

Then finally, in the most moveable part of the organism, the speaking voice enters, which as the result of the most complete determinacy, now also determines everything else in nature and through the word prescribes its boundaries.

Moritz heard the word *Stimme* in *bestimmt*. To determine something (*etwas bestimmen*) means to mark it off from other things or its surroundings through a word. The human tongue, in itself the most determined of things, becomes determination itself in so far as it gives the rest of nature its names. This is why it can reach back as far as its origin in *Zufall* and hear in the word the nature of the accidental, for it is the human tongue that "determined" *Zufall* in the first place.

In the third column, the same movement takes place except under the aspect of sound. The movement, however, is localized in a single image: a tree, through whose leaves the wind blows, in whose branches

a nightingale sings, against which a shepherd leans and calls out the name of his beloved, "oder mit scharfer Spitze der wachsenden Rind ihn [the name] einverleibt.—" (98; or with a sharp point inscribes the name into the growing bark). In the tree merely *Bildung* is determined; the sound of the leaves is monotone. In the bird *Bildung* and *Bewegung* are determined; the song is varied. In the shepherd *Bildung*, *Bewegung*, and *Laut* are determined; the name he pronounces is meaningful.

Where sound is determined, where there is language, there the word turns back on all of nature to encompass it.

> Das Ganze [löset sich] in Harmonie [auf]—das Umfassende sich wieder selbst umfassend, mit leisem Tritt auf seiner Umgrenzung wandelt —und mit dem aufmerksamen Ohre, von der äussersten Zungenspitze, seines Wesens Wiederhall vernimmt. (98)

> The whole dissolves in harmony—the comprehensive one comprehends itself, wanders with light step on its own boundaries—and with attentive ear hears from the utmost tip of its tongue the echo of its being.

Thus the third column likewise concludes with the human tongue. Or does it? The inscribing of the name with a knife in the trunk of a tree seems to fall slightly out of the sequence. It may be that it is "derselbe Hauch der Luft" (the same breath of air) that blows through the leaves, is in the throat of the nightingale, and on the shepherds lips. What carves the name in the tree, however, is not a *Hauch* but a knife, "eine scharfe Spitze" (a sharp point). For that reason it is highly significant that the tongue is here called "die Zungenspitze" (the point of the tongue), acknowledging, as it were, its relation with the knife. While *Hauch* belongs to the utopian moment, *Spitze* clearly belongs to the violent one.

The image of the love-smitten shepherd carving the name of his beloved in a tree replays the opening image of Philomela's rape. The nightingale in the tree might have alerted us—Philomela, after all, was changed into a bird, hence *philomela*, the Latin for nightingale. But in the case of the shepherd, the violence is deflected onto the tree. The tree has already been named in "Die Signatur" as an instance where nature hides her "Schatz" from human view. The shepherd's desire inscribes his beloved's name on the tree, giving the tree its identity as a substitute for his beloved with the very action that opens a wound in the tree. This is a perfect example of how the victim is constituted as a subject by the violence inflicted on it by its assailant.[50]

Moritz's essay began with the image of Philomela's tongue and has at this halfway point returned to the tongue, a tongue, however, that is also a *Spitze*. The point we have reached is important for Moritz: "Hier ist es also wo Bildung und Laut sich scheiden—" (98; thus here it is where *Bildung* and sound go separate ways). It seems that now the fundamental distinction between visual image and linguistic sign is to be made.

> Durch das redende Organ beschreibt die menschliche Gestalt sich selber in allen *Äussrungen* ihres Wesens—da aber, wo das wesentliche Schöne selbst auf ihrer Oberfläche sich entfaltet, verstummt die Zunge, und macht der weisern Hand des bildenden Künstlers Platz. (98)

> Through the speaking organ the human figure describes itself in all the exteriorizations of its being—there, however, where the essential beautiful unfolds itself on its surface, the tongue is silent, and gives way to the wiser hand of the visual artist.

Not only have we circled back to the tongue, we are actually involved in a repetition of the Philomela scene, though the violence is repressed. "Die Zunge verstummt" (the tongue is silent). The tongue becomes incapable of utterance. But that was precisely Theseus' intention when he amputated Philomela's tongue. "Die Zunge wird verstümmelt" (the tongue is mutilated) would simply be the variant that acknowledges the violence in "Die Zunge verstummt."

The confusion of subjects is once again evident. Whose tongue? whose beauty? whose hand? Confronted with Philomela's beauty, the tyrant raped her. Afterwards, his rage and anxiety impel him to render her completely helpless, to transform her into the "perfect" woman. Ovid hesitates, but confirms this:

> This done [the amputation]
> The tyrant (it was said; we scarce accept it)
> Renewed his pleasure on her wounded body.

The amputation of her tongue, this assault on language, is nothing less than the castration of an already violated woman. The tyrant perceives the need to make his violation complete, to transform his victim into an "autonomous" object, not unlike Winckelmann's *bardasse*.

This final outrage, however, sets a fatal chain of inversions in motion. Theseus removed her tongue in order to conceal his deed and strip her of all recourse. His violent act, however, proves to empower her or her tongue to publish the crime even more compellingly; removing her tongue, he

places a knife in her hand. Then there is the cloth she weaves; typically to hide the castration, in her case the cloth reveals it. The cloth becomes, as Moritz says, "eine redende Zunge" (a speaking tongue); it is also a knife (*Spitze*) and the castrated, now doubly powerful phallus. Philomela and her sister, finally, with knife in hand, slaughter Theseus's son and through the "gentle" art of cooking transform Theseus into a woman in so far as he consumes and therefore carries his own son in his belly.

The tongue is both mutilated and mutilating, silent and speaking like never before. Is there really a "hier" where "Bildung und Laut sich scheiden?" We have already seen Moritz invoke the conventional difference between natural and artificial sign systems, only to apply it in a very unconventional manner. At this point he has recourse to the distinction so well known from Lessing between simultaneous (*nebeneinander*) and sequential (*nacheinander*) signification. Moritz calls it the difference between immediate (*unmittelbar*) and mediate (*mittelbar*) representation.

> Indes die Zunge durch eine bestimmte Folge von Lauten jedesmal harmonisch sich hindurch bewegend nur *mittelbar* das Schöne umfassen kann; in so fern nehmlich die mit jedem Worte erweckten und nie ganz wieder verlöschenden Bilder, zuletzt eine *Spur* auf dem Grunde der Einbildungskraft zurücklassen, die mit ihrem vollendeten Umriss dasselbe Schöne umschreibt, welches von der Hand des bildenden Künstlers dargestellt, auf einmal vors Auge tritt. (99)

> Meanwhile the tongue can only *mediately* grasp the beautiful through a determinate sequence of sounds through which it harmoniously passes each time; to the extent, namely, that the images, that are awakened with every word and never entirely erased, finally leave behind a *trace* on the ground of the imagination which, with its completed contour, describes the same beautiful that, represented by the hand of the visual artist, suddenly appears before the eye.

The words leave a trace (*Spur* = *Signatur*) on the ground of the imagination. That trace has a contour; it is a picture, in other words. Once the words have inscribed their picture, there is no longer an essential difference between the picture created mediately through words and the picture immediately represented by the image. Words and their trace, taken together, are "das Schöne selbst." Likewise the lines of an image, taken together, are the beautiful itself. The distinction between word and picture that was supposed to have manifested itself here is almost immediately collapsed. This is confirmed by the fact that the visual sign is created by

"d[ie] äussersten Finger*spitzen*" (my emphasis; the outermost fingertips). Both *Zungenspitze* and *Fingerspitzen* are capable of inscribing the *Spur*.

This newly revealed correspondence between word and image, however, enables Moritz to set up that utopian system of reference mentioned above. He does this in a series of provocative statements that seem to anticipate their better known counterparts in Baudelaire some sixty years later.

> [D]as vollkommenste Gedicht sey, seinem Urheber unbewusst, zugleich die vollkommenste Beschreibung des höchsten Meisterstücks der bildenden Kunst, so wie diess wiederum die Verkörperung oder verwirklichte Darstellung des Meisterwerks der Phantasie. (100)

> The most perfect poem is, unbeknownst to its creator, at the same time the most perfect description of the highest masterpiece of visual art, just as the latter is the embodiment or realized representation of the masterpiece of the imagination.

A poem in no way refers directly to the work of art; it need not even have any subject matter in common. Indeed, to be counted beautiful, it must be autonomous in Moritz's sense, that is, description and what it describes must be the same. But how is it possible for autonomous works of art to refer to each other? The basis for this possibility is their formal identity. In fact, the *Spur* which each work of art leaves behind is identical with every other *Spur* and eventually, according to the rhythm of Moritz's logic, *non-identical* with the work that impressed the *Spur* in the first place.

> So viel fällt demungeachtet deutlich in die Augen, dass die zurückgelassene Spur von irgend einer Sache, von dieser Sache selbst so unendlich verschieden seyn könne, dass es zuletzt fast unmöglich wird, die Verwandtschaft der Spur mit der Gestalt des Dinges, wodurch sie eingedrückt ward, noch ferner zu errathen. (100)

> Nonetheless, this much is obvious, that the trace left behind by something can be infinitely different from the thing itself so that it is finally almost impossible to guess the relationship between the trace and the shape of the thing whereby it was impressed.

Moritz has an image to illustrate what he means. That it is an image of the knife/tongue/hand should not surprise us. "So wie denn jede sich fortbewegende Spitze einerlei Spur zurücklässt, die übrige Gestalt des Dinges, woran sie befindlich ist, mag auch beschaffen seyn, wie sie wolle" (Just as every sharp point leaves behind one kind of trace, regardless of the shape of the rest of the thing of which it is a part).

[156]

The trace is a wound, the formally identical wound left by the *Spitze* of every beautiful work of art, picture or text, regardless of how it is otherwise constituted. In fixing now on the wound and the knife that creates it, Moritz effectively abstracts from the material individuality that seemed to enjoy protection in his utopian system of reference. It appears that works of art are related to one another through a common wound and that that wound is considerably more interesting than what each of them is in itself.

Moritz's abstracting thrust does not stop here, however. He goes on to take a further step that corresponds to the move from *Bild* to *Bildung*, and once again seems to anticipate Kant's *Kritik der Urteilskraft*. The superimposition of all traces, the one self-identical trace, in other words, affords the recognition of something (*etwas*) "das bloss die reinsten Verhältnisse in sich fasst, nach welchen das ganz von einander Verschiedene sich um und zu einander bewegt" (100; that only comprehends the purest ratios in itself, according to which the entirely differentiated moves around and to each other). In Kant's *Kritik der Urteilskraft*, this "something" is pursued in the "Analytik des Schönen," where the strictly formal features of the aesthetic judgment are analyzed in complete indifference to the object of the judgment. Moritz, however, remaining true to his concept of autonomous description, sees the formal conditions of seeing described in the human eye, and most particularly, though he does not say so, in Goethe's eye. It is no longer *Bild* that is beautiful, but the *Bildung* that made the *Bild* possible in the first place.

> Nun giebt es aber in der ganzen Natur keine so sanften und reinen Bewegungen von Linien um und zu einander, als in der Bildung des Auges selbst, in dessen umschatteter Wölbung Himmel und Erde ruht, während dass es das Allerverschiedenste in seinen reinsten Verhältnissen in sich fasst. —
>
> Daher kömmt nichts unter allem Sichtbaren dem Sehenden selbst an Schönheit gleich, und die sanfte Spur des Sehenden in seine ganze Umgebung verhältnissmässig eingedrückt, ist von allem Sichtbaren allein vermögend, uns *unmittelbar* Liebe und Zärtlichkeit einzuflössen. (100–101)

> Now there is in all of nature no such gentle and pure movements of lines around and to each other as in the formation of the eye itself, in whose shaded dome heaven and earth rest, while it grasps in itself the most diversified in its purest proportions. —
>
> That is why nothing among all visible things is equal in beauty to the seeing one himself, and the gentle trace of the seeing one

proportionately impressed onto his entire surrounding is, of all visible things, alone capable of flooding us immediately with love and tenderness.

Nothing is more beautiful than the seeing subject who impresses his "gentle trace" onto his entire surroundings. What else had Moritz meant when in his letter to Goethe he wrote: "[I]ch sehe dann die Welt gewissermassen in Ihrem Auge, und wunsche auch Ihr Auge zu sehen, welches alle die Schönheiten, die ich hier um mich her erblicke, so oft in sich gefasst, und in sich vereinigt hat" (I then see the world to some extent in your eye, and wish also to see your eye, which so often grasped in itself and united in itself all the beauties that I perceive around me here)? There is nothing more beautiful than seeing Goethe see, or better yet—though once again, Moritz is silent about this—than being seen by Goethe, feeling his eye wound you.

Moritz calls it "die sanfte Spur des Sehenden" (the gentle trace of the seeing one) and speaks of "Liebe und Zärtlichkeit." These, he says, are the basis for the enjoyment of the beautiful, "der Genuss des Schönen." The genitive is now entirely ambiguous, subject and object profoundly confused. The enjoyment of the beautiful means Goethe's *Genuss*, for he is, as seeing subject, the most beautiful. What is being replayed here in gentle mesmerized language is the violent rape scene that began the essay. Held by Goethe's gaze, wounded by his eye, Moritz sings an incongruous Magnificat:

> Und wo könnten auch wohl die unzähligen Widersprüche, die wir im Kleinen und im Grossen wahrnehmen; der Druck der Ungleichheit, die Entzweiung des Gleichen; der Raub des Eingreifenden, der Neid des Ausschliessenden; die Verdrängung des Mächtigen, die Rachsucht des Verdrängten; die Empörung des Niedrigen; der Fall des Erhabenen; und alle die gegen einander streitenden Kräfte sich endlich in eine sanftere Harmonie verlieren, als in den reinsten Verhältnissen der Bildung, welch zuletzt alle diese Widersprüche in sich selber auflösst und vereinigt? (101)

> And where indeed could the countless contradictions which we perceive in small and large things; the pressure of inequality, the division of the equal; the theft of the intruder, the envy of the excluding; the oppression of the mighty, the thirst for vengeance of the oppressed; the outrage of the lowly; the fall of the sublime; and all the forces that struggle against each other—where could they finally lose themselves

in a gentler harmony than in the purest proportions of the formation which finally dissolves and unifies all these contradictions in itself?

Plainly this song looks back on the stories of Philomela, Virginia, and the wife of Collatinus. All injustice, Moritz would have us believe, and that includes the injustice he suffered, is formally and aesthetically absorbed in a Goethe-like gaze. But such an assertion is in plain contradiction with the argument that has developed around the image of the knife. This Goethe-like gaze *is* the injustice; it *is* the tyrannical violation of the individuality of person and thing. And Moritz, unbeknownst to Goethe (and himself), was able, like Philomela, to weave into his text an image in words of the face of his assailant.

The reconciliation of all contradictions is visibly duplicated, according to Moritz, in a human face where the eyes predominate. Moritz describes a monumental, almost architectural physiognomy. As such it rivals any, and especially Winckelmann's, description of the Laocoon or Apollo. At the same time, this face is the *prosopon* of the hypogram, its features underscored to produce an image of Goethe's face in the place where Theseus was woven into Philomela's cloth.

> Wo das Auge, durch die höchste und tiefste seiner Spuren, Stirn und Wange scheidend, den denkenden Ernst vom jugendlichen, lächelnden Leichtsinn sondert; indem es in dunkler Umschattung hinter dem Schimmer der Morgenröthe hervortritt, und durch die Wölbung von oben seinen Glanz verdeckt; während dass die Scheidung des Gewölbten über ihm in den einander entgegenkommenden Augenbrauen sich sanft zu einander neigend, die Wiedervermählung des Getrennten in jedem untergeordneten Zuge vorbereitet, und der ganzen sich herabsenkenden Umgebung, bis zu den Spitzen der Zehen, die immerwährende Spur von Scheidung und von Wölbung eindrückt.
>
> So sinkt die erhabne Wölbung der Stirn, gerade da, wo sie durch das Emporragende zwischen Aug' und Wangen sich am merklichsten fortpflanzt, auf einmal, unbeschadet ihrer Hoheit, bis zu dem leisesten, verlohrensten Zuge des Mundes herab, dessen sanftgebogener Rand wiederum auf der stützenden Wölbung des Kinnes ruht, das durch sich selbst emporgetragen, und in sich ruhend, seinen eignen Umriss um sich selber zieht. (101–2)

> Where the eye, through the most sublime and deepest of its traces, dividing forehead and cheek, separates the thoughtful earnest from the youthful, smiling frivolousness; in that it strides forth in dark shadedness behind the shimmer of the dawn, and covers its skin from above through the arch; while the division of what is arched above it,

gently inclining to each other in the meeting of the eyebrows, prepares the remarriage of the separated in every subordinate feature, and in the entire downward sinking surrounding, right to the points of the toes, impresses the ever-enduring trace of division and overarching.

Thus the sublime arching of the forehead inclines, precisely there, where it continues through the tower between the eye and cheeks, all at once, without damaging its exaltedness, down to the softest most lost feature of the mouth, whose gently curved edge rests again on the supporting arch of the chin, that is carried up by itself and rests in itself, and draws its own contour around itself.

There are many things that could be said about this highly idiosyncratic instance of physiognomic description. In its basic structure of "Wölbung" (arch) and "Scheidung" (division) the face seems to be architecturally conceived, almost like a cathedral. But elements of landscape (a Winckelmannian inheritance) intrude ("Morgenröthe" [dawn] and "Umgebung" [surrounding]), as well as the notion of marriage ("Wiedervermählung"). Most striking, but most appropriate, is the recurrence of the *Spur*.

What does Moritz see when he sees Goethe's face above him? He sees an eye, not two eyes, but one, "das Auge." It is a physical fact that when one focuses on the eyes of another, one can focus on only one at a time. The eye is a decentered and duplicated center. "[D]ie höchste und tiefste seiner Spuren," its upper and lower outlines, divide forehead and cheek. The eye emerges from deep shadow into a sunrise (presumably the rosy cheek) but the eye's shine ("Glanz") remains covered by the arching brow. The eye is like a black sun.

The eyebrow gathers up this segment of the face dominated by the eye and inclines it toward its double, completing the upper half of the face. The dynamic of "Scheidung" and "Wölbung" played out here is the primary figure duplicated in the rest of the face and the body. Its enduring trace is imprinted everywhere. The nose draws a vertical line down between the eyes and cheeks (though Moritz is still reluctant to concede the plurality of the eyes: "zwischen Aug' und Wangen"), stopping at the mouth. Unlike Winckelmann's Apollo in one description where "Verachtung wohnet auf seinen Lippen" (derision rests on his lips),[51] Goethe's mouth is marked by "d[en] leisesten, verlohrensten Zug" (the softest, most lost feature of the mouth). In Goethe, *Verachtung* and every other threatening disposition are located in the eyes. The mouth rests on the chin, which rests in itself (again recalling a Winckelmannian phrase), drawing its own contour around itself. The face is complete and self-complete.

"In dieser sanften Hinabsenkung des Gewölbten," says Moritz, "wird endlich der trennende *Zwiespalt* selber doppelt und vierfach schön" (102; In this gentle inclining of the arched, the separating division itself becomes finally doubly and four-times beautiful). It is certainly not the primary meaning, but it is possible also to hear in the "Hinabsenkung" Goethe's descending on Moritz's bed. "Doppelt und vierfach schön"—this is what descended on Moritz. Goethe's face, divided once with a line drawn through the eyes, is "doppelt schön;" divided twice, with a line drawn between the eyes and along the nose, is "vierfach schön." The lines together form the cross. Moritz, like the eunuch, faced the agony of crucifixion. Aesthetic autonomy is purchased through the pain and suffering of the victim.

It is not surprising that Moritz concludes his physiognomy of Goethe's face with remarks about the *Ursprung*. The *Ursprung* in Winckelmann's aesthetics of beauty was seen to be *Unbezeichnung* or castration. In Lessing, it was the fear of the material body and death. For Herder, the *Ursprung* was Haller's *Reiz*, pain and the involuntary response to pain. In Goethe's essay "Über Laokoon," as we shall see, it is the sudden violent *Schlag*. In every case, the origin of beauty involves the pain of the body. For Moritz, the *Ursprung* is in Goethe's face: "Dieser *Ursprung* ist es, welcher durch keinen bestimmten Laut dem Ohre vernehmbar wird" (It is this origin which cannot become audible to the ear through any determinate sound). Remembering Philomela, it is not difficult to understand why the *Ursprung* cannot be spoken. What is then euphemistically described as "die *sichtbare* Auflösung des Widerspruchs in der sanftesten Trennung des Zusammengefügten" (the visible dissolution of the contradiction in the gentlest separation of the conjoined) is the initial rape and mutilation of her tongue. "[Die] innigste...Zusammenfügung des Getrennten" (the most inward conjoining of the separated) is the repeated rape perpetrated on her speechless, defenseless body.

At this point the essay entitled "Die Signatur des Schönen" ends. The original version of the essay, however, "In wie fern Kunstwerke beschrieben werden können?" continued with a vigorous attack on Winckelmann's manner of description. The language is surprising, though not unfamiliar. Moritz's basic criticism is that Winckelmann violates the ethical discretion required by the utopian system of reference.

> Umrisse *vereinigen*, Worte können nur auseinander sondern; sie schneiden in die sanfteren Krümmungen der Konturen viel zu scharf ein, als diese nicht darunter leiden sollten.

> *Winckelmanns* Beschreibung vom Apollo im Belvedere zerreisst daher das Ganze dieses Kunstwerks, so bald sie unmittelbar darauf angewandt, und nicht vielmehr als eine bloss poetische Beschreibung des Apollo selbst betrachtet wird, die dem Kunstwerke gar nichts angeht. (102–3)

> Contours *unify*, words can only separate; they cut into the more gentle curvings of the contours far too sharply for these not to suffer.
> *Winckelmann's* description of the Belvedere Apollo therefore rips apart the whole of this art work as soon as it is immediately applied to it, and not merely considered as just a poetic description of Apollo himself, which has nothing to do with the art work.

One last time the knife makes its appearance, now apparently in Winckelmann's hand. The words of his description mutilate and sunder the beautiful Apollo as Theseus did Philomela. We know, however, that it is for Moritz not really a question of images as opposed to words. His criticism of Winckelmann itself leaves the possibility open that the description may gather itself up, relinquishing the reference to the Belvedere Apollo, and thus become a work of art in its own right.

Moritz's unexpressed and unacknowledged rage against Goethe is deflected onto Winckelmann. He blames Winckelmann for what Goethe did to him. The problem is not with language. The problem is with vision, with the eyes of the seeing subject. The entire meaning of Moritz's essay can be expressed in a syllogism: Seeing is writing; writing is wounding; therefore, finally, seeing is wounding.

The title of the first essay asked "In wie fern Kunstwerke beschrieben werden können?" and seemed to answer that question with the attack on Winckelmann's manner of description. This attack, however, is omitted from the second version of the essay which, in its title "Die Signatur des Schönen," answers the question of the first. The answer, in other words, lies in the notion of *Signatur.*

What is "Die Signatur des Schönen?" It is Goethe's eye, looking at the victim, holding him in his gaze. It is Goethe's eye, raping the victim, inscribing on him his name, his signature. It is Goethe's "Sieg-Natur," Goethe's violent triumph over his victim. It is the hypogram, the depiction in the text of the crime that made the hypogram necessary and possible. It is, above all, the *hypographé*, the accusation, Laocoon's voice, Philomela's cloth—an accusation lodged on behalf of the body and against the tyranny of classicism.

6

Goethe:
Laocoon and Allegory

[D]as Medizinische reizte mich.

Goethe

O ur reading of Moritz's "Die Signatur des Schönen" has placed Goethe in an unaccustomed and lurid light. The face which appeared in the weave of Moritz's text is that of a fantasmatic Goethe, a distorted and exaggerated signifier of grotesque aesthetic desire. While this picture serves as a corrective to the image of Goethe as grand humanist, it is also necessarily one-sided in the extreme. A more balanced picture of Goethe's aesthetics, acknowledging both its anti-humanist thrust as well as its masterful rewriting of predecessor texts, emerges from a reading of Goethe's "Über Laokoon."

This last major text on the Laocoon appeared in 1798 in the first issue of the short-lived journal *Die Propyläen*, jointly edited by Goethe and his friend Heinrich Meyer. Goethe first saw a copy of the statue in Mannheim in 1769, shortly after becoming acquainted with Herder in Strassbourg. Thus *Dichtung und Wahrheit*, Goethe's autobiography, reports a sequence of events that includes close observation of Herder's suffering in connection with the surgery to correct his tear duct; the reading of the manuscript of the *Abhandlung über den Ursprung der Sprache*; attending medical seminars at the clinic; and seeing the collection of antique plaster casts at Mannheim. If at the beginning of our study such a juxtaposition of undertakings may have seemed alienating, it is by now very familiar.

Goethe saw the original statue in 1786/7, during his extended Ro-
man sojourn, but, surprisingly, there is absolutely no mention of it in
either his correspondence or his *Italienische Reise*. It was not until 1798
that Goethe wrote publicly about the Laocoon. The timing is significant:
never before had the statue left Rome or not been available for the public
to view. Napoleon's terms for peace in the Treaty of Tolentino (1797)
had included the transport to Paris of not only the Laocoon, but also the
Belvedere Apollo and the Torso, not to mention Raphael's tapestries. Thus
the most significant works of the classical heritage had been summarily
appropriated by the forces released by the French Revolution. Goethe
counters Napoleon's move by erecting a Laocoon in language.

The immediate context for Goethe's essay, however, was an article by
Aloys Ludwig Hirt, whom Goethe first met in Rome. Goethe himself urged
Schiller to publish it in *Die Horen*, where it appeared in 1797. Address-
ing the perennial question, Hirt contends that Laocoon does not scream
because he is unable to, being physically overcome by the snake's poison
and on the verge of death. Hirt employs a decidedly medical vocabulary,
furnishing a description that more resembles a pathologist's report than an
art historical treatment:

> Laokoon schreit nicht, weil er nicht mehr schreien kann. Der Streit
> mit den Ungeheuern beginnt nicht, er endet: kein Seufzen erpresst
> sich aus der Brust, es ist der erstickende Schmerz, der die Lippen des
> Mundes umzieht, und der letzte Lebenshauch scheint darauf fortzu-
> schweben. Der Kampf hat die äussersten Kräfte des Elenden erschöpft:
> nicht der Biss der Schlange tötet ihn langsam, mächtiger schon als
> das Gift wirkte das Entsetzen, das kraftlose Widerstreben, der An-
> blick seiner ohne Rettung verlorenen Kinder. Das Geblüt, welches
> mit voller Empörung gegen die äussern Teile dringt, und alle Gefässe
> schwellen machet, stocket den Umlauf, und verhindert das Einatmen
> der Luft: die Lunge, durch die Häufung und gedrängte Zirkulation
> des Blutes wird immer gedehnter; das ätzende Gift von dem Bisse
> der Schlange hilft die heftige Gärung beschleunigen; eine erstickende
> Pressung betäubt das Gehirn, und ein Schlagfluss scheinet den Tod
> plötzlich zu bewirken.[1]

Laocoon does not scream because he no longer can. The struggle with
the monsters is not beginning, it is ending: no sigh is pressed from
the breast, it is the asphyxiating pain, that surrounds the lips of the
mouth, and the last breath of life seems to hover there. The battle has
exhausted the most extreme powers of the miserable one: it is not the
snakebite that slowly kills him, more powerful than the poison is the
effect of the horror, the powerless resistance, the sight of his children

lost without rescue. The blood, which is in full rebellion and presses against the exterior parts, and causes all the vessels to swell, halts the circulation, and prevents the breathing of air: the lungs, through the mounting pressure and throttled circulation of the blood, become ever more dilated; the corrosive poison of the snake bite hurries the violent process; an asphyxiating pressure numbs the brain, and a stroke seems suddenly to bring about death.

The precise and explicit details of his description are in the service of what Hirt calls "Charackteristik," an incipient theory of realism. Goethe's "Über Laokoon" does not refer to Hirt by name, though it does address issues raised by him; nor does Goethe consider him a serious rival—indeed, a later contribution to *Die Propyläen*, "Der Sammler und die Seinigen," has him appear on the scene as an impolite, dogmatic, and somewhat stupid individual, no match for the arguments of Schiller and other admirers of Goethe. Nonetheless, it should be noted that Goethe is in agreement with Hirt as to the appropriateness of a medical model for interpreting the statue. As we shall see, what disturbs Goethe about Hirt's diagnosis is, first, that it is medically incorrect and, second, that it is at odds with the aesthetic demands of beauty.

The primary background for "Über Laokoon" is, of course, the major aesthetic and art historical discourse which we have charted in our readings of Winckelmann and Lessing, Herder and Moritz. The editors of the Munich edition of Goethe's works call the essay an " 'Intertext' par excellence,"[2] correctly calling attention to the sense in which "Über Laokoon" reinscribes the terms of the discourses that preceded it. Winckelmann's "edle Einfalt, stille Grösse" returns, as does Lessing's concept of the fertile moment. Goethe is fascinated by the Hallerian *Reiz* of the snake's bite. As for Moritz, in Goethe's "Über Laokoon" we encounter the victor's, not the victim's, discourse. Goethe, as it were, rewrites the texts of his predecessors.

Goethe's essay is frankly different. In all the other texts we have read, we have seen how a classical or classicizing discourse is intersected at its center by an entirely heterogenous discourse (concerning castrati, philological debate and fear of death, Hallerian physiology, and rape). The intruding discourse has the effect of casting classicism in a new and troubling light; the image of the Laocoon is set in meaningful juxtaposition to pictures of anatomy lessons, crucifixions, torture, and animal experimentation. Goethe's "Über Laokoon," on the other hand, is able to admit these and other discourses without becoming other than it is or wants to be. In other words, Goethe's essay is resistant to the subversion effected in the others.

The reason for this resistance is that Goethe's essay itself is profoundly anti-classical and requires no subversive reading to show it. There is no classical center in this essay; the heterogenous discourse is its center. One could say that Goethe's text confirms and authorizes our readings of his predecessors. We shall see that Goethe openly avows that pain is the origin of the statue's beauty, and that he examines the formal structure of pain with all the precision of Haller in the clinic. In other words, there is no evidence of a fear of the body in Goethe's text. Goethe's arguments and reinscriptions of classical aesthetic discourse loop and coil around this unclassical center and origin like the snakes in the statue. The result is that the statue itself, so long the epitome and model of classical beauty and art, becomes in Goethe's text not only an allegory (as opposed to a symbol), but an allegory of the entire discussion that for fifty years was carried out under its name.

In the beginning of the essay, Goethe argues that all the aesthetic qualities of an ideal work of art can be found in the Laocoon, just as, conversely, they could be deduced from the statue. Two of these qualities deserve particular attention: *Ideal* and *Anmut*. Our analysis will show that they correspond to the two terms of the *ut pictura poesis*. *Ideal*, which will be treated first, is analogous to *pictura*, understood not as beauty, but as the stark presence of the visual. To see it is to see pain and experience *Schrecken*. The pain, however, is covered and rendered harmless by *Anmut*, which will be treated second. *Anmut* is the visual representation of the story, of the linguistic sign. It produces or amounts to the distance, the difference and the temporal delay between the stark presence of the pain and its healed representation as a visual allegory. Story is the antidote to pain. For this reason *Anmut* corresponds to the term *poesis*. The third section of this chapter reads the two moments of Goethe's Laocoon as allegory. The final section gives Karl Philipp Moritz, and not Goethe, the last word on Laocoon.

1

We begin with *Ideal*. Goethe writes:

> *Ideal.* Um hierzu gelangen, bedarf der Künstler eines tiefen, gründlichen, ausdauernden Sinnes, zu dem aber noch ein hoher Sinn sich gesellen muss, um den Gegenstand in seinem ganzen Umfange zu übersehen, den höchsten darzustellenden Moment zu finden und ihn also aus seiner beschränkten Wirklichkeit herauszuheben und ihm in einer idealen Welt Mass, Grenze, Realität und Würde zu geben.[3]

To achieve ideal presentation, the artist must be profound, thorough, and persevering in his endeavors. Yet he must also possess the intellectual breadth to grasp his subject fully and to find the best moment to be portrayed. Such an artist can raise his subject above the limitations of the here and now and make it part of an ideal world, lending it the restraint, moderation, immediacy and dignity that befit this ideal world.

The ideal is not usually understood in relation to the selection of the highest and most appropriate moment for representation. The eighteenth century generally saw the ideal as the result of the artistic movement away from and beyond the particularity of nature. Versions of this ideal were evident in Winckelmann's *Unbezeichnung* and Lessing's euphemism. Goethe makes a gesture in this direction when he says: "Die Bildhauerkunst wird mit Recht so hoch gehalten, weil sie die Darstellung auf ihren höchsten Gipfel bringen kann und muss, weil sie den Menschen von allem, was ihm nicht wesentlich ist, entblösst" (78; Sculpture deserves our high esteem because it can and must achieve ultimate perfection in the representation of its subject, since it divests man of all inessential elements; 17). But whereas Winckelmann or any of his epigones might have gone on to talk about the naked body in Greek sculpture, Goethe takes "entblösst" and "entkleidet" in a curious, metaphorical way:

> So ist auch bei dieser Gruppe Laokoon ein blosser Name; von seiner Priesterschaft, von seinem trojanisch-nationellen, von allem poetischen und mythologischen Beiwesen haben ihn die Künstler entkleidet, er ist nichts von allem, wozu ihn die Fabel macht: es ist ein Vater mit zwei Söhnen, in Gefahr, zwei gefährlichen Tieren unterzuliegen. (78)

> Laocoon lends only his name to the sculpture, since the artists have stripped him of his priesthood, his Trojan nationality, and of all poetic and mythological attributes. He is not Laocoon as portrayed in fiction, but simply a father who, together with his two sons, is about to fall prey to two deadly serpents. (17)

The moment of the attack of the snakes has been abstracted from its story in Vergil and other sources—"aus seiner beschränkten Wirklichkeit [herausgehoben]"—and absolutized, in a sense, set free from its narrative constraints. In other words, Goethe seems to oppose the ideal to history, and not to nature. It is true that Goethe's "tragische Idylle," as he would call the Laocoon, still has a before and presumably an after: "ein Vater schlief neben seinen beiden Söhnen, sie wurden von Schlangen umwunden

und streben nun, erwachend, sich aus dem lebendigen Netze loszureissen"
(81; A father was sleeping next to his two sons; they were attacked by two
snakes, and, now awake, they are trying to extricate themselves from this
reptilian net; 17). Goethe will deal with this problem later.

The independence or, if you will, the autonomy of the moment is
important to Goethe. It is on this score that he diverges, too, from Lessing's
concept of the pregnant or fertile moment (*der fruchtbare Moment*). For
Lessing, as we saw, the moment that the visual artist should choose to
represent is everything but autonomous. He would have the artist select
a moment that is subordinate in terms of both chronology and expression
to a subsequent and more expressive moment. This superior and dominant
moment, if represented, would bind the imagination as the snakes have
bound Laocoon. The subordinate moment, on the other hand, is fertile
exactly in so far as it permits the imagination to pass beyond it in the
direction of the most expressive one: "Dasjenige aber nur allein ist frucht-
bar, was der Einbildungskraft freies Spiel lässt" (That alone is fertile which
allows the imagination free play.)[4]

Putting Lessing's argument into semiotic terms, it is clear that he sees
the visual representation as a sign to be read and quickly transcended. The
pleasure that the viewer experiences comes from the suggestive restraint
of the representation, the fact that the artist did not represent the most
expressive moment but leaves the beholder free to do so. If the sculpture or
painting were so tasteless as to represent the strongest, final, most extreme
moment (i.e., Laocoon's scream or his death), the beholder would be
forced to linger with the sign:

> alle solche Erscheinungen, sie mögen angenehm oder schrecklich sein,
> erhalten durch die Verlängerung der Kunst ein so widernatürliches
> Ansehen, dass mit jeder wiederholten Erblickung der Eindruck
> schwächer wird, und uns endlich vor dem ganzen Gegenstande ekelt
> oder grauet.[5]

> All such appearances, they may be pleasant or horrifying, acquire
> through the prolongation of art such an unnatural aspect that with
> every repeated glance the impression becomes weaker, and we are
> finally disgusted or repelled by the entire object.

And, indeed, in the chapter on Lessing, we established the deep-rooted and
fundamental abhorrence of the materiality of the sign that shapes his aes-
thetics. It should be added that what Lessing supposes to be accomplished
by choosing the fertile moment, that is, manifesting restraint and good
taste, is important for Goethe also, only he has the same accomplished by

Anmut, as we shall see. But whereas Lessing's restraint amounts to a kind of invisibility, in Goethe both pain and, even more, its antidote are visible.

The fertile moment is substantially different for Goethe in "Über Laokoon." We have already determined that a certain autonomy is attributed to the moment in so far as it is abstracted from its story. More than that, though, Goethe sees art to be most challenged when it undertakes to represent the most violent, most extreme moment, the moment Lessing abhorred. Continuing his radical revision of Lessing's text, he picks up another of Lessing's ideas, namely that the chosen moment be a transitory one. Goethe calls it "ein vorübergehender Moment" (81; a passing moment). It is transitory, however, not in that it quickly gives way to other moments, or that it is interpretively consumed by the beholder. It is transitory as *fixed* transitoriness, as the moment of radical and violent change from one condition to another: "der höchste pathetische Ausdruck, den sie [die Kunst] darstellen kann, schwebt auf dem Übergange eines Zustandes in den andern" (83; the most sublime expression of pathos which art can achieve is to be found in the transition from one condition to another; 21). Whereas Lessing understood *Ausdruck* and the fertile moment to be essentially at odds, Goethe practically collapses them and understands them to be one and the same.

Goethe provides a series of striking images to illustrate his notion of the moment as *Übergang*. Of the Laocoon he says: "wie sie jetzt dasteht, ist sie ein fixierter Blitz, eine Welle, versteinert im Augenblicke, da sie gegen das Ufer anströmt" (81; I would describe the statue as a frozen lightning bolt, a wave petrified at the very instant it is about to break upon the shore; 18). While the first image concentrates on the suddenness that is fixed in stone, the second joins the suddenness to the violence of an impact, thus anticipating the further images that occur four paragraphs later:

> Man sehe ein lebhaftes Kind, das mit aller Energie und Lust des Lebens rennt, springt und sich ergötzt, dann aber etwa unverhofft von einem Gespielen hart getroffen oder sonst physisch oder moralisch heftig verletzt wird: diese neue Empfindung teilt sich wie ein elektrischer Schlag allen Gliedern mit, und ein solcher Übersprung ist im höchsten Sinne pathetisch, es ist ein Gegensatz, von dem man ohne Erfahrung keinen Begriff hat. (83)

> A good example would be a child running along, full of vitality and joy of life, who is suddenly struck hard by a playmate, or otherwise hurt physically or emotionally. The new sensation has the impact of an electric shock on his entire body. This moment of sudden transition has

genuine pathos and can only be appreciated fully if one has experienced it. (20)

This example and Goethe's use of the word "Gegensatz" remind us of the dialectic of expression as it was developed in Winckelmann's discussion of the Laocoon in the *Gedancken über die Nachahmung*. Two moments, one peaceful (*Ruhe*), the other violent (*Schmerz*), are brought together, but not in a struggle for concealment, as in Winckelmann, but to achieve instantaneous and extreme visibility.

Goethe's image is clearly bent on effect. The readers are invited, much more told to create their own image according to Goethe's instructions. Not only is the child to be imagined as running, but an excess of detail is added to heighten the pathos. Suddenly the child is violently struck, "hart getroffen," "heftig verletzt," unintentionally perhaps ("etwa unverhofft") or maybe metaphorically ("moralisch . . . verletzt"); the effect is the same: the reader winces in sympathetic pain. The point is that the impact, like "ein elektrischer Schlag," is violent, all-consuming, absolute.

If the track that the running child follows is his narrative path (time/ *poesis*), the abrupt, violent interruption of his course (visibility/*pictura*) throws all that preceded the impact into relative meaninglessness. All that is still required is the sense or trace of motion which is brought to a painful halt, just like the wave that crashes against its bank. There is no chronology of effects; the impact and the reaction to it are immediate and total.

The "elektrischer Schlag" significantly picks up both the image of lightning as well as the crashing wave. It also reintroduces the discourse of medicine insofar as Haller, as we may remember, also applied electric shock as a *Reiz*, and for the same purpose, to attain maximum visibility of the body.[6] The *Schlag* is yet another instance, perhaps the most primary, of those moments of violence we have seen in the preceding chapters.

Another example, says Goethe, and an excellent subject for "eine sehr pathetische Statue" would be Eurydike, "die im Moment, da sie mit gesammelten Blumen fröhlich über die Wiese geht, von einer getretnen Schlange in die Ferse gebissen wird" (83; Another example would be Eurydice cheerfully strolling over the meadows, carrying the flowers she has picked, and suddenly stepping on a snake which bites her in the heel; 20). Of course, it is true that Eurydike died in this way. But the story does not matter, at least not for the purposes of the *Ideal*. The use of the word "fröhlich" belongs not at all to the story, but serves like the details in the image of the child to establish the motion and energy of her course. What matters is the structure of the sudden painful interruption of a happy, lively progress, what Goethe calls "der doppelte Zustand des

fröhlichen Vorschreitens und des schmerzlichen Anhaltens" (83; the dual condition of cheerful strolling and painful stopping; 20). Once again such a moment would fully determine its representation: Goethe sees not only the flowers falling, but the pain shooting through all her limbs and the movement frozen in the folds of her drapery.

The structure of the moment as impact and violent change has been established by Goethe's images and their analysis. The same structure is evident in the Laocoon; the *Schlag* takes the form of the snake biting Laocoon in his tender side. The interrupted motion is taken to be the powerful and noble struggle with the snake, broken off in the moment that the snake bites:

> Da sich nun noch in den Füssen, die gefesselt, und in den Armen, die ringend sind, der Überrest der vorhergehenden Situation oder Handlung zeigt, so entsteht eine Zusammenwirkung von Streben und Fliehen, von Wirken und Leiden, von Anstrengen und Nach-geben. (82)

> Since the fettered feet and wrestling arms indicate the situation or action immediately preceding, we have a combination of struggle and flight, activity and passivity, resistance and surrender. (18)

Here the opposition of *Ruhe* and *Schmerz* has been replaced by the sight of a struggling, active body giving way to become a suffering, passive body, and eventually a dead body. Even the bare story of the tragic idyll proves to be of no significance for the ideal moment. The *Schlag* is represented as a concentrated, immediate determining point:

> Um die Stellung des Vaters sowohl im ganzen als nach allen Teilen des Körpers zu erklären, scheint es mir am vorteilhaftesten, das au-genblickliche Gefühl der Wunde als die Hauptursache der ganzen Bewegung anzugeben. Die Schlange hat nicht gebissen, sondern sie beisst, und zwar in den weichen Teil des Körpers, über und etwas hinter der Hüfte.... [D]er Künstler hat uns eine sinnliche Wirkung dargestellt, er zeigt uns auch die sinnliche Ursache. Der Punkt des Bisses, ich wiederhole es, bestimmt die gegenwärtigen Bewegungen der Glieder: das Fliehen des Unterkörpers, das Einziehen des Leibes, das Hervorstreben der Brust, das Niederzücken der Achsel und des Haupts, ja alle Züge des Angesichts seh ich durch diesen augenblick-lichen, schmerzlichen, unerwarteten Reiz entschieden. (261)

> The best way to explain the father's position both in general and in detail ... is to say that the sudden pain from the bite is the primary

cause of his movement. The snake is just in the act of biting, and, what is more, biting a sensitive part of the body, above and just behind the hip [T]he artists have portrayed a physical effect together with its physical cause. I repeat, the location of the bite determines the present movement of the body: the evading motion of its lower part, the contraction of the abdominal muscles, the outward thrust of the chest, the lowering of the shoulder and the head. Even the facial expression is determined by this sudden, painful, unexpected stimulus. (18)

This description of the *Schlag* corrects Hirt's diagnosis of the statue. What is more significant is that the model for the *Schlag* is nothing other than Haller's experimental *Reiz: sinnliche Ursache—sinnliche Wirkung*. Goethe sees everything decided by "diesen augenblicklichen, schmerzlichen, unerwarteten Reiz" (this sudden, painful, unexpected stimulus). He reads Laocoon's body like a physiologist, as Haller would. And the *Schlag* or *Reiz*, to summarize the argument so far, is what he calls *das Ideal*, the absolute transitory moment when pain strikes to produce an extreme of total visibility.

2

The other important quality of all beautiful works of art and the Laocoon in particular is *Anmut*. Goethe admits that his assertion that the Laocoon exemplifies grace will surprise his readers: "Es wird manchem paradox scheinen, wenn ich behaupte, dass diese Gruppe auch zugleich *anmutig* sei" (77; Many readers will find it paradoxical if I maintain that the Laocoon group has grace as well; 16). How can the representation of extreme pain be *anmutig* at the same time?

This is what Goethe says about *Anmut* at the beginning of his essay:

Anmut. Der Gegenstand aber und die Art, ihn vorzustellen, sind den sinnlichen Kunstgesetzen unterworfen, nämlich der Ordnung, Fasslichkeit, Symmetrie, Gegenstellung etc, wodurch er für das Auge schön, dass heisst anmutig wird. (74)

The subject and the manner in which it is portrayed must, however, obey the physical laws of art: order, clarity, symmetry, positioning, and so forth, which render it beautiful to the eye, that is, aesthetically graceful. (16)

Anmut, to paraphrase Goethe, is a visual effect, concerning the exterior of the sign, the sign *as* sign, in other words, the "rhetoric" of art.

A paragraph later Goethe continues:

Jedes Kunstwerk muss sich als ein solches anzeigen, und das kann es allein durch das, was wir sinnliche Schönheit oder Anmut nennen. Die Alten, weit entfernt von dem modernen Wahne, dass ein Kunstwerk dem Scheine nach wieder ein Naturwerk werden müsse, bezeichneten ihre Kunstwerke als solche durch gewählte Ordnung der Teile, sie erleichterten dem Auge die Einsicht in die Verhältnisse durch Symmetrie, und so ward ein verwickeltes Werk fasslich. Durch ebendiese Symmetrie und durch Gegenstellungen wurden in leisen Abweichnungen die höchsten Kontraste möglich. Die Sorgfalt der Künstler, mannigfältige Massen gegeneinander zu stellen, besonders die Extremitäten der Körper bei Gruppen gegeneinander in eine regelmässige Lage zu bringen, war äusserst überlegt und glücklich, so dass ein jedes Kunstwerk, wenn man auch von dem Inhalt abstrahiert, wenn man in der Entfernung auch nur die allgemeinsten Umrisse sieht, noch immer dem Auge als ein Zierat erscheint. (77)

Every work of art must be identifiable as such; this is only possible if it exhibits what we call physical beauty, or grace. The artists of antiquity were not laboring under our present-day misconception that a work of art must appear to be a work of nature; rather, they identified their works of art as such by a conscious arrangement of components, employed symmetry to clarify the relationship among these components, and so made a work of art comprehensible. Through slight variations in symmetry and positioning the most effective contrast became possible, and their painstaking efforts to juxtapose diverse subjects and particularly to achieve harmonious positioning of bodily extremities in groups were most judicious and successful. As a result, each one of their works pleases the eye, even if we disregard the content or see it only in general outline from a distance. (16)

With these words Goethe announces a modification of the *mimesis* concept. Modern artists and theorists (and that includes Hirt and his notion of *Charakteristik*) failed to set off the artwork from nature. They could be accused of *blosse Nachahmung*. Goethe is, of course, not the first to make such an accusation. Quite the contrary; but previously the step past mere imitation had always been in the direction of the ideal (as we saw it at work in Lessing and Herder, for example). The artist strove for an intensification or purification of content and meaning. Goethe, however, focuses on the sign. *Anmut* marks the artwork as different from a natural object (*ein Naturwerk*). It organizes natural signs according to principles that are indifferent, to say the least, to the meaning of those signs. Hence his use

of the word *abstraction*:[7] "ein jedes Kunstwerk, wenn man auch von dem Inhalt abstrahiert, wenn man in der Entfernung auch nur die allgemeinsten Umrisse sieht, [erscheint] noch immer dem Auge als ein Zierat" (each one of their works pleases the eye, even if we disregard the content or see it only in general outline from a distance). The beholder can abstract form from content, can consider the sign apart from its object. A common experience is summoned, perhaps to make his new approach seem less radical: viewing the artwork from a distance where content is not yet discernible, only the form. And the form of the artwork, says Goethe, appears as *Zierat*.

We are still seeking the actual connection or interaction between pain and *Anmut* in the Laocoon. What relation is there between the intense local pain of the snake bite and the abstract configuration of the sculpture best perceived from a distance? The beginning of the entry for the word *Reiz* in Sulzer's *Allgemeine Theorie der schönen Künste* (1779) may help us: "Wir nehmen dieses Wort in der Bedeutung, für welche verschiedene unsrer neusten Kunstrichter das Wort Grazie brauchen" (We take this word in the meaning for which various of our newest art critics use the word *Grazie*).[8] In "Über Laokoon" the words *Reiz* and *reizen* occur some five or six times, but always in the sense of a stimulus, the *Schlag* in other words. *Reiz* in the sense of *Grazie* is what Goethe calls *Anmut*.

The fact that Goethe does not acknowledge the double meaning of the word *Reiz* should not mislead the reader into thinking that such an ambiguity is not at work in "Über Laokoon." In fact, the whole ambiguity of *Reiz* has been placed significantly in the nature of the snakes. The snake bites—*Reiz*. But the snakes also encircle the three figures of the statue, thus creating the abstract *Reiz* of the sculpture, what Goethe called *Zierat*. Indeed, the provocativeness of *Zierat* (*Zier* in its older poetic form) is doubled when we realize that *Zier* is an anagram of *Reiz*. As much as the one snake is responsible for the *Schlag*, the two of them together are responsible for the *Anmut* of the group. The snakes are, as Goethe says:

> Tiere . . . , die nicht als Massen oder Gewalten, sondern als ausgeteilte Kräfte wirken, nicht von *einer* Seite drohen, nicht einen zusammen-gefassten Widerstand fordern, sondern die nach ihrer ausgedehnten Organisation fähig sind, drei Menschen mehr oder weniger ohne Ver-letzung zu paralysieren. Durch dieses Mittel der Lähmung wird, bei der grossen Bewegung, über das Ganze schon eine gewisse Ruhe und Einheit verbreitet. (84)

> creatures which do not have to rely on large numbers or tremendous strength, but rather attack separately on separate fronts. Hence, con-centrated resistance is ineffective; indeed, the snakes, because of their

elongated bodies, are capable of rendering three people almost de-
fenseless without injuring them. As a result of the figures' immobility,
a certain sense of tranquillity and unity pervades the group despite all
movement. (20–21)[9]

The doubleness of the snakes is evident in this passage. They are dangerous
animals; they will kill their victims. Conditions in themselves unattractive,
Lähmung and *Paralysation*, terms from medical discourse, are incongru-
ously turned to the production of *Anmut*: "bei grosser Bewegung, eine
gewisse Ruhe und Einheit zu verbreiten" (a certain sense of tranquillity and
unity pervades the group despite all movement). That these terms crop
up in the discussion of *Anmut* shows how the medical model pervades
Goethe's entire Laocoon-aesthetics. What makes this possible is that both
senses of *Reiz*, no matter how contrary, are understood by Goethe in terms
of their physical materiality, and not in terms of meaning.

Thus the effect of the snakes is to produce *Anmut*. Consider, for
example, the following more general statement about the *Anmut* of the
Laocoon:

> Ich getraue mir daher nochmals zu wiederholen: dass die Gruppe des
> Laokoons, neben allen übrigen anerkannten Verdiensten, zugleich ein
> Muster sei von Symmetrie und Mannigfaltigkeit, von Ruhe und Bewe-
> gung, von Gegensätzen und Stufengängen, die sich zusammen, teils
> sinnlich, teils geistig, dem Beschauer darbieten, bei dem hohen Pathos
> der Vorstellung eine angenehme Empfindung erregen und den Sturm
> der Leiden und Leidenschaft durch Anmut und Schönheit mildern.
> (77–78)[10]

> Therefore, I say again that this work, in addition to all its other
> merits, is at one and the same time a model of symmetry and diversity,
> tranquillity and motion, contrasts and gradations. The viewer perceives
> these varied qualities as a whole that is partly physical, partly spiritual,
> and—because of the sublime pathos of the subject—they arouse plea-
> surable feelings and finally calm the storm of suffering and intense
> emotions with their grace and beauty. (17)

This passage resonates with echoes from Winckelmann, with the very
important difference that it is not "eine grosse und gesetzte Seele" that
achieves the "Ruhe und Einheit." Here Goethe states very explicitly what
happens to the pain or *Schlag*. "Hoher Pathos," "der Sturm der Leiden und
Leidenschaft," the *Schlag*, in other words, is transformed by *Anmut* and
Schönheit into something that stimulates "eine angenehme Empfindung"
(a pleasurable feeling). *Reiz* in the sense of pain is transformed into *Reiz* in

the sense of grace. It is almost as though the happy motion of the child so painfully interrupted by the *Schlag* is transferred to the beholder. Whereas the happy course of the child was the trace of a before in the present of a *Schlag*, the *Schlag* itself becomes the trace of a before in the present of the beholder's *angenehme Empfindung*. Remembering Goethe's abstracted story—a father and his sons were sleeping, snakes encircled them, now they struggle—the end of the story is displaced into the world of the beholder. The represented moment transformed by *Anmut* is fertile, then, insofar as the beholder becomes engaged by the grace of the representation. The end of the story is the beholder's interpretation of form. These remarks, it must be said, anticipate the discussion that will be pursued in the following section.

The snakes are the visual representation of *Anmut*, that is, the transformation of pain into *Ruhe und Einheit*. The snakes turn *Reiz* into *Reiz*. They accomplish this formally by encircling their victims. Thus it is important that the passage quoted above is immediately followed by a statement concerning *Geschlossenheit*: "Es ist ein grosser Vorteil für ein Kunstwerk wenn es selbständig, wenn es geschlossen ist" (78; It is a great advantage for a work of art to be self-contained, complete in itself; 17). A number of words meaning circular or enclosed then follow in quick succession: "in sich selbst geschlossen," "Zirkel," "Kunstkreis," "kleinere Zirkel," and "Kreis." At a later occurrence of the discussion of *Anmut*, Goethe writes: "und das Werk ist abgeschlossen" (84), and then once more he mentions "den Zirkel aller menschlichen Empfindungen" (86; the circle of all human feelings). In the final occurrence Goethe calls the Laocoon "das geschlossenste Meisterwerk der Bildhauerarbeit" (87; the most closed masterpiece of sculpture).

A work can be *geschlossen* in a variety of ways. The simple representation of a Zeus or Hera at peace, resting on and in itself, is *geschlossen* because it has no relation to the exterior world: "die nach aussen keine Beziehung haben" (78). Another sort of *Geschlossenheit* is achieved in the representation of smaller circles within the great circle of mythology. Goethe mentions Apollo and the Muses. Strangely he does not refer to the circle of the Graces, the circle of *Anmut* in the most literal sense. Turning to subjects that include an action of some kind, "zum Leidenschaftlich-Bedeutenden," Goethe distinguishes two sorts of *Geschlossenheit*. The first is the case where the figures in a group stand in some relationship of *Leidenschaft* to each other. Niobe and her children are mentioned as an example, a rather weak example. Goethe and Heinrich Meyer had together concluded from the shape of the bases of the individual sculptural representations of the Niobides that they once formed a half circle.[11] The theory

itself is not persuasive. Even if it were, the group only forms a half circle. Finally, the group as half circle refers to an absent Apollo and Diana who are threatening them, signifying a distinct openness.

In any event, the other sort of *Geschlossenheit* involves the simultaneous representation of cause and effect: the "graceful" boy bending to extract a thorn from his foot,[12] the wrestler (actually wrestlers), groups of fauns and nymphs, and, of course, the Laocoon—the snake's bite as cause, the effect seen in the limbs. A further sense in which the Laocoon is *geschlossen* has already been mentioned: the encircling of the snakes. Another sense is touched by Goethe when he identifies one of the sons as observer: "Hier ist also noch ein Beobachter, Zeuge und Teilnehmer bei der Tat, und das Werk ist abgeschlossen" (84; This son, then, plays the part of spectator, witness of the action and sympathetically involved onlooker, thus rounding out the work; 21).[13] The *Geschlossenheit* of the work of art, in other words, is being understood by Goethe as fundamentally relevant also to the relationship between artwork and beholder. Because of the inclusion of a spectator within the coils of the snake, the beholder on the outside may be effectively excluded. The validity of this conjecture remains to be seen.

"Es ist ein grosser Vorteil für ein Kunstwerk," said Goethe, "wenn es selbständig, wenn es geschlossen ist" (It is a great advantage for a work of art to be self-contained, complete in itself). What does Goethe mean by "selbständig?" For Hegel in his *Ästhetik*, the work that culminates and thinks through all the art historical and art theoretical efforts of the Germans beginning with Winckelmann, *Selbständigkeit* is an important property of the classical work of art. In a section entitled "Selbständigkeit des Klassischen als Durchdringung des Geistigen und seiner Naturgestalt," Hegel writes:

> Diese in sich freie Totalität, welche in dem ihr Anderen, zu dem sie sich fortbestimmt, sich selber gleichbleibt, das Innere, das in seiner Objektivität sich auf sich selbst bezieht, ist das an und für sich Wahre, Freie und Selbständige, das in seinem Dasein nichts anderes darstellt als sich selbst.[14]

> This inherently free totality remaining equal to itself in its opposite which becomes its own self-determination, this inner life which relates itself to itself in its object, is what is absolutely true, free, and independent, displaying in its existence nothing but itself.[15]

For Hegel, the *Selbständigkeit* of the classical work of art consists in the complete agreement, the completely adequate relation, if not identification,

of exterior and interior, of body and spirit, signifier and signified. This is most succinctly stated when he writes: "die klassische Schönheit hat zu ihrem Innern die freie, *selbständige* Bedeutung, d.i. nicht eine Bedeutung von irgend etwas, sondern das *sich selbst Bedeutende* und damit auch *sich selber* Deutende" (For classical beauty has for its inner being the free independent meaning, i.e. not a meaning *of* this or that but what means itself and therefore intimates [interprets] itself).[16] There is, according to Hegel, complete identity of content, form, and interpretation.

For Goethe, *Selbständigkeit* is equivalent to *Geschlossenheit*. Indeed, Hegel's tripartite identity itself would have to count as a kind of severe *Geschlossenheit*. In Hegel, however, this identity means at the same time the overcoming of all difference. *Geschlossenheit* and *Selbständigkeit* in Goethe's sense, on the other hand, are predicated on difference. Transformation, inversion, double-meaning—these form the structure of *Anmut*, which is to say, *Geschlossenheit* and *Selbständigkeit*, in Goethe's essay. The interior, the meaning of the Laocoon, as Hirt well knew, is the *Schlag*, the painful *Reiz*.[17] The exterior, the representation, however, is far from identical with its interior. The words traditionally used to praise and honor the noble heroism of Laocoon—*mildert sich, mässigt sich, bändigt sich*—have lost their reflexive quality and been attributed to the *anmutigmachende Behandlung*. If anyone in the group is to be praised in this respect, it is the snakes that by their encircling distribute *Ruhe* and *Einheit*, thus disarming the pain that would otherwise afflict the beholder.

By attributing the production of *Anmut* to the snakes, and identifying it with the human properties formerly the possession of the Trojan hero, Goethe opens himself to charges of anti-humanism or, to be somewhat anachronistic, formalism. He seems to be stating a disclaimer in advance when he writes:

> Fern aber sei es von mir, dass ich die Einheit der menschlichen Natur trennen, dass ich den geistigen Kräften dieses herrlich gebildeten Mannes ihr Mitwirken [im Kunstwerk] ableugnen, dass ich das Streben und Leiden einer grossen Natur verkennen sollte. (82–83)

> Far be it from me to dispute the unity of mind and body. I do not deny the role of the mind in this splendid physique, nor do I fail to recognize the struggle and suffering of a great spirit. (20)

But that is precisely what he does.

> Angst, Furcht, Schrecken, väterliche Neigung scheinen auch mir sich durch diese Adern zu bewegen, in dieser Brust aufzusteigen, auf dieser

Stirn sich zu furchen; gern gesteh ich, dass mit dem sinnlichen auch das geistige Leiden hier auf der höchsten Stufe dargestellt sei [subjunctive distance]; nur trage man die Wirkung, die das Kunstwerk auf uns macht, nicht zu lebhaft auf das Werk selbst über, besonders sehe man keine Wirkung des Gifts bei einem Körper, den erst im Augenblicke die Zähne der Schlange ergreifen, man sehe keinen Todeskampf bei einem herrlichen, strebenden, gesunden, kaum verwundeten Körper. (83)

I do see that anxiety, fear, terror and paternal love rush through this man's veins, grip his heart and furrow his forehead, and I gladly admit that mental as well as physical suffering are portrayed to perfection. Yet, we must be careful not to confuse the effect the work of art has on us with the work itself. In particular, we should not imagine seeing the effect of a venom in a body which is only at this moment feeling the snake's fangs. We must not imagine a death struggle taking place in the splendid writhing healthy body which is scarcely wounded. (20)

Here Goethe responds most directly to Hirt's description of Laocoon as poison-ridden and death-crazed. Goethe sketches the path of Hirt's misreading. Hirt transferred the effect (*Wirkung*) that the artwork had on him, namely the pain of the *Schlag*, *back* to the artwork itself. In other words, he as beholder picked up the story, responded to pain himself, and then transferred the now advanced situation back to the statue. Goethe does not deny that a temporal line connects artwork and beholder, he only wants to show that Hirt chose the wrong path, the wrong temporal line. Hirt's last step is seen as *eine zu lebhafte Übertragung*, a phrase that reverses the deadly effects of the poison and suggests that Goethe's contrary treatment of the statue might be such as to render it dead. Hirt's problem is that he entirely refuses to see that *Anmut* has transformed pain and created another path for the reader/beholder to pursue. In the process, however, the following has occurred: the Laocoon, to pose the problem in a word, is no longer identical with itself. The Laocoon, so long the epitome of the classical work of art, has in Goethe's hands become a riddle, an allegorical sign.[18] This is the final sense of Goethe's saying that the Laocoon is "das geschlossenste Meisterwerk der Bildhauerarbeit" (the most closed masterpiece of sculpture).

3

William Hogarth is primarily known as the most prominent original engraver of the eighteenth century. In 1753, however, he published an aesthetic treatise entitled *The Analysis of Beauty*, in which he claimed

to have discerned the fundamental principle of beauty, known to great artists in practice from ancient times to his own, but never laid down in a theoretical treatise. There is beauty in a single type of line, he says, the serpentine line, called the line of beauty when it occurs in two dimensions and the line of grace when it occurs in three. The line of grace is an "S" shaped line that moves through and dominates the other lines within a pyramidal composition. One of his examples for illustrating the line of grace within the pyramid was the Laocoon.

Hogarth's *Analysis* appeared in a German translation within months of the English edition. It was translated by Christlob Mylius, a former medical student, playwright and journalist; a friend of Lessing, and protegé of Albrecht von Haller as well as Sulzer. Indeed, Haller and Sulzer unwittingly financed the translation. Mylius called it *Die Zergliederung der Schönheit* and rendered "line of grace" as "Linie des Reizes," thus underscoring elements of medical discourse latent in the English. Our reading of Goethe, who like many Germans of the eighteenth century was well acquainted with Hogarth's treatise, is showing what the "Linie des Reizes" might mean.

In chapter 5 of the *Analysis*, entitled "Of Intricacy," Hogarth lets loose a fascinating series of analogies all based on the structure of pursuit, which, in turn, is based on the line of grace. It is worth quoting at length:

> The active mind is ever bent to be employ'd. Pursuing is the business of our lives; and even abstracted from any other view, gives pleasure. Every arising difficulty, that for a while attends and interrupts the pursuit, gives a sort of spring to the mind, enhances the pleasure, and makes what would else be toil and labor, become sport and recreation.
>
> Wherein would consist the joys of hunting, shooting, fishing, and many other favourite diversions, without frequent turns and difficulties, and disappointments, that are daily met with in the pursuit?—how joyless does the sportsman return when the hare has not had fair play? how lively, and in spirits, even when an old cunning one has baffled, and outrun the dogs!
>
> This love of pursuit, merely as pursuit, is implanted in our natures, and design'd, no doubt, for necessary, and useful purposes. Animals have it evidently by instinct. The hound dislikes the game he so eagerly pursues; and even cats will risk the losing of their prey to chase it over again. It is a pleasing labour of the mind to solve the most difficult problems; allegories and riddles, trifling as they are, afford the mind amusement: and with what delight does it follow the well-connected thread of a play, or novel, which ever increases as the plot thickens, and ends most pleas'd, when that is most distinctly unravell'd?

> The eye hath this sort of enjoyment in winding walks, the serpentine rivers, and all sorts of objects, whose forms, as we shall see hereafter, are composed principally of what, I call, the *waving* and *serpentine* lines.
>
> Intricacy in form, therefore, I shall define to be that peculiarity in the lines, which compose it, that *leads the eye a wanton kind of chace*, and from the pleasure that gives the mind, intitles it to the name of beautiful: and it may be justly said, that the cause of the idea of grace more immediately resides in this principle, than in the other five, except variety; which includes this, and all others.[19]

Underlying Hogarth's analogies is a notion of *ut pictura poesis*. Beginning with the action of the chase and the plot of a novel or drama, all, as we know from Lessing, temporal in their nature, he then adduces the static visual appearance of the winding path the hunted rabbit followed (Lessing's *nebeneinander*), and moves finally to the intricate (abstract) form of the serpentine line, his proud discovery, "that *leads the eye a wanton kind of chace*." The action of pursuit, that is to say temporality, has shifted from the scene itself to the eyes of the beholder, just as it did in Goethe's reading of the Laocoon.

Intricate form, according to the analogy, is the visual representation of plot, temporality made visible. Intricate form is visual allegory. And intricate form is grace: "it may be justly said, that the cause of the idea of grace resides more in this principle, than in the other five." The close kinship between the Hogarth of the *Analysis* and the Goethe of "Über Laokoon" is astonishing.

Goethe's entire discussion of *Anmut* has been about intricate form and exactly in Hogarth's sense. The Laocoon "[erscheint] dem Auge als Zierat" (77; appears as an ornament to the eye; 16). Goethe talks about "die schönsten Beispiele einer symmetrisch künstlichen, den Augen gefälligen Zusammensetzung" (77; the most beautiful examples of a symmetrically artful, eye-pleasing composition; 16). The eye pursues the waving and serpentine lines, whether it be the snakes as they encircle their victims or the lines as they become evident in the bodies of the three figures. Such a visual engagement is like the enjoyment the eye has "in winding walks and serpentine rivers." The eye, in a sense, takes the walk; the eye, in responding to form, completes the path interrupted by the *Schlag*. It completes, as I mentioned above, the story that was broken off. The narrative, the plot of the Laocoon, beginning peacefully in sleep, then becoming a muscular striving that is violently struck, stopped dead, is resumed by the beholder's eye and, by analogy, the allegorist's interpretation as the appropriate response to intricate form. Goethe's essay circles round the sculpture like the

snakes round the priest. In Goethe we find the beginnings of the allegorical interpretation of the Laocoon that is the counterpart of its intricate form.

The Laocoon became an allegorical sign the moment it was no longer self-identical nor self-interpreting. Interior and exterior are not only different, they are at odds. *Anmut* transforms the extreme visibility of the *Schlag* into a sort of linguistic sign in so far as it introduces distance, difference, and delay. (We might remember Herder's distinction between the tactile lover and the visual beholder; the distance maintained by the latter has the effect of transforming the three-dimensional statue into the two dimensional angularity of a letter from the alphabet.) This necessarily generates confusion since the meaning of the Laocoon is no longer clear. Goethe's reading of the statue culminates in a frankly allegorical interpretation. The remarkable thing is that what for Goethe is allegorically depicted in the Laocoon is the *ut pictura poesis* resolved.

Here is Goethe's interpretation:

> Der Mensch hat bei eignen und fremden Leiden nur drei Empfindungen: Furcht, Schrecken und Mitleiden, das bange Voraussehen eines sich annährenden Übels, das unerwartete Gewahrwerden gegenwärtigen Leidens und die Teilnahme am dauernden oder vergangenen— alle drei werden durch dieses Kunstwerk dargestellt und erregt, und zwar in den gehörigsten Abstufungen.
>
> Die bildende Kunst, die immer für den Moment arbeitet, wird, sobald sie einen pathetischen Gegenstand wählt, denjenigen ergreifen, der Schrecken erweckt, dahingegen Poesie sich an solche hält, die Furcht und Mitleid erregen. Bei der Gruppe des Laokoons erregt das Leiden des Vaters Schrecken, und zwar im höchsten Grad, an ihm hat die Bildhauerkunst ihr Höchstes getan. Allein teils um den Zirkel aller menschlichen Empfindungen zu durchlaufen, teils um den heftigen Eindruck des Schreckens zu mildern, erregt sie Mitleiden für den Zustand des jüngern Sohns und Furcht für den ältern, indem sie für diesen auch noch Hoffnung übriglässt. So brachten die Künstler durch Mannigfaltigkeit ein gewisses Gleichgewicht in ihre Arbeit, milderten und erhöhten Wirkung durch Wirkungen und vollendeten sowohl ein geistiges als ein sinnliches Ganze. (86)

A human being reacts with only three kinds of emotion to his own suffering or that of others: fear, terror and pity, that is to say anxious anticipation of approaching evil, sudden awareness of present suffering and compassion for present or past suffering. All three reactions are represented as well as evoked by this work, and they are portrayed with appropriate gradations. Since plastic art always aims at portraying one particular moment, the artist who chooses a tragic subject will always

select the one that evokes terror. Literature, on the other hand, prefers subjects that evoke fear and pity. In the Laocoon group, the father's suffering evokes terror, indeed in the highest degree—sculpture has here reached its pinnacle in achieving this end. However, partly in order to have the viewer experience the whole gamut of emotions, and partly in order to soften the violent impact of terror, the artists evoke pity for the younger son and fear for the older by allowing a glimpse of hope for him. Through this diversity, the artists have managed to lend their work a certain balance; they have softened as well as strengthened one effect by means of other effects. And they have achieved a spiritual as well as a physical totality. (22)

Perhaps the first thing to strike the reader is the appearance suddenly of two terms that could only have come from Aristotle's *Poetics*: *Furcht* and *Mitleid*. "Die Poesie [hält] sich an solche [Gegenstände]..., die Furcht und Mitleiden erregen" (Literature prefers subjects that evoke fear and pity). Compare Aristotle: "Tragedy, however, is an imitation not only of a complete action, but also of incidents arousing pity and fear."[20] This English translation, however, veils a problem that Lessing had already pointed out. It concerns the Greek word *phobos*, here translated as fear, in German as *Furcht*. Wolfgang Schadewaldt notes that "Furcht...erst seit Lessing in Deutschland zur stehenden Wiedergabe von *phobos* geworden [ist]" (In Germany, fear has been the standard translation of *phobos* only since Lessing).[21] Indeed, before Lessing's interference, the translation sounded like this: "Die Tragödie...soll Mitleid und Schrecken erregen" (Tragedy should arouse pity and terror).[22] Lessing objects to the word *Schrecken* because of the suddenness and the immediacy it implies, qualities that he finds inconsistent with Aristotle's larger schema. *Schrecken* would amount to the stark presence of the visual sign, pain, in other words. Hence the change he proposes: "Das Wort, welches Aristotles braucht, heisst Furcht: Mitleid und Furcht, sagt er, soll die Tragödie erregen; nicht Mitleid und Schrecken" (The word which Aristotle uses is fear: pity and fear, he says, should be aroused by the tragedy; not pity and terror).[23]

Goethe's use of the two Greek words is consistent with Lessing's redistribution of them into three: *Mitleid*, *Schrecken*, and *Furcht*, even if opposed to his motive. *Mitleid* and *Furcht* belong to poetry; *Schrecken*, on the other hand, in Lessing's sense of sudden surprise and terror, belongs preeminently to the visual arts, "die bildende Kunst." *Schrecken* is the immediate response to the appearance of the *Schlag*. Should one raise the objection that Aristotle is talking about tragedy, about another species of visual representation, we find that Aristotle himself can be used in support of Goethe. Aristotle states: "The tragic fear and pity may be aroused by the

Spectacle; but they may also be aroused by the very structure and incidents of the play—which is the better way and shows the better poet. The Plot in fact should be so framed that, even without seeing the things take place, he who simply hears the account of them shall be filled with [fear] and pity at the incidents."[24]

Turning to Goethe's allegorical interpretation, we see that the three terms, forming a circle ("[der] Zirkel aller menschlichen Empfindungen"), thus reminding us of the *Geschlossenheit* or *Anmut* of the Laocoon, are at the same time distributed along a time axis. Reading left to right, the young son who is fully encircled by the snakes stands for an enduring or past condition, arousing "Teilnahme am dauernden oder vergangenen [Leiden]" (sympathy for enduring or past suffering). The father stands for "das unerwartete Gewahrwerden gegenwärtigen Leidens" (the unexpected awareness of present suffering), for *Schrecken* in other words. This *Schrecken* takes place in the present. The second son stands for "das bange Voraussehen eines sich annährenden Übels" (the fearful anticipation of an approaching evil), for *Furcht*, and at the same time for *Hoffnung* in so far as he is barely entangled and might still possibly escape. He represents the future. Interestingly, he was also identified by Goethe as the observer and witness, "Beobachter" and "Zeuge," that role which the beholder assumes in completing the story.

The co-presence of the poetic elements of pity and fear, of past and future, in the representation of present *Schrecken* is said by Goethe to be explicable in part as a way of moderating (*mildern*) "den heftigen Eindruck des Schreckens" (the powerful impression of horror). But such moderation is the function of *Anmut*. The co-present signs of the effects of poetry surround the father in his immediate suffering like the snakes that encircle all three. *Anmut* or *Zier*, it would seem, renders the *Schlag* or *Reiz*, the visual sign, into a linguistic sign, or at least embeds the *Schlag* in a sort of text, thereby defusing it. The text, however, is a visual text; the linguistic sign is visually perceived. The narrative axis—past, present, and future—is gathered up by *Anmut*, even if we do "read" from left to right, and folded back on itself to become a total present. The story, however, is in no way the story of Laocoon the priest as it is recorded in the *Aeneid*. Goethe has completely divested the sculpture of that story. It is instead the story of the sculpture's interpretation as allegory. The Laocoon, then, is a representation of *ut pictura poesis*, both as problem or riddle and as the solution. The solution consists in the conviction that *Anmut* or beauty is time made visible. The Laocoon is simultaneously a visual text and a linguistic picture, the triumph, as Goethe would have it, of classical art.

But what has Goethe done to the Laocoon? How has he rewritten the texts of his forerunners? One thing is clear: he has not been uneasy about pain. One could sense a certain relish in the elaboration of the imaginary scenario in which the child unexpectedly suffers pain. Similarly, Goethe did not hesitate to analyze pain quickly and precisely according to the Hallerian model. He is not interested in the meaning of pain. He is interested in its material and formal structure, its all-consuming physical intensity. This is very different from Winckelmann and especially Lessing and Herder. Moritz too seemed to linger over pain, but more in an involuntary daze.

We saw that Goethe understood pain in terms of the fertile moment, thus radically rewriting Lessing. Pain is an extreme *Nebeneinander*, an assault on vision, unless it is dispersed and moderated by the visual signs of poetry, the *Nacheinander* in this new sense. By rendering the *ut pictura poesis* visual, just as Lessing sought to arrogate the positive values of both sign systems to the linguistic, Goethe effectively ends the debate, but also makes it superfluous. Is the analogy between the visual and literary arts meaningful if both are understood as visual?

Finally, the Laocoon has become an allegorical sign, and not a symbol. There may indeed be a line that connects a Winckelmannian conception of the classical statue to the Romantic symbol, but only if there is a detour around Goethe's "Über Laokoon." Goethe's Laocoon, as we saw, is an allegory of time made visible. In that respect, it is homologous to the timelessness of *Unbezeichnung* and the eunuch, as well as, though more distantly, to the denials of mortality and the body in Lessing and Herder. Where Goethe differs from all of them, is through the positive assertion and subsumption of what they denied. Pain, the body, and temporality are profoundly there—no scream, no sigh, merely the calm pleasure of the beholder, Goethe's pleasure, as his eyes traverse Laocoon's body.

4

Moritz, too, felt Goethe's eyes. We recall the scene sketched by Tischbein and his description: "[A]ls Sie vor Moritz auf den Knien lagen ihn haltend und ich musste ziehen und Sie ihm sein Höllisches Fluchen mit sanften Freundes Worten dämpften." If Moritz is in the position of the pain-stricken Laocoon, then Goethe holds the place of *Anmut* as he tries to calm and moderate Moritz's excessive expression of pain. But that position, as we know from reading "Über Laokoon," is occupied by the snakes, who also apply the *Reiz*. Goethe's words may have seemed the gentle ones of a friend, but his attendance may have been more on the order of Hallerian observation. Friendship alone does not sufficiently explain Goethe's intense

involvement not only with Moritz's injury and convalescence, but also with Herder's prolonged and repeated surgery in Strassbourg. For this reason we will allow Moritz, not Goethe, to have the last word on Laocoon, for it is also a last word on Goethe himself.

The reading of "Über Laokoon" has arrived at the concept of time made visible. Moritz too knew this as a tantalizing possibility and sought for images to convey it. Repeatedly and in the most various contexts he developed the image of the town seen first as one wanders one street at a time and then from a mountain overlooking the town where the *Nacheinander* of one's becoming acquainted with the geography is transformed into the *Nebeneinander* of a picture.[25] Andreas Hartknopf, for instance, in the novel by the same name, must choose at one point between a straight road and a meandering path that in fact circles around to enclose the village as well as to become the visual and immediate representation of the daily repetitions of a simple, happy life. He is charmed by the beauty, autonomy, and playfulness of the meandering path:

> Auf dem krummen Fusswege, der sich durch die grünen Saaten schlängelte, malte seine Phantasie, das in sich selbst vollendete ruhige Leben aus, das kein höher Ziel als sich selber kennt, und seinen schönen Kreislauf mit jedem kommenden Tage wiederholt.[26]

> On the crooked footpath that snaked through the fields of green seedlings, his imagination painted an image of the self-contained peaceful life, which knows no higher goal than itself, and repeats its beautiful circuit with every new day.

Thus far there is agreement between Goethe, Moritz, and Hogarth. The line of grace is visible time. What Goethe and Hogarth, however, failed to see or failed to mention is that visible time, the beautiful *Nebeneinander* of a transformed *Nacheinander*, is also a kind of death. Hartknopf realizes this as he looks down on the village where he and his wife live: "In diesem Bezirke lag nun sein Leben, seine Reisen, sein Wirkungskreis—hier endigte sich seine Laufbahn, und war wie auf einer Landkarte ihm vorgezeichnet" (In this range lay his entire life, his travels, the circle of his actions—here the path of his life ended, and was drawn out before him as on a map).[27] Having regarded his village, the visual representation of his past, present, and future, from a distance, he descends into it, into the tangle of *Anmut* to find what is at its center, the *Schlag*:

Mit schnellen Schritten wandelte Hartknopf die Anhöhe wieder herab—denn der Tag hatte sich geneiget; und so wie er hinunterstieg, zog sich immer enger und enger sein Horizont um ihn zusammen

Alles lief nun in einem fürchterlichen Punkte, in einer traurigen Spitze aus.—

Unaufhaltsam lief der Sand im Stundenglase, und das Ziel war da, nichts war dazwischen als die einförmige Wiederkehr dessen, was schon da war.— Schrecklich eröffnete sich der Abgrund dicht vor den Füssen des Wandrers.—

Das enge Grab war nun da—die Erde scholl dumpf auf den Sarg— keine Aussicht, kein Gedanke an die Zukunft mehr.—Alles verbauet, verschlossen, und gehemmt—zwischen öden Mauern, die des Tages Glanz verdeckten.—[28]

With hurried steps Hartknopf descended again—for the day had ended; and as he went down, his horizon shrank more and more narrowly around him.

All things ran to a terrible point, to a tragic point.

The sand fell relentlessly in the hourglass, and the end was already there.— The abyss yawned frighteningly close before the feet of the wanderer.—

The narrow grave was now there—the earth fell with muffled thuds on the coffin—no prospect, no more thought for the future.— All things constructed already, closed off, and constricted—between bleak walls that concealed the brilliance of the day.—

At the center there is time, sand falling in an hour glass, sand that becomes the soil falling on a narrow coffin. Visible time, beauty, the line of grace, *Geschlossenheit*—what are they if not death made visible?

Moritz develops the same imagery and reasoning in the third book of *Anton Reiser*. Here Reiser has descended into a small churchyard and cemetery:

das Winzige und Kleine des Dorfes, des Kirchhofes und der Kirche tat auf Reisern eine sonderbare Wirkung—das Ende aller Dinge schien ihm in solch eine Spitze hinauszulaufen—der enge dumpfe Sarg war das letzte—hierhinter war nun nichts weiter—hier war die zugenagelte Bretterwand—die jedem Sterblichen den fernern Blick versagt. —Das Bild erfüllte Reisern mit Ekel—der Gedanke an dies Auslaufen in einer solchen Spitze, dies Aufhören ins Enge und noch Engere und immer Engere—wohinter nun nichts weiter mehr lag—trieb ihn mit schrecklicher Gewalt von dem winzigen Kirchhofe weg und jagte ihn

vor sich her in der dunkeln Nacht, als ob er dem Sarge, der ihn einzuschliessen drohte, hätte entfliehen wollen. —Das Dorf mit dem Kirchhofe war ihm ein Anblick des Schreckens, solange er es noch hinter sich sahe—.[29]

The tininess and smallness of the village, the cemetery, and the church had a remarkable effect on Reiser—the end of all things seemed to him to run out in such a point—the narrow stifling coffin was the last— there was nothing behind here —here was a wall of boards nailed shut—which denied every mortal the farther view. —The image filled Reiser with disgust—the thought about everything running out to such a point, this stopping in the narrow and even narrower and ever narrower—behind which nothing lay—drove him with terrible violence from the tiny cemetery and chased him through the dark night, as if he had wanted to escape the coffin that threatened to close him in. —The village with the cemetery was a vision of terror to him, as long as he continued to see it behind him—.

Reiser reads a pleasant landscape that might have entertained Hogarth's eye, and sees it, consistent with Goethe's model, as "ein Anblick des Schreckens" (a vision of terror). The *Spitze*—Herder's *Reiz*, Moritz's knife, Goethe's *Schlag*—is not dispersed in *Anmut*, rather the lines of grace are traced to their origin in pain and death. The possiblity of this opposite movement was already suggested in the anagram: *Zier / Reiz*.

Moritz barely wrote a word about the Laocoon. There is, however, a fragment in the *Reisen eines deutschen in Italien*, written in Rome and at the very time that Goethe was there as well. In this fragment, Moritz does not refer to the *Schlag*. What he does see is constriction:

Man sieht in dieser Gruppe das Alter mit der Jugend von der allge-waltigen Zerstörung umfasst; den Vater mit den Söhnen von umwin-denden Ungeheuern in einem Jammerstande umschlungen.—

Man denke sich statt der Schlangen in dieser Gruppe, den reis-senden Tyger, den verwundenden Pfeil, den tödtenden Dolch—nichts kommt dem Entsetzen dieser furchtbaren Umwindung bei, wo die mächtigen Ungeheuer in schrecklichen Krümmungen den Gliederbau umfesseln—das Edle, Gebildete erliegt der Macht des Ungeheuern; der Mensch dem Wurme.[30]

One sees in this group age along with youth in the grasp of all-powerful destruction; the father with the sons clasped together in an hour of suffering by the constricting monsters.—

Instead of the snakes in this group, imagine a mauling tiger, a wounding arrow, a deadly dagger—nothing can be compared to the horror of this frightening constriction, where the powerful monsters surround the body in terrible loops—nobility, culture is defeated by the power of the monstrous; man succumbs to the worm.

"Der reissende Tyger," the arrow and the dagger, these are instances of the *Schlag*.[31] Moritz, however, ignores the snake bite and sees the threat in the constriction of the snakes, what Goethe called *Anmut*. What distinguishes Moritz's reading, and makes it a last word on Goethe, is that he alone dared or was honest enough to recognize and name one final aspect of the snake, to realize its association with the worm from the tradition of the *memento mori*. Thus Moritz gives Goethe's allegory one last turn, bringing it into line with allegory as we understand it since Benjamin. The Laocoon, exemplar of classical beauty, the figure of *ut pictura poesis*, stands for Moritz like a baroque funeral monument, at once itself and its Other.

CONCLUSION:
LAOCOON IN THE CLINIC

The readings of Winckelmann, Lessing, Herder, Moritz, and Goethe have produced multiple images of the Laocoon. The castrato, the crucified Christ, the animal in Haller's clinic, the victim of rape or torture: these are the radically unclassical counterparts of the Laocoon, riveted together through pain. Each stands for a heterogenous discourse that pierced the tranquillity of classical aesthetics and exposed the latter's ambivalent relation to the body and the material sign. Classical discourse may assure us that it celebrates the human body, may even boast of a manly intimacy with the body; the interpretation pursued in this study has shown that the pain of the body is at the center of the aesthetics of beauty, and that the desires of this aesthetics are responsible for the infliction of the pain it seeks to hide.

In Winckelmann, as we saw, the conflicting aesthetic and semiotic demands had already posed problems in the *Gedancken*. He acknowledged that pain was necessary for the production of meaning, but worried that it misrepresented the soul and violated beauty. In the *Geschichte der Kunst*, the Laocoon group no longer figured with the central theoretical significance of the earlier work. Winckelmann's argument strayed past classical statues to fix on the body of the eighteenth-century castrato. The castrato better exemplified classical beauty, and resolved the conflict of aesthetic and semiotic demands in its *Unbezeichnung* or "Undesignation" as Winckelmann termed his new concept. Pain seemed no longer to be a force of representation, though when Winckelmann described the castrato's body, his gaze finally came to rest on the eunuch's buttocks, the expanse of flesh over the "heiliges Bein," his German translation for *os sacrum* or, more commonly, *Kreuz* (cross). *Unbezeichnung* turned out to be a euphemism for castration understood as a type of crucifixion.

Conclusion: Laocoon in the Clinic

Euphemism was the primary trope in Lessing's treatment of the issues surrounding the Laocoon as well. For Lessing it was a matter of resolving the dispute between aesthetic and semiotic demands in terms of the nature of the media of representation. He placed sculpture and painting under a severe law of beauty because of their potentially flagrant materiality. Our reading, however, disclosed a force even stronger than this sexual fear, namely the fascinated abhorrence of the dead body. Lessing not only restricted visual art on account of its materiality, he denied the materiality of language. This denial, in fact, was authorized by the philological violence he practiced in deciding on the appearance of death in antiquity in his *Wie die Alten den Tod gebildet*, the amplification of a footnote in the *Laokoon*. By turning (in the sense of forcefully twisting) the word *diestrammenous*, he unturned or untwisted the contorted legs of death as described in Pausanias. Lessing's euphemism not only cloaks violence, it is violence.

In Herder we saw evidence of a strong desire to approach the body. He made the approach in three related texts of the 1770s—*Vom Erkennen und Empfinden*, *Abhandlung über den Ursprung der Sprache*, and *Plastik*. The first approach could be said to have taken place in Albrecht von Haller's anatomy theater; at least he used the language of Haller's physiology. The second approach took place in the delivery room, and the third in the bedroom, the place of erotic encounter. But, in every case, at the crucial moment, the discourse swerved or "passed out," as it were, from fear of the material and mortal body. Herder's psychology, his theory of the origin of language, and his aesthetics are all versions of this swerve away from the body.

Moritz's aesthetics turned on the figure of torture and rape. We saw that *Die Signatur des Schönen* begins with Ovid's story of Philomela, more precisely, Philomela's tongue. Philomela was raped by her brother-in-law, who then ripped out her tongue to prevent her from publishing his crime. The dismembered tongue found a close substitute in a cloth that Philomela embroidered with her story. The cloth or tongue was for Moritz an example of the beautiful, where sign and signifed are so close as almost to be one. He failed to theorize pain and violence in this essay except in a vague aesthetic theodicy, but attentiveness to the image of the knife allowed us to discern the victim's discourse, which is also Moritz's discourse. His essay, too, is like Philomela's cloth. It lodges an accusation against Goethe and the classical aesthetics of beauty.

Goethe's "Über Laokoon," as we saw, is another matter. Goethe's text rewrote the classical discourse of his predecessors in such a way as to invert the ratio of their strategies and desires. He frankly accorded physical pain the central position in the production of beauty. That origin

or *Reiz* (Goethe used Haller's term) was moderated by *Anmut* or *Zier*, the elaborate material composition of the art work, which counters the physical violence of the pain and disarms it for the viewer. What was important to note, is that at both levels, *Reiz* and *Zier*, we are dealing with strictly physical phenomena.

The result of Goethe's revision of the Laocoon was that the statue became radically estranged from its narrative as well as its settings in the other texts we considered. The Laocoon had become an allegory of its aesthetic career in the eighteenth century. While Goethe interpreted the allegory in terms of *ut pictura poesis*, we saw that Moritz's only description of the Laocoon placed it in the tradition of the *memento mori*. The Laocoon had become not only an allegory, but a baroque funeral monument. The death that it marks is not only its own, but also that of classical aesthetics.

Near the end of chapter 1, we had occasion to consider the story of Marsyas and a late sixteenth-century engraving of this scene, which depicted a triumphant Belvedere Apollo holding the flayed skin of the inhumanly suffering Marsyas. (We mentioned Titian's painting of the same motif in an endnote.) This image stood as an emblem at our starting point. It anticipated the counter-images and heterogenous discourses that would be found in the readings of Winckelmann, Lessing, Herder, Moritz, and Goethe. Beauty wields a knife, fit for castration, dissection, experimental stimulation, or amputation. It serenely enacts its multifarious negations of the body.

Insofar as a baroque emblem stood at the beginning, it seems fitting that this study should conclude by engaging two nineteenth century works of what might be called a sort of "medical" realism. I am referring to Thomas Eakins's painting *The Gross Clinic* (1875) and a photograph by Duchenne de Boulogne from his *Mécanisme de la physionomie humaine ou analyse électro-physiologique de l'expression des passions* (1862). Both of these, though in different ways, insist on representing the hard materiality of pain and the body. Thus it could be said that pain and the body are positively if differently valorized in the baroque and in realism, while for classicism pain and the body are a necessary condition, but a condition that is denied— indeed, that Classicism, in fact, *is* this denial.

The Gross Clinic by Thomas Eakins has been masterfully discussed by Michael Fried in *Realism, Writing, Disfiguration*. Focusing on the bloodstained scalpel in Dr. Gross's gesturing hand, the open wound being probed by his assistants, the portrait of Eakins himself intently sketching the operation, and the horrified reaction of the mother of the patient, Fried calls into question conventional theories and models of realism (according to which a realist painting faithfully, even "photographically" represents

some reality), and shows that in Eakins, and in a tradition perhaps dominated by Caravaggio, realist painting represents the human body in such a way as to confront the viewer with "a new and stupefyingly powerful experience of the 'real.' " Fried sees in Eakins's "aggressions," as well as in his particular use of chiaroscuro, "an implied affront to seeing—a stunning or, worse, a wounding of seeing—that leads me to imagine that the definitive realist painting would be one that the viewer literally could not bear to look at."[1] In Goethe's terms, what Fried is describing as the realist project in Eakins is nothing other than the *Schlag*, the Hallerian *Reiz*, the painful and insistent confrontation with corporeality.

If we look back at the images of Marsyas and at the pictures of classicism intersected by heterogenous discourse, there is an important difference between all of these on the one hand and the Eakins painting on the other. There is an intense and relentless human drama in *The Gross Clinic*. We may shudder and be horrified at the same time as we are continually drawn back to the wound and the scalpel in utter fascination,[2] but nothing in the painting directly horrifies us about humanity. "[T]he subject of *The Gross Clinic*," as Fried says, "is surgery, an art of necessary violence" and that "functions as an implicit moral justification of the experience, as does the recognition that the patient is anesthetized and so can feel nothing himself."[3] What tended to shock and repulse in the Marsyas pictures was the surplus of cruelty and violence as well as the aesthetic serenity of its application. The extra detail of the little dog lapping up the blood in the Titian; the castration of boys for the production of singing voices and ambiguously gendered bodies; the sacrifice of Iphigenia; the multitude of animals subjected to pain who were expressly *not* anaesthetized; the rape of Philomela, the amputation of her tongue—this is the type of detail that is missing from the *The Gross Clinic*. In Eakins we find that the insistence on corporeality takes place within what Fried calls "the absorptive realist tradition." In France, "[t]he advent of Manet around 1860 marked the emergence of a radically different sort of realism—nonabsorptive, instantaneous, in a certain sense theatrical."[4] Perhaps the terms of this tradition can better help us to come to grip with the "pictures" of classicism. Certainly they are the correct terms for discussing the photographs of Duchenne de Boulogne, photographs, moreover, that are the perfect actualization of Goethe's anti-classical aesthetics of the "Über Laokoon."

Guillaume-Benjamin-Amant Duchenne de Boulogne was a neurologist who exploited the method of "electrisation" for therapeutic as well as research purposes, that is, the controlled application of electric charges to the muscles and nerves in order to produce what he called "a new sort of anatomy, to which might be applied the two words which Haller wished

to give to physiology—'living anatomy,' *anatome animata*." In *Mécanisme de la physionomie humaine*, Duchenne continued in the eighteenth-century tradition of physiognomy (Lavater),[5] but "scientifically" pursued. He was interested in producing "l'orthographe de la physionomie en mouvement."[6] His book is divided into two parts, the first dealing with medical science, the second with art.

His method was state-of-the-art. He isolated the muscle that was to receive the electric shock (often through a trial and error approach). The positive electrode was placed on the originating point of the muscle while the circuit was closed by attaching the negative pole to any part of the body. The electric charge was applied and a photograph was made at the moment that the muscle stood out most graphically. Seventy-four pictures accompanied the *Mécanisme*. As Paul-Jules-Louis Guilly writes: "L'album sur le *Mécanisme de la Physionomie* inaugura l'ère de la photographie appliquée à l'anatomie et aux sciences biologiques."[7] Chance had brought him the perfect subject: a man, "de caractère inoffensif et d'intelligence bornée,"[8] who suffered from facial anaesthesia. Duchenne could pursue his experiments with impunity.

We see Duchenne and his subject together on the frontispiece of the *Mécanisme* (fig. 8). The subject is posed much like a ventriloquist's dummy (theatrically). Duchenne applies electrodes to either side of the man's face in order to produce not the painful grimace of the Laocoon (not yet), but a welcoming smile. The photo is a perfect type of the Laocoon, in addition to being an uncanny realization of Goethe's Laocoon-aesthetics: the electric shock (Goethe's metaphor) is applied—*Reiz* (precisely in Haller's sense); stimulus and response are both in evidence, not to mention the closed circuit—*Geschlossenheit*; Duchenne and the electrodes' wires surround the subject (not unlike Goethe at Moritz's feet) and transform the brutal operation into a "neutral" scene of science—*Anmut*. Critical for Duchenne's enterprise is the choosing of the "fertile" moment (in Goethe's, not Lessing's, sense), the point when the facial muscle is most significantly displayed, the moment of absolute transitoriness. The new technology of the photograph allows this moment to be captured. Finally, the fact that everything is concentrated on the surface, the body of the subject, and in complete dissociation from his actual state of mind—this corresponds to the radical aesthetic materialism of Goethe's "Über Laokoon."

Duchenne's experiments produced a wide array of photos. Having isolated various muscles and assigned them names such as the muscle of attention and the muscle of pain, he began composing more complex tableaux by stimulating complementary muscles. His project was called an "orthography," in part because he was able, on the strength of his

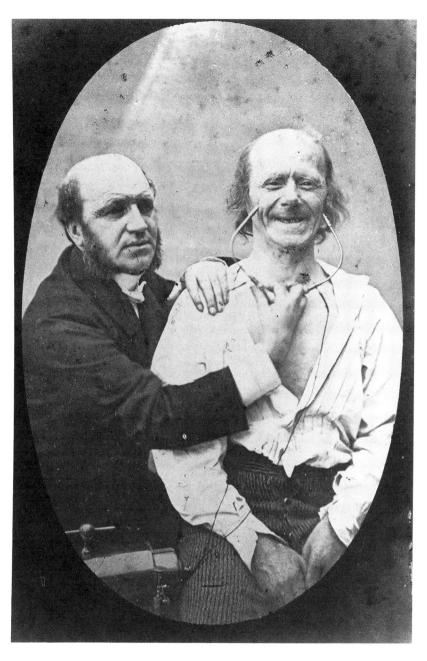

Fig. 8. Title page of Duchenne de Boulogne's *Le Mécanisme de la phys-iONOMIE humaine*, 1862. Courtesy of the National Library of Medicine.

photographic evidence, to "correct" certain masterpieces of art which he had long admired. Inevitably, the Laocoon was chief among them.

The muscle of pain is located above the nose and eyebrows as we see in one of Duchenne's photographs (fig. 9). The resemblance to the Laocoon is as uncanny as it was intentional. Writing about this aspect of the Laocoon's physiognomy, so much admired by Winckelmann, Duchenne remarks: "Le modèle des parties latérales de son front est une fantaisie de l'artiste Agésandre; il est impossible, car aucune contraction musculaire partielle ou combinée, ne saurait le produire."[9] Thus Duchenne had a "corrected" model of Laocoon's head fashioned to illustrate his point (fig. 10).

The contemporary response to Duchenne's work was mixed. One critical voice stated: "On reprochera à M. Duchenne de dépouiller l'art de toute idéal le réduire à un réalisme anatomique tout à fait dans les tendances d'une certaine école moderne. Et de fait, les essais qu'il a tentés sur trois célèbres antiques, l'Arrotino, le Laocoon et la Niobié, dont il, dit il, corrigé les fautes d'orthographe, paraîtront une application un peu brutale, peut-être, aux amoureux de l'idéal."[10]

It is likely that the "certain modern school" of art referred to must be the Realists. In *Realism*, Linda Nochlin confirms that:

> many critics condemned the scientific aspect of Realism for its gross materialism, terming it "the reproduction of the material world with all its most strikingly materialistic qualities," while others, with more precise and up-to-date terminology, condemned the alliance of Realism and modern science by likening the procedures of the Realists to those of the "scientifically" objective and mechanically accurate methods of the daguerrotypist or photographer.[11]

From Michael Fried, however, we have learned to distinguish between different realist projects and traditions and to be suspicious of those who cling to a photographic model of realism. The nineteenth-century idealist critique that connects Duchenne's experiments, realist painting, and photography is, in fact, a veil for a deeper uncertainty, which shares much with the way that Lessing sought to conceal violence with euphemism. What is discomforting about the photographs of Duchenne's experiments (and *not* about realist paintings like *The Gross Clinic*) has nothing to do with the camera. What is deeply troubling is the tableau itself, the picture of science calmly and obscenely applying electrodes to a human face to produce first a welcoming smile, shed of all meaning, except for its testimony to the power of science, and then to reproduce the physiognomy of Laocoon.

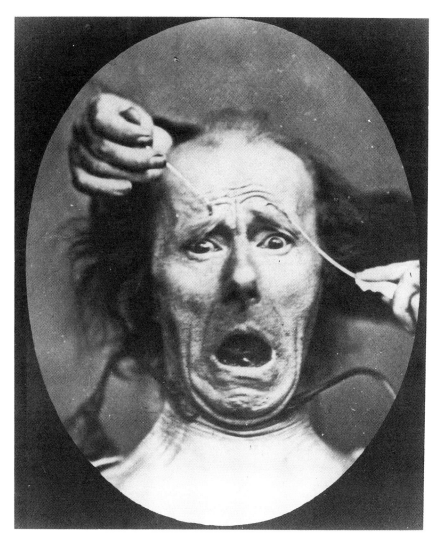

Fig. 9. Photograph from Duchenne de Boulogne's *Le Mécanisme de la physionomie humaine*, 1862. Courtesy of the National Library of Medicine.

FIG. 10. LAOCOON (AS REMODELED BY DUCHENNE). COURTESY OF THE NA-
TIONAL LIBRARY OF MEDICINE.

Classical aesthetics is thus confronted with a mirror image of itself as its
Other. A Laocoon with snakes faces a Laocoon with electrodes. There is
now no denying that classicism is the place where discourses and desires of
all kinds combine under the veil of "edle Einfalt, und eine stille Grösse"
in the production of human pain.

The result of these interpretive reversals is that we can now justifiably
place the picture of the Laocoon between the sixteenth-century engraving
of Marsyas and Apollo and the photograph of Duchenne and his subject,
emblems of the baroque and of realism. Both cast a penetrating light on
the middle image and the eighteenth-century aesthetic theory it supports.
They focus on the science and technique of physical pain. They alert us
that, no matter what classicism says to the contrary, the condition for ideal
beauty is material pain. Pain is beauty's story.

NOTES

Introduction

1. With this formulation I acknowledge my debt to a book that has been of great significance to my thinking, Elaine Scarry's *The Body in Pain*.
2. Eliza Marian Butler, *The Tyranny of Greece over Germany* (Boston: Beacon Press, 1958), 47.
3. Butler, 47.

Chapter One

Unless otherwise indicated, the translations from the German are my own, largely because of the unavailability of others.

1. Pliny, *Natural History*, trans. Frank Justus Miller (Cambridge: Harvard University Press, Loeb Classical Library, 1977).
2. Kenneth Clark writes: "Pliny's description of the *Laocoon* group had touched the imaginations of Renaissance artists, and even before its excavation attempts had been made to draw what it could have been like." *The Nude: A Study in Ideal Form* (Garden City: Doubleday Anchor, 1956), 323.
3. For a short history of the statue see Francis Haskell and Nicholas Penny, *Taste and the Antique* (New Haven: Yale University Press, 1982), 243–47. For details see Bernard Andreae, *Laokoon und die Gründung Roms* (Mainz am Rhein: Philipp von Zabern, 1988). Christian Gottlieb Heyne's "Laokoon" in *Sammlung antiquarischer Aufsätze* (Leipzig: Weidmanns Erben und Reich, 1779) reports that the baths belonged to Titus.
4. Reinhart Raffalt, *Sinfonia Vaticana* (Munich: Prestel Verlag, 1966), 234ff.
5. It is Eliza Marian Butler who calls the statue baroque in her 1935 book, *The Tyranny of Greece over Germany*, 47. She goes on to remark how difficult it is to explain "the fact that Winckelmann used the terms simple and serene to characterize this complicated, intricate, naturalistic piece of work, which is so painfully realistic at close quarters; and which, seen from a distance in its niche in the Vatican, resembles a decorative, graceful, fragile arabesque, of which every part is in motion."

6. Andreae, 146–47.

7. An English translation of this poem can be found in Margarete Bieber, *Laocoon: The Influence of the Group since Its Rediscovery* (New York: Columbia University Press, 1942), 2–5.

8. See Kenneth Clark on the effect the discovery of the Laocoon had on Michelangelo. He calls the statue "the sanction of his deepest need," 323.

9. William S. Heckscher, *Rembrandt's Anatomy of Dr. Nicolaas Tulp* (New York: New York University Press, 1958), 51.

10. For example, Gérard Audran, *Proportions du corps humain mesurées sur les plus belles figures de l'antiquité* (1683), translated into German as "Des menschlichen Leibes Proportionen, von denen vortrefflichsten und allerschönsten Antichen genommen und mit Fleiss abgemessen durch Mr. Audran, Professeur der Königlichen Mahler-Academie zu Paris" (1688).

11. For philological and historical treatments of these terms see Walter Rehm, "Götterstille und Göttertrauer" in the book by the same name (Bern: A. Francke Verlag, 1951), especially 101–16; Wolfgang Tammler, "'Edle Einfalt'. Zur Geschichte eines kunsthistorischen Topos," in his *Wort und Bild* (Berlin: Erich Schmidt Verlag, 1962), 161–90; and Reinhard Brandt, "ist endlich eine edle Eifalt, und eine stille Grösse," in *Johann Joachim Winckelmann, 1717–1768*, ed. Thomas W. Gaehtgens (Hamburg: Felix Meiner Verlag, 1986), 41–53. Peter Szondi discusses the terms interpretatively in *Poetik und Geschichtsphilosophie*, vol. 1, ed. Senta Metz and Hans-Hagen Hildebrandt (Frankfurt am Main: Suhrkamp, 1974), 42–46.

12. Winckelmann, *Gedanken über die Nachahmung der griechischen Werke in der Malerei und Bildhauerkunst*, ed. Ludwig Uhlig (Stuttgart: Philipp Reclam, 1982), 4. The English translation is from *Reflections on the Imitation of Greek Works in Painting and Sculpture*, trans. Elfriede Heyer and Roger C. Norton (La Salle, Illinois: Open Court, 1987), 5.

13. For an account of the *querrelle* see Hans Robert Jauss, "Literarische Tradition und gegenwärtiges Bewusstsein der Modernität" and "Schlegels und Schillers Replik auf die "Querelle des Anciens et des Modernes," both in *Literaturgeschichte als Provokation* (Frankfurt a/M: Suhrkamp, 1979).

14. See Szondi, as well as Friedrich Meinecke, *Die Entstehung des Historismus*, ed. Carl Hinrichs (Munich: R. Oldenbourg Verlag, 1959), 291–302; and Horst Rüdiger, "Winckelmanns Geschichtsauffassung: Ein Dresdener Entwurf als Keimzelle seines historischen Denkens," *Euphorion* 62:2 (1968), 99–116.

15. For a history of this topos see Rensselaer Lee, *Ut pictura poesis: The Humanistic Theory of Painting* (New York: Norton, 1967).

16. Vergil, *The Aeneid*, bk. 2, trans. Allen Mandelbaum (New York: Bantam Books, 1961), 36f.

17. *Gedanken*, 20; *Reflections*, 33f.

18. Andreae, 137ff.

19. Christian Gottlieb Heyne, *Sammlung antiquarischer Aufsätze* (Leipzig: Weidmanns Erben und Reich, 1779), 1:18.

20. Heyne, 18.
21. Heyne, 21.
22. Wilhelm Heinse, *Ardinghello und die glückseligen Inseln*, ed. Max L. Baeumer (Stuttgart: Philipp Reclam, 1985), 239.
23. Heinse, 239.
24. Friedrich Schiller, "Über das Pathetische," in *Vom Pathetischen und Erhabenen*, ed. Klaus L. Berghahn (Stuttgart: Philipp Reclam, 1981), 65.
25. Aloys Ludwig Hirt, "Laokoon," *Die Horen* 3 (1797).
26. Hirt, "Versuch über das Kunstschöne," *Die Horen* 3:7 (1797), 35.
27. While Goethe ridiculed Hirt, Hegel later in his *Ästhetik* refers generously to him as "einer der grössten wahrhaften Kunstkenner unserer Zeit." He is discussing him in connection with precisely those essays that Goethe mocked. G. W. F. Hegel, *Ästhetik*, 2 vols. (Berlin: Das Europäische Buch, 1985), 28.
28. Hirt, "Nachtrag zum Laokoon im zehnten Stück," *Die Horen* 12 (1797).
29. Walther Amelung, *Die Sculpturen des Vaticanischen Museums*, vol. 2 (Berlin: Georg Reimer, 1908), 201.
30. Amelung, 201.
31. Georg Daltrop, "Ancient Sculpture," in *Art Treasures of the Vatican*, ed. D. Redig De Campos (Englewood Cliffs, N.J.: Prentice-Hall, 1974), 235.
32. Goethe, "Über Laokoon," in *Sämtliche Werke*, ed. Karl Richter (Munich: Carl Hanser, 1986), 4.2:73; *Essays on Art and Literature*, ed. John Gearey, trans. Ellen von Nordroff and Ernest H. von Nordroff (Suhrkamp: New York, 1986), 15.
33. Albin Lesky, *A History of Greek Literature*, trans. James Willis and Cornelis de Heer (New York: Thomas Y. Crowell, 1966), 82.
34. Heinrich Brunn, "Die Söhne in der Laokoongruppe," in *Kleine Schriften*, vol. 2 (Leipzig: G. B. Teubner, 1898; first published in *Deutsche Rundschau* 29 [1881]), 506.
35. Both Carl Robert, *Bild und Lied* (Berlin: Weidmannsche Buchhandlung, 1881) and Bernard Andreae have excellent accounts and summaries of the three traditional sources.
36. Robert, 196.
37. Robert, 202.
38. Robert, 209.
39. Brunn, 513.
40. Peter Heinrich von Blankenhagen, "Laokoon, Sperlonga und Vergil," *Archäologischer Anzeiger* 84 (1969), 258.
41. Sichtermann, 195.
42. Sichtermann, 195.
43. Friedrich von Ramdohr, *Über Mahlerei und Bildhauerkunst in Rom für Liebhaber des Schönen in der Kunst* (Leipzig: Weidmanns Erben und Reich, 1787), 48.
44. Daltrop, 237.
45. Amelung, 73.

46. Ramdohr, 49.
47. *Gedanken*, 20; *Reflections*, 33.
48. Winckelmann, *Werke*, ed. Heinrich Meyer and Johann Schulze (Dresden: Walter, 1812), 5:143f.
49. Erich Neumann writes: "Among the Germanic peoples, the water lady is the primordial mother and the linguistic connection between *Mutter*, 'mother'; *Moder*, 'bog'; *Moor*, 'fen'; *Marsch*, 'marsh'; and *Meer*, 'ocean,' is still evident." See *The Great Mother*, trans. Ralph Manheim (Princeton: Princeton University Press, 1955), 260.
50. *Werke.*
51. Heyne, 21f.
52. G. Rudolf, "Hallers Lehre von der Irritabilität und Sensibilität," in *Von Boerhave bis Berger: Die Entwicklung der kontinentalen Physiologie im 18. und 19. Jahrhundert*, ed. Karl E. Rothschuh (Stuttgart: Gustav Fischer Verlag, 1964), 30.
53. Muscle tissue, for example, is still described using Haller's terms.
54. Albrecht von Haller, *Von den empfindlichen und reizbaren Teilen des menschlichen Körpers*, ed. Karl Sudhoff (Leipzig: Johann Ambrosius Barth, 1922), 12.
55. For a brief account of the statue see Haskell and Penny, *Taste and the Antique*, 262–63.
56. For sources and discussion of antique representations of the Marsyas story see Hans Blümner's article, "Marsyas," in *Denkmäler des Klassischen Altertums*, vol. 2, ed. A. Baumeister (Munich and Leipzig: R. Oldenbourg, 1887), 886–91.
57. See Werner Hofmann, *Marsyas und Apoll* (Munich: Georg D. W. Callwey, 1973) for an art historical meditation on the Marsyas story.
58. All Winckelmann's descriptions of the Belvedere Apollo can be found as an appendix to Hans Zeller's *Winckelmanns Beschreibung des Apollo im Belvedere* (Zurich: Atlantis, 1955).
59. Ovid, *The Metamorphoses*, trans. Horace Gregory (New York: Viking Press, 1958), bk. 6, lines 383ff., 174.
60. The flaying of Marsyas can also be seen in a late painting by Titian (1570–75). As Harold E. Wethey writes, "the cruelty and goriness of the interpretation [of the Marsyas motif] exceed any other conception by Titian" (91). The painting differs slightly from the engraving in that Marsyas is strung up upside-down on a tree like a slab of meat and the flaying is only just beginning. A beautiful youth kneels to make the incision: authorities differ as to whether it is Apollo. In the foreground, a small dog laps up blood from the ground. This detail, as Wethey says, "has seemed revolting to most people" (92). See Wethey, *The Paintings of Titian* (London: Phaidon Press, 1975), vol. 3, *The Mythological and Historical Paintings*.

Chapter Two

The actual wording from which the epigraph is taken runs: "Socrates (or, for that matter, Winckelmann) certainly had it coming to him."

1. Winckelmann, "An Hans Wiedewelt," 9 Dec. 1760, letter 377 of *Johann Joachim Winckelmann: Briefe*, ed. Walther Rehm, 4 vols. (Berlin: Walter de Gruyter, 1952), 2:107. Carl Justi quotes a later letter of Winckelmann to Wiedewelt where Winckelmann reminisces about the time when they shared a room in 1757: "Erinnern Sie sich in Ihrer Residenz an unsere munteren und freundschaftlichen Unterhaltungen, die wir des Morgens an dem Kamine in unserer oder vielmehr in Ihrer Wohnung zu Rom hatten, wo ich von Ihnen das Geschäft des Teekochens erhielt und es so gern übernahm. Spielte ich dabei meine Rolle nicht gut, und sorgte ich nicht recht ehrlich für das Vergnügen und die Zufriedenheit meines Stubenburschen?" *Winckelmann und seine Zeitgenossen*, 3rd ed. (Leipzig: F. C. W. Vogel, 1923) 2: 93. One cannot help but wonder if perhaps the memory of this scene was involved in Winckelmann's choice first to tell Wiedewelt about the newly discovered Ganymede.
2. See James M. Saslow, *Ganymede in the Renaissance: Homosexuality in Art and Society* (New Haven: Yale University Press, 1986).
3. "An Baron von Stosch," 15 Dec. 1760, letter 379 of *Briefe*, 2:109.
4. *Geschichte der Kunst des Alterthums* (Dresden: Walter, 1764), 276f.
5. Thomas Pelzel, "Winckelmann, Mengs and Casanova: A Reappraisal of a Famous Eighteenth-Century Forgery," *Art Bulletin* 54 (1972), 301.
6. Pelzel's article seeks to reascribe the painting to Casanova.
7. Pelzel writes that "the painting corresponds so exactly, both in theme and in the physical attributes of Ganymede, to Winckelmann's own taste and persuasions, that the virtually inescapable conclusion presents itself that the forgery was deliberately conceived with these factors in mind" (308).
8. See G. S. Rousseau, "The Pursuit of Homosexuality in the Eighteenth Century: 'Utterly Confused Category' and/or Rich Repository," in *'Tis Nature's Fault: Unauthorized Sexuality during the Enlightenment*, ed. Robert Purks Maccubbin (New York: Cambridge University Press, 1987), as well as Denis Sweet, "The Personal, the Political, and the Aesthetic: Johann Joachim Winckelmann's German Enlightenment Life," *Journal of Homosexuality* 16:3/4 (1988).
9. Herder, *Denkmahl Johannes Winckelmanns* (1777), in *Herders Sämmtliche Werke*, ed. Bernhard Suphan (Berlin: Weidmannsche Buchhandlung, 1892), 8:451.
10. Goethe, "Winckelmann und sein Jahrhundert," *Sämtliche Werke* 6.2:359.
11. *Gedanken*, 20; *Reflections*, 33f.
12. Winckelmann, *Werke*, 6:104.
13. Sophocles, *Philoctetes*, trans. David Grene, in *Sophocles III*, ed. David Grene

and Richmond Lattimore (New York: Washington Square, 1967) 231. Line numbers will be indicated in the text.

14. Herder, ["Bemerkungen bei Winckelmanns Gedanken etc.,"] in *Werke* 8:106. The square brackets in the quotation belong to the editor and indicate that Herder amended "Nichts" to "Tod," basically equating them for our purposes.

15. *Geschichte*, xxvi.

16. "An Stosch," 18 Sept. 1767, letter 880 of *Briefe*, 3:287.

17. For a good descriptive account of the second edition and the history of its writing see Justi, 3:440-48. When Heinrich Meyer (Goethe's "Kunst-Meyer") and Johann Schulze assumed the editorial duties of the first collected Winckelmann, they adopted the following plan for the *Geschichte*: "Wir haben ihn [the text] aus den beiden Ausgaben dieses Werks und aus den Anmerkungen Winckelmanns auf die Weise zusammengestellt, wie wir glaubten, dass Winckelmann selbst wurde verfahren haben Nichts ist verändert worden, die Entstellungen der Wiener Herausgeber ausgenommen; nichts wesentliches ist ausgelassen, sondern jeder Gedanke in der von Winckelmann ursprünglich bestimmten Gestalt gerade da dem ganzen einverleibt, wo er die zweckmässigste Stelle zu finden schien." *Werke* 3:3. For my interpretation of the *Geschichte* I have decided to use the Meyer version according to the simple principle: "more is better."

18. "An Berendis," 28 Sept. 1761, letter 441 of *Briefe*, 2:176f.

19. "An Francke," 30 Sept. 1758, letter 243 of *Briefe*, 1:421.

20. Franz Haböck, *Die Kastraten und ihre Gesangskunst* (Stuttgart: Deutsche Verlags-Anstalt, 1927), 232. This remarkable book treats the history, anthropology, physiology, and musicology of the castrati.

21. "An Usteri," 3 Oct. 1761, letter 444 of *Briefe*, 2:181f. The availability of such youths for all manner of exploitation can be explained by the fact that poor parents regarded the castration of one of their sons (the one with a "lovely singing voice") as a chance, however remote, of financial salvation should the boy become an opera star. Naturally most did not. For a thoroughly entertaining and rich fictional account of the lives of eighteenth-century castrati in Italy see Anne Rice's novel *Cry to Heaven* (New York: Pinnacle Books, 1989).

22. Joseph Wiesener, "Winckelmann und Hippokrates," *Gymnasium* 60 (1953), 149-67; my translation.

23. *Werke*, 4:65.

24. About breasts Winckelmann writes: "Was hat denn das Weib schönes, was wir nicht auch haben; denn eine schöne Brust ist von kurzer Dauer, und die Natur hat dieses Theil nicht zur Schönheit, sondern zur Erziehung der Kinder gemacht, und in dieser Absicht kann es nicht schön bleiben" (What does the woman have that is beautiful that we do not also have; for a beautiful breast is of short duration, and nature did not make this part for beauty, but for the rearing of children, and in this sense it cannot be beautiful). "An P. Usteri," letter 868, *Briefe* 3:277). This is another indication that for Winckelmann functionality interferes with beauty.

25. See Francette Pacteau, "The Impossible Referent: Representations of the Androgyne," in *Formations of Fantasy*, ed. Victor Burgin, James Donald, and Cora Kaplan (New York: Methuen, 1986).
26. *Werke*, 4:67.
27. *Werke*, 4:75.
28. *Werke*, 4:87.
29. *Werke*, 4:89.
30. *Werke*, 4:90.
31. *Werke*, 4:106. "In allen diesen Betrachtungen war die Schönheit allezeit die vornehmste Absicht der Künstler, und die Fabel nebst den Dichtern berechtigte sie, in Bildung auch der jungen Helden bis zur Zweydeutigkeit des Geschlechtes zu gehen, wie ich vom Hercules angezeiget habe, und wie in der Figur des Achilles geschehen konnte, welcher vermöge der Reizungen seiner Gestalt, und in weiblicher Kleidung unter den Töchtern des Lycomedes, als ihre Gespielin, unerkannt blieb; und also erscheinet derselbe in dieser Vorstellung auf einem erhobenen Werke in der Villa Belvedere zu Frascati, welches über die Vorrede meiner alten Denkmale gesetzt ist.... Ich war bey dem ersten Anblicke hierüber zweifelhaft an der Figur des Telephus, welcher [107] von dessen Mutter Auge erkannt wird, da sie diesen ihren Sohn ermorden wollte. Das Gesicht dieses jungen Helden ist völlig weiblich, wenn man es von unten herauf betrachtet, und es scheinet etwas Männliches in dasselbe zu mischen, wenn man es von oben herunter ansiehet."
32. *Werke*, 4:67. "Das Gewächs der Verschnittenen ist an bisher unbemerkten Figuren von Priestern der Cybele durch gedachte weibliche Hüften derselben von den alten Künstlern angezeiget, und es ist diese Völligkeit der Hüften auch unter der Kleidung kenntlich an einer solchen Statue in Lebensgrössen, die nach England gegangen ist."
33. *Geschichte*, 3:xxiv.
34. Hans Joachim Moser, *Musik Lexikon* (Berlin: Max Hesses Verlag, 1935), 386-87.
35. *Trattato preliminare*, in *Werke*, 7:79.
36. *Werke*, 4:39.
37. *Werke*, 4:40.
38. For a normalizing account of *Unbezeichnung* see Hermann Cohen, *Kants Begründung der Aesthetik* (Berlin: Ferd. Dümmlers Verlag, 1889), 51. Cohen basically denies the *Unbezeichnung*, saying: "Mithin ist die Unbezeichnung vielmehr eine Bezeichnung höherer, genauerer Art, eine methodische Bezeichnung, welche nur den zufälligen, gelegenen, empirischen Bestimmtheiten des Individuellen als des Einzelnen gegenüber, also in polemischer Ironie Unbezeichnung genannt wird."
39. The "mother" I am speaking of is the "mother" within Winckelmann's aesthetics. The archetype of the "Great Mother" in Erich Neumann's work by the same title is relevant only as a possible background (the connection with water assures that), though by no means essential.

40. See also Ernest Borneman, *Sex im Volksmund* (Herrsching: Manfred Pawlak Verlagsgesellschaft, 1984) where *Spiegel* is simply defined as "Gesäss."
41. For a psychoanalytic treatment of the crucifixion as a type of castration that takes place against the mother's sacrum see Georg Walther Groddeck's essay "Der Sinn der Krankheit" (1925) in Groddeck's *Psychoanalytische Schriften zur Psychosomatic*, ed. Günter Clauser (Wiesbaden: Limes Verlag, 1966), 135.
42. *Sämmtliche Werke*, ed. Josef Eiselein, (1825; Osnabrück: Otto Zeller, 1965) 4:43; *The History of Ancient Art*, trans. G. Henry Lodge (Boston: James R. Osgood, 1880), 340.
43. Gerald Heres, "Jupiter und Ganymed, 'das schönste Gemälde aus dem Altertum,'" in Max Kunze, ed., *Johann Joachim Winckelmann und Adam Friedrich Oeser* (Stendal: Beiträge der Winckelmann-Gesellschaft, 1977).
44. Pelzel, 309.

Chapter Three

1. See William S. Heckscher, *Rembrandt's Anatomy of Dr. Tulp: An Iconological Study* (New York: New York University Press, 1958), 86f.
2. Another example is William Hogarth's *Reward of Cruelty* (1751), an engraving that I treat in connection with the Laocoon in "Discourses of Medicine and Art: Goethe and Haller on *Reiz*," a paper delivered at the Canadian Society for Eighteenth Century Studies Conference held in Kingston, Ontario in October 1990.
3. The Laocoon was discovered in 1506 and circulated in the form of engravings and Laocoon-inspired paintings almost immediately thereafter, more than enough time, in other words, for Baldung Grien to have seen its image.
4. See Jasper Griffin, "Euphemisms in Greece and Rome," (32–43) and John Gross "Intimations of Mortality," (201–19) in *Fair of Speech: The Uses of Euphemism*, ed. Dennis Joseph Enright (New York: Oxford University Press, 1985).
5. Gustav Gerber, *Die Sprache als Kunst*, 2 vols. (Berlin: R. Gaertners Verlagsbuchhandlung, 1885), 2:280, 311.
6. Gotthold Ephraim Lessing, *Sämtliche Schriften*, ed. Karl Lachmann (Stuttgart: G. J. Göschen, 1893), 9:14. Subsequent references, indicated with page numbers in the text, will be to this edition.
7. The classic discussions of allegory are, of course, to be found in Walter Benjamin's *Ursprung des deutschen Trauerspiels* (Frankfurt am Main: Suhrkamp, 1982) and Paul de Man's essay, "The Rhetoric of Temporality," in *Blindness and Insight: Essays in the Rhetoric of Contemporary Criticism* (New York: Oxford University Press, 1971).
8. *Laocoon*, trans. Edward Allen McCormick (Indianapolis, New York: Bobbs-Merrill, 1962), 16–17.
9. As we saw in the chapter on Winckelmann, *Unbezeichnung* is Winckelmann's curious neologism for the idealizing quality of classical beauty.

10. Neil Flax, "From Portrait to *Tableau Vivant*: The Pictures of *Emilia Galotti*," *Eighteenth Century Studies* 19:1 (1985), 39–55.
11. Consider W. J. T. Mitchell's essays on Lessing and Burke in *Iconology: Image, Text, Ideology* (Chicago: University of Chicago Press, 1986). In the former he actually drafts tables of the pertinent oppositions (110).
12. This situation has been corrected to some extent. Winckelmann's *Gedancken* is now available in a translation by Elfriede Heyer and Roger C. Norton from Open Court Publishers. Many of Goethe's essays on art are available in the English Suhrkamp edition of Goethe in twelve volumes, volume three, translated by Ellen von Nardroff and Ernest H. von Nardroff. Winckelmann's *Geschichte der Kunst* has not been translated in over one hundred years.
13. See Gwen Raaberg's essay, "*Laokoon* Considered and Reconsidered: Lessing and the Comparative Criticism of Literature and Art," in *Lessing and the Enlightenment*, ed. Alexej Ugrinsky (New York: Greenwood Press, 1986), 59–67, for an overview of some of the many *Laokoon* incarnations.
14. Gunther Gebauer, ed., *Das Laokoon Projekt: Pläne einer semiotischen Ästhetik* (Stuttgart: J. B. Metzlersche Verlagsbuchhandlung, 1984), 1.
15. David E. Wellbery, *Lessing's Laocoon: Semiotics and Aesthetics in the Age of Reason* (New York: Cambridge University Press, 1984), 7.
16. Wellbery, 7.
17. The figure is suggested by Wellbery's language itself: "Regarding the freedom of the imagination the consequence is this: in the plastic arts the imagination is not entirely itself, has not yet established itself in its autonomy. Rather, it remains outside itself, entangled in and restricted by actual things in their existential nature." (129)
18. Wellbery, 163.
19. Wellbery introduces this term at page 118 with regard to the materiality of signs and uses it consistently to identify painting's (erotic) charms. Flagrancy is perhaps shorthand for what both Mitchell and Jacobs treat more extensively in their consideration of the passage in Lessing about women of ancient times who dreamt of snakes impregnating them.
20. Wellbery, 166.
21. Wellbery, 168–69.
22. The second stage before "[das] Ende des ersten Teiles" consists of a pedantic critique of Winckelmann's *Geschichte der Kunst des Altertums*, which Lessing pretends has only just been published: "Des Herrn Winckelmanns Geschichte der Kunst des Altertums ist erschienen. Ich wage keinen Schritt weiter, ohne dieses Werk gelesen zu haben" (166). On reading this temporal deception see Carol Jacobs, "The Critical Performance of Lessing's *Laokoon*," *MLN* 102:3 (1987).
23. Carol Jacobs, "The Critical Performance of Lessing's *Laokoon*," 499. I admire Carol Jacobs's reading of the performative aspect of Lessing's text very much. Her treatment of the dispute over the dating of the statue vis-à-vis Vergil's *Aeneid* as a concealed dispute over the priority of Lessing to Winckelmann,

poetry to painting, is very persuasive. My one reservation about her essay is that it seems to be more her desire than a deconstructive necessity in the text that causes the opposition between painting and poetry, visual and linguistic sign, to collapse. To make it work, to create the symmetry of natural signs becoming artificial signs and vice versa, she must ignore significant distinctions and qualifications.

24. Jacobs catalogues them for us: "We read of a weasel defecating into Socrates' mouth, of noses from which discharge flows, of 'die langen über die Finger hervorragenden Nägel . . . welche die Wangen zerfleischen, dass das Blut davon auf die Erde rinnet,' of a heap of 'zerrissene Lappen, voll Blut und Eiter,' of 'Haarlocken von Schmeer trieffend,' and finally of the flaying of Marsyas in which his 'skin cracked from his body/in one wound' " (498–99). These examples are trumped by a final one: "For two entire pages, through the mouths of Beaumont and Fletcher, Lessing speaks of eating suppositories, wens, and poultices previously used on wounds" (500).

25. I have altered the translation slightly so as to render *frostiges Spielwerk* literally.

26. For other passages including the word *frostig*, see 59 and 115.

27. Wellbery, 116.

28. W. J. T. Mitchell's remark is apt: "The apparent argument from the mutual respect of borders turns out to be an imperialist design for absorption by the more dominant, expansive art" (107). Wellbery basically acknowledges the same, though without critically pursuing the political metaphorics, in a diagram that includes the rectangle of painting contained within the much greater rectangle of poetry. Cf. Wellbery, 142.

29. A very detailed account of the literary descendants of Lessing's figure of death can be found in Ludwig Uhlig, *Der Todesgenius in der deutschen Literatur* (Tübingen: Max Niemeyer, 1975).

30. *Iliad*, 16:679f.

31. Uhlig, 16; my translation.

32. Uhlig, 17; my translation.

33. Uhlig, "Lessing's Image of Death and the Archaeological Evidence" in Ugrinsky, *Lessing and the Enlightenment*, 79–85. Uhlig perceptively notes that "[t]he antiquarians of the eighteenth century tried to correlate two sources different both in origin and in scope. Traditional Humanism . . . was based on a long-established body of literary works dating back in part to very early periods. . . . The monuments that were known [on the other hand], or were just being unearthed, were usually restricted to rather late periods of antiquity. The archaeologists, trained in the Humanist tradition, interpreted their finds by trying to relate them to the classical literature with which they were familiar, and in these interpretations they often committed understandable anachronisms" (80–81).

34. *Pauly Wissowa*, 2nd set, vol. 9.5:1245. In a more extensive treatment of the same problem in *Alkestis, der Mythos und das Drama* (Vienna and Leipzig: Hölder, Pichler and Tempsky, 1925), Lesky argues that "im Thanatos des

Euripides [steht] eine jener Figuren vor uns. . . , die zum ältesten Bestand des Mythen- märchens überhaupt gehörten" (62). Carl Robert, by contrast, in *Thanatos* (Berlin: G. Reimer, 1879), holds that "Hades [and all it implies] lebt im Volksglauben, während Thanatos nie über die Zwischenstufe zwischen Begriff und Persönlichkeit hinauskommt" (32).

35. *Pauly Wissowa*, 1268.
36. Walter Rehm, *Der Todesgedanke* (Halle: Max Niemeyer, 1928).
37. Rehm, 272.
38. Lessing, quoted by Rehm, 279.
39. *Der Todesgenius*, 14.
40. *Todesgenius* 10.
41. J. G. Frazer, ed. and trans., *Pausanias's Description of Greece* (New York: Biblo and Tannen, 1965), 3:601.
42. Heyne, *Über den Kasten des Cypselus, ein altes Kunstwerk zu Olympia mit erhobnen Figuren* (n.p.: n.p., 1770), 35.
43. Heyne, 24.
44. Heyne, 36.
45. Heyne, 36.
46. Heyne, 27.
47. Heyne, 27.
48. Heyne, 35.
49. Other later philologists agree that *diestrammenous* means turned outwards, though most dispute that that means that the feet are deformed. H. Stuart Jones, for example, says that "the word does not necessarily imply malformation, but may mean simply 'turned outward' " ("The Chest of Kypselos," *Journal of Hellenic Studies* 14 [1894], 69.) Other suggestions to normalize the feet turned outward include Heyne's observation about archaic style, imagining the child as running, and comparing the emblem to the present day (= turn of the century) manner in which Greek peasants carry their children. (Cf. O. Waser's article on Thanatos in Roscher's *Lexicon*.) I believe Heyne is right, however, in insisting that there is no escaping the implication of deformity.
50. Herder, *Werke*, 15:450–51.
51. Herder, 462ff. It should be noted that in the first version of the essay (1774) Herder stopped short of this interpretation. By 1786 it was obviously irresistible.

Chapter Four

The epigraph is from a country and western song that I heard once on the radio as I traveled through Pennsylvania. I have not succeeded in learning who sings it.

1. In "Antiquity Now: Reading Winckelmann on Imitation," *October* 37 (1986), Michael Fried has pointed out that the Italians and Raphael actually function as a curious (third) middle term, partaking of characteristics of both. Cf. 90ff.

2. Johann Gottfried Herder, *Briefe* vol. 1, ed. Wilhelm Dobbek and Günter Arnold (Weimar: Hermann Böhlaus Nachfolger, 1977), 129.

3. *Briefe*, 130.

4. Herder, *Werke* 3:9.

5. *Werke*, 3:11.

6. *Werke*, 3:12.

7. *Werke*, 3:143.

8. *Werke*, 3:135.

9. *Werke*, 3:136.

10. *Werke*, 3:136.

11. *Werke*, 3:137.

12. Patrick Gardiner, "Johann Gottfried Herder," in *The Encyclopedia of Philosophy*, ed. Paul Edwards (New York and London: Macmillan and Free Press, 1967), 3:487.

13. Robert Thomas Clark, *Herder: His Life and Thought* (Berkeley and Los Angeles: University of California Press, 1955), 223. "In the *Plastic Art* [*Plastik*] of 1770 there is no mention of Haller; in the *Plastic Art* of 1778, although Haller is not mentioned, there is evidence of his influence. In the 1774 draft of *Vom Erkennen und Empfinden* there is a passing mention of Haller, which is expanded in the draft of 1775; in the final printed work of 1778 Haller is made the pivot of the entire structure of Herder's psychology."

14. See the discussion in Rudolf Haym, *Herder nach seinem Leben und seinen Werken dargestellt* (Berlin: R. Gaertner, 1880), 1:663–78.

15. *Werke*, 8:15.

16. *Werke*, 8:16.

17. Johann Christoph Adelung, *Grammatisch-Kritisches Wörterbuch der Hochdeutschen Mundart*, vol. 2 (Vienna: B.Ph. Bauer, 1811), 1740. See also Grimm, *Deutsches Wörterbuch*, vol. 5 (1873), 1931f.: "da aber vermutlich die Kraft des Armes die urspr. Bed. ist, genauer die Kraft der Hand, so darf man dem dahinter versteckten Stamme die Bed. greifen, packen zutrauen (wie schon Adelung that)."

18. *Werke*, 8:169. Subsequent references will be to this volume and indicated in the text.

19. The allusion to Pygmalion reminds us of the subtitle to the *Plastik*, "Aus Pygmalions bildendem Traume," and shows to what an extent Herder's psychology and his aesthetics are a common enterprise.

20. Haller, 15.

21. Haller, 12.

22. Haller, 33.

23. Haller, 37. See also Haller's *Grundriss der Physiologie für Vorlesungen*, an adaptation of Haller's Latin physiology, ed. and trans. Samuel Thomas Sömmerring (Berlin: Haude und Spener, 1788), 441: "Denn die contractile Kraft, die bei jedem Reiz, zu welcher die Bewegung des Herzens, der Därme, und vielleicht alle Bewegungen in Menschen gehört, erfordert nicht einmal die Gegenwart

der Seele, sie bleibt in Todten zurück, wird durch mechanische Ursachen, Wärme, Blasen erweckt, und verlässt die Fiber nicht, so lange als sie noch nicht durch Erkältung steif geworden, obgleich die Verderbung des Gehirns die Seele, welche vernimmt und will, längst verjagt hat, und der Muskel des Herzens aus dem Leibe selbst gerissen, und von allem nur denkbaren Sitz der Seele getrennt ist."

24. Herder's "misreading" should be understood in the context of a "productive misreading," along lines similar to those developed by Harold Bloom in *The Anxiety of Influence* and *A Map of Misreading*.

25. Haller, *Grundriss*, 441.

26. Haller, 33.

27. Haller, 34.

28. It is interesting to note how the Philoctetes image, so important in the *Ursprung* essay, unmistakeably crops up here.

29. Haller, 13.

30. Karoline Herder, *Erinnerungen aus dem Leben Johann Gottfried Herders* (1820), quoted in *Johann Gottfried Herder, Sein Leben in Selbstzeugnissen, Briefen und Berichten*, ed. Hans Reisiger (Berlin: Propyläen, 1942).

31. Herder, *Abhandlung über den Ursprung der Sprache* (Stuttgart: Reclam, 1966), 26. Subsequent references to this edition will be documented in the text.

32. Liliane Weissberg, "Language's Wound: Herder, Philoctetes, and the Origin of Speech," *MLN* 104:3 (1989), 548–79.

33. Grimm, 1:88.

34. Adelung, 1:972.

35. Grimm, 1:88.

36. *Werke*, 3:13.

37. Weissberg, 566.

38. Weissberg, 573.

39. See Weissberg's account of his Strasbourg time, 567–71.

40. Weissberg, 578.

41. See Herder's letter to Merck, letter 109 in *Herder Briefe*, 1:267f.: "Siehe! es naht schon meinem rothen dämmernden Auge / das Messer des Schmerzes und des Heils! ein Lichtstral, tödtend und belebend!" See also his letter to Karoline, February/March 1771: "Erlauben Sie, dass ich Ihnen vor dies mal nur ein paar Zeilen schreibe. . . . Ich schone meine matten blauen Augen,— das Licht thut mir wehe!" By "Zeilen" he means a few lines of verse, which then follow: "Mattes Auge, du trübst! / fliehst vom Stral ins Dunkle, / birgst dich, leidendes Auge, / ins Dunkle!" etc..

42. *Briefe*, letter 138, 1:319f.

43. Ovid's *Metamorphoses*, book 10. For other treatments of Pygmalion in the eighteenth century see Heinrich Dörrie, *Pygmalion: Ein Impuls Ovids und seine Wirkungen bis in die Gegenwart* (Opladen: Westdeutscher Verlag, 1974).

44. *Werke*, 8:17f. Subsequent references will be to this volume and documented in the text.

45. There is an excellent and sustained argument regarding the connection between sexuality and touch in Sander Gilman's *Sexuality: An Illustrated History* (New York: John Wiley and Sons, 1989). See especially the chapters entitled "Icons of Sexuality in European Seventeenth-Century Art and Science" and "Goethe's Touch."

46. See Clark, *Herder: His Life and Thought*, 201ff. Whether Goethe meant to satirize Herder in this short play is still disputed. Clark notes that the play satirizes two ideas that can safely be called Herder's: "Herder's primitivism and his use of the conception of 'Kraft.'" Moreover there is the coincidence of the name of the woman who falls in love with the satyr, Psyche, the nickname of Herder's Karoline. I would merely add that the play begins as a parody of both the *Philoctetes* and Herder's *Abhandlung*. Before the satyr/Herder enters the stage, the audience hears from afar: "U! U! Au! Au! Weh! Weh! Ai! Ai!" and the hermit who will help the satyr says: "Welch ein erbärmlich Wehgeschrei! / Muss eine verwund'te Besti' sein." The satyr, it turns out, has broken his leg.

47. As early as 1776 Herder was working on a translation and treatise on the Song of Songs. In 1778, the same year as the *Plastik* and *Vom Erkennen und Empfinden* appear, Herder publishes *Lieder der Liebe: Die ältesten und schönsten aus Morgenland: Nebst vier und vierzig alten Minneliedern*. Against the scruples of the time, Herder insists that the songs are what they seem to be—erotic. R. Haym was the first (and the only) one to remark the connection between *Plastik* and the Song of Songs. He says: "Eine bisher noch nicht erwähnte Eigenthümlichkeit [der *Plastik*] besteht in den zahlreichen Beziehungen, die der Verfasser, in seiner Beschreibung und Ausdeutung der menschlichen Lieblichkeit, auf biblische Vorstellungen, namentlich auf die poetischen Anschauungen des Hohenliedes nimmt." See Haym, 83f.

48. A rather loose paraphrase of Hamlet, whose "all trivial fond records / all laws of books" includes no reference to painted images.

49. The "ivory" of the Song of Solomon is intertextually joined to Ovid's rendering of the Pygmalion story. His statue was made of ivory. (I am grateful to Michael Fried for pointing this out.)

50. I wish to mention an outstanding essay on the *Plastik* by Dorothea E. von Mücke entitled "Pygmalion's Dream in Herder's Aesthetics, or Male Narcissism as the Model for *Bildung*" (*Studies in Eighteenth Century Culture*, vol. 18 (Madison: University of Wisconsin Press, 1989). In many respects her reading runs parallel to mine. She argues that Greek sculpture, not only in Herder, "functions . . . as a vehicle for a specific form of denial. The unpleasant facts (the mortality of the body, poverty, disease and suffering) are not repressed, but their acknowledgement is strangely suspended, held at bay by a more pleasant perception (the beauty and immortality of man's ideal and soul)." As for Herder, his "Pygmalion relates to the sculpture in terms of a complex

narcissistic structure. The erotic attraction towards an other is replaced by a desire for an ideal self, the statue is to endow Pygmalion with the form of his own soul." Where I disagree with von Mücke is in assessing the earnestness of Herder's attempt to approach the body. For her the "figure" of "passing out" would be meaningless since Herder is stuck in a structure of male narcissism even before he begins. This is what allows her to say that "[i]n a way, it is not even quite correct to speak of tactile sensations with regard to the latter [the *Plastik*]. The feeling which Herder discusses in his writing on sculpture is not localized in the fingertips feeling the texture of a surface, but means the total comprehension of the spatial form, of the body's organization in space, the *Körpergefühl* (body feeling) which provides the beholder with a comprehensive notion of an organized totality." I believe I have shown that the *Plastik* really does begin with the sense of touch and that spatial and visual comprehension depend on it.

Chapter Five

It should be noted of the epigraph that the word *romanhaft* at that time could mean both pertaining to the novel and pertaining to an amorous affair. Nor should we fail to note the cross in *durchkreuzen* or the *Reiz* in *reizen*.

1. Letter to J. H. Campe, 20 Jan. 1787, *Werke*, 2:863.
2. Letter to Goethe 14 May, 1821.
3. Letter to Campe, 20 Jan., 1787, *Werke*, 2:863.
4. Friedrich Noack, *Deutsches Leben in Rom: 1700 bis 1900* (Stuttgart and Berlin: J. G. Cotta'schen Buchhandlung Nachfolger, 1907).
5. Robert Minder, *Glaube, Skepsis und Rationalismus: Dargestellt aufgrund der autobiographischen Schriften von Karl Philipp Moritz* (Frankfurt am Main: Suhrkamp, 1974).
6. Mark Boulby, *Karl Philipp Moritz: At the Fringe of Genius* (Toronto: University of Toronto Press, 1979).
7. Raimund Bezold, *Popularphilosophie und Erfahrungsseelenkunde im Werk von Karl Philipp Moritz* (Würzburg: Königshausen and Neumann, 1984).
8. This has become virtually a commonplace in the recent literature on Moritz. Two examples are Erman Waniek's article, "Karl Philipp Moritz's Concept of the Whole in His 'Versuch einer Vereinigung . . .' (1785)," in *Studies in Eighteenth-Century Culture*, vol. 12, ed. Harry C. Payne (Milwaukee: University of Wisconsin Press, 1983) and the article by Martha Woodmansee, "The Interests in Disinterestedness: Karl Philipp Moritz and the Emergence of the Theory of Aesthetic Autonomy in Eighteenth-Century Germany," in *Modern Language Quarterly* 45 (1984).
9. Elaine Scarry, *The Body in Pain* (New York: Oxford University Press, 1985). In the section called "The Structure of Torture," she writes: "It is the intense pain that destroys a person's self and world, a destruction experienced spatially

as either the contraction of the universe down to the immediate vicinity of the body or as the body swelling to fill the entire universe. Intense pain is also language-destroying: as the content of one's world disintegrates, so the content of one's language disintegrates; as the self disintegrates, so that which would express and project the self is robbed of its source and its subject" (35).

10. Scarry lends words to the silent voice of the victim who "confesses" under interrogation: "To assent to words that through the thick agony of the body can be only dimly heard, or to reach aimlessly for the name of a person or a place that has barely enough cohesion to hold its shape as a word and none to bond it to its worldly referent, is a way of saying, yes, all is almost gone now, there is almost nothing left now, even this voice, the sounds I am making no longer form my words but the words of another" (35).

11. There are excellent discussions of the cultural meanings of rape in *Rape: An Historical and Social Enquiry*, edited by Sylvana Tomaselli and Roy Porter (New York: Basil Blackwell, 1989).

12. *Werke*, 1:299f.

13. *Werke*, 1:302.

14. *Werke*, 1:302.

15. This is, of course, the problematic treated by Harold Bloom in *The Anxiety of Influence*, though the "victim's discourse" is not among those "ratios" which he analyzes. As Bloom writes: "My concern is only with strong poets, major figures with the persistance to wrestle with their strong precursors, even to the death" (5).

16. Goethe, *Werke* (Hamburg: Christian Wegner = Hamburger Ausgabe, 1961), 11:534.

17. In terms of rape, these moments could be compared to "rape-free" cultures and "rape-prone" cultures as discussed in "Rape and the Silencing of the Feminine" by Peggy Reeves Sanday in *Rape: An Historical and Social Enquiry*.

18. This is the main project of the last section of "Über die bildende Nachahmung." See Thomas P. Saine, *Die Ästhetische Theodizee* (Munich: Wilhelm Fink, 1971), 161–73.

19. Letter to Charlotte, 14 Dec. 1786, *Tagebücher und Briefe Goethes aus Italien* (Weimar: Goethe Gesellschaft, 1886), 236f.

20. *Briefe*, 236.

21. *Briefe*, 235.

22. *Briefe*, 242.

23. Dated 6 Jan. 1787. *Briefe*, 246f.

24. Interestingly, the one successful theater role that Reiser plays is that of a woman, "Clelie, d[ie] Geliebte[] des Medon" (396ff).

25. Herder, *Briefe*, 116.

26. Letter of 21 Feb. 1789, *Briefe*, 116.

27. Referring to the letter of Herder which we quoted, Mark Boulby writes: "He [Herder] goes on to accuse Moritz of nothing less than 'idolatry,' a word he

may well have felt entirely appropriate if he had once heard him calling Goethe, as was his habit, 'God' " (187). Boulby provides no reference for this.

28. Boulby does both, 187–88.
29. Letter to Goethe, *Werke*, 2:887.
30. *Werke*, 2:887.
31. *Werke*, 2:888f.
32. *Werke*, 2:889.
33. Bezold, 84–102.
34. Salomon Maimon, *Gesammelte Werke* (Hildesheim: n.p., 1965- 76), 4:619.
35. For the definition of *hypographé* and its related forms I have referred to Liddell & Scott's *Greek-English Lexicon*.
36. Compare the structure of "dictation" as developed by Avital Ronell in *Dictations: On Haunted Writing* (Bloomington: Indiana University Press, 1986).
37. It would not be out of place to recall Michael Fried's treatment of the scalpel in Dr. Gross's hand in *Realism, Writing, Disfiguration: On Thomas Eakins and Stephen Crane* (Chicago: University of Chicago Press, 1987), 87f. and throughout.
38. Paul de Man, "Hypogram and Inscription," in *The Resistance to Theory*, ed. Wlad Godzich (Minneapolis: University of Minnesota Press, 1986), 44.
39. De Man then goes on to problematize the hypogram insofar as prosopopeia "means to *give* a face" and involves all the uncertainties connected with writing and inscription.
40. Moritz, *Schriften zur Ästhetik und Kunst*, ed. Hans Joachim Schrimpf (Tübingen: Max Niemeyer, 1962), 93. Subsequent references will be to this edition and documented in the text.
41. Ovid, *The Metamorphoses*, trans. Horace Gregory (New York: Viking Press, 1959), 179.
42. Remember Moritz's use of the word *weben* in his letter to Goethe.
43. Compare "Über die Allegorie" (1789) in *Schriften*: "Das wahre Schöne besteht aber darin, dass eine Sache bloss sich selbst bedeute, sich selbst bezeichne, sich selbst umfasse, ein in sich vollendetes Ganze sey" (113).
44. Todorov writes: "We might say, then, that all the characteristics of a work of art are concentrated in a single notion, which the romantics will later call *symbol*. But Moritz still uses this word in its old meaning (that of arbitrary sign), and in fact he has no term to designate this characteristic signifying capacity of art; he settles for beauty, art, mythology. On the other hand, he does have a term designating the opposite of symbol (and in this he will be followed by other romantics): *allegory*" (161). For a systematic presentation of the coordinates of the symbol-allegory debate in German Romanticism see Michael Titzmann, "Allegorie und Symbol im Denksystem der Goethezeit," in *Formen und Funktionen der Allegorie*, ed. Walter Haug (Stuttgart: Metzler, 1979).
45. Todorov, 161.
46. W. J. T. Mitchell, "Space and Time: Lessings *Laocoon* and the Politics of

Genre," in *Iconology: Image, Text, Ideology* (Chicago: University of Chicago Press, 1986).

47. In other circumstances I would try to avoid gender discrimination. In this chapter, however, it seems the juster course to remain with the "he" of male discourse.

48. His thinking about nature as reflected in "Die Signatur" as well as in "Über die bildende Nachahmung" is strongly influenced by Goethe, who used Moritz as a sounding board for his theory on the morphology of plants. See Goethe's *Italienische Reise*, 405, (September 1787).

49. Interestingly, Moritz calls his fall from the horse a *Zufall.* "meine Wanderungen in Rom, die ich Ihnen zu beschreiben anfing, sind durch einen widrigen Zufall eine Zeitlang unterbrochen worden" (*Reisen eines Deutschen in Italien*, 201). The *Zufall* stripped him of his ability to communicate, stripped him of his *Bestimmtheit*, and made him entirely reliant on Goethe to restore him to himself and to language. We must also remember that the fall from a horse, together with the fence-climbing accident, was one of the most common euphemisms for the surgical castration of young boys.

50. One can never be sure whose knife, whose name, whose body. This can be seen in a contemporary version of the image of the tree-carving shepherd in the film *Sid and Nancy*, where Sid Vicious inscribes Nancy's name on his own chest with a razor.

51. Compare Lavater's descriptive poem of a portrait of Goethe by Johann Heinrich Lips: "Voll Verachtungskraft und zerschmetternder Stärke die Lippe."

Chapter Six

1. A. L. Hirt, "Laokoon," *Die Horen* 3 (1797), 16.
2. See the "Kommentar" to Goethe, *Sämtliche Werke* 4.2, ed. Karl Richter (Munich: Hanser, 1986), 973.
3. Goethe, "Über Laokoon" in *Sämtliche Werke*, 4.2:74. Translated as "On the Laocoon Group," *Essays on Art and Literature*, 16. All subsequent references to the essay will be to these editions and are indicated in the paper by page numbers in parentheses.
4. Lachmann, 9:19.
5. Lachmann, 9:20.
6. The eighteenth century was very significant for advances in the understanding of electricity. Shortly before Goethe's birth the "Leiden jar" was fashioned, a device for storing and releasing electricity. The various scientists involved made these advances only by experiencing the effects of electricity on their own bodies. Johann Heinrich Winkler, one of Goethe's professors in Leipzig, on one occasion loaded the device to such a degree "dass er den Schlag sehr schmerzhaft fühlte; mehrere Tage fühlte er sich angegriffen und litt infolge dessen an Nasenbluten, was ihm sonst fremd war, besonders in den Gelenken war eine derartige Erschütterung eingetreten, dass er acht Tage

lang nicht hatte schreiben können; fast noch angegriffener war seine Frau von solchen Erschütterungen, sie hatte mehrere Tage in Bette zubringen müssen." See Edm. Hoppe, *Geschichte der Elektrizität* (Leipzig: Johann Ambrosius Barth, 1884), 19f. Goethe reports an unsuccessful childhood attempt to construct an "Elektrisiermaschine" in *Dichtung und Wahrheit*, part 1, book 4. The inventory of the contents of his home after his death shows that he had been in possession of several Leiden jars and other electrical apparatus.

7. For a treatment of Goethe's essay under this aspect see the article by Neil Flax, "Fiction Wars of Art," in *Representations* 7 (1984). Flax sees in Goethe's essay the first expression of a formalist aesthetic, and opposes Goethe's text to Diderot (and Michael Fried).

8. Johann Georg Sulzer, "Reiz," in *Allgemeine Theorie der schönen Künste* (Leipzig: M. G. Weidmanns Erben und Reich, 1779), 4:46.

9. The translator has avoided terms from medical discourse.

10. The *Sturm* is clearly in reference to Winckelmann's metaphor.

11. *Die Propyläen.*

12. Paul de Man once called this statue "a miniature *Laokoon*, a version of the neoclassical triumph of imitation over suffering, blood, and ugliness." See "Aesthetic Formalization: Kleist's *Über das Marionettentheater*," in *The Rhetoric of Romanticism* (New York: Columbia University Press, 1984), 280.

13. It is difficult to overlook the similarity this statement and the concern with *Geschlossenheit* in general bear to the project pursued by Michael Fried in his *Absorption and Theatricality: Painting and the Beholder in the Age of Diderot* (Berkeley: University of California Press, 1980).

14. Georg Wilhelm Friedrich Hegel, *Vorlesungen über die Ästhetik*, 2 vols. (Berlin: Aufbau Verlag, 1985), 417.

15. G. W. F. Hegel, *Aesthetics: Lectures on Fine Art*, trans. T. M. Knox (Oxford: Clarendon Press, 1975), 1:431.

16. Hegel, 413 (427); his emphasis. There are, of course, other statements to be found in Hegel that qualify the completely adequate relation between exterior and interior. "Die seligen Götter trauern gleichsam über ihre Seligkeit und Leiblichkeit," Hegel says, because they seem to anticipate that the perfection they now enjoy will dissolve in history.

17. See A. L. Hirt's essay, "Laokoon," *Die Horen*, 3 (1797) and his "Nachtrag zum Laokoon" in 12 (1797). Hirt's essay, of course, was the primary occasion for Goethe's.

18. This was Hirt's objection in the "Nachtrag zum Laokoon": "Aber lasst uns auf einen Augenblick eine Bändigung des Affectes, eine Bemeisterung, ein Moderiren des Ausdruckes annehmen Jedem äussern Ausdruck correspondiert ein Affect in der Seele: wenn aber der Künstler den äussern nicht markiert, wie kann man den innern errathen?" (26).

19. William Hogarth, *The Analysis of Beauty*, ed. Joseph Burke (Oxford: Oxford University Press, 1953).

20. Aristotle, *Poetics*, trans. Ingram Bywater, *The Basic Works of Aristotle*, ed. Richard McKeon (New York: Random House, 1941) 1452a, ll. 1–2.
21. Wolfgang Schadewaldt, "Furcht und Mitleid?" in *Antike und Gegenwart: Über die Tragödie* (Munich: DTV, 1966), 16.
22. Lessing, *Hambürgische Dramaturgie*, sections 74–75, in *Lessings Werke*, vol. 2, ed. Kurt Wölfel (Frankfurt am Main: Insel, 1967).
23. *Hambürgische Dramaturgie*, 417.
24. Aristotle, 1453b, ll. 1–6. The translator, Ingram Bywater, actually uses the word horror where I have substituted fear; he is, in other words, inconsistent in his translation of *phobos*.
25. See "Gegenwart und Vergangenheit," in *Schriften*, ed. Schrimpf, 58; also *Andreas Hartknopf: Eine Allegorie*, 1:406; *Predigerjahre*, 1:500–501 in Moritz, *Werke*; and "Die metaphysische Schönheitslinie," *Schriften*, 151–57.
26. *Werke*, 1:501.
27. *Werke*, 1:517.
28. *Werke*, 1:518.
29. *Werke*, 1:303f.
30. *Schriften*, 248f.
31. Contemporary etymology derives *Reiz* from *reissen*.

Conclusion

1. Fried, *Realism*, 64f.
2. This dynamic is described by Fried, *Realism*, 61f.
3. Fried, *Realism*, 62.
4. Fried, *Realism*, 43f.
5. For an extensive survey of the tradition of physiognomy in both the eighteenth and nineteenth centuries see Graeme Tytler, *Physiognomy in the European Novel* (New Jersy: Princeton University Press, 1982).
6. Duchenne, vii.
7. Paul-Jules-Louis Guilly, *Duchenne de Boulogne* (Paris: J.-B. Baillière et Fils, 1936), 198.
8. Guilly, 198.
9. Quoted in Guilly, 204f.
10. Quoted in Guilly, 207.
11. Linda Nochlin, *Realism* (Baltimore: Penguin, 1971), 44.

WORKS CONSULTED

Primary Works

Aristotle. *The Basic Works of Aristotle.* Ed. Richard McKeon. New York: Random House, 1941.

Duchenne du Boulogne. *Mécanisme de la physionomie humaine ou analyse électro-physiologique de l'expression des passions.* Paris, 1862.

Goethe, Johann Wolfgang. *Sämtliche Werke.* Ed. Karl Richter. Munich: Hanser, 1986. 21 vols.

Haller, Albrecht. *Grundriss der Physiologie für Vorlesungen.* Trans. Samuel Thomas Sömmering. Berlin: Haude und Spener, 1788.

———. *Von den empfindlichen und reizbaren Teilen des menschlichen Körpers.* Ed. Karl Sudhoff. Leipzig: Johann Ambrosius Barth, 1922.

Hegel, Georg Wilhelm Friedrich. *Ästhetik.* Ed. Friedrich Bassenge. Berlin: Das Europäische Buch, 1985. 2 vols.

Heinse, Wilhelm. *Ardinghello und die glückseligen Inseln: Kritische Studienausgabe.* Ed. Max L. Baeumer. Stuttgart: Philipp Reclam, 1985.

Herder, Johann Gottfried. *Briefe.* Ed. Wilhelm Dobbek and Günter Arnold. Weimar: Hermann Böhlhaus Nachfolger, 1977.

———. *Herders Sämmtliche Werke.* Ed. Bernhard Suphan. Berlin: Weidmannsche Buchhandlung, 1877–1913. 33 vols.

Heyne, Christian Gottlob. *Sammlung antiquarischer Aufsätze.* Leipzig: Weidmanns Erben und Reich, 1779. 2 vols.

Hirt, Aloys Ludwig. "Laokoon." *Die Horen* 3 (1797).

———. "Nachtrag zum Laokoon im zehnten Stück." *Die Horen* 12 (1797).

Hogarth, William. *The Analysis of Beauty.* Ed. Joseph Burke. Oxford: Oxford University Press, 1953.

Kant, Immanuel. *Kritik der Urteilskraft.* Ed. Wilhelm Weischedel. Frankfurt am Main: Suhrkamp, 1974.

Lessing, Gotthold Ephraim. *Sämtliche Schriften.* Ed. Karl Lachmann. Stuttgart: G. J. Göschen'sche Verlags Handlung, 1895. 23 vols.

Maimon, Salomon. *Gesammelte Werke.* Hildesheim: n.p., 1965–76. 4 vols.

Moritz, Karl Philipp. *Schriften zur Ästhetik und Poetik.* Ed. Hans Joachim Schrimpf. Tübingen: Max Niemeyer, 1962.

———. *Werke.* Ed. Horst Günther. Frankfurt am Main: Insel, 1981. 3 vols.

Ovid. *Metamorphoses.* Trans. Frank Justus Miller. Cambridge: Harvard University Press, Loeb Classical Library, 1977. 2 vols.

Pliny. *Natural History.* Trans. H. Rackham. Cambridge: Harvard University Press, Loeb Classical Library, 1979. 10 vols.

Ramdohr, Friedrich v. *Über Mahlerei und Bildhauerkunst in Rom für Liebhaber des Schönen in der Kunst.* Leipzig: Weidmanns Erben und Reich, 1787.

Schiller, Friedrich. *Werke, Nationalausgabe.* Ed. Benno von Wiese. Weimar, 1963. 30 vols.

Sulzer, Johann Georg. *Allgemeine Theorie der schönen Künste.* Leipzig: Weidmanns Erben und Reich, 1799. 4 vols.

Winckelmann, Johann Joachim. *Briefe.* Ed. Walther Rehm. Berlin: Walter de Gruyter, 1952. 4 vols.

———. *Geschichte der Kunst des Alterthums.* Dresden: Walter, 1764.

———. *Sämtliche Werke.* Ed. Joseph Eiselein. 1825. Osnabrück: Otto Zeller, 1965. 11 vols.

———. *Werke.* Ed. C. L. Fernow (vols. 1 and 2) and Heinrich Meyer and Johann Schulze. Dresden: Walter, 1808–25. 11 vols.

Secondary Works

Amelung, Walther. *Die Sculpturen des Vaticanischen Museums.* Berlin: Georg Reimer, 1908. 2 vols.

Andreae, Bernd. *Laokoon und die Gründung Roms.* Mainz am Rhein: Philipp von Zabern, 1988.

Aurnhammer, Achim. *Androgynie: Studien zu einem Motiv in der europäischen Literatur.* Cologne: Böhlau, 1986.

Begenau, S. H. *Zur Theorie des Schönen in der klassischen deutschen Ästhetik.* Heidenau: VEB Mitteldeutsche Kunstanstalt, n.d.

Benjamin, Walter. *Ursprung des deutschen Trauerspiels.* Frankfurt am Main: Suhrkamp, 1982.

Bezold, Raimund. *Popularphilosophie und Erfahrungsseelenkunde im Werk von Karl Philipp Moritz.* Würzburg: Königshausen and Neumann, 1984.

Bieber, Margarete. *Laocoon: The Influence of the Group since Its Rediscovery.* New York: Columbia University Press, 1942.

Blanchot, Maurice. *The Gaze of Orpheus.* Trans. Lydia Davis. Ed. P. Adams Sitney. Barrytown: Station Hill, 1981.

Blankenhagen, Peter Heinrich v. "Laokoon, Sperlonga und Vergil." *Archäologischer Anzeiger* 84 (1969).

Bloom, Harold. *The Anxiety of Influence.* New York: Oxford University Press, 1981.

Blümner, Hans. "Marsyas." In *Denkmäler des Klassischen Altertums.* Ed. A. Baumeister. Munich and Leipzig: R. Oldenbourg, 1887. 2 vols.

Bosshard, Walter. *Winckelmann: Aesthetik der Mitte.* Zürich: Artemis, 1960.

Boulby, Mark. *Karl Philipp Moritz: At the Fringe of Genius* Toronto: University of Toronto Press, 1979.

Brunn, Heinrich. *Kleine Schriften*. Leipzig: G. B. Teubner, 1898. 2 vols.

Bürger, Christa. *Der Ursprung der bürgerlichen Institution Kunst*. Frankfurt am Main: Suhrkamp, 1977.

Butler, E. M. *The Tyranny of Greece over Germany*. Boston: Beacon, 1958.

Chrobok, Paul. *Die ästhetischen Grundgedanken von Herders Plastik in ihrem Entwicklungsgange*. Hamburg: H. Sieling, 1906.

Clark, Kenneth. *The Nude: A Study in Ideal Form*. Garden City, N.Y.: Doubleday Anchor, 1956.

Clark, Robert Thomas. *Herder. His Life and Thought*. Berkeley and Los Angeles: University of California Press, 1955.

———. "Herder's Conception of 'Kraft.'" *PMLA* 57:3 (1942), 737–52.

de Man, Paul. *Blindness and Insight: Essays in the Rhetoric of Contemporary Criticism*. New York: Oxford University Press, 1971.

———. *The Resistance to Theory*. Ed. Wlad Godzich. Minneapolis: University of Minnesota Press, 1986.

———. *The Rhetoric of Romanticism*. New York: Columbia University Press, 1984.

Dörrie, Heinrich. *Pygmalion: Ein Impuls Ovids und seine Wirkungen bis in die Gegenwart*. Opladen: Westdeutscher Verlag, 1974.

Durden, William G. "Parallel Designs: Space, Time and Being in Karl Philipp Moritz's *Anton Reiser*." *The Germanic Review* 54 (1979).

Enright, Dennis Joseph, ed. *Fair of Speech: The Uses of Euphemism*. New York: Oxford University Press, 1985.

Flax, Neil. "Fiction Wars of Art." *Representations* 7 (1984).

———. "From Portrait to *Tableau Vivant*: The Pictures of *Emilia Galotti*." *Eighteenth-Century Studies* 19:1 (1985), 39–55.

Frazer, J. G., trans. *Pausanias's Description of Greece*. New York: Biblo and Tannen, 1965. 4 vols.

Fried, Michael. *Absorption and Theatricality: Painting and the Beholder in the Age of Diderot*. Berkeley: University of California Press, 1980.

———. "Antiquity Now: Reading Winckelmann on Imitation." *October* 37 (1986), 87–97.

———. *Realism, Writing, Disfiguration: On Thomas Eakins and Stephen Crane*. Chicago: University of Chicago Press, 1987.

Fugate, Joe K. *The Psychological Basis of Herder's Aesthetics*. The Hague and Paris: Mouton, 1966.

Gaehtgens, Thomas W., ed. *Johann Joachim Winckelmann, 1717–1768*. Hamburg: Felix Meiner, 1986.

Gardiner, Patrick. "Johann Gottfried Herder." *The Encyclopedia of Philosophy*. Ed. Paul Edwards. New York and London: Macmillan and Free Press, 1967.

Gebauer, Gunther, ed. *Das Laokoon Projekt: Pläne einer semiotischen Ästhetik*. Stuttgart: J. B. Metzler, 1984.

Gebhardt, Martin. *Goethe als Physiker*. Berlin: G. Grote, 1932.

Gerber, Gustav. *Die Sprache als Kunst.* Berlin: R. Gaertner, 1885. 2 vols.

Gilman, Sander. *Sexuality: An Illustrated History.* New York: John Wiley and Sons, 1989.

Groddeck, Georg Walther. *Psychoanalytische Schriften zur Psychosomatic.* Ed. Günter Clauser. Wiesbaden: Lime, 1966.

Guilly, Paul-Jules-Louis. *Duchenne de Boulogne.* Paris: J.-B. Baillière et Fils, 1936.

Haböck, Franz. *Die Kastraten und ihre Gesangkunst.* Stuttgart: Deutsche-Verlags Anstalt, 1927.

Haskell, Francis, and Nicholas Penny. *Taste and the Antique.* New Haven: Yale University Press, 1982.

Häsler, Berthold, ed. *Beiträge zu einem neuen Winckelmannbild.* Berlin: Akademie, 1973.

Hatfield, Henry Caraway. *Winckelmann and His German Critics 1755–1781.* New York: King's Crown, 1943.

———. "Winckelmann: The Romantic Element." *The Germanic Review* 28 (1953).

Haym, Rudolf. *Herder nach seinem Leben und seinen Werkendargestellt.* Berlin: Rudolf Gaertner, 1880. 2 vols.

Heckscher, William S. *Rembrandt's Anatomy of Dr. Nicolaas Tulp.* New York: New York University Press, 1958.

Heise, Wolfgang. "Winckelmann und die Aufklärung." In *Beiträge zu einem neuen Winckelmannbild.* Ed. Berthold Häsler. Berlin: Akademie, 1973.

Heres, Gerald. "Jupiter und Ganymed, 'das schönste Gemälde aus dem Altertume.' " In *Winckelmann und Oeser.* See Kunze, ed.

Hofmann, Werner. *Marsyas und Apoll.* Munich: Georg D. W. Callwey, 1973.

Hoppe, Edm. *Geschichte der Elektrizität.* Leipzig: Johann Ambrosius Barth, 1884.

Irmscher, Hans Dietrich. "Mitteilungen aus Herders Nachlass." *Euphorion* 54 (1960), 281–94.

Jacobs, Carol. "The Critical Performance of Lessing's *Laokoon.*" *MLN* 102:3 (1987).

Jauss, Hans Robert. *Literatur Geschichte als Provokation.* Frankfurt am Main: Suhrkamp, 1970.

Jones, H. Stuart. "The Chest of Kypselos." *Journal of Hellenic Studies* 14 (1894).

Justi, Carl. *Winckelmann und seine Zeitgenossen.* 3rd ed. Leipzig: F. C. W. Vogel, 1923. 3 vols.

Käfer, Markus. *Winckelmanns hermeneutische Prinzipien.* Heidelberg: Carl Winter, 1986.

Knodt, Eva. *"Negative Philosophie" und dialogische Kritik : Zur Struktur poetischer Theorie bei Lessing und Herder.* Tübingen: Max Niemeyer V, 1988.

Kultermann, Udo. *Geschichte der Kunstgeschichte.* Frankfurt am Main: Ullstein, 1981.

Kunze, Max. "Winckelmann und Oeser." In *Winckelmann und Oeser.* See Kunze, ed.

———, ed. *Johann Joachim Winckelmann und Adam Friedrich Oeser.* Stendal: Beiträge der Winckelmann Gesellschaft, 1977.

Lange, Victor. "Goethe im Glashaus: Klassizistische Kunstmassstäbe, Altdeutsche Kunst und Neudeutsches Künstlerwesen." In *Heidelberg im säkularen Umbruch.* Ed. Friedrich Strack. Stuttgart: Klett-Cotta, 1987.

Langen, August. "Karl Philipp Moritz' Weg zur symbolischen Dichtung." *Zeitschrift für deutsche Philologie* 81 (1962).

Lee, Rensselaer W. *Ut pictura poesis: The Humanistic Theory of Painting.* New York: Norton, 1967.

Leppmann, Wolfgang. *Winckelmann: Ein Leben für Apoll.* Frankfurt am Main: Fischer, 1986.

Lesky, Albin. *Alkestis: Der Mythos und das Drama.* Vienna and Leipzig: Hölder, Pichler and Tempsky, 1925.

———. *A History of Greek Literature.* Trans. James Willis and Cornelis de Heer. New York: Thomas Y. Crowell, 1966.

Liebert, Robert S. *Michelangelo: A Psychoanalytic Study of his Life and Images.* New York: Yale University Press, 1983.

Meinecke, Friedrich. *Die Entstehung des Historismus.* Munich: R. Oldenbourg, 1959.

Minder, Robert. *Glaube, Skepsis und Rationalismus: Dargestellt aufgrund der autobiographischen Schriften von Karl Philipp Moritz.* Frankfurt am Main: Suhrkamp, 1974.

Mitchell, W. J. T. *Iconology: Image, Text, Ideology.* Chicago: University of Chicago Press, 1986.

———, ed. *The Language of Images.* Chicago: University of Chicago Press, 1980.

Moser, Hans Joachim. *Musik Lexikon.* Berlin: Max Hess, 1935.

Mücke, Dorothea E. v. "Pygmalion's Dream in Herder's Aesthetics, or Male Narcissism as the Model for *Bildung.*" In *Studies in Eighteenth-Century Culture.* Vol. 18. Madison: University of Wisconsin Press, 1989.

Müller, Lothar. *Die kranke Seele und das Licht der Erkenntnis. Karl Philipp Moritz' Anton Reiser.* Frankfurt am Main: Atheneum, 1987.

Neumann, Erich. *The Great Mother: An Analysis of the Archetype.* Trans. Ralph Manheim. Princeton: Princeton University Press, 1974.

Nisbet, H. B. *Herder and Scientific Thought.* Cambridge, Great Britain: Modern Humanities Research Association, 1970.

Noack, Friedrich. *Deutsches Leben in Rom: 1700 bis 1900.* Stuttgart and Berlin: J. G. Cotta, 1907.

Nochlin, Linda. *Realism.* Baltimore: Penguin, 1971.

Pacteau, Francette. "The Impossible Referent: Representations of the Androgyne." In *Formations of Fantasy.* Ed. Victor Burgin, James Donald, and Cora Kaplan. New York: Methuen, 1986.

Pater, Walter. *The Renaissance.* New York: New American Library, 1959.

Pelzel, Thomas. "Winckelmann, Mengs and Casanova: A Reappraisal of a Famous Eighteenth-Century Forgery." *Art Bulletin* 54 (1972), 300–15.

Raffalt, Reinhart. *Sinfonia Vaticana.* Munich: Prestel, 1966.

Redig de Campos, D., ed. *Art Treasures of the Vatican*. Englewood Cliffs: Prentice-Hall, 1974.

Rehm, Walter. *Götterstille und Göttertrauer*. Bern: A. Francke, 1951.

———. *Griechentum und Goethezeit: Geschichte eines Glaubens*. Leipzig: Dietrich, 1936.

———. *Der Todesgedanke in der deutschen Literatur vom Mittelalter bis zur Romantik*. Halle: Max Niemeyer, 1928.

Reisiger, Hans. *Johann Gottfried Herder. Sein Leben in Selbstzeugnissen, Briefen und Berichten*. Berlin: Propyläen, 1942.

Robert, Carl. *Bild und Lied*. Berlin: Weidmann, 1881.

———. *Thanatos*. Berlin: G. Reimer, 1879.

Ronell, Avital. *Dictations: On Haunted Writing*. Bloomington: Indiana University Press, 1986.

Rosenberg, Martin. "Raphael's *Transfiguration* and Napoleon's Cultural Politics." *Eighteenth-Century Studies* 19:2 (1985), 180–205.

Rothschuh, Karl E. *Physiologie*. Munich: Karl Alber Freiburg, 1968.

———, ed. *Von Boerhave bis Berger: Die Entwicklung der kontinentalen Physiologie im 18. und 19. Jahrhundert*. Stuttgart: Gustav Fischer, 1964.

Rousseau, G. S. "The Pursuit of Homosexuality in the Eighteenth Century: 'Utterly Confused Category' and/or Rich Repository?" In *'Tis Nature's Fault: Unauthorized Sexuality during the Enlightenment*. Ed. Robert Purks MacCubbin. New York: Cambridge University Press, 1987.

Rüdiger, Horst. "Winckelmanns Geschichtsauffassung." *Euphorion* 62:2 (1968), 99–116.

Rudolph, G. "Hallers Lehre von der Irritabilität und Sensibilität." In *Von Boerhave bis Berger*. See Rothschuh, ed.

Saine, Thomas P. *Die Ästhetische Theodizee*. Munich: Wilhelm Fink, 1971.

Saslow, James M. *Ganymede in the Renaissance: Homosexuality in Art and Society*. New Haven: Yale University Press, 1986.

Saunders, Gill. *The Nude: A New Perspective*. London: Herbert, 1989.

Scarry, Elaine. *The Body in Pain*. New York: Oxfod University Press, 1985.

Schadewaldt, Wolfgang. *Antike und Gegenwart: Über die Tragödie*. Munich: DTV, 1966.

Schrimpf, Hans Joachim. *Karl Philipp Moritz*. Stuttgart: Metzler, 1980.

———. "Vers ist tanzhafte Rede." In *Festschrift für Jost Trier*. Ed. William Foerste and Karl Heinz Borck. Cologne: Böhlau, 1964.

Schweitzer, Bernhard. *J. G. Herders "Plastik" und die Entstehung der neueren Kunstwissenschaft*. Leipzig: E. A. Seemann, 1948.

Sichtermann, Helmut. "Der wiederhergestellte Laokoon." *Gymnasium* 70:3 (1963).

Spickernagel, Ellen. " 'Helden wie zarte Knaben oder verkleidete Mädchen': Zum Begriff der Androgynität bei Winckelmann und Angelika Kauffmann." *Frauen Weiblichkeit Schrift*. Ed. Renate Berger et al. Berlin: Argument, 1984.

Starobinski, Jean. *Wörter unter Wörtern: Die Anagramme von Ferdinand Saussure.* Trans. Henriette Beese. Frankfurt am Main: Ullstein, 1980.

Stolnitz, Jerome. "On the Origins of 'Aesthetic Disinterestedness.'" *The Journal of Aesthetics and Art Criticism* 20 (1961).

Sweet, Denis. "The Personal, the Political, and the Aesthetic: Johann Joachim Winckelmann's German Enlightenment Life." *Journal of Homosexuality* 16:3/4 (1988), 147–62.

Szondi, Peter. *Poetik und Geschichtsphilosophie.* Vol. 1: *Antike und Moderne in der Ästhetik der Goethezeit.* Frankfurt am Main: Suhrkamp, 1974.

Tammler, Wolfgang. *Wort und Bild.* Berlin: Erich Schmidt, 1962.

Thomasberger, Andreas. "Goethes Übersetzung des aristotelischen Katharsis-Begriffes im Kontext der philosophischen Aesthetik seiner Zeit." In *Goethe et les arts du spectacle.* Ed. M. Corvin. Paris, 1982.

Todorov, Tzvetan. *Theories of the Symbol.* Trans. Catherine Porter. Ithaca: Cornell University Press, 1982.

Tomaselli, Sylvana, and Roy Porter, eds. *Rape: An Historical and Social Enquiry.* New York: Basil Blackwell, 1989.

Tytler, Graeme. *Physiognomy in the European Novel.* Princeton: Princeton University Press, 1982.

Ugrinsky, Alexej, ed. *Lessing and the Enlightenment.* New York: Greenwood, 1986.

Uhlig, Ludwig. "Lessing's Image of Death and the Archaelogical Evidence." *Lessing and the Enlightenment.* See Ugrinsky, ed.

———. *Der Todesgenius in der deutschen Literatur.* Tübingen: Max Niemeyer, 1975.

Waniek, Erdmann. "Karl Philipp Moritz's Concept of the Whole in his 'Versuch einer Vereinigung . . .' (1785)." *Studies in Eighteenth-Century Culture.* Vol. 12. Ed. Harry C. Payne. Milwaukee: University of Wisconsin Press, 1983.

Weissberg, Liliane. "Language's Wound: Herder, Philoctetes, and the Origin of Speech." *MLN* 104:3 (1989), 548–79.

Wellbery, David. *Lessing's Laocoon: Semiotics and Aesthetics in the Age of Reason.* New York: Cambridge, 1984.

Wescher, P. *Kunstraub unter Napoleon.* Berlin: Mann, 1976.

Wiesener, Joseph. "Winckelmann und Hippokrates: Zu Winckelmanns naturwissenschaftlich-medizinischen Schriften." *Gymansium* 60 (1953), 149–67.

Woodmansee, Martha. "The Interests in Disinterestedness: Karl Philipp Moritz and the Emergence of the Theory of Aesthetic Autonomy in Eighteenth Century Germany." *Modern Language Quarterly* 45 (1984).

Zeller, Hans. *Winckelmanns Beschreibung des Apollo im Belvedere.*Zurich: Atlantis, 1955.

INDEX

Abstraction, 174
Achilles, 50, 53, 101
Adelung, Johann Christoph, 94, 96, 112
Aeschylus, 63; *Oresteia*, 67; *Eumenides*, 63
Aesthetic autonomy, 59, 142, 148
Aesthetics, 68; classical, 11, 131, 198
Agamemnon, 65–66, 84
Allegorical, 84, 87, 182
Allegory, 19, 22, 31, 65, 88, 148, 166, 189, 215. *See also* Symbol
Amelung, Walther, 23, 29
Analogy, 100–101, 105, 106, 115, 180–81
Anatomy lesson, 62
Anatomy table, 130
Anatomy theater, 106, 191
Andreae, Bernard, 14
Androgyne, 52
Animal experimentation, 97–98
Anmut (grace), 94, 96, 166, 172–76, 179, 181, 184, 189, 194
Antinous, statue of, 11, 29, 60
Antiphrasis, 63
Apollo, 34, 35, 130, 177; Belvedere, 11, 16, 22, 23, 29, 31, 50, 60, 164; other statues of, 53, 54; Winckelmann's description of, 35, 144, 159, 160, 162
Arctinus of Miletus, 24, 25
Ariès, Philippe, 80
Aristotle, 47, 183
Athenodoros, 13
Attis, 53, 54
Ausdruck (expression), 45, 48, 69, 169

Babbit, Irving, 68

Bandinelli, Baccio, 23
Bardasse (catamite), 41, 43, 50, 59, 154
Baroque, 14, 58, 62, 189, 192, 198, 199
Bartholomew, Saint, 129
Baudelaire, Charles, 156
Baumgarten, Alexander Gottlieb, 69
Beauty, 139, 192; classical, 10, 47, 178, 189; decentering of, 32, 33; law of, 66, 69, 128; Moritz's theory of, 147; origin of, 55; and pain, 11, 32; Winckelmann's theory of, 55–57
Belli, Giovanni, 50, 57
Belvedere fountain, 29, 33
Benjamin, Walter, 148, 189
Berendis, Hieronymus Dietrich, 49
Bernini, Gianlorenzo, 45
Bezold, Raimund, 134, 144
Blankenhagen, Peter Heinrich von, 26
Body, 68, 75, 95, 105, 106, 115, 118, 124, 127, 130, 191
Boerhaave, Hermann, 97
Boulby, Mark, 134
Brunn, Heinrich, 25, 26
Bruno, Giordano, 145
Butler, Eliza Marian, 10, 11, 199

Caffarelli, Ernesto Vergara, 26
Campe, Joachim Heinrich, 96
Casanova, Giovanni, 42, 49
Castrati, 49–52, 60, 190, 204. *See also* Eunuch
Castration, 52, 57, 59, 60, 192
Caylus, Anne-Claude-Philippe, Comte de, 76, 82

Index

Symbol, 19, 22, 31, 59, 148, 166, 215. *See also* Allegory

Temporality, 52, 71
Terror, 65
Timanthes, 65, 66, 69
Time, 56
Tischbein, Johann Heinrich Wilhelm, 132–33, 146
Titus, 13, 18, 30
Todorov, Tzvetan, 135, 148, 215
Tongue, 147, 148, 151–52, 153, 154–55, 156, 191
Touch, 113, 119–22
Transitoriness, 169, 194
Trope, 84, 89

Ugly, the, 72
Uhlig, Ludwig, 78, 81
Unbezeichnung (undesignation), 30–31, 32, 56–57, 59, 95, 109, 128, 167, 185, 190
Ut pictura poesis, 17, 19, 32, 74, 75, 78, 143, 166, 170, 180, 182, 184, 185, 192
Utopian moment, 138–39
Utopian system, 156, 157

Vatican, 9, 16, 23, 24, 33
Vergil, 19, 24, 25, 30; account of Laocoon, 17–18, 30
Victim, 68, 131, 134, 135, 138, 141, 153, 161, 162, 165
Victimage, 68, 140
Violence, 11, 57, 68, 75, 89, 95, 136, 138, 139, 150, 153, 154, 169, 191, 192, 193
Virginia, 67
Vischer, Friedrich Theodor, 22
Visibility, 32

Water: aesthetics of, 30–31, 56–57; imagery of, 58; Laocoon and, 30
Weissberg, Liliane, 107, 115–16
Wellbery, David, 69, 70, 71, 74–75, 207
Wiedeweldt, Hans, 38
Winckelmann, Johannes Joachim, 16, 17, 19, 30, 38–61, 63, 66, 123, 124–25, 190; death of, 24; description of Apollo, 35, 144; *Gedanken*, 16, 43–48, 54; *Geschichte*, 30, 31, 48–59; and Vergil, 18
Wound, 63, 143, 157

Zufall (chance), 151–52